D0428585

ALSO BY BRYAN FORBES

TRUTH LIES SLEEPING *(short stories)*
THE DISTANT LAUGHTER
INTERNATIONAL VELVET
THE SLIPPER AND THE ROSE
FAMILIAR STRANGERS
THE REWRITE MAN
THE ENDLESS GAME

Nonfiction
NOTES FOR A LIFE *(autobiography)*
NED'S GIRL: THE LIFE OF DAME EDITH EVANS
THAT DESPICABLE RACE: A HISTORY OF THE
BRITISH ACTING TRADITION

Screenplays include
THE ANGRY SILENCE
SÉANCE ON A WET AFTERNOON
KING RAT
THE WHISPERERS
THE RAGING MOON
THE L-SHAPED ROOM
THE LEAGUE OF GENTLEMEN

Teleplay
JESSIE

A SPY
AT
TWILIGHT

A SPY
AT
TWILIGHT

BRYAN FORBES

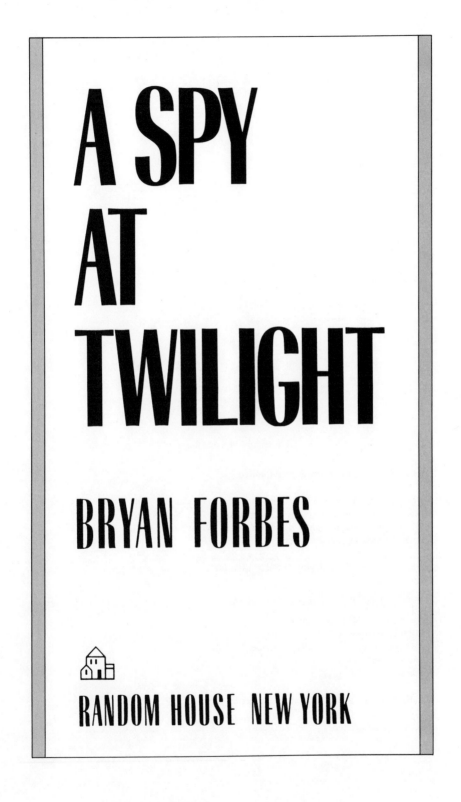

RANDOM HOUSE NEW YORK

Copyright © 1989 by Bryan Forbes Limited

All rights reserved under International and Pan-American Copyright Conventions.
Published in the United States by Random House, Inc., New York.
Originally published in slightly different form by William Collins PLC, London, as *A Song at Twilight* in 1989.

Library of Congress Cataloging-in-Publication Data
Forbes, Bryan.
 A spy at twilight/Bryan Forbes.
 p. cm.
 A sequel to: The endless game.
 ISBN 0-394-57767-1
 I. Forbes, Bryan, 1926– Endless game. II. Title.
PR6056.063S68 1990
823'.914—dc20 89-43434

Manufactured in the United States of America
98765432
First American Edition

This book is for Carol Stoll

a once great bookseller
and a dear friend
with my love

Every revolution evaporates and leaves behind only the slime of a new bureaucracy.

FRANZ KAFKA

A SPY
AT
TWILIGHT

MOST SECRET

HILLSDEN, Alec George Arthur, born 1926, educated West Ham Grammar School, married and subsequently divorced Margot Anne Willars no issue. No known political affiliations (see positive vetting records in restricted section). Served in Intelligence Corps 1944-5 obtaining war-substantive rank of Warrant Officer II. Seconded to MI6 upon demobilization and posted to Vienna station. Returned London 1950 attached D4 without special privileges. Posted to Cyprus 1952, Beirut 1954, then had spell as Military Attaché Toronto embassy with temporary rank of Major before transfer to Washington and later Bermuda. Rejoined Austrian station 1968 and remained there until 1978. During this second period formed adulterous liaison with Caroline Oates, GM (deceased/File 704/RT907 also File 709/RT/AZ re Nicolson). Returned to London (Ref: 8634/DF) until defection. Accused murder of Sir Charles Belfrage and implicated in Glanville affair. Present whereabouts U.S.S.R. Granted Soviet citizenship and given rank of Colonel in G.R.U. Case still open, refer any additional information DG only immediate. END.

Extract from entry in MI6 records

1

THE FAT BOY had not spent that Christmas in London for pleasure. Unlike Baudelaire his eyes were not drawn upward to the stars when he walked the streets, and the festive season left him unmoved. Murder was the only gift he ever gave, death the only gift he was likely to receive.

In order to meld into the landscape and prepare for his next assignation he had taken what the French call a *chambre de bonne* on the sixth floor of a building in the Brixton area, paying a month's rent in advance—just enough to satisfy the landlord's avarice. With his usual thoroughness he had assumed a new identity before entering England via the Harwich ferry at the beginning of December: his hair had been cropped and dyed a lighter color, and for weeks before he embarked he had maintained a rigid diet, shedding some twenty pounds, for he was well aware that the facile nickname the Western press had pinned on him spelled danger. He was still big, but much of the grossness had gone from his face and gut, and he wore clothes a size too large which gave the illusion of less bulk. Several times since commencing his career he had endured plastic surgery, notably to reduce his telltale bee-stung lips; the Libyan surgeon had done a reasonable job, but the wound had turned septic, leaving a scar on the upper lip that stood out on his olive complexion. He had tried a moustache, but the hair had not grown on the scar and he had resorted to blotting it out with a feminine cosmetic cream.

He had no love for London, his accidental birthplace, or for the British for that matter. Born Rojas Jorge Rejano, he had suffered nine taunted years in a succession of English private schools until his obscenely rich and despised parents had returned home to Argentina; and it was there, suffocated by affluence, that he spent his formative years, indolent at university, only graduating in hatred. By the time he was seventeen he was a concealed member of Argentina's hard-line Moscow-

oriented Communist Party. When he came of age he inherited a large trust fund set up by his grandfather and used the money to sever all filial ties, making his way to Moscow via East Germany. In Moscow he enrolled in the Patrice Lumumba University, a finishing school for subversives directed and largely staffed by the K.G.B. Regarded as promising material, his teachers sent him to Camp Matanzas in Cuba where he received further advanced training in urban guerrilla tactics, weaponry and killer karate. As with many other youthful revolutionaries of that period, he lacked the historical justification of a deprived upbringing, so he dedicated his life to the destruction of his own class. If, at the beginning, he had slavishly carried out Moscow's orders, he had long since exceeded them, disregarding individual causes, selling his lethal talents to the highest bidder and creating a unique terrorist currency to suit his own chilling philosophy. He was a whore for death, hawking his wares to a motley list of clients.

At precisely four o'clock that Boxing Day afternoon, after first donning a pair of fake pebble-lens spectacles, the Fat Boy left the room he would never return to. Outside, the city had started to come back to life. A light sprinkling of snow had fallen overnight, and the skies were still leaden. The streets had that air of quiet solemnity that always follows a day of celebration; for most people life was not quite normal but hung between the evening of pleasure and the morning, when the struggle for survival recommenced.

He carried a plastic bag of groceries and walked unnoticed and anonymous to the Oval Underground station, occasionally grimacing to himself as he picked his way past scattered piles of refuse that would not be collected until the New Year. The station booking office was likewise fouled with discarded junk-food cartons. He purchased a ticket for a distant destination before boarding the first train to arrive. After traveling a few stops he switched platforms and doubled back, repeating this maneuver twice more before he was satisfied he was not being tailed. Only then did he board a train to a district in the East End of the city.

He emerged in an area of London that had once been a prime target for the Luftwaffe. Rebuilt by planners more concerned with redrafting the political map than with following the elementary dictates of architectural form, it had lost all identity, becoming with the passing of the years a faceless wasteland. The clusters of high-rise buildings gave the appearance of having been carelessly fashioned from children's toy bricks. Many were crumbling, and the hollow postwar promise of a

4

better life for the underprivileged mocked from every broken window, every weather-soiled balcony.

Picking his way across an open piece of ground originally set aside as a children's playground, he skirted the defunct gallowslike swings, the twisted metal of a broken merry-go-round, and entered one of the tower blocks. Inside the bare concrete hallway that stank of stale beer, an old man covered with cardboard lay sleeping off the night's excesses by the side of a lift that no longer functioned. The Fat Boy walked softly, approaching each graffiti-daubed landing with caution until he reached the fourth floor. A baby was crying behind one of the row of identical doors, and he heard a man shout an obscenity to silence it.

The scarred door he knocked on was opened immediately by a slatternly-looking girl in her twenties. She wore a T-shirt emblazoned with the face of a pop star who had long since died of a heroin overdose. She welcomed him with a seasonal greeting, but he made no response, walking past her and into the main room. Removing the bogus spectacles, he scanned the room with a practiced eye, then moved to inspect the kitchen and small bedroom. Only then did he acknowledge the girl.

"You live like a pig," he said.

She shrugged. "When you live here you stay in character with your neighbors if you don't want to attract attention." There was no resentment in her voice. "You want coffee?"

He nodded and went to the window, looking down into the street without disturbing the frayed curtains. The girl watched him while boiling some water in a saucepan.

"Where is it?" the Fat Boy asked.

"In the bathroom."

A cockroach scuttled across the linoleum at his approach. Ducking under a line of washing strung across the room, he stood on the toilet seat, lifted the lid of the old-fashioned water tank and removed a small parcel wrapped in an oiled bag.

"It's clean," the girl said when he returned. Now she spoke in French. "It came in the diplomatic bag. Untraceable."

The Fat Boy swept debris from the table and carefully unwrapped the parcel, revealing a further sealed plastic bag containing a revolver fitted with a silencer. He did not answer her but dismantled the weapon and checked it thoroughly, examining every bullet, loading and reloading the magazine until satisfied that the bullets fed smoothly. Before finally replacing the magazine he tested the trigger pressure.

5

"Okay? Satisfied?" She placed a cup of black coffee in front of him.

"What car did you get?"

"A small Ford."

He grimaced as he took his first sip of coffee. "This cup smells of disinfectant." He turned the cup around and drank from the spot nearest the handle.

"Well, you wouldn't want to catch anything, would you?" she said, but the sarcasm was lost on him.

"Did you test it?"

"The cup or the car?" she answered with the same wasted irony. " 'Course I tested the car. What d'you take me for? Here!" She dropped the ignition keys on the table. "It's got a full tank of gas, the plates have been changed, and the engine and chassis serial numbers filed off."

Removing some of her clothes from the only comfortable chair, the Fat Boy sat down and checked the gun yet again. "I don't like this type. They're not a hundred percent reliable."

"It's what I was supplied with." She stared at him. "You've lost a lot of weight. I hope the clothes fit you. I went by the measurements I was given."

"Where did you buy them?"

"In Northampton a month ago. Why a jogging outfit? What's that all about—you going in for a health cure?"

"Save the jokes."

"What joke? Only trying to make conversation. I've been on my own in this bloody dump for six weeks." She lit a cigarette and held out the packet for him, but he ignored the offer. "Being on your own doesn't worry you, I suppose."

"No."

"Well, it makes me stir crazy. I hate this country."

"All the more reason to be here. When you leave make sure you take everything with you."

"Don't tell me my job," she said. "Anyway, you could die in this pit and nobody would know for weeks." She stubbed out her cigarette on the tabletop. "Do you want to be entertained while you're waiting? I take it you're staying the night? Tell me and I'll try to oblige."

He stared at her. "Such as?"

"How about some jolly British Christmas cheer on the telly?"

"I'd rather watch paint dry."

"A video, then? Fancy some porn?"

6

"That how you pass your time?"

"If you can't join them, watch them, is my philosophy." She met his eyes without turning away.

"Don't tell me you went out and bought them?"

She got up and fed a tape into the machine. "No, I didn't buy them. Santa left them for me. I found them here. Not great quality, pirated American stuff, third generation. Some of it looks as though it was shot in a snowstorm."

She fiddled with the rewind button. "This one isn't bad, set in a girls' school, though the pupils are a bit long in the tooth to be wearing gym slips."

The action commenced almost at once, with the school janitor giving a practical biology lesson in one of the classrooms. A blonde student of indeterminate age immediately succumbed to the janitor's advances. Quickly stripped and spread-eagled over a school desk, she resembled little more than a pink carcass being roughly manhandled. It was like watching a documentary on a meat market.

"Does it excite you?"

"Why would it?" he said.

"That's what they're made for. Does nothing turn you on?"

"Not when I'm working."

"And after work?"

"You'll never know, will you?"

He got up from the chair and went to the window once more. It was dark now, and after scanning the street below he pulled the curtains closed. The girl stopped the videotape and switched on a light.

"Well, I tried," she said. "How would you like to spend the rest of your time?"

"Let me see the clothes."

She fetched them from the bedroom, and he examined every article carefully.

"If they need altering, I'll fix them."

He stripped in front of her. "Be all right with a belt," he said, when he had tried on the trousers. The jogging top also passed muster.

"Very fetching," the girl said. "I'm glad I did something right."

As he took them off again and threw them to her she caught the scent of male sweat. It occurred to her that despite his act of studied calm he, too, was capable of fear. For the first time since he'd entered the flat he seemed human.

7

"Did you time the route for me?"

"Of course. Half a dozen times. Don't forget it's Christmas; this bloody country shuts down. At that hour there'll hardly be any commercial traffic, but to be on the safe side I took the average. Give yourself forty minutes at the outside and you've got it made. You can park in Exhibition Road; plenty of empty spaces there."

"You have something else to give me, don't you?"

The girl went into the kitchen, returning with a package. "Composition C4," she said, handing it to him. "Semtex is too dangerous now that they can trace it."

"Make yourself useful and get me something to eat."

While the girl prepared a meal he passed the time reading one of the Sunday tabloids, which featured such exclusives as "Cheeseburger Kills Space Alien" and a report that Marilyn Monroe was alive and working as a nanny. Only once did he give a laugh.

"What?" the girl said.

"This story: 'Human Mole Tunnels to France.' "

"They make those up, if you ask me. Be interesting when they finally finish the real Channel tunnel, won't it?"

"Yes. We already have plans for that. Once they've had their opening ceremony, we'll give them a closing ceremony."

"At least they've got a workers' militia now, so maybe one revolution's under way."

"Don't talk like a cretin. The British don't know how to spill their own blood."

They watched the nine o'clock news bulletin while they ate; then the Fat Boy announced he was turning in. He took the only bed without asking, leaving the girl to sleep in the armchair.

The next morning he was up before she awoke, dressed in the jogging suit and carrying his ordinary clothes in the plastic grocery bag. After listening for any sounds on the landing he left the room. The noise of the door closing roused her. She went to the window and watched as he walked to the parked Ford and drove away, her breath misting the view. "Happy New Year," she said softly, but it took an effort to believe that happiness existed for anybody, least of all for herself.

At seven that morning Hyde Park seemed an unlikely setting for murder. It was near-deserted at that hour—only a troop of Household Cavalry from Knightsbridge Barracks exercising their horses in Rotten

Row and a few overweight stalwarts grimly jogging around the perimeter track. Patches of overnight fog still clung to the ground, and where the horses had passed piles of fresh dung steamed. Those plane trees that had not been plucked like healthy teeth in the 1987 hurricane presented drooped branches brittle with ice, and the grass beneath them was rigid with frost. Even so, despite the ravages of winter, it still looked lusher and less sinister than the black rocks and parched grass of New York's Central Park.

Opposite in Kensington Road, two uniformed Special Branch officers on diplomatic assignment waited for their relief shift to arrive. They stood shifting their numbed feet in the doorway of a Middle Eastern legation, a few steps from the building where once the S.A.S. had performed live on television with spectacular effect to free a group of hostages. Their current duty was to guard a visiting emissary who had come to solicit an arms deal from the British government in order to sustain a subversive war. Since the man's enemies were thick on the ground in London (the British being crassly willing to provide a battleground for warring foreigners), twenty-four-hour protection had been provided at public expense. It was not the most popular duty, certainly not to the elder of the two policemen, a married man with three sons named Langton, who had been known to voice views that conflicted with the recently strengthened Race Relations Act.

"Funny things, horses," he said, staring across to the park as the Household Cavalry cantered by. "Can't say I've ever taken to horses. Bovine creatures."

"No. Cows are bovine," his companion, Constable Jenkins, corrected.

"Well, you know what I mean. Nothing up top. Very little between the ears. And they're color blind."

"That a fact?"

Langton stared at him, irritated that his second statement should also be challenged. "It's a *known* fact to most people. No, give me dogs any day. I was a handler before I was transferred. Had a wonderful bitch. Alsatian. That dog could have won Brain of the Year. She had more grey matter than half a dozen chief constables."

"Still got her?"

"No. She copped a lump of brick up in Yorkshire during the coal strike. Cried my bloody eyes out, I did."

Constable Jenkins, who looked absurdly young and sported a tentative moustache that he mistakenly believed gave him added maturity,

let a hand rest on the bulge of his Smith & Wesson, which he had never fired in anger. The thought of Langton crying over the loss of a dog made him uneasy.

"That's the trouble with animals," he said finally. "They always die before we do. What time d'you make it?"

"Thirteen past."

"Only another three quarters of an hour, then."

Both men lapsed into silence, willing the remaining minutes of their watch to go faster. A solitary jogger came into view wearing a woolen balaclava a size too large and pointed, giving him the appearance of a demented garden gnome. He crossed the road from the Alexandra Gate and disappeared down Exhibition Road.

"Easiest way to bring on a heart attack," Langton observed. " 'Course, it's another Yank fad. The quest for eternal youth. Did you see that television program the other night?"

"Which was that?"

"How they stay young in California. You wouldn't credit the lengths they go to. They had a plastic surgeon on who'd remade his wife. Literally reassembled her, like a human Lego kit. Took bits off her arse, had a go at the old hooter, siliconed her tits and as far as I made out sucked about a hundredweight of fat out of her thighs."

Jenkins whistled through his teeth, impressed at last. "Sucked?"

"Yeah, they vacuum it out apparently."

"Bloody roll on."

Jenkins's disbelief was cut short by the arrival of a squad car that did a Hendon Police School textbook U-turn and pulled up in front of them with blue lights flashing. But it didn't contain their expected relief team, merely a couple of the traffic boys.

"You know anything about a body being found in the park?" the driver asked.

"No. Should we have?"

"Central had an anonymous phone call stating there's a stiff close to the Round Pond."

"You'd better go look for it, then. Could be one of your lot lying down on the job. You'll probably find a woman under him."

"Thanks. Very droll. You're a big help."

The driver backed up the way he had come, activated his siren and gunned the car across the road and into the park. Shortly afterwards he and his companion walked past the bandstand toward the Round Pond. They spotted the body as they approached; it was a well-dressed male

lying facedown close to the water. Both policemen circled him at first, making no attempt to disturb him.

"D'you think he's dead, or just drunk?"

The driver considered the options. The C.I.D. boys threw a fit if anybody encroached on their sacred territory, especially if it was a homicide. On the other hand, he did not want to look foolish if all they were dealing with was a well-heeled alcoholic.

"You all right, chummy?" he said loudly. "Come on, let's have you. Can't lie there; you'll catch your death this weather."

There was no reaction.

"Have a look. Turn him over."

His companion knelt by the body and pushed a hand under it to feel for a heartbeat.

"That's odd," he started to say, but they were the last two words he ever uttered and the driver ever heard, for his hand touched something metal and the world around them disintegrated.

Half a mile away Langton and Jenkins heard the explosion. Acting on instinct, Langton immediately radioed for assistance, since memories of a past I.R.A. outrage when soldiers and horses had been blown to pieces came quickly to mind. Ignoring orders, he left Jenkins on guard and ran through the early commuter traffic, hampered by the weight of his gun and mobile radio and with the frozen grass crunching beneath his pounding feet. He slowed down as he neared the site of the explosion. Although familiar with the carnage of motorway accidents, nothing had prepared him for what he now found. The fact that he had been talking to the victims only minutes before gave the tragedy greater poignancy. At first glance he could have believed he was looking at a patch of poppies growing, but as he advanced closer he saw that they were bright fragments of human flesh. He went forward cautiously and had to fight not to gag as bile rose to his mouth. Dear God, he thought, what do we do it all for? Just a pension and the Queen's commendation for bravery if we last the course.

He sank to his knees a few yards from the center of the explosion but immediately scrambled up again: close to him was a man's hand standing upright, a wedding band on the ring finger—for all the world like the Victorian ornament his grandmother had kept on her dressing table.

Two joggers approached, a girl and a young man, both beautifully dressed in white, with headbands and Walkmans. Langton waved them to stay back.

"Can we help?" the young man shouted.

"No, thank you, sir. Just keep well away. Did you see anything?"

"We just heard the bang."

The girl suddenly became aware of what she was looking at, and her face lost much of its rosiness. "Oh, Jesus!" she said, crying.

"Did you notice anybody near here?"

"Only another jogger." The young man was also ashen, but fascinated at being so close to death as an observer. "Who was he?"

"Why d'you say 'he'?" Langton challenged, ever the policeman.

"I just assumed—"

"What you see is all that's left of three bodies. Two of them were policemen, just doing a job." Despite the joggers' innocence he could not keep the bitterness out of his voice.

He swung around at the sound of multiple sirens cutting through the distant traffic roar: the banshee screams of the American type fitted to patrol cars and the deeper note of Fire Brigade klaxons. A few moments later a convoy of two police cars and a Heavy Rescue Unit entered the park and pulled up on Lancaster Walk. Half a dozen officers ran toward the scene. Langton met them halfway and reported as much as he knew. Sobered by the death of colleagues, they stood in a bunch until members of the Bomb Squad arrived accompanied by a senior officer. Langton was closely questioned before anybody moved in.

Once the bomb experts had satisfied themselves there were no other booby traps, the area was cordoned off and all entrances to the park closed to traffic. Reinforcements were brought in and they began to scour the immediate vicinity for clues. The grisly remains were carefully collected, tagged and taken away in plastic bags. A television newsreel crew and press photographers, quickly alerted, were kept at a distance and had to be content with a cursory statement from the incident officer. Beyond the park railings the usual clutch of onlookers that are always drawn to scenes of tragedy were kept moving, but the majority of commuters traveling past were unaware of the horror until the first bare details were given over the radio.

"Any trace on the anonymous tip-off?" Langton asked.

The incident officer shook his head.

"No clue at all?"

"Not so far."

"And just telling us about a body? No warning of a booby trap?"

"That's right. You'd better get back to your post," the officer said, dismissing him. "File a report as soon as you go off duty."

Langton returned to the steps of the legation where the relief pair had already taken over, though now he and Jenkins were in no hurry to depart.

"How bad is it?" one of the newcomers asked.

Langton took his time before answering. "When they killed horses," he said finally, "it made the headlines all over the world. But a couple of dead coppers will probably only rate the inside pages."

His companions nodded, accepting, like Langton, the increasing isolation of their lot in a society where all the old values had been overturned.

The police were not the only ones uneasy about the changing pattern of their lives. There was evidence to suggest that the majority of ordinary citizens, young and old, black as well as white, had the same feeling that a corruption of the spirit had eroded society. For some, more privileged than most, the boom years of the eighties when the yuppies had celebrated the approach of Christmas by pouring Beaujolais Nouveau over their Porsches and girlfriends were now but a memory, looked back upon as an earlier generation had revered the sixties. Nobody quite knew how or why the bubble had burst. Was it the Big Bang, Black Monday, the fault of the Japanese, the Iranians, the American deficit or the show-business glitz foisted on the royal family by the tabloids? Had the greenhouse effect played a part? Was it lead poisoning, battery chickens, toxic additives to the staple diet, the spread of hard drugs, the atomic fallout contaminating the Sunday roast, or the sewage being dumped into the rivers that frightened many into using expensive bottled water for the sacred cup of tea? Theories abounded and blame was spread, there being no shortage of experts ready to claim their moment of glory on the television screens and contest for the Platitude of the Year award. Some felt the buck stopped right there: television was the root of all their evils; the nightly diet of soap operas, quiz games and lamentably puerile sitcoms had so dulled the general perception of traditional English life that it was small wonder half the school leavers could neither read nor write. Was it the Pill, easy abortion, or the spread of AIDS? Was it plastic money, plastic food, the decaying inner cities? Violence stalked all streets, even in remote rural areas; child abuse and the abduction and murder of children sometimes appeared endemic; burglaries were an accepted hazard of everyday life and no longer confined to the rich. Some blamed drink, some blamed God, others

reviled trendy bishops who had forsaken God for the mammon of politics. Still others charted the national decline from the moment when the England football team had failed to qualify for the World Cup, while a section claimed that the display of topless models in certain national newspapers had irrevocably corrupted family life. Whatever the cause, few denied that the country, like the weather, was not what it had been, though exactly what it had been proved impossible to determine. It was said by many to be the worst of times while they struggled to recall what had been the best of times.

Perhaps those who had the greatest cause to be concerned were the least concerned. Denied office for well over a decade, the incumbent Labor government, now controlled by the hard left and headed by the Right Honorable Toby Bayldon as Prime Minister, were keen to make up for lost time by blotting out all traces of the Thatcher years. There was nothing very surprising or new about this: every British government since the end of the war had followed the same dreary path—any advance made by the outgoing administration was automatically pronounced a disaster to be removed at the earliest opportunity, regardless of cost or practicability. Without benefit of a written constitution and a second house, British politicians subordinated themselves to party disciplines more draconian than in any other democratic legislature, frequently voting without having any conclusive grasp of what they were voting for, committed to election manifestos that were either fatuous or else swiftly rendered obsolete by events. Above all, the Prime Minister of the day exercised almost unlimited power, his immediate predecessors having succeeded in diminishing collective responsibility to the point where it was scarcely discernible.

Shortly after a hurried lunch taken at his club, Dr. Colin Hogg, C.B.E., the senior Home Office pathologist used by the security services, began his preliminary examination of the Hyde Park remains. It had been impressed upon him that his most urgent task was to identify the third body and establish whether death had occurred prior to the triggering of the booby trap. But Hogg worked at his own pace: he was not a man to be hurried by civil servants.

His assistants had little enough to go on, and priority was given to separating the gruesome collection of human fragments. They were helped by the fact that the records revealed that both the dead policemen had the same blood group, and the hope was that the third man would

prove to have a different one. While they carried out their tests, Hogg began his own methodical procedures, dictating his findings to an overhead microphone connected to a tape recorder. He began by concentrating on two reasonably intact sections of lower jaw. He immediately noted that the first of these had some superb bridgework, which suggested it was of American origin or done by a British dentist trained in American techniques. He photographed this using a macro lens and then took X rays. The second specimen had fewer fillings, and indentations on the incisors suggested that the owner had once worn a corrective brace. Hogg removed minute particles of food for further examination.

Surprisingly for someone who had spent a lifetime concentrating under artificial light, Hogg still had 20/20 vision. The knuckles of his left hand were arthritic, but his right hand was steady with the scalpel and he dissected with the delicacy of an etcher. One of his idiosyncrasies was to wear thick orange gloves of the kitchen sink variety rather than the thin transparent ones issued by the department. "I have no intention of catching AIDS at my time of life," he remarked to his assistants. "It would not only be unseemly but, as a bachelor, it would also give rise to a false diagnosis of my sexual proclivities. You can imagine what a field day our tabloid press would have, given half the chance."

It was now that Hogg spotted something. Embedded in a segment of flesh that he later confirmed came from the genital region of a male in his late forties was a piece of silk material barely larger than a postage stamp. He cleaned it carefully and examined it under a microscope. Woven into it were some letters: *net Re.* They meant nothing to him, and he set the fragment aside, preserved in a plastic envelope.

"I think I've isolated the unknown victim, sir."

"You *think.* You don't *think* about anything in my laboratory, Charles. You make tentative statements, or else voice positive conclusions. Which is it?"

"The test came up AB, sir, distinct from the two policemen."

"Then say so. Good. That's a start. Wipe my forehead with a tissue."

It was another four hours before they had every exhibit tabulated. The severed hand with the wedding ring on it gave them the only certain identification since the ring was engraved on the inside, *Liz and Bill, 22 July 1984,* which was later traced to one of the policemen. Having sent his assistants out for a quick meal, Hogg began to build up a mental picture of the third victim, dictating into the minirecorder.

"Preliminary findings as follows. Principal victim white Caucasian male. Blood group AB. Age estimated between thirty-five and forty. Of medium height, with a decent head of hair, color auburn, possibly with traces of dye. One hand matched with blood group. Fingernails manicured, pointing to a sedentary occupation. Liver sample denotes upper levels of alcohol consumption, but lung tissue clear. Death estimated to have occurred prior to the explosion; actual cause of death as yet not ascertained. Further tests to be carried out on the viscera. Fragments of cloth fused to section of forearm analysed as pure wool, color dark blue. Thus victim unlikely to have been a park derelict; evidence so far suggests somebody who enjoyed an above-average standard of living and could afford superior dentistry, which may prove to be of foreign origin. Positive identification impossible from the remains. Dental records most likely source of information. Examination continues. Timed at eighteen thirty-seven hours."

"Play that back and give me your reactions, Charles," Hogg commanded when the two assistants returned. "Yours, too, Graham, when you've emptied your mouth. What is that you're eating?"

"Chocolate, sir."

"Excessive intake of refined sugar leads to early deterioration of brain cells, did you know that?"

"No, sir."

"Well, you do now. Let's put it to the test. You start."

Both young men concentrated. Graham, the younger of the two and a regular recipient of Hogg's sarcasm on these occasions, prayed for inspiration.

"A banker, possibly, sir?"

"And by what tortuous thought process did you arrive at that instant deduction?"

"Sedentary occupation, sir, and the quality of the suit he was wearing."

"You think only bankers wear decent suits, do you?"

"No, sir."

"If you found me dead wearing a Marks and Spencer pullover, do I take it you'd immediately conclude I was a shop assistant?"

"No, sir."

"Then don't make ludicrous guesses. Let's have your two pennyworth, Charles."

The second assistant hesitated, then began, "Based on what you've

told us, sir, there's a distinct possibility that the victim was American—" But he got no further.

"I told you no such thing."

"Oh, I thought you said the dental work was almost certainly not done in this country, sir."

"I said it was superior dental work, but people travel and often require treatment while abroad. If they're affluent enough or have taken the sensible precaution of insuring against such eventualities, they will avail themselves of the best."

"I'm sure you're right, sir."

"Of course I'm right. Is that the extent of your wisdom?"

When cornered, as he was now, Charles developed a slight stutter. "I c-c-could make one other suggestion, sir."

"Yes?"

"The label fragment you discovered."

"What about it?"

"I might be able to fill in the missing letters. You see, sir, m-m-my girlfriend r-r-really supplied the clue."

"How could you have discussed this with your girlfriend?"

"N-n-no, sir, you misunderstand . . . me. I haven't discussed it, n-n-naturally. You see, sir, she wears a c-c-certain type of underwear."

"Charles, you know me to be a patient and tolerant man, especially when dealing with people of subnormal intelligence, but I have no wish to stand here and listen to the salacious details of your private life."

By now Charles was sweating. He shot a desperate look at Graham, but no help was forthcoming. "If I c-c-could f-f-finish, sir, the missing letters might be 'JA' for the f-f-first word and 'GER' for the second." He waited, but Hogg merely stared at him.

"J-J-Janet Reger."

"Janet Reger?"

"Yes, sir."

"And what does that signify? The name means nothing to me."

Only now did Graham take over, thereby hoping to claim some of the glory.

"It's a brand name, sir, for exotic ladies' lingerie."

"And why would your hypothetical banker be wearing a garment produced by a purveyor of female undergarments?"

"Well, I have seen it reported, sir, that certain men do go in for that sort of thing."

"Transvestites, you mean?"

"Not necessarily. I believe quite normal men get into them."

"Your definition of 'normal' is patently not mine, but, believe it or not, I'm always willing to broaden my horizons. Tell me more."

"I don't know any more, sir. But I can assure you it does go on."

"A further indication that our society is degenerating." Hogg rounded on Charles. "I stand corrected and amazed, Charles, by your extensive knowledge of the darker side of human nature."

"There's n-n-no accounting for taste, is there, sir?"

"In matters sexual, no. But let's concentrate on these exotic female undergarments, since you have my undivided attention. What are we talking about, French knickers?"

"Could be, sir."

"Well, they say one's education is never finished until one is in the grave." Hogg stripped off his gloves with a flourish and cast them into a disposal bin, then went to the washbasin, operating the taps with a foot pedal, and commenced scrubbing his hands. "Assuming you both reduce your intake of sugar, it's possible that one day you might add something of value to the sum of human knowledge. Type up all my notes before you leave and make sure the dental records are immediately circulated. We'll continue first thing in the morning."

"Excuse me, sir," Graham said, "but the Home Office were anxious for you to give them a report tonight."

Hogg turned at the door to the washroom. "Were they? Let me tell both of you something, and, if you learn nothing else while under my tender care, have this engraved in large letters above your beds: we were not put on this earth to be humbled by civil servants—that is not what God intended when He labored for six days. If—*when*—they ring, tell them my report will be presented when I am ready to present it and not before. I am taking my niece to the theater. She is the only member of my family I can tolerate for more than half an hour, and it happens to be her birthday. Tell them dead men take their time to tell tales."

With this parting maxim he disappeared. The two assistants collapsed, laughing.

"French knickers!" Charles screamed. "That brought a bloom to his cheeks. The silly old sod got quite excited."

"You know what I felt like telling him?"

"No, what?"

"I wish I had the nerve to say: 'Sir, I think we're piecing together the last hours of some old queen who trolled the park in a suspender-belt

and happened to die on top of an unexploded wartime bomb brought to the surface during the hurricane.' "

"Christ! I'm glad you didn't."

"Why does he have to be such a bloody know-it-all?"

"B-b-because he is," Charles said. "Because the old b-b-bugger just is."

2

BILL WADDINGTON WAS somebody who passed unnoticed in the Piccadilly lunchtime crowds; it was an attribute that had been useful to him in his previous career in the Firm. On this particular day he was breaking in a new pair of shoes and trod warily on the wet pavements; he had scratched the soles with a pair of scissors before setting out, but they still slipped. As he approached Langan's Brasserie he spotted the inevitable paparazzi waiting for celebrities, but after giving him a glance they turned their backs to the slanting rain. Not for the first time he thought what a boring existence they must have: keeping endless vigil in the hope of catching the transiently famous off guard. It was a strange world they trapped with their lens—not the great or near-great, but Teleprompter readers, spent footballers and, favorite of all, those topless models afflicted with torpedolike udders and their mentally shriveled escorts.

Although ignored by the paparazzi, all unknowingly Waddington was photographed entering Langan's from a fifth-story window of an office block on the opposite side of the road, the hidden observer using a 300-mm lens fitted to a motorized Nikon with a rifle mount.

Inside, the bar was crowded with a clutch of hopefuls who didn't have bookings. They nursed their drinks and forced smiles whenever the headwaiter looked their way. Waddington deposited his raincoat and asked if his host had arrived. "I'm lunching with Mr. Keating."

"Yes, sir. Mr. Keating is through the bar."

Waddington was not sure he would be able to recognize Keating. They had once both been in the Firm, but contact had been lost a decade ago. He had no idea why Keating had decided to seek him out, but these days a free meal was a free meal.

"Bill, how good of you to find time to see me," Keating said, portly as Buck Mulligan and rising with some difficulty from an armchair. He had aged since they last met, but the changes in his appearance stemmed more from good living than from the advance of the years. Well groomed, florid of complexion, but still handsome, the sort of face that always graced the social pages of the glossy magazines: the rich, Waddington had noted, had a sameness about them. Keating gave the immediate impression that, like Fitzgerald's Gatsby, he never had to wear a shirt twice, and his immaculate single-breasted suit made Waddington feel shabby and out of place. Whatever experiences they had once shared were now separated by affluence.

"Hope this place was a good choice."

"Splendid," Waddington replied, and felt compelled to add, "My expenses don't usually stretch to Langan's."

Keating did not pick up on this. "I use it because the food's good," he said, "and it's so noisy you can't be overheard. Most of the clientele's show business—they're so busy talking about themselves they haven't got time to eavesdrop."

"Are we going to be worth eavesdropping?"

Again there was no reaction from Keating. "D'you want to go straight in or have a drink here first? What's your tipple?"

"Oh, I'll just have a glass of wine with lunch. D'you mind if we eat straight away? I only have an hour, I'm afraid."

"No problem."

Keating deposited his half-smoked Davidoff in the nearest ashtray and took Waddington's arm, steering him through the crowded bar into the equally crowded restaurant. "Driving you hard, are they?" He nodded to the maître d' with the assurance of somebody accustomed to favored treatment, and they were immediately ushered to a table at the far end of the room.

"My boss demands his pound of flesh," Waddington said. "But it's a living."

"Yes, I'd heard on the old grapevine you'd left the Firm. Without knowing the circumstances, I'm sure you were well out of it." He waved away the proffered menu. "I know exactly what I'm going to have. Give

me some pâté and then a Dover sole, plain grilled with some *mange-tout*. And don't try to tempt me with French fries, because I seduce easily. What d'you fancy, Bill? Not on a diet like me, I hope?"

"Still looking at the moment. Is there a house speciality?"

"There used to be, but sadly he's no longer with us." The in-joke was lost on Waddington. "It's all good. Choose what you like. Bring us a bottle of the eighty-six Chablis, Rico. Not too cold."

Feeling under pressure, Waddington made a quick choice and immediately regretted it. Successful men like Keating intimidated him. He made small talk until the wine arrived.

"Tell me about your present setup." Keating sampled the wine and pronounced it drinkable. There was an air of calculated sophistication to all his actions. At close range he gave off a strong scent of cologne, and as he spread his pâté with the air of a man to whom the word cholesterol was anathema Waddington glimpsed a solid-gold Rolex, that mandatory symbol of captains of industry. It occurred to him that he was dining with one of the unacceptable faces of capitalism. Once again he was conscious of his own shabbiness.

"My setup? Nothing very spectacular. Bloody dull, in fact. After I showed my backside to the Firm I got a job with a small outfit, owned by a pompous little twit, that sells security installations to the well heeled. You know the type—still uses his army rank thirty years after the event."

"Got him in one."

"I'm there as a 'consultant.' What about yourself?"

"Can't complain, Bill. I've moved around, trying to keep one step ahead of the mob, dabbling in a number of things. Had a fling with property development at one point but didn't like the company I had to keep. I finally found my spiritual home in the film industry."

"How spiritual is it?"

"Somewhere between the Church of England and the Moonies." Keating laughed at his own joke.

Waddington said, "I've always heard film production is a very risky business."

"Oh, I'm in at the right end, Bill. Nothing creative; I just supply the last third of the money and take the first share of the profits."

"A far cry from the old days."

"Thank God. Do you keep in touch with any of the gang? Mind you, quite a few are under the sod or have committed social suicide by writing

their boring memoirs. Still, that keeps the courts busy. Horses for courses."

Waddington nodded in agreement. "The answer is no, I haven't kept up with anybody."

"Crossed them off the Christmas card list, have you? Very wise. What is it they say? You can't revive old love affairs. Which in turn asks the question, was it love for you and me? I mean, did any of it ever matter? Nothing matters very much, and most things do not matter at all. Our past lives were built on a myth."

"People die and kill for myths."

"Interested to know whether you departed with a bang or with a whimper," Keating said, although the way he put it denoted a lack of interest.

"I was given the old heave-ho in the economy purge when this Labor government got in."

Keating said, "Somehow I can never quite believe they won the election. Such a third-rate lot. Not that I rated the previous mob. The Tories inevitably render themselves insufferable in power. The moment the votes are counted they switch over to cruise control—no nuclear pun intended! They were competent, I suppose, and they tried to keep our defenses up to scratch. Politics and politicians get up my nose. If you ask me, we Brits have always preferred to be governed by nonentities. Macmillan was the last Prime Minister I had any time for." He broke a bread roll, buttered it, then put it to one side. "Heard a good one in the club the other day. Somebody described Bayldon and his cabinet as a black hole surrounded by a vacuum. Quite good, yes?"

Although Waddington laughed at this reference to the current Prime Minister, his mind was elsewhere; instinct told him that Keating had not tracked him down to swap political anecdotes. "D'you ever miss the old days?"

"No way. The place fell apart for me when C. retired."

"Dinnsbury, you mean?"

"Yes. Couldn't stand the new *número uno* at any price, never hit it off with him, so I got out while the going was good. God, we used to be the bloody elite, Bill, remember? The elite," he repeated, as he quaffed his first glass of Chablis. "But they threw it away, cut our balls off, shafted us, all those closet Reds in Whitehall. And you know why? Because we were onto them."

Waddington let him talk, acting on the old principle that one should

never commit too soon. Listen, observe, but don't unpin your hair before the money's on the table, as the whore said.

"We were the last bastion, my friend. Now dark mortality threatens at every corner. Seems to me that those who control our destinies have majored in malice, though I grant you there were some rotten eggs in our own basket—no question about it, but I like to think they were all laid at a particular time in the same privileged nest. They drank at the same trough, to mix my metaphors. And don't tell me they weren't protected by the ultimate closed shop: the old boy network. The admission fees are high, but once you're in, you're in for life. Christ, it went all the way to the Palace. Imagine if somebody put that into a novel, they'd be carted off to the funny farm. But it wasn't fiction; Chummy there was lording it for years, touching his yellow forelock to the royals while good men were betrayed."

"You're talking about Glanville, I take it?"

"Yes. I was one of the so-called Young Turks, remember? I took some of his early interrogations. We smelled him out; every time he opened his mouth he gave off guilt like halitosis—and he had a terminal case of it, by the way—but we got nowhere. A cold, sanctimonious fish, camp as a row of tents as soon as he had a couple of gins inside him. The smug bastard knew he had us; there wasn't sufficient evidence to bring him to trial, so we were forced to strike a deal and give him immunity. It took that writer chap to bring it out in the open, otherwise he'd still be there. You study the photographs of him, look at all of them in that charmed fairy ring and ask yourself why weren't they flushed years before. Any average village copper would have sniffed them out, yet they survived, traveling first class all the way. That's why I couldn't wait to quit."

Keating paused momentarily and requested that his grilled sole be taken off the bone.

Waddington had the distinct feeling that the conversation was being steered away from the real purpose of the reunion. Keating had never been a close friend, and they had never worked together. At one time Keating had been earmarked for the top job; Dinnsbury, the then Director General of MI6, had gone on record that he considered him the best and brightest hope. That had been enough to squash his chances the moment Dinnsbury was put out to pasture. The mandarins never liked to have court favorites promoted.

Keating continued to expound his theory of a calculated conspiracy

as they ate their main course. Like many fat men, he attacked food as though at any moment it might be snatched from him.

"If they believe Glanville was the last rotten egg in the basket, I'll go to the foot of our stairs, as my mother used to say. . . . Funny expression, that; don't know why it suddenly came to mind. Haven't used it for years, and I'm not quite sure what it means."

"My mother used it, too," Waddington said, and for the first time during the meal he felt he had something in common with Keating.

"What are your views on the perennial supermole theory? I know it keeps a whole slew of ferreting journalists in business, but the possible cast list gets longer every year."

"Part of me goes along with it, and maybe there was somebody, some dedicated scalp hunter who's long since under the sod. It's the nature of the beast; there's a sneak in every classroom."

"Do you use these things?" Keating asked, offering a Davidoff.

"No, but I'm willing to be converted." Waddington accepted one from an initialed leather case.

Keating chomped off the end of his cigar. "I suppose the star class sneak from our little group was friend Hillsden. I was reminded of him recently when I came across an item in one of the papers. Did you see it?"

"No. What was that?"

"Just a paragraph saying he'd been spotted being helped out of a Moscow restaurant, pissed to the eyebrows."

"Poor old Alec," Waddington said, finding that the sudden mention of Hillsden disturbed all manner of memories, rolling back the years when their life together at the Firm had seemed full of purpose.

"Well, I imagine they all take to the bottle sooner or later. I know I would if I found myself incarcerated in that bloody country."

"Still, I hear things are decidedly better since the reforms."

"Cosmetics. It'll take another generation for Gorbachev to castrate the old guard—if he survives, that is. The power game's the same whichever system you vote for: nobody relinquishes the perks without playing dirty." Keating's face was momentarily obscured behind a cloud of cigar smoke. "Going back to Hillsden and his kind, I'm bloody sure Moscow is a lonely corner of a very foreign field if you're stuck there for good. You were very close to him at one time, weren't you?"

"Close as anybody, I suppose. Excluding his wife. Or maybe even closer in one sense. The marriage crumbled when she found out his real occupation. She never joined him over there."

"Did you ever suspect he'd go over?"

Waddington took his time before answering. "No. No, I didn't. It floored me, if you want the truth."

"Why?"

"Because it was totally out of character."

"But isn't that true of every successful defector? The really clever ones are never suspected until it's too late."

"Yes, granted, but Alec didn't fit in with your 'rotten eggs' theory, did he? He wasn't an Apostle, he didn't even go to a minor public school, nor was he gay. Okay, he had a couple of black marks against him in his file, but they were ordinary human failings, hardly signposts pointing to anything covertly sinister. . . . For my money, he was set up."

"How interesting you should say that. Bears out what somebody else said the other day."

"Who was that?"

"Oh, nobody you'd know. We just happened to be talking about a television program—that *Smiley's People* thing—and Hillsden's name came up. Who d'you think would have set him up?"

"Obviously, I don't know for sure. It's just a gut feeling I have. For instance, I'll never believe he murdered that Foreign Office bod—what was his name—Bellridge?"

"Belfrage. Sir Charles Belfrage."

"That wasn't Alec."

"There was a connection, though."

"He came into contact, sure, in the course of business. Belfrage was Bayldon's principal private secretary when Bayldon was home secretary."

"I got the impression that the evidence at the time was fairly conclusive."

"What evidence?" Waddington said rather too loudly. "There wasn't any, only conjecture. Alec never carried a gun to my knowledge. I studied the papers before I left the Firm and it smacked of a textbook job by a professional hit man. The police never came up with a single lead. I admit it coincided with Alec's disappearance, but that only strengthens my theory. I believe they tacked that extra crime onto him to hide their failure to solve it. Very convenient—everything tidied away, we can all sleep easily."

"Except," Keating said, "except—being devil's advocate—he had served time in prison prior to his disappearance. Sent down for queer bashing, I believe. Maybe a little smoke points to bigger fires?"

"You have studied him, haven't you?"

"Well, after all, we were once birds of a feather," Keating said blandly.

Waddington shook his head. "Like I said, none of it fits. A punch-up in a gay pub, who knows who started it? Most times it wouldn't have got into court, but in his case it did and the magistrate was some pious old dyke, from all accounts, who elected to make him an example. No, I don't buy it, any more than I buy Alec as a common murderer."

"Desperate men often commit irrational acts. Perhaps he knew the net was closing in."

"Okay, that was the popular explanation, and I daresay he was desperate in one sense. His marriage kaput, a lousy pension and, as I quickly discovered, not many job opportunities when you're thrown on the scrap heap."

"Here. Your cigar's gone out." Keating offered a solid gold Dunhill lighter, so heavy that Waddington almost dropped it. "I'm not really disagreeing with you. But if you're right—and it fits with my own thoughts on the matter—he knew something that had to be smothered. Is that what you're saying?"

"Yes. Right up to the moment he disappeared, I was convinced he was sniffing too close to one of our classic cesspools."

"Did he confide in you?"

"Yes and no. To an extent. We discussed most things, especially after the murder."

"You've lost me. What murder are we talking about? You can't mean you were in contact after Belfrage's death?"

"No. Caroline's."

Keating looked blank.

"Caroline Oates."

"She was murdered?" Keating's surprise seemed genuine enough.

"You never heard that?"

"You're telling me for the first time."

"Presumably you knew the scuttlebutt about her and Alec?"

"Vaguely. Remind me."

"She was his mistress for a time. They became lovers when they were both in the Austrian station with Jock Calder. Alec got his marching orders because of their affair. Control read them the riot act from his own version of the Old Testament: thou shalt commit all manner of crimes in the name of the Firm, but thou shalt not have carnal knowl-

edge with a fellow operative. A curious kind of departmental morality, I always thought."

"Yes, some of it comes back now that you mention it."

"Shortly after Alec was sent home, the whole network was blown. Everybody was wiped out. Caroline was taken in Berlin, and Jock . . . well, according to the official report he was drowned. Caroline was traded a few years later—what was left of her. She wasn't even walking wounded—a wheelchair case. Moscow Center did a really good job. Our grateful employers pinned a medal on her for services above and beyond and tucked her out of sight in a nursing home for incurables, where she was eventually murdered."

Keating was silent for a while, nursing the ash on his cigar. "Strange nothing came out," he said finally.

"That's what riled Alec. He pressed hard for a full internal investigation, but was warned off. The reason Control gave was that he didn't want to rock the boat. It was just after the Glanville scandal broke, the new government had just been elected and everybody was treading on eggs. Caroline was quickly cremated and the file closed."

"You say she was a wheelchair case?"

Waddington nodded. "I never saw her, but from all accounts she was virtually a vegetable. I remember Alec saying that to me: 'Why would anybody want to murder a burnt-out case?' He was obsessed by it."

"How was she murdered?"

"Injection. Old Hogg—did you ever come across him? Home Office pathologist who did all our special cases—he identified it as a shot of DS7, that instant way of shuffling off life's mortal coil that Adolf provided for the S.S. . . . Have you ever put a dog down?"

"Not personally."

"Nor me, but I saw it done once. We had a Yorkshire terrier who came to the end of his time. Had cancer of the liver, poor little sod. I held him while the vet put the needle in. Worked like a charm—you couldn't count ten before he'd gone." Memory of the incident changed Waddington's face. "We should all go as quickly. Well, I gather DS7 works just as fast—complete respiratory failure in less than a minute. Alec had such guilt about her that it destroyed him, altered his whole personality. He might have faked many things, but I know he didn't fake that. He was convinced that the reason they killed her was that she still had something to tell."

"Well, not to the Russians, presumably?" Keating observed. "Some-

body on our side, you mean? Somebody from the Firm's dirty tricks department?"

"Yes, why not?"

"Makes me even more happy I'm out of the game earning an honest living—well, *almost* an honest living."

At this point Keating's chauffeur appeared by the table to tell him he was being paged on his car phone. Keating excused himself and lumbered to the exit. Outside he eased himself into the front passenger seat.

"Yes? . . . Not a good idea to use this phone. Too easy to hack into. . . . No, I'm still at lunch with him. But you were quite right: a useful contact and he seems to share our view that the absent friend was railroaded. I'll fill you in later.

"Sorry about that," he said to Waddington on his return. "The trouble with the film industry is that you have to wet-nurse the creative talent. They bleat on about every little detail if they think their artistic integrity is being threatened."

Keating was served a fresh cup of espresso and added a frightening amount of sugar to it while indicating to the waiter that he wanted the check. "I wish I'd known Hillsden better in the old days. Never know, I might have been able to help. . . . Too late now. Burned his boats," he added from behind a cloud of cigar smoke that provoked angry glances from the occupants of nearby tables. "The only thing that gives me private satisfaction is the thought that the Firm and Moscow Center must be running around like blue-arsed flies, what with *glasnost, perestroika* and all that crap. Not welcome news for our old profession; threatens to put everybody on the breadline. You and I know that peace in our time is just window dressing for the masses; the game will go on as before, because don't tell me that our buddies back in Langley are looking to go on welfare. All the players have a vested interest in keeping the pot boiling."

Waddington nodded. "I guess there won't be much call for secret services if everybody shakes hands and becomes friends."

"Ah, but there's nothing like a friend when it comes to betrayal," Keating said with a ghost of a smile. He signed the bill without looking at it and added a twenty-pound note as a tip. "We should both be happy we're on the sidelines."

"Except I can't pretend that flogging intruder alarms to exiled Iranians fulfills a lifelong ambition."

"Pays well, presumably?"

"Just about enough to cover the alimony."

"Oh, you've gone down that road, have you? I'm on my third. Did you have children?"

"No."

"Well, be grateful for that. I'm supporting a whole brood of dropouts. I didn't spill my seed to any good effect. Not that I envy the young these days. It can't be much fun living with the specter of AIDS. At least we didn't have that to contend with in our gilded youth. All we had to worry about was catching a dose of the clap or getting a girl in the pudding club. I heard an ugly rumor the other day. Apparently there's a very hush-hush project under way up north. According to my informant, the figures for AIDS victims have been heavily doctored. The real total could be anything up to five hundred percent more than admitted. I was told they're building a sort of super leper colony, a self-extermination camp for terminal cases."

"God! You think there's any truth in it?"

"I think it's bloody possible."

"Political dynamite."

Keating shook his head. "No. They'll all close ranks if it's true. Nobody wants that hot potato."

The whole conversation puzzled Waddington. Men like Keating who drove around in the latest Rolls costing three times his own annual salary didn't issue luncheon invitations out of the blue without good reason. Where's the catch? he thought. Or have I missed it? He made a show of looking at his wristwatch, which in contrast to Keating's genuine article was a cheap Hong Kong imitation of a Cartier, just about to shake itself to bits.

"Well, this has been very pleasant," Keating said. "Thanks for finding the time. I hope I haven't made you late. Can I give you a lift anywhere?"

"No, it wouldn't do for me to arrive back in a Roller. The Captain would think I'd landed a new client."

"Perhaps you have. You never know. We must do it again, and sooner next time. It's good to go down memory lane occasionally."

Waddington got to his feet, conscious that he hadn't managed to keep his cigar alight.

"Take my card," Keating said. "And let's keep in touch. Never know, I might be able to put something your way. The film industry is a many-splendored thing; there are always openings."

To the regulars in Langan's it looked like a normal encounter; they assumed Waddington was an agent trying to hype a film deal with a producer and was going away empty-handed. Few heads turned as he made his way to the cloakroom. As he waited for his coat he turned back to see that Keating had now been joined by a young woman. She had her back to him, but from the clothes she was wearing and the flow of her abundant hair, he sensed she was the type that gravitated effortlessly to wealth—spoiled girls beyond his experience who never yielded their favors without a price tag attached. It was none of his concern, but he wondered if, despite three marriages, Keating still played the field.

The rain had turned to drizzle during lunch but, slightly fogged with Chablis, Waddington welcomed the dank air on his face. As he walked past Keating's Rolls to Piccadilly he was photographed again, the concealed observer securing three motorized shots before the angle of the building obscured him.

Waddington bought a midday edition of the *Standard,* making a gift of the dead cigar to the news vendor. The front page was given over to a report of the outrage in Hyde Park. Although so far nobody had claimed responsibility for the murders, the authorities were convinced it was the work of the Provisional I.R.A. It was the time of the terrorist cuckoo, planting lethal eggs in harmless nests.

Catching a bus to return to work, he studied the newspaper report. There were pictures of the two dead policemen under a headline that read: RIDDLE OF THE THIRD MAN. How odd, Waddington thought. At one time that headline would have meant something else, and for the second time that day he thought of Philby—Philby and Alec Hillsden, both exiles in a country they had once professed to despise.

3

A LONG WAY from Piccadilly and the London he had once known with the familiarity of a taxi driver, the man in Waddington's thoughts walked the streets of Leningrad with no purpose other than to kill time.

Alec Hillsden's appearance had changed from the last photograph on the Firm's file. His hair was greyer now, speckled white at the sides; in addition, he had grown a beard, giving his regular English features a coarser look. Boredom had increased his drinking habits, and the cheeks above the beard had become mottled. The strangers he walked among might well have taken him for a literary man, for he had acquired a Chekhovian look, the look of a man to whom the present is not quite real, his sights fixed on distant horizons.

Since being exiled from his native land he had become reasonably fluent in spoken Russian for his everyday needs, though he still had some difficulty reading it. More than anything else, the need to combat loneliness and keep up with events in the world he had left behind had speeded the learning process. As one of the privileged he was allowed certain Western newspapers and periodicals, but often they only served to intensify his sense of alienation.

There were new, untried freedoms in the Leningrad air, but Hillsden shared none of them, for his life had reverted to an old and familiar pattern; sometimes it seemed to him he had never known a day bright with promise. Often in the past, before joining their sparse ranks, he had wondered about the lives of defectors: was the umbilical cord ever severed? Past experiences with the Firm, when he had spent long months debriefing those who had made the move to the West, had revealed few clues as to their real emotions. Now he knew why. And they had been the genuine article; unlike himself, they had made a conscious choice, yet were condemned to be eternal tourists carrying the luggage of regret. In his own situation he carried the added weight of bitterness, knowing that he had been tricked.

Leningrad was the third alien city to offer him a surrogate home. In

relative terms he preferred it to Moscow, where his last illusions had been buried. He had made an effort to blot out all memories except one of his stay in Moscow: the only good thing about those early days had been to discover a kind of loving with a girl named Inga, transient like everything else in his new life, something unexpected, enjoyed, then snatched away—the old cat-and-mouse technique both sides had long perfected. Later, when his defection had become public, closing the door forever, his G.R.U. mentor had permitted him to renew the liaison with this same girl and arranged for them both to occupy a Black Sea villa. Again no illusions as to why: concessions were never granted without a purpose. In many ways Hillsden and the girl were birds of a feather, both carriers of the same secret from their first meeting in Moscow—an episode both would have preferred to forget, but couldn't. Hillsden was aware that Inga had been told not only to share his bed, but also to penetrate his thoughts. Knowing that she had no choice in the matter, he harbored no resentment. His G.R.U. hosts had accepted him in their midst and ostensibly he had passed their tests, but he remained an outsider.

Although he and Inga had originally been thrown together on a blind date, to his surprise (since there had been few casual affairs in his life) Hillsden had been immediately attracted: she had a gentle, vulnerable personality, reminding him (he who always made literary comparisons) of Maugham's heroine in *Cakes and Ale,* one of life's losers. A peasant girl from Georgia, she had been working in Moscow as a hotel waitress when they met and had a smattering of English he found as engaging as doubtless his stumbling attempts at colloquial Russian amused her. He had learnt that her soldier fiancé had been killed in Afghanistan, so they shared equally the loss of a love. Totally unlike his ex-wife or Caroline, and younger than he had any right to claim, Inga proved to be a compliant, uninhibited mistress, inclined to fat, but firm-breasted and voluptuous when naked. Through her he rediscovered a tenderness he once felt he had lost forever.

"Why is it," Hillsden once asked her, "that women's breasts always feel as if they are weighted within, like mercury in a silk pouch?"

"I don't understand."

"Know what mercury is? The stuff they put in thermometers?"

"You mean my breasts are hot?"

"No. Forget it. Just one of my fanciful flights, and translation is beyond me. You wouldn't know what 'bristol' means, either, would you?"

Whenever she failed to comprehend she invariably laughed.

"It's cockney rhyming slang."

"What is 'cockney'?"

"Argot. See, this"—touching her face—"is your 'boat race,' face; 'mince pies' equals eyes; 'plates of meat,' feet; 'trouble and strife,' wife; and so on."

By now she was totally lost.

"Bristols are these beautiful objects." He fondled the softness of her breasts. " 'Bristol City'—titty. Get it?"

She shook her head.

"Well, never mind. Took me an age to catch on, and I still used to get flummoxed."

"Is very difficult, I think, English."

"You think right. Plus we're the laziest nation on earth when it comes to speaking in a foreign tongue. Pure arrogance. We've always taken the line. 'To hell with it; the natives should speak our lingo.' You speak better English than I'll ever speak Russian."

"Am I the first foreign girl you ever went to bed with?"

" 'Let me think,' he said, searching back over his hideous past. 'Second.' "

"Who was she?"

"German."

"Young?"

"Ish. But I was young then."

"Rich?"

"No. Why d'you ask that?"

"I've always imagined girls in the West to be rich, wearing perfume and wonderful clothes."

"Some, yes, but I guess I didn't happen to meet any of them."

"Not even your wife?"

"She had nice clothes—nothing special, but nice. Rich women need rich husbands, and that wasn't yours truly."

"What was she like?"

"Innocent," Hillsden replied after a pause. "Innocent of life and what I was. She deserved better from me . . . like you."

"For me this is rich," she said without guile.

He silenced further questions by making love to her, using the act to blot out a past he could not bear to recall. At other times, watching her clean the villa, he was consumed with a sense of loss. The differences between their manufactured intimacy and his failed marriage brought

back too many memories of the life he had been tricked into leaving. It was tacitly understood between them that they were both puppets being manipulated. The rules had been laid down long ago; it was, after all, just one more layer of deception coating their day-to-day existence.

Once, when they were both agreeably in their cups, Inga broached the subject of a more permanent relationship.

"Alexi," she said, using her chosen equivalent of his name that he found curiously affecting, "how would you feel if I became your strife and trouble?"

He smiled at her attempt to remember the slang he had taught her. "Is that a Russian proposal?"

"If you want it to be."

"My dear, I'm too old for you."

"But we suit each other. And we know each other for what we are. Most people don't have that. It takes them a lifetime to find out just a little. From the first time we were together we had to share secrets. Bad secrets."

"Yes," he said, not wishing to put her down.

"Old doesn't matter. What matters is affection, respect. When we first see each other you were so polite, so different from other men I meet, and you protected me. When I am told to come to that apartment I am expecting to be treated like a whore, but you gave me respect. I remember very much what you said when I did as I had been told and asked should we make love."

"What did I say?"

"You told me I didn't have to do anything I did not want to do."

"You mean I behaved well for once?"

"No, don't joke. It was nice. You weren't like your friend Jock."

"It takes all sorts. Don't let's go back on that. Look, my sweet, naïve Inga, I'm very fond of you and in different circumstances I'd be lucky to marry you. But you don't want some old crock like me. You'll move on—you *should* move on. Either your youth will take you away or they'll move you on. I know that and you know that. Ships like us have to pass in the night."

She began to cry. "Is it you still miss England? Say it's that, please."

"I miss what England once stood for," Hillsden answered carefully.

"I shall miss you always if we part. My first Englishman."

"Will you? Well, I'm glad you think you will."

A few months later his prediction came true: Inga disappeared out of

his life. He woke one morning to find her gone, all personal traces having been removed while he slept. She had not even left a note, just a small bunch of flowers by the bedside, a gesture he found unbearably moving. In the days that followed he discovered he was desolate without her, familiarity sometimes being more binding than passion. The villa soon lost the small feminine touches she had brought to it, and he quickly reverted to the disorganized life of a bachelor, cutting domestic chores to a minimum and neglecting to change his clothes regularly. For the first time in many years he was, to all intents, a free man. The irony of his situation was not lost on him. He had lived a double life for so long that now he compared himself to an amputee who can still imagine feelings in a missing limb.

4

"NEVER UNDERESTIMATE HUMAN greed," Commander George Pearson said darkly, sharing a philosophical mood with Alan Lloyd, his number two. "Take me, for example. Why did I order a second helping of bread-and-butter pudding? I don't need it, but I took it, and now I expect I shall eat it." He stroked the belt of fat round his middle. "And I'll tell you something else: greed is stronger than the sexual urge."

"You've got the hump today," Lloyd observed.

"I'm disturbed, chum. Disturbed. In our well-regulated, seemingly civilized society, satanic forces are always at work, and at times like this the cloud sits right over me."

As senior officer in the Metropolitan Police anti-terrorist squad, Pearson was overworked and looked older than his forty-nine years. He lived with a grumbling duodenal ulcer that snatched meals and the police canteen food did little to placate. A married man with two teenage children he seldom saw and who were openly critical of the police in

general, he could not be judged a completely happy man. Whereas at the beginning of his career the enemies of the state had been clearly defined, the threats now came from many directions, and the lines of demarcation were blurred. Like the weather, the climate of treason was difficult to predict from day to day.

"Have you studied old Hogg's report?" Pearson asked.

"Yes."

"And? Any conclusions?"

"It's got some very curious aspects," Lloyd said. "Somebody, it seems, went to a great deal of trouble to remove a citizen." Recently promoted, he was ambitious enough not to commit himself to hasty judgements. "Have you definitely ruled out the I.R.A.?"

"On the whole, yes. An isolated sectarian murder away from their own killing grounds? No. Doesn't sit with me. Granted they are getting subtler and it was a particularly sophisticated operation, I still don't go for it. If we take it that their real aim was to attack the mainland security forces, then it seems an ill-considered affair even for them. How could they be certain the booby trap would be triggered by the police? Any curious good Samaritan could have disturbed the body. I think it was pure chance those two poor bloody coppers bought it."

"Hogg reckons the unknown stiff was dead before the explosion."

"And Hogg, we know, tells it like it is."

"What really intrigued me," Lloyd said, "was the bit about the female underwear. That's a new one. Very bizarre."

"Oh, I don't know. When I first joined the force I had a station sergeant—tough as old boots, looked a bit like Wallace Beery, could drink most of us under the table—who took early retirement when they nabbed him wearing high heels outside the Hammersmith Palais. Pathetic really, because even in drag he still looked like Wallace Beery. So don't mock it. Follow it through; it might be the only lead we've got. Who was he? That's the first thing we have to discover; then perhaps we might be on our way to finding out who took such elaborate pains to eliminate the poor bastard."

Pearson pushed the remains of the bread-and-butter pudding to one side and cadged a cigarette from Lloyd. "Murder's also a form of greed, a greed for power," he added, coughing at the first inhale. "Whoever planted the bomb needed to prove something."

"If we eliminate the I.R.A. how about the Middle East connection?"

Pearson shook his head. "They go for straight assassinations. Nothing

subtle about these bastards. I don't know why, but my ulcer's telling me that when we get lucky, *if* we get lucky, we're going to disturb a cesspool."

"Are we on our own?"

"Yes and maybe no. Officially it's the C.I.D.'s case, but a little bird whispered that the Century House mob are sniffing around, and that makes me particularly uneasy."

Although new to the job, Lloyd was sufficiently aware of the power play that existed between the various branches of the British security services to appreciate Pearson's concern.

Century House was a twenty-story tower block close to Waterloo Station on the South Bank of the Thames, one of a number of concrete monoliths erected postwar when the planners championed ugliness and size as a substitute for architectural taste. Anonymous like many of the surrounding buildings, its façade was stained by the elements like an ugly woman on whose face the mascara has run. Since the late 1960s it had housed the headquarters of MI6, known colloquially as "the Firm," the branch of the British secret service responsible for overseas espionage and counterespionage. Until the aftermath of the prolonged fiasco of the *Spycatcher* trial, when the Thatcher administration introduced legislation to prevent further egg being sprayed on its face, a ponderous myth had been maintained denying the existence of the security forces in peacetime. Until then nothing about it was to be found on the statute books, nor was it recognized by common law. There had even been a period when its operatives were paid in untraceable gold sovereigns, since the budgets and operational finances were never openly debated in Parliament. Details of its past activities were zealously guarded, and there was never any public recognition of its successes; only major scandals occasionally forced attention to its failures. It necessarily followed that if the secret service officially did not exist, then the same twisted logic dictated that it had no staff or Director General. This Alice in Wonderland scenario fooled nobody and achieved the reverse effect by ensuring the maximum speculation and media attention, since the penetration of secrets, whether personal or public, is one of human nature's abiding attractions. The current Director General was Sir Raymond Lockfield, commonly referred to within the Firm as "Control." Until the 1989 Act was passed and he and his organization were afforded a quasi-legitimacy, his name and function were known to most of what used to be called Fleet Street and certainly to the K.G.B.

37

"Why particularly uneasy?" Lloyd asked.

"Put it this way: why should Lockfield's truffle hounds be trespassing on our territory? What do they know that we don't? And if they know something, why aren't they sharing it?"

He forked a single raisin from the remains of his bread-and-butter pudding and popped it into his mouth. "But two can play at their game. No reason for them to have a monopoly on dirty tricks, if you get my drift. Are you with me?"

"All the way," Lloyd said, without quite knowing what he was letting himself in for.

The nominal master of MI6 was the Foreign Office. Control reported directly to the Prime Minister, and in theory was closely scrutinized by the Joint Intelligence Committee, on which body he served.

Born in Delhi, the only son of an Indian army officer, Lockfield had been sent back to England at the age of seven following the death from cholera of his mother. A War Office friend of his father had secured him a place in a decent prep school, where he showed enough academic promise to gain an entrance to Westminster. From there he won an open scholarship to Trinity College, Cambridge, eventually taking the Classical Tripos and a First in Modern Languages. His scholastic triumphs were allied to a highly visible right-wing stance. His father's army pension allowed few luxuries to flow to his son, and for most of his time at Cambridge Lockfield had been poor in comparison to his contemporaries. It was during this period, when he was most susceptible to the persuasion that all men had not been created equal, that he had been sounded out by one of his tutors, a placid old buffer most people took to be an amiable eccentric. Subtly, persuasively, applying no undue pressure, this man had guided the impressionable young Lockfield toward an understanding of what the future could be. It was in the quiet backwaters of Cambridge that the definitive map of his life had been drawn.

It had been generally accepted that Lockfield would either gravitate to the Foreign Office or else opt for a parliamentary career. He had in fact fought one by-election as a Conservative candidate, having been cynically selected for the thankless task of contesting a staunch Labor seat in the Welsh valleys, always a certain graveyard for the Tories, and predictably he lost his deposit. This brief flirtation served to instill in him a hidden contempt for the political machine and those who were wedded to it: he found most of them insufferably arrogant, woefully ill

informed about the world, blinkered to everything but their own self-advancement. What mattered, however, was that he had made the accepted gesture; afterwards newfound friends in Whitehall eased his passage into the Foreign Office. He worked his way through the ranks during the prewar years and when the war came swiftly gained a commission into the Intelligence Corps. By the end of hostilities he held the rank of lieutenant colonel. Because of his special qualifications, his demobilization was delayed; he stayed on in Germany until mid-1946, working with the Allied Control Commission in Berlin, with direct responsibility for the repatriation of Russian prisoners of war.

Returning home, he joined MI5, and after the reorganization in 1953 he transferred to MI6 (Section V), heading the political subversion division during the height of the cold war. In 1968 he was promoted to Assistant Director, finally becoming Director General during the last Tory government. His credentials were sea green, and both sides of the House expressed satisfaction that at long last the right choice had been made.

On the day Pearson and Lloyd were preoccupied with their own problems, Control was on a short fuse. It had begun with a particularly difficult meeting of the Joint Intelligence Committee arguing the Firm's budget requirements for the coming year. These would be handled under the Secret Vote, the annual sum allowed by Parliament without debate. Although Bayldon had assured him that it was only a question of going through the motions and that what he had put in for would eventually be forthcoming, he had resented having to suffer a third degree at the hands of the Committee chairman, a black MP from Liverpool. Returning to his office, he had been greeted with the news that one of the Firm's secretaries had been caught in possession of a quantity of cocaine at Heathrow and that the most scurrilous of the tabloids was poised to run the story, the girl having lost her nerve and revealed her place of employment. He immediately put in a scrambled call to the Commissioner of Police, who was sympathetic but stated that unfortunately the girl had already been charged and the law must take its course. Resigned to accepting the inevitable furor and thoroughly disgruntled, he took lunch alone in his private dining room, only to have this interrupted by Markham, his deputy.

"I hope it's important, Julian," Control snapped.

"Well, it could well be. Apparently a character called Mitchell who works at G.C.H.Q. has failed to appear for the third day running."

Control paused in the act of dissecting his smoked trout. The Govern-

ment Communications Headquarters at Cheltenham had been a sensitive area from its inception; any hint of subversive activity there always threw the government of the day into a panic. "What makes you think that piece of news is worth interrupting my lunch for?"

"Your recent memo telling us to keep close tabs on G.C.H.Q."

Control grunted, extracting a fishbone as thin as a hair. "Well, if it's three days old, why wasn't I told sooner? Didn't anybody check before?"

"I think it was assumed he might be ill. He was complaining he was coming down with the flu the last time anybody saw him."

"What does he do there?"

"He's a grade one cryptologist and head of his section."

"Christ! That bloody place is a running sore. Well, have all the normal checks been carried out?"

"As far as I know, but of course, strictly speaking, it only becomes our concern if he's slipped the country. All the airports and ports are being watched."

"What about his home?"

"He lived alone. There is a housekeeper, but she's Filipino and speaks very little English. All this is secondhand, but my sources are reliable."

"Presumably she speaks enough to say whether he's in or out."

"She hasn't seen him since he had dinner on Wednesday evening."

"What about his desk? He was grade one, you say? What were his special responsibilities?"

"His section monitors all G.R.U. transmissions in and out of Moscow. As head of section he would have unrestricted access to anything that came in."

Control got up from his lunch table and went to the window. A sea gull dipped out of the low clouds, passing like a shadow, but the noise of its cry did not penetrate the double-glazed windows. Markham winced as Control cracked three knuckles in succession; he recognized the danger signs. Without turning, his superior said, "Keep on top of it, and don't worry about treading on MI5's toes. Put a couple of good men on it and tell them they have a free hand."

"Right, sir."

"Report back directly to me." He stopped Markham by the door. "You said your sources are reliable. How reliable?"

"The word I should have used is *impeccable.*"

When Markham had gone Control went to his desk and dialed a

number on his scrambler. He waited but got no response. Leaving his lunch unfinished, he took his cashmere overcoat and bowler hat from the closet and left the building without telling any of the staff where he could be reached.

"Why me, Sergeant?" Constable Whiting asked. "Why not one of the girls?"

"Because the experience will be good for you, lad. All part of life's rich pageant. In any case, don't argue. Get on with it and bring back the goods."

Whiting left the desk reluctantly. "And a receipt. Don't forget that!" the station sergeant shouted after him.

Heading along Regent Street in the direction of Oxford Circus, Whiting fingered the wad of twenty-pound notes he had been entrusted with. His temporary wealth troubled him almost as much as the reason for his mission, and the fact that he was in uniform was an added worry. Twenty-two, unmarried, very much the probationer with just over a year's service in the force, he was well aware of the ribbing he could expect on his return. The only time he had seen a comparable sum of money had been when a drug pusher had attempted to bribe him, but at least that incident had been in the course of duty. His present assignment had never been covered in the police manual.

He made for Dickens & Jones in the Circus and wandered around the ground floor looking for a directory board that would point him in the right direction, eventually discovering that the department he wanted was on the second floor. On arrival he found it as daunting as he had expected: counter after counter of bras, panties, flimsy nightgowns, all the accoutrements his fevered imagination associated with the female mystique. A half-open changing room revealed a glimpse of a middle-aged matron wriggling into a corset. As he hurriedly turned away he almost knocked over a lifelike dummy displaying a bra for the fuller figure.

His agony was relieved by an assistant, and to his dismay she was roughly his own age and pretty as well. His last hope had been to find some kindly old biddy who would have sympathized with his predicament; he was more at home with old people.

"Can I help you, officer?" The last word was slightly accentuated.

"Yes, probably. I hope so; that's to say, I don't know," Whiting replied, using his official voice that had only been tested twice in court.

41

"I'm looking for the . . . things . . . ladies' things . . . underwear."

"Well, you've come to the right department." The laugh lines at the sides of the girl's eyes deepened, although she kept a straight face. "Anything in particular?"

"A selection."

"Pushing the boat out, are you? Right. Okay, you've got lots to choose from. What size is she?"

"Size?"

"Yes."

"Oh, I don't think size matters. He didn't mention sizes."

"You're buying for somebody else, are you?"

"That's right."

The assistant gave him an old-fashioned look. If it hadn't been for his uniform, she would have passed him on to the manageress at that point. She was no stranger to oddballs.

"You have to have a size, you know. Is it for your . . . his . . . girlfriend?"

"Er, not exactly."

"A mother or a sister, perhaps?"

"No, all I need is a selection, different pieces. Just a moment." He fumbled in his top pocket and produced his notebook. "Do you stock things made by Janet Reger?"

The girl brightened at this. "Going for the best, are you?"

"To tell the truth, I don't know what I'm going for," Whiting blurted, deciding his only chance was to make her an ally. "I'm under instructions, you see. Official business. To buy specimens." Sensing that this still wasn't a concise enough explanation, he glanced around to make sure they were not being overheard. "To do with a crime."

I bet, the girl thought. A crime not yet committed.

"Well, let's see what we can come up with. The Janet Reger range is over here. I must warn you it's not cheap. Very daring and super quality, but not cheap."

She led him to another part of the department where he was confronted with a variety of articles he normally associated with the calendars stuck on the backs of locker doors.

"You choose," he said desperately. "Here"—producing the wad of money—"give me something for that lot."

"All of it?"

"I don't care. Just choose and get me out of here."

"The last of the big spenders, eh? I wish I had you for a boyfriend."

"Well, that could be arranged," Whiting said, gaining some confidence now that he had taken the plunge. "Here's my number"—he pointed to his shoulder. "You can always find me at Savile Row."

"I think I've got your number," the girl said, but smiling. Whiting chalked her up as a possibility and made a mental note of her name from the identification tag on her well-filled blouse.

She chose three garments for him and wrapped them.

"Be sure and give me a receipt. I have to produce it for my sergeant."

"You're sure you're not buying them for him?"

"That'll be the day."

"Well, any time, Number Eighty-Seven," the girl said, handing him his parcel. "I prefer serving men. Some of the old crows we get in here drive you round the bend. My half day's on Wednesday and I've never been out with a policeman."

"You're on, Isabel. This is a first time for me, too."

"There we are, Sarge," Whiting proclaimed on his return to the station. "Piece of cake. When you want me to shop for you again, say the word. I enjoyed that."

"Did you now?" the sergeant replied, miffed. "Well, now you can enjoy something else. Go to that takeaway Indian restaurant on the corner of Old Compton Street; there's a punch up to sort out. A waiter threw a plate of curry at one of the customers, who not unreasonably felt aggrieved. This the receipt?"

"Yes, Sarge. Can I ask you something? What do the C.I.D. want this gear for?"

"It's the commissioner's birthday and they're going to surprise him with a number from *A Chorus Line.* Don't ask questions, lad. Ours is not to reason why. They're all bent in that mob. Take my tip: stay young and innocent."

Still puzzled as to exactly why the ubiquitous Keating had stood him lunch, Waddington found that Alec Hillsden was constantly in his thoughts—memories floating to the surface just as, long after the event, a still pool will suddenly give up clues to a crime. He had always hated unfinished business and had felt strangely wounded by Alec's inexplicable flight; because of their relationship he had taken it as a personal betrayal. Sudden withdrawal of friendship was never less than a blow to one's pride, and the passage of time had done little to lessen the feeling

of loss. It was the absence of any rational explanation that rankled most—the fact that, despite all evidence to the contrary, he still did not believe his own judgment could have been so wrong. Old Alec might have been a different animal, treading paths in their jungle that Waddington had never explored, but he had never been less than straight in his dealings with friends.

This loss of confidence in his ability to judge character together with the fortuitous combination of two other major events in his life, had cast Waddington adrift. He and his wife had no sooner decided that they could not reconcile their long-standing differences than the main cause of their discontents was removed. Before the divorce became absolute Waddington had been informed he was being compulsorily retired from the Firm with a reduced pension. The grounds given were that it was now government policy to cut back on the security services in view of the improved relations between the West and the Soviet bloc.

After the statutory warning that any breach of the Official Secrets Act would bring down the full strictures of the law, he had shredded the contents of his desk and then shared a boozy and ultimately debauched farewell party with several fellow redundants before leaving the building for the last time. This departure, far more than the end of his marriage, had left him disoriented, though the divorce itself had been reasonably amicable. With no children to suffer traumas or confuse the issue, there had been few wrangles over the division of the spoils. Waddington had cashed in an insurance policy and given his wife the proceeds since she had expressed a wish to buy a barn in her native Yorkshire, while he kept their previous home in Beaconsfield and half the contents.

Although no stranger to loneliness, he found life as a floating bachelor presented an entirely new set of social problems. Life before the break had meant sustaining a bogus middle-class image of respectability with neighbors and his wife's circle of friends, the latter necessarily removed from any connection with the Firm. Many of these now cut him in the high street—the women generally assuming that he was the guilty party, the men not wishing to be tainted by association. Since his culinary skills were limited to heating canned soup in the microwave or scrambling eggs, he ate out most nights, often deliberately seeking out cheap and indifferent restaurants, choosing necessity rather than pleasure.

Job opportunities for his age group had proved to be sparse. He had been chary about revealing his past, since he had rightly surmised there was no advantage in describing himself as a former wine salesman, the

cover he had used with the Firm. Although he had scoured the classified ads in both national and local papers, he had received few replies and at one point had seriously considered emigrating to Australia, only to have his application turned down. Then, with his savings fast running out, he had chanced upon a technical magazine in his dentist's waiting room that carried an article extolling the job opportunities in the growth industry of home security. He consulted the yellow pages and at the third try was given an interview with a company called Breakproof. The owner and managing director proved to be a weedy little snob who insisted on being addressed as "Captain." Judging his man correctly, Waddington conducted his interview with clipped precision, lying that he had just returned home from Canada following the death of his parents. He wore his old Intelligence Corps tie and sat at attention throughout the session.

"Let me put my false teeth on the table," the Captain began, and for one ghastly moment Waddington thought he meant it literally. "In the event I decide to take you on—and I'm considering a number of applicants—I must caution you that I run a very tight ship, to borrow a naval term. As an army man yourself you'll appreciate that when one is dealing with security matters everything has to be tickety-boo. We market and install the latest equipment to customers who want the very best. Your function, assuming you're offered the post, I can only describe as a technological padre, giving comfort to the many out there who feel that their lives are under threat. Do you follow my gist?"

"Oh, absolutely, sir. Very apt comparison, if I may say so."

"Naturally the comfort we offer is material rather than spiritual, and of course you work on a basic salary plus commission. We preach the sort of faith people understand: faith in the reliability of our product, which happens to be of Japanese origin—though we don't volunteer this information unless pressed—faith in our integrity as personified in the name of my company and, most of all, faith in the honesty of my employees. There are a host of cowboys out there, Waddington, taking the public for a ride."

"I can quite believe it, sir."

"*Cowboys* is a polite name for them. Did you know, for instance, that in the Greater London area a break-in takes place every thirteen minutes?"

"Unbelievable, sir!"

"We are living in violent times—brought about, I have no doubt, by

the fact that National Service was recklessly abolished. What the youth of today needs is a taste of discipline. You benefited from it, and so did I. Six weeks' square bashing at Pirbright Barracks would do most of these criminal layabouts a power of good."

"I couldn't agree more, sir," Waddington said, suppressing a rising desire to tell the old fool to go fuck himself. "It's refreshing to hear somebody speaking common sense for a change. Having been out of touch, coming home I was appalled by the loutish behavior and general lack of manners." He had got the Captain's measure, and the lies came trippingly off his tongue.

"To be reactionary in these troubled times is to be progressive. My own view is that we should reintroduce capital punishment and the cat o'nine tails. I see here that you're not married," the Captain continued in the same breath, consulting Waddington's application form.

"No, sir."

"I prefer my employees to have a secure home life. Security in all things. No good locking other people's doors if your own is wide open."

"I was married. I'm divorced."

The Captain pursed his lips. "Not a womanizer, I hope?"

"I don't think so, sir, though I prefer the company of women to that of men, given the choice."

"What are your political views?"

"I'm uncommitted, sir."

The Captain frowned. "Can we afford such luxuries? I'll make no secret of the fact that I find our present administration regrettable."

"You won't find me disagreeing, sir."

After waiting a week, Waddington received word that he would be given a month's trial. The job proved to be boring rather than challenging, but at least he wasn't sitting at a desk from nine to five. Waddington swiftly discovered that the majority of Breakproof's clients seldom questioned the cost; all they wanted to be told was that their bodies and possessions would be protected twenty-four hours a day. As the Captain had indicated, much of the equipment was extremely sophisticated, ranging from passive intruder beams to bulletproof shutters, and was monitored from a central control panel. The fine print of the contracts did not miss a trick and made it a condition that the installations could not be purchased outright but only leased, and were subject to a maintenance agreement. This ensured a profit margin of some five hundred percent within the first year. "Safety is never cheap," was one of the Captain's favorite sayings.

The day Waddington returned to his office after the lunch with Keating he had exceeded the permitted hour by eleven minutes and was immediately accosted by his employer.

"I don't pay you to take extended lunches, Waddington. This outfit is run by the clock, as you well know. And why the hell don't you answer your bleeper?"

"I got held up in traffic and had no idea you'd been trying to get me, sir. The battery must be on the blink."

"Nobody is indispensable, Waddington. There are legions of younger men out there hungry for your job. I've made an appointment for you to see a Mrs. van Norden in Cranley Gardens. Here's the indent. She's waiting for you, so get over there straight away. And suck a mint on the way. Your breath reeks of stale cigar smoke. I'm amazed you can afford cigars."

"We bachelors, you know, sir, have nothing else to spend our money on."

Cranley Gardens lay between Kensington and Chelsea in an area that had undergone extensive architectural plastic surgery in the previous decade; the rows of terraced turn-of-the-century town houses had been divided up into expensive apartments, sometimes twelve to a building. In many cases this had been tastefully done, with the original fireplaces and ornate ceilings preserved, and the conversions commanded high prices. It was considered a smart address, but the sight that greeted Waddington when he arrived at Mrs. van Norden's house was not in keeping with the general air of affluence. A clapped-out American convertible, rusted and overdue for the junkyard, was parked directly in front of the porticoed entrance. Three Arab youths were bent over the open hood poking at an engine that looked as though it had been submerged in grease. Waddington stepped over their bag of tools and pressed the entryphone button alongside Mrs. van Norden's name.

There was a pause; then a light over the machine shone on his face and a distorted female voice said, "Yes? Who is it?"

"I'm the gentleman from Breakproof, madam."

"Do you have any form of identification?"

"Yes. I don't know whether it will register on this camera." He held up his identity card to the lens. "Not a very good likeness, I'm afraid." He felt stupid talking to a machine and was aware that the Arabs at the curb were listening to every word.

There was another pause. "Flat G, first floor," the woman's voice said. A buzzer sounded, releasing the lock. The hallway was carpeted

and tastefully decorated. When Waddington reached the first landing the door facing him was partially opened, but held secure on a chain.

"Show me your identity card again," the unseen woman said.

Waddington dutifully produced it.

"One can't be too sure these days." Apparently satisfied at last, Mrs. van Norden slid the chain and allowed him inside. Waddington found himself in a large high-ceilinged room that he guessed had once formed part of the original drawing room. The period fireplace had been left intact, though it now housed an imitation log fire. All the furnishings were in expensive good taste, anonymous, like an advertisement.

Mrs. van Norden's disembodied voice had given him no clue to her age or appearance, but now that they were face to face he was pleasantly surprised. Instead of the usual middle-aged matron ablaze with jewelry (known in the trade as "Cartier mutton dressed as lamb"), he was face to face with an extremely bedworthy woman in her early thirties wearing an authentic Chanel suit (which Waddington recognized, since his ex-wife had once treated herself to a cheap copy in the sales), adorned with a single tear-shaped diamond on a gold chain that dipped between her cleavage. The face above the necklace was no hardship to behold. It was, in fact, a face that most men would willingly give diamonds to if allowed the chance. Her hair was shoulder length and so carelessly immaculate that it demanded to be ruffled.

"I'm sorry to be so cautious, Mr. Waddington, but a woman living alone has to take precautions these days."

"Absolutely, madam. Never take risks. . . . So how can we help you?"

"Don't call me 'madam.' Makes me feel a hundred. This isn't my principal home, just a pied-à-terre I use when I come up to town to get my hair done or have lunch with a girlfriend."

"And you'd like us to upgrade the security, I take it? I noticed you've got a decent lock on the door, and the chain, but of course any door can be jimmied. If you want extra protection, we could reinforce it with a steel surround and fit concealed bolts on the hinge side."

"That sounds wonderful. I'm all for sleeping in a vault."

Waddington walked to the large French windows looking out onto the street. "At least the period shutters are still in place. Nobody's really improved on those. Do you close them at night?"

"When I remember."

"You should, though as a general rule burglars are leery about gaining entry from the front of a building—too exposed. What other rooms are there?"

"Just the kitchen, bedroom and bathroom. It's just a poky little funkhole really." She gave just the slightest emphasis to the word "poky."

"May I?"

"Please. You'll find the bedroom a bit of a shambles."

Waddington went through into the bedroom, which was mirrored on two walls. The bed itself was tented with a dozen pillows scattered on it, again looking as though it had been arranged to await the photographers. The curtains were drawn. He opened them and looked out.

"All you've got here is a simple window lock."

"No good?"

"Well, they're effective up to a point, but I wouldn't put too much faith in them."

"What d'you suggest?"

"We've had great success recently fitting our exclusively designed steel shutters."

"Would I like those? Wouldn't they completely bitch the décor?"

"No, they're mounted outside and operated electrically by a small bedside switch."

"I'd buy that. You're so full of ideas, Mr. Waddington. Why didn't I find you before?"

Why didn't you? Waddington thought. Preferably when I was eighteen and raring to go. The bedroom was making him decidedly uneasy. He moved to the bathroom.

"This doesn't have a window, I see, just an extractor fan."

"Oh, yes, they cram them in where they can when they do these chintzy conversions. I ripped out the original bath and put in a Jacuzzi. Do you like Jacuzzis?"

"Can't say I've ever tried one."

"You haven't lived."

They completed the tour, with Waddington making other suggestions to improve the system. "Would you like us to submit an estimate?"

"Just do it; it all sounds wonderful." She led the way back to the main room. "How about a drink? I think you've earned one."

"Only if you are."

She returned from the small kitchen waving a bottle of white wine. "Can you open this? I've got the curse of the weak wrists."

While Waddington did the honors, Mrs. van Norden produced two crystal glasses of a splendor he had previously only seen in glossy magazines.

49

"I can't tell you . . . what's your first name?"

"William . . . Bill."

"Bill, you've no idea what a relief it is to find somebody who knows what he's doing. I had to call a plumber the other day, and some teenage dwarf turned up who completely bitched the bidet. And, believe me, life without a bidet is not worth living. He hadn't got a clue. Thought it was a footbath, can you believe? I mean, how do some people exist? There was a time when one could get hordes of those divine little Korean people who worked night and day for next to nothing, but not any longer. I suppose our new lords and masters have decreed that servants are counterrevolutionary. In the event, I had to trek back to my country place to get sane."

She rattled off this monologue while pouring the white wine like pints of beer.

Waddington nodded sympathetically, thinking: She's the type they'll bring back the guillotine for. "Where is that?"

"Where is what?"

"Your country home?"

"Just outside Amersham. Thank God I've still got some staff there. Cheers. Do you find staff a problem?"

"Not really, no. For the simple reason that I don't have any."

She gave him a blank look before continuing, "Come to think of it, I could do with you taking a look at the situation down there. It's somewhat isolated, and my couple live in the cottage, and the system my husband put in is beyond me. It goes off if the cat farts, and of course the police get very beady—letters from the Chief Constable keep streaming in, saying next time it happens they won't respond."

"It's probably one of those cowboy installations," Waddington said, falling into his sales routine. "Doesn't your husband understand it?"

"What husband?"

"I'm sorry, I thought you mentioned him."

"Did I? That was a mistake. I gave him back to the world, and he gave me what he thought was a generous settlement. I live on my own; that's why I'm terrified at night."

"Well, if that's the case, I'd be glad to take a look at what you've got and make suggestions to improve it."

"Would you?"

"Only too happy."

"Let me scribble down the address and telephone number."

She went to a disorganized desk and wrote on embossed notepaper with a silver Tiffany pen. Waddington always noticed such small details. There's something about you, Mrs. van Norden, he thought, that doesn't quite ring true. Why would a well-heeled piece of crumpet be spending time, to say nothing of vintage Chablis, to chat up next year's Willy Loman? A dyke, perhaps? Did the departed Mr. van Norden find the heat turned off in the bedroom? No, I usually get strong vibes from dykes, and this one is giving off vibes of a different sort. But let's not be picky, Waddington, old sport; trade isn't that good, and business is business.

"Can you read my writing?" she asked, handing him the address. "When d'you think you could come? I mean, the sooner the better."

"Let me take a look at my diary; then I'll ring and make an appointment."

"Terrific."

Waddington finished his wine and left lighter of step, but halfway home it occurred to him that although he might be able to safeguard Mrs. van Norden against most eventualities, there was a strong possibility that he would need protection himself. He glanced up into his driving mirror to check whether some alchemy had transformed him into Dorian Gray, but it was the same ordinary face that stared back.

5

IT WAS A sullen start to the New Year; gales ravaged the south coast, much of Devon and Cornwall suffered floods, while in the north and in Scotland heavy falls of snow made many of the roads impassable and several outlying villages were cut off. Most of the population had cause to wonder why they had celebrated the night before.

Although the ports and airports were on special alert, the authorities

had their hands full sorting out the havoc caused by the storm. In any event the police and security forces were on the lookout for the missing cryptologist, and the Fat Boy slipped out of the country without hindrance. The Ford he had parked in Exhibition Road was duly clamped and remained immobilized for three days before being towed away. It then remained in the police pound for a further month before it was examined, and only then was it discovered to have false number plates and to be listed as a stolen vehicle. No connection was ever made.

The girl who had supplied the gun and plastic explosive device stayed put for a couple of weeks before she, too, went to earth. Acting on a prearranged plan, and with no shortage of funds, she first purchased some smart ski clothes, then checked into the Park Lane Hilton, had her hair permed, and booked a holiday in Switzerland. She traveled on a forged British passport until she landed in Zurich. There she was met by a middle-aged woman who, from all appearances, could have been her mother. An exchange of passports took place while they had coffee together in a café, and she traveled on to Frankfurt by train under her own name. There she made contact with her cell, was taken out of active service for six months, and obtained work as an au pair girl to an American family. They quickly thought the world of her.

Back in England the media finally got wind of Mitchell's disappearance. The Home Office issued a terse statement that was economical with the truth, playing down Mitchell's importance and stating that he handled only low-classification material. For a few days the story spawned the usual criticism of the lack of security in sensitive areas, before the headlines were taken over by one of those events which from time to time satisfy the morbid fascination of the British for sex scandals in high society. The most debased of the Sunday tabloids uncovered a ring of prominent citizens that included a High Court judge, a television personality, three members of the stock exchange and, predictably, a clergyman, who had all taken part in spanking orgies with young male prostitutes. A circulation war was created, with even the more staid national papers jumping on this lucrative bandwagon.

Although public attention was thus diverted, Pearson and his team were still occupied with trying to identify the third corpse. The two policemen had been buried with full honors, but the fragments of the unknown man had yet to be given a grave; nobody had come forward to claim or inquire about a missing father, son or husband. It was as if the remains in Hogg's plastic bags had no value whatsoever.

"Why can't these bloody cases ever be simple?" Pearson said, going over the facts yet again. His New Year's resolution to give up smoking had lasted exactly three hours, and he wheezed as he spoke. "I felt convinced that when Mitchell went walkabout we had it buttoned up." He stubbed his cigarette out in his coffee cup, a habit that had several times led to threats of divorce from his wife. "What do we have? Precious little. A man is shot and then placed on top of a cunning little bomb designed to blow him and anybody else to pieces the moment it's disturbed. Therefore . . . what? Make an assumption, Alan."

Lloyd stared down at the mass of paperwork on Pearson's desk. "Obviously whoever shot the poor bastard wanted to dispose of the body in no uncertain terms."

"And didn't give a toss who else got hurt in the process. To my way of thinking, that rules out your average murderer. By now I would have expected somebody to shout 'Bingo!' and claim a holiday for two in sunny Belfast." Pearson reached for another cigarette. "But since the shamrock heroes haven't come forward and we've heard nothing from any of the Middle East mobs all we have is an unknown stiff who apparently liked tucking his family jewels into ladies' knickers. Not a lot to go on."

"The only other break is the bullet fragment." Lloyd picked up one of the reports. "Our ballistics genius is ninety percent sure it was fired from a modified French police revolver."

"So?"

"Well, so far we've been assuming the victim was British. Perhaps he wasn't. Perhaps somebody followed him to London."

"Okay. Then what was he doing in Hyde Park at that time of the morning? And who knew he'd be in Hyde Park at that time of the morning? We know the French order things differently, and if it wasn't for the bomb I might go along with the old *crime passionel* syndrome. A lovers' tiff, a couple of drag artists who fell out. But the bomb doesn't fit into that scenario. Jealous queens are not noted for being explosives experts. No, this a professional hit job."

"Perhaps we'd be better off using a medium," Lloyd said. "That always produces results in the movies."

"Oh, very helpful. All we've got to go on is a coincidence. Mitchell goes walkabout and the following day a man is blown up in Hyde Park."

"Correction," Lloyd interrupted. "A *dead* man is blown up. Hogg reckoned he was shot before the bomb was triggered. Point is, was he

shot in the park and then dumped, or was he brought there? If he was brought there, we ought to be looking for a vehicle."

"Yes. Stupid of me to forget that. I haven't been sleeping well. What d'you do for that?"

"Not sleeping?"

"Yes."

"Don't know that I'm ever bothered. Must have a clear conscience."

"If we could somehow tie in Mitchell," Pearson said, reverting to his original train of thought, "I might get my head down on the pillow." He studied the case reports yet again. "We seem to be tracking a nonperson. An only son of deceased parents, no relatives—not in this country, at any rate—mortgage paid up, secure job with a good pension, on the face of it no worries." Picking up Mitchell's passport, he compared the photograph to the one on the security tag issued by GCHQ. Both showed the same bland, slightly jowly face of a man in his early forties. No distinguishing marks. He flicked through the passport; it contained an ordinary tourist visa for the United States with one entry for a trip to Miami and on succeeding pages rubber stamps showing he had visited Spain twice and Greece once. "You've seen this?"

"Yes," Lloyd said. "Just holidays from the look of it. He probably went to Disney World on the Miami trip."

"Disney World is right here, if you ask me. He belonged to no clubs, no political party. No known girlfriends. Or boyfriends for that matter. And I don't believe it; nobody lives that anonymously, especially in women's underwear. I think we should go back to the house and take a second look."

They were let into Mitchell's house by his diminutive Filipino housekeeper. Pearson had often remarked that it was a characteristic of her race to conceal their fears by giving the impression they were giggling. While answering his questions, she kept both hands cupped over her mouth, and her pronunciation of English was so strange that she could have been talking in a different language. She had already been checked out, and her papers and work permit were in order.

"Did Mr. Mitchell entertain friends here?"

"No, sar. No people not coming."

"Never?"

"No, sar."

"So you just cooked for him?"

"Yes, sar. I cook, clean house, do washing for him."

"Did he ever have ladies call here?"

The cupped hands went across her mouth. "No ladies, sar. Good man."

Pearson was about to ask whether she had ever washed any female garments for Mitchell, but thought better of it. No such clothing had been found in previous searches. "What I'm asking is—and don't be frightened, because nobody is going to harm you—whether you remember *anybody* who came to visit Mr. Mitchell, ladies or gentlemen. Take your time, just try to think."

"Mr. Mitchell stay alone most nights. Play music."

"He didn't stay home *every* night, did he?"

She began to cry. "What become of me now?"

"You're not going to get anywhere," Lloyd muttered.

"No, you're probably right." Pearson tried a few more questions, talking quietly, but it was a waste of time; she was dismissed and went tearfully to her room. For the next hour the two men again searched the rest of the house. Nothing new was discovered, and at the end of the fruitless effort they sat in the kitchen, cursing their luck.

"Call me old-fashioned if you like," Pearson said, "but I've always believed it's the small details that hang a man—a strand of hair, blood under a strangled girl's fingernail. You've always got to look for the needles in the haystack."

It was only then that he noticed something. "Let me ask you something, Alan. You ever read G. K. Chesterton?"

"G. K. who?"

"Chesterton. He wrote the Father Brown stories, among other things."

"That was on television, wasn't it?"

"I wouldn't know. Some of us don't get time to sit in front of the box."

"Are we playing Trivia, or what?"

"I remember a particular story about a postman who was a murderer. He took the body out of the house in his sack. Nobody suspected him for one simple reason. Know what that was?" Alan shook his head. "Everybody saw him, but *nobody* saw him, if you get my meaning. He was just a familiar object, so familiar that he didn't register."

"What's that got to do with Mitchell? You think the postman did him in because he didn't get a Christmas tip?"

"Turn around. Look behind you. What do you see?"

Lloyd swiveled. "Dishwasher. Cupboards. Coffee machine. Last year's calendar."

"Look on the floor."

Lloyd stared where directed. "A dog bowl."

"Exactly. But where is the dog? Nobody ever mentioned a bloody dog, did they? Everybody missed that, including you and me."

Pearson jumped to his feet, ran up the stairs to the housekeeper's room, knocked on the door and waited until she unlocked it. "I'm sorry to trouble you again, Rosa, but did Mr. Mitchell have a dog?"

"Yes, sar. Nice dog. Good behaved."

"Where is the dog now?"

"Gone, sar."

"Did the other policemen take him away?"

"No, sar. He go out with Mr. Mitchell." Tears began to course down her cheeks again.

"You mean that night? The night Mr. Mitchell disappeared?"

"Yes, sar."

"What kind of dog was it? A big dog?"

"Big, sar. Charlie."

"Was that his name?" Her hands went to her mouth as though she had been caught uttering some blasphemy. "Charlie? That was his name, was it?"

She nodded. He questioned her further, but she was unable to identify the breed. All he could get from her was that it was a large brown dog. After calming her down he sent Lloyd out to buy an illustrated book on dogs, and when he returned they sat down with her and went through it page by page. Finally when they got to the section on Labradors she pointed to one of the illustrations.

"That one? You're quite certain?"

"Yes, sar. That like Charlie."

"Did Charlie have a collar with his name on it?" This seemed to confuse her further. Pearson ran a finger round his neck and spoke very slowly. "A collar. With his name and address on it. Did he have one of those?"

She whispered her reply from behind her hands. "Yes, sar."

They left the house and sat in the squad car to talk things over.

"So what happened to good old Charlie?" Lloyd asked. "Clever of you to spot the bowl, Chief."

"That's because I'm an animal lover as well as a pretty face."

"Think it's a break?"

"Well, it's more than we had before. If we locate Charlie, it might give us a lead. Right! The first move is to have the Yard contact all the animal

welfare services. You can get yourself down to the Battersea Dogs' Home. Ever been?"

"No."

"You'll cry your bloody eyes out; that's why I'm not coming with you. Went there once when my little daughter lost her poodle. Nightmare! I couldn't take it. Let's go."

Others were also perplexed, none more so than Control. He had good cause: Mitchell had been his own man. Through Mitchell he had been kept fully informed of all G.R.U. traffic passing between Moscow and London before anybody else. Mitchell had protected his rear and given him early warning of any change in Moscow's strategy.

Ever since the Thatcher government had removed union recognition, G.C.H.Q. had been a breeding ground for dissent, but Mitchell had not taken part in any of the demonstrations against the union ban and had been one of the first to accept the lump-sum compensation offered by the government in return for signing a no-strike agreement. On the face of it, he had never put a foot wrong, which was why his disappearance was so inexplicable.

Twice in one week, taking a risk he had hitherto been careful to avoid, Control visited the dead-letter box set up for Mitchell's drops in the hope that contact would be reestablished. Both times he came away empty-handed. As each day passed he became more anxious about being cut off from Moscow. Mitchell could not be replaced in a hurry: agents with his expertise and carefully placed did not grow on trees.

Coupled with this dilemma was an awareness that the Prime Minister was becoming increasingly intransigent. While it could not be said that Bayldon had absolute power, the process of absolute corruption had begun. Like others before him who had gained great office by deviousness rather than by ability, he had quickly fallen into the trap of believing the image created by the party's publicity machine. He had conveniently forgotten by which route he had been steered into Downing Street: in his own mind he was there by divine right. On several occasions he had deliberately flouted his side of the bargain, refusing to implement the agreed plans so meticulously plotted prior to the coup. He had countered Control's displeasure by insisting that he was constrained by public opinion and his standing in the polls. The setting up of the militia had provoked fierce criticism from many quarters.

"In my judgment, I think we should let things quiet down for the time

being," Bayldon said at one of their meetings at Chequers in a room that had been made bugproof and was regularly swept. "I have a draconian budget to get through the House, one that is hardly likely to be received with any enthusiasm. Taxes have to rise, savagely in certain instances, to pay for our new socialist paradise. Politics, Raymond, is the art of the possible."

"A maxim once appropriated by a Tory," Control observed. "Rab Butler, as a matter of fact. He used it as the title of his autobiography."

Momentarily dented, Bayldon recovered by saying, "One should always borrow the best from one's enemies. What I am trying to explain to you is that only I can judge the pace of things. One can't rubber-stamp a revolution."

"Can't one? I would have said history teaches it's the only way."

"It's not the British way. I have my finger firmly on the pulse of the British public. They can be led, but not forced."

"Well, be that as it may, I can't conceal from you that there is considerable irritation in another place regarding the lack of progress in dismantling our nuclear deterrent. You will recall that was high on the agreed agenda. I am being pressed to obtain some positive timetable."

"The first stage will begin later this year."

"That's already six months later than agreed. A further delay would be taken as a hostile act. Evidence that the dismantling has started is needed for the Moscow summit in July."

Bayldon met Control's eyes. "I want to be sure of the French attitude before taking a final decision."

"The French are of no consequence."

"Try telling them that."

"The *Force de Frappe* does not enter into anybody's reckoning. I understand their farmers are more dangerous."

"Please don't try to teach me my business," Bayldon said at his most icy. "The Cabinet has already approved my strategy."

"So it's *your* strategy now?"

"Raymond, I happen to be the one in office."

"It's up to you to manipulate the Cabinet. Why else d'you think you are there?"

The reminder was not to Bayldon's liking. "Let's not open Pandora's box. The fact is, I'm in the job. You may have assisted along the way, but as far as I know you're not in a position to remove me. The boot is now on the other foot. It wouldn't take a great deal of effort for me

to persuade the Cabinet that your entire department is now superfluous and a squalid waste of public money."

"You don't think so?"

"I know so. Try to stitch me up and you'll stitch the only friend you've got." Suddenly he smiled, revealing teeth that had recently been capped after his wife had criticized his appearance on television. "Raymond, Raymond, why are we having this conversation? I am here to preside over the orderly transition from a reactionary regime to a full-blooded radical state, always keeping in mind the fact that historically the electorate of this country are creatures of habit. The majority have a built-in Luddite mentality, resistant to change. The changes must come about gradually if we are to succeed in our joint aims. Our task is to sell the idea that what we impose upon them is what they have always wanted. It's a straight marketing exercise, like putting across a new brand of soft drink. You seem to forget that unlike you, I am highly visible. Be good enough to leave politics to me. We still have an Opposition, you know."

"Emasculated."

"You wouldn't think so at question time."

"But since you abolished broadcasting from the House, who knows? What percentage of the public reads *The Times* or the *Telegraph*? And those who do are against you anyway. You're safe for another three years if you play your cards right. In three years you could reinvent the wheel."

There was something in Control's delivery that caused Bayldon to backtrack. "Don't get the wrong idea. I'm very conscious of the tasks I have to carry out. All I'm saying is that I'm constrained—'handicapped' would be a better word—by the permanent civil servants."

"Purge them."

"Not easy."

"There are ways of skinning those cats. Give me names and let me take care of it. You have no idea how rewarding a few carefully planted rumors about their private lives can be. Of course, you've denied yourself the traditional way of removing turbulent priests and the like."

"How d'you mean?"

"Previously you knighted them or sent them to the Upper House. Quick, cheap and effective."

"I had to stand on the election manifesto." Then Bayldon added, "It didn't do much to alter *you.* "

"Ah, but I was a special case," Control said evenly. "And I was never

a turbulent priest. Though I could be, if things don't go according to plan."

"This is a stupid conversation. You know very well that I intend to honor my side of our arrangement. All I'm saying is that in order to bring about the major changes we both know are necessary I have to play it by the existing rules."

"You knew Moscow's rules going in."

"I would remind you that we're still a democracy."

"So I'm told," Control said, "so I'm told. But of course one must never believe everything one reads in the papers. And of course up until now you've never had to test your popularity in a general election."

"What you and . . . our friends . . . don't seem to realize is that there is only a certain amount of parliamentary time available in any day. They may be able to reverse policy overnight, but we have to comply with procedures. If I attempt too much too soon, somebody will smell a rat."

"The agreed priorities have to be honored."

"Atomic submarines aren't Dinky toys with clockwork motors. One can't float them out to sea and sink them. Plus the fact that every week I get reports back from Washington that if we take unilateral action what *they* will sink is the pound. You don't seem to appreciate that I have to juggle a dozen balls at once."

"Well, you wanted the job," Control said, and there was ice in his voice. "You were hungry for it, as I recall, and that particular appetite is not yours exclusively; there will always be others anxious to feast at the same table."

Bayldon's voice became more placatory. "Raymond, you and I have always known we were playing for high stakes. Correction, the *highest* stakes. Equally, we can neither of us be under any misapprehension of the problems we face. To bring this off in the way that we both want, to establish a true communist society—"

"Don't use that word, not even to me," Control interrupted.

"This room is safe enough. You assured me."

"Even so."

"Very well, then, to 'reverse centuries of reactionary rule' cannot be accomplished by the stroke of a pen. The committed Left has never achieved parliamentary power in England. Their real power has always been on the workshop floor, within the unions. We have to restore that, go back to our origins. Then, in the House, disguise the medicine by flavoring it, a laxative masked with a nice taste, so that it slips down

their throats unnoticed. I've got several surprises up my sleeve. The old parrot cry of "soaking the rich" isn't the answer. Everybody, including the brothers wants to be rich, so our approach has to be more subtle. We have to instill fear, and the process has already begun. I've clipped the wings of the police. We could be in for a crime wave, and when that happens the public will scream for draconian measures, mark my words. And I don't mean just letters to *The Times;* I'm talking about your average citizen, that great amorphous mass out there in suburbia who think that a takeaway Chinese meal is haute cuisine. That's where the militia will come in. And of course I shall look to you to play your part and supply a few distinguished scapegoats. We shall need household names. You mustn't think that because I'm proceeding cautiously I'm not being diligent." Bayldon smiled for the first time. "So don't give me oblique threats, Raymond. Your advice and cooperation will always be welcome, but threats aren't on. I take exception when anybody positions tanks on my front lawn."

"I'm glad you're quoting from an impeccable source," Control said evenly. "Wilson used that phrase, as I recall. He lost in the end, of course."

Control left Chequers very disturbed. He had no special regard for Bayldon, either as a man or as a politician. The man had been selected for one reason only: he was more corruptible than most. But now his conceits had become dangerous; he was too arrogant and ambitious to realize he was third-rate, goaded forward by an even more ambitious wife, the most potent of all human combinations.

As he drove back to London on treacherous icy roads, he began to think again: that which he and Moscow had joined together could as easily be cast asunder.

Sometimes life without Inga proved emptier than Hillsden could tolerate. There were nights when, stupefied with the scotch he was allowed to buy, he considered pleading with Abramov to bring her back. These days he was often drunk, shrinking his old personality, falling prey to self-pity as he contemplated the life sentence ahead. His rare contacts with the outside world only intensified the need to bury himself. He roamed the empty villa half-dressed, going from room to room, talking to himself like the shuffling inmate of an asylum. This period of hopelessness lasted several weeks until some inner resilience, a hangovered awareness of what he had become, pulled him back from the brink.

Almost casually, at first treating it as a necessary therapeutic exercise,

he started to put his past life down on paper, hoping that by so doing he could somehow expunge those treacheries and lost loves that still consumed him. Much to his surprise, what began as an escape from oblivion gradually became something he felt he had abandoned forever, the restoration of that old familiar: risk. As he scribbled, the bottle of scotch forgotten, he found that he was writing not autobiography but an instrument of revenge, shaping his sentences into poisoned darts that could kill from afar. Once this realization hit him, a more dangerous idea took hold. Destroying the score or so pages he had written, he began again, this time laboriously reducing his handwriting to minuscule proportions and filling both sides of each sheet. As the manuscript progressed he secreted the pages into the lining of the fur coat he had acquired during his original stay in Moscow.

Thus he passed the summer, putting in long hours at his desk during the nights and sleeping late into the hot afternoons. He omitted nothing, knowing that if the plan he had conceived was to work he had to make the material too explosive to ignore, albeit always conscious of the fact that if he succeeded he would be signing his own death warrant.

It wasn't until he reached the period he had spent in the old Austrian station that the momentum slowed. Memories of Caroline and Jock and the guilt he still retained for his neglect of her during those final years in the nursing home became almost too painful to record. It was now that he was overcome by a sense of total inadequacy—so common to all writers, regardless of talent, but in his inexperience shattering—a conviction that he had embarked upon an exercise in futility. For over a week he reverted to the bottle before finding the determination to continue.

The finished manuscript ran to the best part of fifty double-sided pages. He divided them into equal halves, then carefully stitched them inside both sides of the lining of the fur coat. It was only then, elated that he had reached the end, that he gave some thought to his next moves. He was forced to acknowledge that the effort that had cost him dear would be of no consequence unless he could ensure it found its way back to England. He drew some comfort from the knowledge that he was following in illustrious footsteps: far greater risks had been taken with greater works than his, savagely painful documents written on hoarded scraps of paper in the bleakness of the Gulag that had somehow found their way to the free world.

In the subsequent weeks Hillsden thought of nothing else, devising,

analyzing and rejecting scheme after scheme before he decided on one that contained the germ of success. Even so, it depended on chance happenings coming in the right order, none of which he could predetermine. Yet anything—exposure, failure, death even—was preferable to the slow disintegration he had been condemned to before: that had been Caroline's end, and he needed to atone.

The recently promoted Major General Abramov of the G.R.U., the Soviet army's elite security arm, had every reason to feel satisfied by the way in which his handling of Hillsden's defection had been received. His immediate superior, General Geichenko, who was not given to distributing casual bouquets, had singled him out for special mention, hinting that he had a more exacting assignment in mind. But it was not in Abramov's makeup, nor in the very nature of the career he had so resolutely pursued from the outset, ever to feel totally secure. Complacency was for idiots; that was not the way of things. He was as careful at concealing his ambition as he was at hiding his true thoughts. Nobody penetrated his veneer of modest charm, which, allied with his clean-cut looks, had always ensured sexual success. A Muscovite by birth, educated at the university, he spoke several languages fluently and had a firm grasp of world affairs. There was a certain fastidiousness about him—the way he wore his immaculately cut uniforms, the Western-style haircut he affected, his way of holding a wine glass, the Dutch cheroots he smoked—that set him apart from his fellows. He treated the women he used with a remote courtesy, never allowing them to see any emotion, so that they departed from his bed satisfied but none the wiser.

There were ample historical reasons for Abramov's caution. Ever since the days of the revolution there had always been bad blood between the two arms of the Soviet security forces, and that had been intensified during the Stalinist purges, when the top ranks of the army had been decimated. That hideous chapter had never been forgiven or forgotten by the army, and it was during this period that the seeds of dissent had been sown between the G.R.U. and the K.G.B., for Stalin had used the latter as the main instrument of carrying out his perverted and (as the coming war was to prove) mistaken policy. Historically the K.G.B. had always been closer to the Politburo than the G.R.U. During the years of mass executions, when nobody was safe and the merest suspicion was enough to denounce the innocent, be they man, woman or child, the rivalry between the two factions had bordered on paranoia:

63

it became part of the Russian consciousness to live in fear, for whole sections of the populace to be at the mercy of small-time bureaucrats strutting their meager authority in every town and village, concealing their own fear of those immediately above them by acting with greater ruthlessness than the situation demanded. It mattered not that the guiltless died by the countless thousands or else were deported to the living hell of the Gulag. What mattered was that the chain links of fear, on which all despotic regimes depend, should not be broken.

Even when after Stalin the bloodletting dwindled to a comparative trickle, the K.G.B. remained in the ascendant, culminating in the rise of Beria to the highest offices in the land, his stranglehold on the jugular of Soviet society seemingly unbreakable. Plots and counterplots abounded within the Kremlin itself, the watchers in turn watched, their telephones tapped, their every movement tabulated, so that in order to survive they had to create secret organizations within secret organizations, never certain where or how the information they collected would be used.

Geichenko was a survivor with a long memory. His father, also a top-ranking officer, had survived the Stalinist era only to be denounced by Beria for daring to criticize the performance of the second Five-Year Plan, and as a child Geichenko himself had been sentenced to ten years' exile in a labor camp. Ironically it was the war and the army that had saved him. His future shaped by those early experiences, once he had risen through the ranks to a position of power he had made it his business to surround himself with a hand-picked bevy of bright young officers who were his eyes and ears: he was a student of history and had noted that this was how Montgomery had operated to good effect. He demanded nothing less than total loyalty, and those who failed to live up to his exacting standards were swiftly culled. Abramov, a member of this inner group, was a favored son who owed his rapid progress to Geichenko's paternalism.

The G.R.U.'s coup of landing Hillsden from under the K.G.B.'s nose, and indeed the way in which Geichenko had masterminded the entire British operation, meant that Abramov got his share of reflected glory. He had always been attracted to Western attitudes, and being in a position of privilege he had access to Western literature. During the many weeks when he had first interrogated and then debriefed Hillsden, their attitude toward each other had undergone subtle changes. He respected Hillsden, and their dialogues had often acquired a philosophi-

cal depth, straying from the business at hand to wider fields. It so happened that in the end he had been compelled to stretch Hillsden to the limits, and the Englishman had not failed him, passing all the tests set him, including the hardest of all. Because of this, and because Abramov had always admired him as a fellow professional, their relationship had gradually deepened into a curious sort of friendship, though not to the extent that Abramov compromised his own future. He always held something back even from those closest to him. It was his nature. He gave just enough of himself to inspire trust, a technique that had always served him well, for once trust had been established he had observed that friends and enemies alike dropped their guard, became careless—and carelessness was a tool he could always turn to his own advantage.

The girl, Inga, had served her purpose, placed in Hillsden's life as an extra insurance policy, for the confidences shared on the pillow often made a vital difference. Since he never allowed his own life to be governed by a woman, he gave only passing consideration to Hillsden's feelings in the matter. Other girls could always be provided if the necessity arose, and he justified his action by convincing himself that in any case Inga was of inferior intellect to Hillsden, ignoring the fact that in the history of human sexuality intellect has not figured high. So when making one of his periodic visits to Hillsden Abramov was surprised and unprepared for the change of mood.

"I've never seen you like this, Alec. You seem depressed."

"Not depressed so much as disenchanted. I'm becoming a hermit crab here."

"I know your real problem. You want someone to share your bed. That can be arranged."

"No, no more 'arrangements,' Victor. I'm too old for that game. It's just that I have an urge to see more of my adopted country. I'm a city boy, born and bred. I'm stagnating here. I want to sample some culture, theaters, museums."

"But most people would envy you this situation."

"Maybe, but I'm not most people. You should know that."

"You prefer the cold to the seaside?"

"I prefer cities. Not Moscow. Moscow doesn't hold happy memories. But Leningrad, for instance."

"Well, I want you to be content, Alec. Your useful life isn't over yet. I will note your request and discuss it with General Geichenko."

65

"Will it go with your blessing?"

"Alec, you insult me. When have I ever neglected your well-being?"

"There's always a first time, Victor, and time is not on my side."

A month passed before word came back that permission had been granted. Within a further month Hillsden made the journey to Leningrad, taking with him the few personal possessions he had acquired. He enjoyed settling into the drab, if roomy, apartment he had been allocated just off Leningrad's Arsenal Street and close to the Finland railway station: the two names gave him private satisfaction, reminding him as they did of a football team he had once supported and Edmund Wilson's erudite book. He set about making it more comfortable, and since his status allowed him luxuries denied the majority of Soviet citizens he gradually transformed it into a home.

Although the beauty of the city and its surroundings—the bright glitter of water everywhere (a revelation this), the four hundred bridges he solemnly counted during various excursions, the great flowering of baroque and classical architecture—astounded him, Hillsden never lost sight of the real objective behind the calculated move. He had chosen it as the city closest to the West, the one where he stood the best chance of making the vital contact he needed to set his plan into motion.

Naturally his first guest was Abramov, who came in a festive mood. "I have been given good news, Alec, that I wish to share. Today I was told I am to be moved to the Second Directorate."

"Congratulations."

Hillsden was aware that the Second Directorate was the department of the G.R.U. responsible for North and South America, as well as the United Kingdom.

"Yes, and I have come prepared to celebrate with you." He produced a bottle of fifteen-year-old malt scotch. "What is it you always say? 'You will feel no pain when this passes your lips.' "

"On the nail. We will drink superior scotch in inferior glasses. Sit you down." Hillsden removed his fur coat from the back of a chair; it was part of his careful planning not to conceal the coat, but to have it openly on display. "Make yourself comfortable. It isn't much, as they say, but it's home."

"I like to know that you think that way."

As the scotch was poured Hillsden remarked, "According to *Pravda,* excessive consumption of alcohol is now a social crime."

"True. Everything in *Pravda* is true, as you and I know. But a drink between influential friends does not count."

"I know *you're* influential, General, but are we friends?"

"How can you ask such a question after all we've been through together?"

"I like to have it confirmed regularly."

"Then I will do that."

They toasted each other.

If only, Hillsden thought, we could accept each other for what we really are and admit that we have both been duped; admit how tawdry the whole game of spying is, how pointless in a world where the majority are starving. Who had sold the secrets of nutrition, who had microfilmed the cure for cancer or for AIDS? All we ever betray for is death. Nothing the Firm, the K.G.B., the G.R.U. or the C.I.A. did could ever help the child with the distended belly and the eyelids slowly being eaten by flies. All we ever achieve, he thought as they swapped pleasantries and anecdotes, is to prolong agony, extend the suspicions, multiply the betrayals. The only cause that was never short of funds was hatred. He saw in Abramov sacred and profane shades of his old self, and he pitied him.

"There is the possibility," Abramov confided, "that I might be posted to England."

Once again Hillsden was pierced by the irony that whereas Abramov could move around the world, even visiting England, he was confined and trapped.

"Really? That's amazing. We should drink to that. Would you be posted to the embassy?"

"Yes, naturally."

"Well, if that happens you'll be living on Millionaires' Row."

Abramov looked blank. "Is that one of your great pieces of British humor? A joke in poor taste?" Humor, other than the coarsest variety, was not one of Abramov's strong points.

"No. Your London embassy is close to Kensington Palace in a private road known locally as 'Millionaires' Row.' From your bedroom window you'll be able to point a telephoto lens and observe members of the royal family going about their business. How about that? Maybe it *is* a joke of sorts."

"Alec, I will have more serious duties to perform. In any case, I find the whole concept of monarchy a futile exercise in bourgeois sentimentality. How is it possible to still have such an institution? It is arcane."

"I forgot. You go in for regicide, don't you?"

"Don't say such things, even in fun, to anybody but me. Others might take such a remark as a sign that you are not yet fully converted."

"I'm stating a historical fact. You can't rewrite history."

"Why not? History is just another weapon to be used in the class struggle; surely you must have grasped that by now. You are curiously naïve about certain things, my friend. Although you've come a long way since first we met, you still have some distance to travel. Learn our ways. Think our thoughts. History is what *we* decide. We plan, we wait, we allow others to make the mistakes; then, and only then, do we move in and pick up the spoils."

"I'm sure that's good advice, and I'll remember it," Hillsden said, thinking: I am learning your ways. Learning them to use them against you one day. "May I?" He poured himself another generous measure of malt. "You know the thing I've noticed most since coming to Leningrad? A new feeling in the air. A shiver of freedom."

Abramov drained his glass, taking the malt like vodka. "It was necessary for us to take a calculated step in that direction—what I believe the Americans call a p.r. exercise." But freedom is like this excellent scotch: give people too much of it too quickly and they become overconfident and start believing in miracles. . . . If I go to London, I shall miss our discussions, Alec. We have shared much together. We did, after all, share a moment of truth together without flinching. Together we wiped the slate clean."

The oblique reference to the elimination of Jock took Hillsden off guard: the subject had never been mentioned between them since the fateful night. So much for honesty, he thought, his and mine. He can't bring himself to say it directly, and Jock's murder was the only thing I omitted from my hidden manuscript. There were so many Polaroids of memory that refused to be obliterated, the colors unfaded by time: Caroline alive, Caroline broken on Hogg's steel slab, a close-up of Jock's bleary face pleading justification.

"The ever-present past," he said, looking away.

"The *necessary* past, Alec. There will always be difficult choices to be made in the life we both lead. It's what separates us from the rest."

Again Hillsden was taken back to Caroline. She had used more or less the same expression. He thought: the night before she went back into Berlin, the last time we made love, the last time I saw her alive, I asked her what made her the way she was and she answered, "The life we lead." How far removed and yet how close it seemed. So many journeys since, so many fresh betrayals, and now journey's end here, the mask in place, toasting a counterfeit friendship. Abruptly changing the sub-

ject, he said, "I shall want to know what you make of London if you get there."

"What tips can you give me? I want to arrive fully prepared."

"When in doubt, talk about the weather," Hillsden said, wishing he had a real friend to confide in, somebody familiar, but the only person who came to mind was Waddington.

A few yards from Abramov's possible London destination, Pearson confessed himself stymied. Despite intensive inquiries, there was no trace of the missing Labrador. The police had made house-to-house calls in the immediate vicinity of Mitchell's home, and reward notices had been placed in local shops. As Pearson had predicted, Lloyd found his visit to the Battersea Dogs' Home traumatic: every caged animal he looked at greeted him as a potential savior, and though there were several Labradors, none of them could be positively identified as Charlie; nor did recent records show a dog answering to his description. Lloyd departed a shaken man, knowing that many of the abandoned pets would shortly have to be put down.

By a remote coincidence it was the hapless Constable Whiting of Janet Reger fame who stumbled upon the answer. He had been transferred from West End Central to Hampstead, a move that did not fill him with joy since it took him further away from Isabel, with whom he was now enjoying a fruitful relationship.

"Here's a good one for you, Whiting," his new station officer said one morning, "your reputation having preceded you."

"How's that, then, Sergeant?"

"I was told that at Central you were known as 'La Bête Humaine.' Shall I translate? 'The Human Animal.' So I thought this little problem would be right up your alley. Get yourself along to this flat in Lyndhurst Road and investigate the case of the barking dog. The neighbors have been complaining it's been driving them apeshit."

Whiting duly found his way to the premises but failed to gain entry. The neighbor who had phoned the police, an old-age pensioner living in the flat below, was only too anxious to unburden herself. She and Whiting stood outside the door and listened to the dog; they could hear it scratching at the door, and it was obvious that the animal was desperate.

"The poor thing's been howling night and day. Terrible, I couldn't hear the television. 'Course, these places are badly built. The walls are

paper thin; you can hear everything that goes on, sometimes things you'd rather not hear, especially that young couple living below me. They're not much better than animals."

"Whose dog is it?" Whiting asked, finally getting a word in.

"Well, that's the thing. Nobody seems to know."

"They must know who lives there."

"Nobody *lives* there, like I live here. I mean, it's not occupied full time. There's a man what comes and goes, but we haven't seen him recently."

"D'you have his name? Know where he works or anywhere we could contact him?"

The old woman shook her head. "I know most of them here because I take in the mail; not that I'm nosy—don't think that—but I'm usually around, you see. The others go to work during the day. But he never seems to get any letters."

"So nobody's been in to feed it as far as you know?"

"No, the poor thing must be starving."

"Isn't there a caretaker who could let us in?"

"With our landlord you're lucky if you get a dustbin."

"And nobody's got a spare key?"

"No. Can't you break the door down?"

"Not without authority I can't."

"Oh, I thought you lot could get in anywhere. Not like *The Professionals,*" she said, referring to a television series. "They don't seem to have any trouble."

Whiting returned to the station and reported the situation. "I'm not too keen to go in there alone, Sarge. Never know with dogs like that. Could have rabies."

"Right, son. Leave it to me."

Later that same day a member of the dog-handler unit, together with an inspector from the R.S.P.C.A. who was armed with a tranquilizer gun, went to the house. By now there was no noise from the dog. The door to the flat proved to have double security locks and had to be forced.

The sight that greeted the two men once they had gained entry was sickening. The stench of animal feces was overpowering, and they rushed to open windows. Much of the flat had been wrecked; in its frenzy the dog had chewed the furniture; the sofa was literally torn apart and there were deep scratch marks on the walls and door panels. They found the emaciated animal lying in the bathroom, where presumably

it had gone to find water; the bowl of the water closet was dry. The R.S.P.C.A. inspector immediately gave it an injection as a precaution before he examined it. The dog's jaws were flecked with foam and blood; some of its teeth had been broken off during its ordeal, and one back leg was twisted at an unnatural angle.

"Will you be able to save it?"

"Difficult to say. We'll have a try. From the look of him he wouldn't have lasted much longer. I'll get him to our nearest depot and let the girls take care of him."

"Poor bastard."

"Yeah, but the real bastard is the one who let him get this way. Come on, old fellow, let's get you to hospital. What's your name?" He felt for the collar, bloodstained like the dog's matted coat. "Charlie, is it? All right, Charlie, easy now; no one's going to hurt you."

He wrapped the dog in a blanket and carried him down to his van. Left alone, the police dog handler radioed for assistance to secure the flat again. He remained by the open window, looking around at the wreckage. There was nothing to denote the lifestyle of the unknown occupant. The furniture was utilitarian, the walls bare. It bore all the signs of being an occasional pied-à-terre. Resentment mixed with anger grew in the dog handler, not only for the cruelty meted out to the pathetic Labrador, but also against those rich enough to afford two homes. He kicked at an upturned coffee table, knocking it to one side. In doing so he revealed what to his experienced eye was a large blood-stain on the carpet. He bent down to examine it more closely. Although the dog had been bleeding from the mouth, it seemed to him unlikely that it could have hemorrhaged to that extent. He touched the patch: it was dry, and darker in places where clots had congealed. Straightening up, he returned to the window when he heard a police siren approaching. The patrol car drew up in the street below, and he shouted his whereabouts to the two occupants. It was only then that he noticed a bullet hole in the wall close to the window frame, and the suspicion that he was concerned with something more than mere cruelty to an animal began to dawn.

"Christ almighty!" the first patrolman said as he entered the flat. "Somebody been taken short after a curry dinner? What have we got here? Bloody hell, thanks for warning us."

He and his companion held their noses as they advanced into the room.

The dog handler pointed to the stain on the carpet. "Well, it started

out just saving a starving dog, but now I'm not so sure. What d'you make of that?"

He directed their attention to the bullet hole. "And this."

"Out of our league, I think. Get on the blower and call C.I.D."

They waited downstairs in the fresh air until the plainclothes crime squad arrived. "It's all yours," they said, "and welcome to it."

News of the discovery was quickly conveyed to Pearson, who immediately went to the flat. By the time he arrived it had been fumigated. The forensic team had established that the stain on the carpet had been formed by human blood; further tests proved it corresponded with the group of the Hyde Park victim. A photograph of Mitchell was shown to the old woman in the flat below, and she identified it as the man she had occasionally seen using the premises. A spent bullet was prised from the wall and sent away for a more detailed analysis. Pearson ordered that the whole place be taken apart. At about ten P.M. one of his team got the break he'd been waiting for: concealed inside an inoperative VHS video recorder was a powerful shortwave radio, a miniature camera and a codebook.

6

OFTEN HILLSDEN WOULD wake in the middle of the night, his mind consumed with the same imponderables. He wished he had the sort of brain that could solve the *Times* crossword in ten minutes flat, or the mentality of an Agatha Christie. Her Miss Marple or that fatuous Belgian would have the answer to his problem in a flash; they never failed to discover who killed the vicar in the locked room with the key on the inside.

More and more his thoughts turned to Waddington—slightly stuffy, fixed-in-his-views-but-wholly-reliable Waddington. Once Control had

brought him in from the cold to be a desk jockey, Wadders had been the only person in the Firm he had ever felt he could trust. The rest had been a dreary bunch, some of them halfway round the bend, deballed, treading water until pension time, their minds ossified, terrified to take decisions unless one of the equally emasculated standing committees approved. Only Waddington stood out from the mob, a beacon of hope.

As an exercise of mind and body Hillsden took a series of long walks through the streets of Leningrad and set himself to recall the dialogues he'd had with Waddington in the aftermath of Caroline's murder. Then he had used Wadders as a sounding board for his own theories, Waddington arguing, sometimes agreeing, sometimes skeptical, though seldom dismissing anything out of hand. Memory often distorted past events, as most autobiographies proved, but Hillsden was certain that he had convinced Waddington of the existence of a conspiracy. There had been no opportunity for them to join forces and follow through; Control had seen to that. At the spider's beckoning, I walked straight into the parlor, Hillsden thought, spurred on by anguish over Caroline, accepting the reasons he sold me. Control had been one step ahead every inch of the way, baiting each succeeding trap—first warning me off any further interrogation of Glanville, knowing full well I would go against his orders, then making sure I would appear to be the last person to see Glanville alive. Afterwards, with my voice, my threats on tape, he had me cold. With Glanville and Caroline dead, I was the only one left to dispose of. *"I'm sending you back, Alec, to where it all began"*—making it sound like an enormous favor and promising I'd be stepping across Checkpoint Charlie, traded, once it was over. All that remained was to shut one last door behind me the moment I was out of the country. It had to be something he could make public, so he pinned Belfrage's murder on me. How eagerly, blindly I went along.

Hillsden walked the streets, silently cursing his past gullibility. That was why he had to get the manuscript to Britain and in safe hands. The warts were all there on the pages: names, dates, the whole diabolical scenario. But maybe he attached too much faith to the credibility of others? Was it naïve to expect that anybody, even the most fervent antigovernment critic, would swallow the proposition that the Prime Minister was being directly manipulated by Moscow? There was a spurious precedent: the groundswell of rumor that still surrounded Harold Wilson's sudden and unexplained resignation; at the time, on much scantier evidence, many people had been prepared to accept the possibil-

ity of Communist influences in Number 10. In that instance a group of past and discredited members of the Firm had been branded as the villains, but what if it had been tried before and failed? What if Wilson—wily, pragmatic old Harold with his raincoat and his uncanny political instincts—had seen through it in time and spiked their guns? Then a replacement Manchurian candidate would have been needed during the Thatcher years, groomed and kept on ice until the right moment.

The more Hillsden turned it over in his mind, the more he was persuaded that Waddington was the only reliable recipient of his manuscript. If a way could be found to get it to him—that was the next hurdle to overcome—and Waddington accepted it as genuine, he at least stood a chance. A president of the United States had been impeached on far less.

As he continued to wrestle with the problem, he had no means of telling that the courier he would eventually use, a grade two supervisor in the Passport Office named Frampton, was at that moment making his own innocent plans for an appointment in Samarra.

Frampton could not remember a time when he had not felt ill at ease. He was only in his mid-thirties, but already worry had aged him, lightly foxing his skin so that it now had the texture of an antiquarian book bound in vellum. In contrast, his seventy-year-old widowed father had the complexion of a schoolboy, rubicund on the cheekbones where a lifetime's dedication to sherry of the cheapest variety had broken the small blood vessels, but otherwise as clear as if freshly scrubbed.

The trail that led to Hillsden began on Christmas Day, which in the Frampton household was an annual nightmare. Frampton junior had always known he was different from the rest of the family, that he had nothing in common with the relatives who made the ritual pilgrimage: second cousins whose names he could not remember and aged, fully dentured aunts who talked of nothing but the dead and those about to die of some terminal condition, as though the marking of Christ's birth was the ideal occasion to recall all life's miseries. Every Yuletide they arrived, locustlike, laden with unsuitable gifts.

When Christmas lunch was finished Frampton sat on the edge of his chair, poised ready to escape at the earliest opportunity. The qualities of the meal, which he had found obscenely lavish, were being solemnly debated with much picking of false teeth and the occasional scarcely concealed belch. There was a slight lull while everybody watched the Monarch's speech on television, which took as its theme the need to

vanquish the specter of starvation in the Third World. Gluttony appeased, the audience around the table nodded in agreement. Once it was over some attacked the mince pies and lemon curd tarts again, for the mere mention of food had triggered off hunger pangs.

Leaving the debris behind, the whole tribe then migrated to the sitting room. This had the look of a stage set in the process of being struck at the end of a long run, the furniture arranged in a haphazard pattern of his father's devising that ensured nobody could sit in comfort. If guests wished to use the sofa, they had first to navigate around armchairs isolated in the middle of the room, all facing away from the fireplace. Another television was placed at an angle in one corner, partially obscured for most of the viewers by a desk piled high with Frampton senior's hoarded correspondence. A grandfather clock with Westminster chimes vibrated the photographs on the mantelpiece every quarter hour while consistently showing the wrong time. Pride of place was given to a birdcage housing a dispirited mute budgerigar that sat staring at its smeared reflection in a small mirror. If, as frequently happened when the room was crowded, somebody knocked over an ornament or stumbled against the three footstools positioned like land mines for the unwary, the bird went into a spiraled frenzy, releasing a cloud of small feathers and millet husks into the air. It had never been known to talk and had one deformed, hooklike claw. With a conviction nobody dared challenge, Frampton senior insisted it was a hen and had named it Elsie. He retained a curious love-hate relationship with it, cursing the mess it made, saddened that it would never come to his finger, yet bound to it in the way some men are bound to a loveless marriage.

Frampton made an effort to join in the conversation which, with no spirit of goodwill, centered around an absent uncle who was apparently living in sin with his housekeeper. The strain of concentrating on this boring saga gave him a headache, so he excused himself and went up to his room. There he took stock of his gifts: the usual hideous ties, gloves that did not fit, and the *pièce de résistance* this year, a musical beer tankard that, when lifted, played a theme from *The Student Prince*.

He went to his record player and selected a recording of Mahler's Fifth, a favorite ever since he had seen the film of *Death in Venice*. He was determined one day to visit the Lido. Throughout most of his life the family had taken their holidays together; even after his mother died the custom had continued, always to safe, dull haunts in England, staying in boardinghouses or unlisted hotels, never abroad, for his father had an abiding dislike of foreigners. Frampton could never forget the

humiliation of having to queue for the communal bathrooms and toilets that were characteristic of such humble establishments. Then, three years previously, in a rare show of defiance, he had booked himself a holiday in the Soviet Union, a deliberately contentious choice made in the certain knowledge that his father would never accompany him. The act of rebellion had never been forgiven, though it had provided Frampton senior with a new line in vituperation. "See what your Red friends are up to now," or "Amazed you don't go and live there permanently since you think the Bolshies are so bloody superior."

Paradoxically, the freedom Frampton had experienced away from the suffocating paternal presence in a country not noted for its freedoms had seemed to him like beginning life all over again. Since it was novel he had scarcely noticed the petty restrictions, nor had the food served in his Moscow hotel seemed inferior to the boardinghouse stodge he had endured in the past. He savored every moment and went home enriched, determined to repeat the experience at the earliest opportunity.

Returning the following year, he had ventured further afield and explored Leningrad, going with even higher expectations and a certain smugness toward those in his party who solicited his advice, as an old hand, on how to behave; heretofore no one had ever asked his opinion on anything. Leningrad was preferable to Moscow; it appeared to him to be steeped in the mysteries of Imperial Russia, for this time he had prepared himself by reading the works of Tolstoy and Chekhov. His first visit to the ballet was a revelation; he had the heady experience of discovering a purpose to his hitherto mundane life. Back in London the cult of the ballet had always seemed an elitist luxury, for the price of a good ticket at Covent Garden had always been beyond his means. Now, sitting in the old Maryinski Imperial Theater, renamed the Kirov, confronted by the matchless precision of the Leningrad company, a sense of wasted years gripped him. It did not escape his notice that he was not part of a privileged audience but was enjoying the enchantment with equals. When the lights went up at the first interval he found himself sharing his pleasure with a young Russian named Leonid Kiprenski in the adjoining seat. Speaking extremely good English, his new friend willingly explained the plot of the next ballet in the program, and by the end of the evening they were on first-name terms.

"I would very much like you to visit my apartment, John. I have a wonderful collection of posters and ballet books."

"How very kind of you. Is that allowed?"

"Allowed? What do you mean?"

"Well, we have a guide who plans everything for us. I don't know whether we're supposed to go off on our own."

"Is permitted, believe me. Things have changed. I will speak to your guide and fix it. No problem. Which hotel are you in?"

Frampton gave him the details, and later that same evening the guide approached him as he collected his room key. "Mr. Kiprenski has spoken to me of your meeting. I think it would be pleasant for you to visit with him. We like our tourist guests to see how we live."

The ease with which this was accomplished further strengthened Frampton's view that all that he had heard about Russian bureaucracy was exaggerated. The following day he was driven to one of a group of apartment blocks in the outer suburbs. An ancient concierge guarded the entrance, but when the driver spoke to her Frampton was allowed through without hindrance. Leonid's apartment was on the sixth floor; there was no lift, and Frampton was out of breath by the time he reached the door.

Leonid admitted him into a room some twelve feet square, comfortably furnished, though to Frampton's Western eyes the style was reminiscent of the sixties. One wall was bookshelved from floor to ceiling; the others were hung with framed posters, most of them celebrating ballet and opera productions.

"I have prepared tea," his host said. "Just like England, I hope. What is it your poet wrote? 'And is there honey still for tea?' I have learned this poet by heart; he is very romantic, I think. You know his works better than me, no doubt."

Frampton colored, ashamed that his general ignorance of the arts should be so swiftly uncovered. "I'm not a great poetry reader, I'm sorry to say."

"Oh, he was such a handsome young man, this Rupert Brooke. Like Byron in another age, and like Byron he died tragically. But then beauty is often tragic. I admire beauty, don't you?"

"Very much so."

"I could not live without beauty."

"Well, you certainly have a beautiful apartment."

"I am pleased you think so. I waited eleven years, you know, to get a place of my own."

"Eleven years? Really?"

"Oh, yes, I am very fortunate."

77

"Your posters," Frampton said, trying to change the conversation since he was not sure how to react to the revelation about the apartment, "quite a collection."

"They remind me of what my life might have been," Leonid replied, fussing with a small samovar. "I trained as a ballet dancer, you see. Unfortunately, I was not good enough, and I had no wish to be second-rate. The ballet is for stars, not for in-betweens."

"I have to confess I've only just started to take an interest in the ballet. What d'you do now?"

"Now I write criticism about people I envy. No, that is not true—a little joke in poor taste. I try to be fair about my old colleagues. I do that and I also translate for a publishing house. It's not the same as being the soloist in *The Sleeping Beauty,* but there it is. What do you do, John?" He handed Frampton his tea in a glass.

"Oh, my life's very dull compared to yours. I work in a government office. It's a responsible position, I suppose, but not very exciting. I attend to passports and visas."

"Visas! But that must be an important post. And your wife, does she work also?"

"I'm not married."

"Ah, we've both escaped that, eh?"

"I don't know that I escaped it; I just haven't met anybody who wanted to marry me. I live with my father. He's widowed; my mother died some years ago."

They chatted amicably, and Leonid played some ballet music, explaining the intricacies required of the dancers during certain passages. At one point he gave a demonstration of some steps. "I'm very rusty. Once you give up daily practice the muscles don't work as they should."

"It must be a hard life, being a dancer."

"The hardest."

"But still you miss it?"

"There are other pleasures in life, and at least now I can stay up late at night without a conscience. The discipline of the ballet is stricter even than the army. Every single day of your life you are on parade; you must go to class no matter how you feel. Hour after hour, the same exercises until you are ready to drop. And always there is somebody better than you, watching, waiting for you to fail so that they can take your place."

Frampton was fascinated by these inside glimpses of a world he had never known. It never occurred to him to question why Leonid had chosen him as a friend; he took it that Russians, contrary to what he

had always been conditioned to believe, were naturally gregarious and sociable. When they parted company both promised to keep in touch by correspondence.

"I shall be back," Frampton said, "and perhaps one day you will visit London and I can return your hospitality."

There was the slightest change of expression on Leonid's face. "That would be nice, but there are still certain obstacles."

"Aren't you allowed to travel?"

Again a hesitation. "Well, it is not encouraged, shall we say? When we apply for a visa we are asked, 'Have you visited all of your own country yet?' and if, truthfully, we say 'No,' they tell us, 'See Russia first and then think about traveling abroad.' " Then he quickly added, "But things are changing, so maybe one day you will give me tea in London."

Immediately on his return home Frampton wrote Leonid a long letter and, casting financial discretion to the winds, became a member of the Friends of Covent Garden. He was determined to enlarge his artistic education. He also purchased a Russian-language course on cassette and attempted to master the rudiments, without great success, though he was careful to keep these activities from his father. Anticipating his parent's ridicule, he asked Leonid to reply to a post office box rather than to his home address. His own letters became more and more intimate, for like many lonely people he was best able to express his innermost thoughts on paper.

When his next holiday came around Frampton booked his own passage rather than join a package tour. Arriving in Leningrad he took particular pleasure in greeting his friend with a few of his newly mastered Russian phrases. He had brought gifts from England: several books on the Royal Ballet, some cologne from Penhaligan and a box of biscuits from Fortnum & Mason. In return he was treated to another visit to the Kirov and, after the performance, taken to a restaurant frequented by members of the company and introduced to them. The whole experience, coupled with too much unaccustomed vodka, proved so exhilarating that he almost passed out when gaining the fresh air. Therefore he raised no objection when Leonid suggested he not go back to the hotel but instead spend the night in his apartment.

They shared the only bed. Frampton fell asleep immediately, and it wasn't until the small hours of the morning that he awoke, sobered, to find Leonid caressing a part of his anatomy he had hitherto never considered an object of worship. Despite the shock he found he could not prevent himself responding. He had known little passion in his life,

and apart from occasional visits to prostitutes (which abruptly ended when the AIDS epidemic hit the headlines) his sexual experience had been arid. Even so, he was not so naïve as to be unaware that he was being led to the frontier of a secret and dangerous country. As if sensing this, Leonid stopped his expert ministrations, stroked Frampton's face and spoke a colloquial endearment in Russian before reverting to English.

"Does what I do scare you? If so, I will stop. It's just that I am very attracted to you. You realized that, I am sure."

"No."

"Then you are shocked?"

"Not shocked, exactly."

"You don't find me agreeable, perhaps?"

"No, I like you very much. It's just that nobody has ever said . . . done this to me before."

"Forgive me, but I could not help myself. From your letters you wrote to me, I read between the lines and thought you shared my hopes."

"I've heard . . . there are terrible risks," Frampton said.

"Not if you go about it the right way. And there are no risks with me; I'm clean, I promise you. When I knew you were coming back, I took the test. So you don't have to worry on that account." While he soothed with words, Leonid continued to manipulate Frampton, keeping him aroused. "Just relax, give in to it; I know you want it . . . I'll make you happy." He pulled back the bedclothes and positioned himself between Frampton's legs. "You'll find how exciting it is, what you've been missing."

To Frampton it was the twisted realization of many past fantasies, as though he were listening to a dialogue he had often rehearsed but never acted upon. In the barren aftermath of his occasional visits to a brothel he had often imagined scenes of love returned, when he would say such things to the unknown woman of his dreams. Fantasy had always been more successful than reality in satisfying his sexual hunger. With the help of pornographic magazines he had developed a complex system of stimulation to enliven his solitary pleasures. Now, as he surrendered to Leonid's experienced mouth, the slate of memory was wiped clean. New images swirled behind his closed lids while Leonid brought him to an unaccustomed fulfillment, and he knew he was powerless to alter anything that lay ahead.

During the rest of his holiday Frampton's sexual education was completed. Their relationship deepened, although he still found it difficult

to understand how the younger man, somebody of superior culture and intellect, could possibly find him worthy of such affection. Leonid often pressed him for details of the homosexual scene in England, asking questions that Frampton could not answer with any accuracy; his knowledge, such as it was, had been gleaned secondhand, sexual innuendo always being bandied about in the office where he worked. Now he gradually became introduced to the universal language of homosexuality, to its passwords and camp slang that so easily crossed otherwise impenetrable frontiers.

When the time came for him to return home their farewells took on an almost unbearable poignancy. Frampton could not contemplate the separation, and at one point during the flight locked himself in the toilet to avoid being seen weeping.

Now, as he sat in his bedroom listening to the sounds of Christmas below, he made a decision. He had deliberately not taken a summer holiday this year but had accumulated the leave due him, a whole six weeks. He made up his mind to use it all on a prolonged reunion. His father would abuse him for callously neglecting his filial duties, but he would live with that, for knowing Leonid had given him new courage. There and then he began a letter telling Leonid of his plan, using the only Christmas gift that had given him pleasure, a new Parker pen he had bought for himself. As the smooth nib skimmed over the notepaper he wrote his glad tidings in the mistaken belief that soon he would be journeying toward a love that would never end.

7

OUTWARDLY THERE WAS little to suggest that Keating was ruffled. Yet at the time he made up his mind to seek out Waddington he was bitterly regretting his propensity for acquiring wives: wives, moreover, who followed a depressing pattern, periodically fouling the order of his life.

His first marriage had been a mistake that anybody of tender years could make: a pubescent childhood sweetheart with an insatiable appetite for adolescent sex had seemed to fulfil a full-blooded young man's fevered prayers. A white wedding, a honeymoon in Bermuda, then home to a four-bedroom detached house in upwardly mobile suburban Weybridge, the gift of his wealthy parents. But in no time at all the delectable, ever-compliant, bikini-clad creature, pride of the pink Bermuda beaches, had become a surly and heavily pregnant shrew whose sole domestic skill was an ability to burn a boiled egg if cajoled into setting foot in the kitchen, and who eventually produced a male child that cried solidly for six months. Within two years Keating had walked out, though divorce before the permissive age was a protracted affair and he was compelled to act the guilty partner, spending a long and boring night with "a woman unknown" (the euphemistic legal term of the time) in a Brighton hotel. He considered her old enough to be his mother and, far from committing adultery, they played Scrabble until a paid private detective "discovered" them in bed the following morning. Justice being hypocritically satisfied and the divorce granted, he played the field for a decade, keeping clear of matrimony but catching two doses of the clap until, touching thirty, he became bored with the so-called thrill of the chase.

Throughout this period Keating worked as a partner in his father's stockbroking firm, and since in those days insider trading was considered a natural perk of the trade he made money and enjoyed spending it. He fell in love again during a cruise on the *Queen Mary,* this time with an American fashion model, the only daughter of a Chicago meat baron ("Daddy made his pile from hogs' bellies," as she put it). They lived in a variety of places while the marriage lasted, parting in Washington where the second Mrs. Keating filibustered in the sack with at least three members of the Republican Party (Daddy didn't approve of Democrats) before finally running off with a West Coast type who promised to get her into movies.

It was around this time that Keating was recruited into MI6. Dinnsbury, the then Director General, was personally responsible for netting him: the Washington office at that time was notably troublesome, and he thought that somebody with Keating's personality, wealth and social contacts was a better bet than the usual languid Establishment types favored by the Foreign Office. Dinnsbury never hunted with the pack and was attracted to those of like disposition, so Keating was a natural choice.

Keating stayed on in Washington for a further two years, dabbling in a variety of lucrative business deals and keeping his ear close to the ground. He was popular with the diplomatic set and formed friendships with several C.I.A. mavericks before returning home. There he married again, this time choosing a pleasant, home-loving woman of his own age who produced three children in five years and was quite content to lead a domestic life tucked away in their country home. Keating maintained a London pad that she seldom visited unless the Harrods sales were on, while on the surface he acted the role of the successful entrepreneur, only going home to the bosom of the family on weekends. The three children proved a disappointing brood, and he was content to leave their upbringing to their mother—a mistake, as it happened, for they became hopelessly spoiled.

When Dinnsbury was put out to pasture and Lockfield took over, Keating made no secret of the fact that he was not enamoured of the new setup. He clashed with Lockfield at an early stage, rumor having it that he had refused a posting to Cairo. Whatever the true story, shortly afterwards he vacated his desk at Century House and dropped out of circulation. Officially he had never been on the payroll; at the time he was recruited he had apparently negotiated a special arrangement, which again suggested Dinnsbury's method of operation, and this was one of the primary reasons for his dismissal.

Now the equanimity of Keating's life was again threatened: the children having grown up and fled the coop, the current Mrs. Keating, hot-flushed with menopause, announced that village life no longer held abiding attractions for her and she intended moving back to London. She discovered organic food, plastic surgery and aroma therapy in quick order, had her hair dyed blond and began to wear clothes more suited to a teenager. They had many acrimonious bouts on the subject, which invariably ended in hysterics. Keating had no intention of surrendering his own lifestyle or freedoms in order to accommodate the bizarre whims of a woman he no longer found attractive. Nor did it suit him to dispose of the country home at that moment; the housing market was depressed, especially for estates of any size, as the time had passed when oil sheikhs arrived on the doorstep with suitcases full of bank notes prepared to buy anything with four walls that took their fancy.

In the end he was forced to call in the lawyers and hammer out a compromise: he would buy his wife a London house of her own, paying all expenses plus a generous allowance in return for a three-year trial separation. It was a particularly irritating and time-consuming episode

he could well have done without, since he was poised to consummate a new business venture and could ill afford the aggravation. It meant that he would have to consider delegating some of the responsibility for his varied enterprises—a course he had hitherto avoided, for he had always played his cards close to the chest. It needed careful thought.

"Do you like orgies?" the Italian ambassador's wife asked when the conversation lapsed, addressing Charles Greening, the minister for the arts, who sat on her left. Seated at her right hand, Control strained to hear the reply.

"No, I don't think I do really. I never know who to thank."

Greening had cultivated a trendy personality following his appointment, but he had yet to put it across with conviction; most of the time he gave the impression that he was an actor in the first week of rehearsal trying to settle on a characterization that would see him through the run. Having delivered his response, he now laughed at his own wit, glancing across the dining table to see if anybody else was joining in. Disappointed that nobody was, he made a note to try to plant it in one of the gossip columns; he needed all the publicity he could get since his speeches on the arts rarely commanded any media attention.

"What is your opinion, Sir Raymond?"

The ambassador's wife leaned towards Control, momentarily displaying even more of her ample bosom, which constantly threatened to overflow from her Valentino gown. She was wearing an overpowering perfume that throughout the meal had made Control quite light-headed. She epitomized all that was most endearing about her race: excitable, indiscreet, given to broad gestures and a lack of inhibition.

"About orgies? I think any I attended in my gilded youth were fairly tame by modern standards. Public school life didn't present many opportunities for *la dolce vita*. I doubt if pillow fights in the dormitory could be counted as orgies. We were flogged, of course, and I believe there was one headmaster at Eton who was said to be more familiar with his pupils' behinds than with their faces."

"How very droll! And so British. Tell me, what do you hear about Edwina and Henry? Are they splitting up?"

"I'm sorry?"

"Edwina and Henry. Don't you know them? The Maitlands. He seems to know everybody."

"Except me. I'm afraid I don't keep up with society gossip."

"But you should; it's one of life's few remaining pleasures."

Conversation at the dinner table had been a series of such *non sequiturs,* and the effort of keeping up with them had partially ruined Control's enjoyment of the superb food. He was always delighted to be invited to Winfield House, the London residence of the American ambassador; dinners there were invariably superior to anything laid on by the Foreign Office. The present ambassador, an engaging self-made man from Wisconsin, dispensed with pomp and protocol; speeches were kept strictly to a minimum, and the wineglasses were constantly charged with the best Californian vintages. The moment guests stepped inside the elegant hallway they were wrapped in genuine American hospitality which at this level was unsurpassed; the Yanks, Control thought, have always had the art of enjoying themselves.

Few outsiders appreciated the extent to which the business of government was really conducted outside Whitehall. With the advance of technology many of the old smoke signals had disappeared. Who now remembered that lights burning in the Foreign Office after midnight had once betokened a crisis? Yet despite the computers, fax machines and satellites the human factor still played a major role: a discreet hint in the club, a nudge over the first gin and tonic of the day, the whispered confidence over dinner that could never be recorded and was always denied. Reputations were destroyed, advancements thwarted between courses; policies were decided upon far from Downing Street, in country houses, in back rooms on council estates, in closed cars parked in highway rest stops, on holiday beaches, at the races. And always the manipulators acted without reference to the ballot box.

Control used every means at his disposal to sift fact from rumor, to decipher the winks from the nods, the muted appraisals from the already-acted-upon. Having had advance notice of the guest list—a mixed bag of politicians, business tycoons, television celebrities, together with members of the diplomatic corps and the armed forces—he had been anxious not to miss this particular evening at Winfield House. The ambassador had been instructed to wave the flag ever since Bayldon had announced his intention to remove the American nuclear presence from British soil. This had provoked Congress into taking an increasingly isolationist stance towards NATO: their land forces in Europe had been scaled down, and the new President, anxious to sustain a popularity rating in the polls, had introduced import tariffs on overseas goods. Since taking up office Bayldon had made two trips behind the Iron

Curtain, but had so far boycotted Washington. The once "special relationship" between Britain and America was under strain and the ambassador, a committed Anglophile, was under orders to rebuild bridges.

"The trouble with your opera," the Italian ambassador's wife said, turning her attention to Greening once again, "is that it's like your religion, dull, and the trouble with your religion is that, like your opera, it lacks theatricality."

"It's not *my* religion," Greening said, trying to keep his end up. "I'm actually an atheist."

"Darling, how can you sin if you're not religious?" She suddenly switched. "Tell me, who is that man sitting next to the girl in that hideous orange dress?"

Greening looked and lowered his voice. "Colin Deacon."

"Should I know him? His face looks familiar."

"He's a Member of Parliament. You've probably seen him on television. He's never off, more's the pity." Greening could not keep the irritation out of his reply.

"Is he in the government?"

"No, thank God!"

"How can you thank God if you're an atheist? Obviously, you hate this man."

"I wouldn't go as far as that."

"Why not? Darling, one should always have people one dislikes intensely. They're always so much more interesting than one's friends. Of course, if you can also dislike your friends that's best of all. Is he one of yours?"

"My party, you mean? Yes, unfortunately. But an outsider. He doesn't accept the Whip."

"What does this mean, 'the whip'?"

"It's a—well, how can I explain it? An expression—no, not an expression. A ritual, I suppose, would be the best way of putting it. When the vote is taken, we have Whips that go around and make sure that the vote is carried."

"And they do this with whips?"

"Not literally. It's more ceremonial."

"Wonderful! I love it. In Italy they punch each other."

Control declined to come to Greening's aid. Without knowing it, the ambassador's wife had zeroed in on the very man Control was anxious to sound out after dinner. Deacon was the bogeyman of the Labor Party. Once spoken of as a possible leader, he had put himself out of the

86

reckoning by his refusal to play by the rules, but still commanded considerable grass-roots support and always scored heavily at the annual conferences, for he was a gifted demagogue, delivering the sort of speeches the rank and file wanted to hear. For as long as anybody could remember, in or out of office, the Labor Party had always been in the throes of a civil war. Deacon was always in the front line, spurring on the rebel troops and incurring the wrath of the party's hierarchy, for he consistently preached betrayal, taking his texts from those tablets that were, to some, written in stone. At one time a close ally, Deacon now made no secret of his loathing of Bayldon; his public invective was eagerly seized upon and given prominence by the Tory press. He was interesting material for somebody like Control, for despite being out in the cold his political ambition was undiminished. Whenever he was written off as a spent force he somehow managed to bounce back and capture the headlines. Bayldon had attempted to buy him off when choosing his first cabinet, offering him a minor ministerial post, a ploy that Deacon rejected, preferring to remain on the back benches where he could inflict maximum damage on those he considered his inferiors.

At the end of the meal the ladies departed and the men were left to sample some excellent port that Greening immediately passed in the wrong direction. Their host made a short, tactful speech, expressing the hope that the two countries would not drift further apart, and there was a general discussion about the world situation. Control noted that Deacon made no contribution. It wasn't until they were invited to rejoin the ladies in one of the magnificent adjacent rooms that he made contact.

"Splendid dinner."

"Yes," Deacon said. "Laid on for a purpose, of course."

"Well, you'd understand that. Is anything in politics ever done for purely social reasons?"

If Deacon had a sense of humor, it rarely surfaced. He did his best to give the impression that he was a man of destiny, and there was something slightly manic about him; even the way he carefully arranged his thinning hair was sinister rather than pathetic. He was a man who actively sought martyrdom, and the talents he possessed, which were not inconsiderable, had been diluted by spite.

"Actually, I'm glad to have the opportunity of bumping into you," Control said. "I'd like to pick your brains about something. Nothing urgent, but perhaps you'd find time in your busy schedule to have a meal one day?"

Deacon's reply was characteristically guarded. "As long as you don't

expect me to cooperate on any matters of security. You can't have overlooked my many speeches on the Official Secrets Act."

"Oh, I wouldn't commit such a basic gaffe. It's just that there are one or two matters of mutual interest that are worth exploring."

"Such as?"

"Why don't I give you a call and we'll try to find a convenient date to meet?"

"Well, you know where to find me. My phone number's in the book. Unlike your own." Deacon walked away. Control lingered at the party for another hour, then paid his respects and left.

While waiting for one of the Marines to bring his car, he was surprised to witness Keating's arrival, and further discomfited to be greeted in familiar fashion.

"Hello, Raymond. Leaving early to get your beauty sleep?"

"One might ask why you are arriving late."

"One might, and the answer would be that I'm on a diet. I came for the really interesting part of the evening. Everybody will be slightly in their cups, I hope, and therefore indiscreet, whereas I shall be stone cold sober. One of Dinnsbury's ploys I've always been happy to emulate."

The deliberate mention of Dinnsbury struck a particularly sour note with Control, but he was denied an opportunity to reply as Keating sailed past him and his car arrived. He drove off through the unlit park feeling extremely irritated by the encounter.

His home was a fifth-floor apartment in a modern block in Pimlico, close to Ebury Street, where Mozart had once lived. He was not listed under his real name on the residents' panel; apartment 52 was apparently occupied by a Mr. Purvis, generally thought to be a stockbroker by the other tenants. Before Keating had moved in, a team of the Firm's sweepers had sanitized every room.

That night he did not go straight home, but instead drove to a safe house on the outskirts of Hounslow. He let himself in with a duplicate key. In the heavily curtained living room a young woman sat watching a late-night television program.

"Apologies," Control said. "Sorry to be so late. Were you able to amuse yourself?"

"I've been watching a film about the happy new face of the Russian bear."

"Sorry I missed it. I always enjoy good fiction. What are you smiling at?"

"I never realized you had such a sense of humor."

"Ah, well. One learns something of interest every day. Did you give yourself a drink?"

"I couldn't find one."

"Here." He went to an antique corner cupboard that opened to reveal a small, well-stocked bar. "The Firm's housekeepers do sometimes live up to expectations. I'm going to have a nightcap. Would you care to join me? I hate solitary drinking."

"Just a small one. Whisky with water."

As he prepared the drinks, taking a glass of port for himself, Control said, "Are you pleased to be active again?"

"Yes. Yes, I am."

"One must never rush these things. I thought a long sabbatical was a prudent move. Does it seem strange to be back in the field?"

"It's different."

"Different from what?"

"The old days."

"Ah, yes, the old days," Control said, sipping his vintage Cockburn. "Well, of course, we've moved on from then. Unless, of course, you were referring to your erstwhile partner. Pity about him. I don't usually take to Germans, but he had exceptional qualities. What was his name?"

"Günther."

Control nodded. "I'm not very good at remembering pseudonyms. I was more at home when we only used numerals. Well, he was a considerable loss. Perhaps his enthusiasm for the craft of violence contributed to his last mistake. It's a German characteristic to act as though they are immune to error."

"That's a strange word for it—'craft.' I've never heard it described that way before."

"So," Control said, abruptly switching to the business of the moment, "have you made contact?"

"Yes. But can I ask you something? Why is it necessary to keep tabs on him? I thought he was out of it."

"One should never let sleeping dogs lie, especially those who left the fireside hearth with a grudge."

"Is that how it was?"

"I fancy so. In any case, better to be safe than sorry. One can shred paper and pull the plug on computers, but the human memory . . . now,

that's an altogether more complex proposition, unless of course one takes the final solution. Is that whisky too strong for you?"

"No, it's fine. He wasn't that well placed, was he? By that I mean I understand he was small fry."

"It's the little foxes, isn't it, who raid the vines?" Control said blandly. He sat behind his desk and picked up one of his collection of lead soldiers. It was half painted, and he examined it against the light. "Attention to detail, that's the important thing. Take these. So beautifully made, but a slip of the brush, like the slip of a tongue, and one must start over again. Do you have a hobby?"

"Yes, I collect men. Isn't that why you use me?"

Beneath the moustache Control's mouth twitched into what she took to be a smile. For the first time in their relationship she had the feeling that in different circumstances she might have added him to her list of conquests.

Control carefully replaced the lead soldier. "General Murat," he said. "Now there was a ladies' man. When he faced the firing squad his last words were 'Spare my face. Aim at my heart.' "

"And did they?" Pamela van Norden asked.

"History doesn't record." Control savored the last mouthful of port. "The reason I asked you to meet me here was to brief you on a number of developments. The process of changing the color scheme in Downing Street is progressing, albeit at a leisurely pace. We still have a long way to go. The current assignment is really in the nature of a dry run for you, but now that you're back in harness I shall have other uses for you. Your ill-fated marriage proved useful—a legal change of name is always an excellent cover—and it's extremely unlikely that your quarry would make the connection with your old persona."

"He's quite different from Hillsden," Pamela said, "though of course Hillsden was special."

"Well, he certainly received special treatment. Even so, don't ever mention his name to anybody. Hillsden has to be buried, forgotten. We know he's out of sight; I want him out of mind as well."

8

To COUNTER HIS boredom Hillsden had become a frequent theatergoer. Given his privileged status, he never had any difficulty in obtaining tickets. Not only did it help pass the solitary evenings, it also saved him from being forced to watch Russian television, prolonged exposure to which was more harmful than the local unfiltered Astra brand of cigarettes. Abramov had also permitted him to have a radio powerful enough to pick up the BBC World Service, but the sound of English voices made him too nostalgically depressed, and he had balked at Abramov's suggestion that he make contact with some of his fellow defectors, for he was afraid he might not be able to conceal his hatred if he came face to face with some of the old gang he had once hunted. Equally, there was always the chance that with their superior knowledge they might find the chinks in his armor.

When his virtually monastic existence became unbearable, Hillsden resorted to casual sex with a woman he picked up in a restaurant. It was a barren one-night stand that he was in no hurry to repeat, and he confessed the incident to Abramov when next they met just to be on the safe side, conscious that when finally he made his move he needed to know whether he was under continued surveillance.

"Yes, I was aware of it," Abramov told him.

"I thought I'd passed your reliability test long ago."

"Alexi, if I didn't trust you, you'd be buried by now. Just a sensible precaution, mostly for your sake. I care for your welfare. Although they are few and far between, we do have certain minority elements in our society working against the best interests of the state. Mostly Jews, dissidents, religious fanatics and the like. They might try to use you. You're living a Russian life now; you have to make yourself think as we do."

"I try; believe me, I try."

"You're pleased with the housekeeper I found for you, aren't you? Say if you're not and I will change her. I want you to be content."

"She's fine; it's just that passing the time of day with a *babushka* is not exactly stimulating. I don't have enough to occupy myself with."

"How is your Russian coming along?"

"Slowly."

"Why don't you enroll in the university and take a proper course?"

"Aren't I a bit long in the tooth to start being an undergraduate?"

"Age is not a drawback. I have an uncle who graduated in physics when he was sixty. Try it. You'd meet a different group, admittedly younger, but full of enthusiasm for the future. Perhaps what you really want is a more permanent relationship. At the university you might well find somebody more to your taste."

"Would I be to their taste? That's the question."

"You underestimate yourself, Alexi."

"I'm not looking for you to pimp for me."

"Would I suggest anything so crude? I'm merely saying that by taking a course at the university you'd not only improve your Russian, you'd also meet people on your intellectual level."

"What makes you think I've got an intellect?"

"Alexi, don't insult me. We know your worth, your background; we've always known it. You're well read; one might almost say you have a literary bend."

"Bent."

"What?"

"The word is *bent.*"

"Thank you. I am always grateful when you correct my English. If and when I get to London, it will be important for me to speak colloquially."

"Okay, assuming I agree to enroll, are you sure the other students won't think I'm a plant? My background, as you put it, is hardly likely to inspire instant friendship. They'll know who I am."

"But you're regarded as a hero, Alexi. One of the elite."

After a further show of reluctance, Hillsden allowed himself to be persuaded and Abramov was as good as his word; the normal bureaucratic formalities were dispensed with and he found himself enrolled in an English-language course, a choice he felt gave him a slight edge over his fellow students. They were not all in their late teens; some were much older, and he naturally gravitated to this group.

It was halfway through the term when he joined, and he found that they had been assigned two novels—*Oliver Twist* and Graham Greene's

The Heart of the Matter—as well as a play of Shakespeare's. To his relief he was familiar with all three. His classmates were polite, but kept their distance during the first weeks. He had to demonstrate that he was there to work before they gradually thawed. For his part, Hillsden scrupulously avoided any topic likely to arouse suspicion about his motives, but answered their questions on the English texts while in turn they gave him assistance on translations. It was a pleasant way to become more familiar with a language, and he made good progress. Although he had no yardstick by which to judge university life, he sensed that there was probably little difference between Leningrad and Oxbridge. The girls were attractive, some of them stunningly so, with clear skins, well-groomed hairstyles and discreet makeup; there was none of the uniform dowdiness he remembered from Western newsreel footage. Equally, they did not flaunt their feminism, and their overt political attitudes were muted. *Glasnost* had lifted the lid, and students of both sexes sported bright clothes and exuded an infectious zest for life. Even so, Hillsden could detect the same scent of rebellion common to students the world over smoldering beneath the surface: the desire to kick over the traces, the refusal to accept old values without question. Just as they sometimes surprised him by their frankness, he could amaze them when he refuted their misconceptions about the life he had left behind, and it was at such times, when forced to describe what now seemed a foreign country, that his desire to get even overwhelmed him. He never forgot the purpose of the manuscript in the lining of his overcoat.

Hillsden was in the library one day, struggling through a term paper, when he became aware that he was being closely observed by one of the older students in his class, Galina. He guessed she might be thirty or so, and that she was a country girl. Ever the literary romantic, Hillsden compared her to those heroines Coppard always described in his short stories: enigmatic creatures, met by chance, who gave themselves to strangers in the dark bedrooms of English inns. She had a good figure that would one day thicken but that now beckoned to be embraced. He had noticed her from the day he started the course, and though they exchanged greetings in class, this was the first time they had been alone together.

"Are you having difficulties?" she asked. He had an arrangement whereby his fellow students spoke to him in English and he attempted to reply in Russian.

"Yes. I find the grammar very difficult."

"More so than your own language?"

"That I wouldn't know. You'd have to tell *me.*"

She came closer and looked over his shoulder.

"I seem to put everything back to front."

Galina sat beside him and corrected a few of his mistakes. In turn Hillsden explained a passage from the Shakespeare they were studying. She wore no perfume, but the scent of her, clean and feminine, was disturbing at close proximity.

That night they had a meal together. Galina took him to a restaurant close to the university patronized by many of the students, and Hillsden had the feeling that she had deliberately chosen it in order to show them together. His first impression of her proved wrong: she was not a country girl, but born and bred in Leningrad. Her father was a historian who for the last seven years had been researching and writing what was intended to be the definitive work on the siege of Stalingrad. Galina was concentrating on languages in the hope that one day she would be allowed to travel freely.

"Is it getting any easier to travel?"

"Perhaps, slowly," she said. "We have a lot of catching up to do. You must have been to many countries?"

"Yes."

"Tell me."

"Oh, America, France, the Middle East . . . Austria."

Mention of Austria brought a sudden intensity of feeling, his mind working on two levels at once.

"And now you are here," she said, "in Russia for the first time."

"And my traveling days are over."

It was the first time the subject had even been hinted at.

"We were all very curious about you when you arrived in class."

"I can well imagine."

"We knew who you were, of course. Are you able to talk about it?"

For the first time in years Hillsden felt no danger in the question. "If you mean, do I *mind* talking about it, the answer is no. On the other hand, I don't want to compromise you by association."

Galina stretched out a hand across the table and touched his. "But it's all over now, isn't it, that part of your life? And you were working for *us.*"

Hillsden smiled and made no attempt to caress her hand. "That's right."

"So tell me what it was like."

94

Old cautions surfaced, and it crossed his mind that once again Abramov had planted a companion on him.

"Well, the whole story would take too long, but if you want to know how I feel I'll tell you a story about myself. When I was a schoolboy I once performed in a play. I was given the role of a Nubian slave in *Antony and Cleopatra.*"

"We studied that last year," she interjected.

"Then you know I wasn't playing a leading role. We had a very enthusiastic English teacher who I suspect was a frustrated actor, and he insisted on realism. I had to stain my whole body. I dare say nowadays they have some easier way of doing this, but I was forced to sit in a bath of permanganate of potash that dyed me a sort of purplish brown. I literally changed color."

"Your face as well?"

"No, I wasn't required to go in for total immersion. I made up my face with sticks of Leichner's five and nine—the brand all the professional actors used."

"What a memory!"

"It's been well trained," Hillsden said. "Anyway, to go on with the story, I happen to have a birthmark, and though the color gradually faded from the rest of my body, the birthmark remained stained for life. You started by asking me whether that part of my life was over, and yes, it is—except that I'm stained by it. I was a spy, and you can't betray without its leaving a mark."

Galina was silent for an appreciable time. "Yes," she said finally. "Yes, I can see that." She sipped her drink. "Why did you?"

"Betray?"

"Yes."

"You don't start out that way. At first it's just a job like any other. A fairly boring job, to tell the truth; there's no glamour in it. Well, take the Greene book we're studying. He says it like it is. Most of the time you feel like Scobie—dirty, soiled. You enter other people's lives by the back door. Remember the scene where he finds the letter the captain of the boat has written to his daughter—I think it was his daughter—and he has to read it and confiscate it? A little act, nothing world-shattering, of no consequence to the progress of that war, but it destroys another man's life."

"But aren't most"—she balked at saying the word "spies"—"people in that position motivated by ideals?"

"I wouldn't know. Some of them, perhaps."

95

"You?"

"In the beginning, maybe. It's like continuous adultery. Who are you betraying in the end—yourself or others?"

She said nothing else, and they finished their meal and left. Hillsden walked with her to the student quarters where she lodged. At the entrance she turned and kissed him, as though on an impulse, but whether from affection or out of pity Hillsden could not tell. He returned the kiss on her cheek, rather as though he was seeing a daughter off to boarding school.

He had no further classes to attend that week, and he found that he was dreading their next meeting in case what he had told her about his past would put a stop to any closer relationship. Four days went by before they shared the same lecture, and Galina came and sat beside him.

"I missed seeing you," she said openly. "What have you been doing with yourself?"

"Studying. And I went to the theater."

"I love the theater. There's a new production of an English play you might know being performed by a group I belong to. It isn't a proper theater. We use an old warehouse we've rigged up. If you'd like to come, there will be a discussion afterwards in which everybody joins in and comments. Tomorrow night should be fun because we've invited a critic to give his views."

"I'd love to join you."

"It's on the outskirts of town, so we'll have to go by bus. I'll meet you in the main hall after class."

They traveled during the busiest period of the day. "So this is *chas pik*?" Hillsden said, airing his colloquial Russian for the rush hour. He was amazed how many people managed to cram themselves into the vehicle. Galina was pressed tightly against him, and their faces almost touched whenever the bus took a corner. "I'm glad I know you; otherwise I might be arrested for indecent assault," he whispered. "This is rather like that scene in *A Night at the Opera.*" Galina looked blank. "Have you never seen the Marx Brothers?" Even as he asked the question he wondered if mention of the word "Marx" might be misunderstood by those closest to them.

The converted warehouse was half a mile's walk from the nearest bus stop, and they arrived just as the performance was about to begin. As Galina had described, it was theater in the round: rough seating and, when the lights were up, devoid of atmosphere. A young and talented

cast gave their version of J. B. Priestley's *When We Are Married*. Hillsden had a vague memory of the plot, having seen it when the British repertory system was in its heyday, and with occasional help from Galina he was able to follow most of it and to enjoy the comedy. Priestley, he learned, was a popular novelist in Russia, where he was considered a true socialist. Like the cast, the audience was young and enthusiastic.

At intermission Hillsden was taken to meet the critic; predictably, he found the man was one of those instantly recognizable poseurs who are always drawn to the arts, given to exaggerated gestures and obviously enjoying the opportunity to hold court. His male companion was never introduced.

"I didn't catch his name," Hillsden said when they resumed their seats for the next act.

"Leonid Kiprenski."

"Is he any good?"

"He mostly writes about the ballet. I think he was once a ballet dancer himself."

At the end of the performance Kiprenski took the stage and delivered a gushing and condescending speech about the social significance of the play. "Priestley was a minor playwright who worked in watercolors rather than in oils, and this comedy of manners doesn't present a true picture of the British proletariat of the period," was one of his most pretentious statements.

"Rubbish," Hillsden commented under his breath as Kiprenski went on to damn the cast with faint praise. A spirited question-and-answer session followed, with the actors defending their interpretations and giving as good as they had received.

"Did you find it interesting?" Galina asked, when the evening came to an end.

"I enjoyed the performance very much. Can't say that I agreed with most of what your critic said afterwards. After all, there's nothing wrong with working in watercolors. Turner didn't do so badly. I thought that a particularly pompous remark. But I guess it's difficult for foreigners to really understand a North Country comedy. I'm told we always make a hash of Chekhov."

Just as they were leaving Kiprenski approached Hillsden. "My friend tells me I was very rude. I never introduced him to you, and you have something in common."

"Oh?"

97

"You're both British. This is John Frampton. He's here on holiday."

His companion came forward and shook hands. "Alec Hillsden," Hillsden said, "and this is Galina Fedorenka. Are you enjoying your holiday?"

"Very much so. This isn't my first visit. I've been to Russia three times."

"Well, you've certainly found your way off the usual tourist track."

"That's thanks to Leonid."

There was a pause. "As I'm sure you know, I'm not on holiday," Hillsden said.

The directness of the remark seemed to embarrass Frampton, and Hillsden felt compelled to make amends. "You'll be able to go home and tell everybody you not only had a good time, you also met a notorious character. Where *is* home?"

"London. Forest Gate."

"How is it these days?" Hillsden found himself prolonging the conversation for no reason other than that Frampton was the first Englishman he had talked to since his abduction.

"Oh, very much the same. The summer was a washout."

"Of course. Where are you staying here?" he continued out of politeness.

"I got him into the Evopeiskaya," Leonid said.

"Very elegant. What it is to be a critic and have influence. Well, very nice to meet you, Mr. Frampton. Enjoy the rest of your stay."

"Oh, I shall. This is home from home to me."

They finally got away and caught a bus back to the center of town. The return journey was less crowded, and they were able to sit together.

"An odd twosome," Hillsden remarked. "Do you think we should draw the obvious conclusion?"

"I think so, don't you?"

"Amazing any of them still take the risk. Quite apart from the dreaded AIDS, it's forbidden, isn't it?"

"Yes, but like everything else in Russia it depends who you are and what influence you have in the right quarters. As you know, everybody is equal here, but some are—"

"More equal than others," Hillsden finished for her.

"Exactly."

"Influence won't save anybody from the plague, though."

Their first mention of matters sexual brought about a lull in the

conversation. Hillsden thought, how subtly all our attitudes have changed; a tiny sliver of ice has been inserted into every relationship, whether we like it or not. An atheist, he did not believe in divine retribution, but rather that nature, the great leveler, was carrying out one of its periodic culls.

Because of this he was hesitant about inviting Galina back to his apartment for a nightcap and searched for the right words. "I was going to suggest we go to the Evopeiskaya for a drink, but I don't want to run into those two again . . . I have some perfectly good scotch in my apartment . . . or we could go somewhere you know of." He felt like a schoolboy fumbling to secure a date.

"I'd ask you back to my place," Galina said, "except I share with two other girls. I'd love to sample your scotch; I don't get many opportunities."

When they arrived she stood amazed in the doorway. "My! It's so big compared to most. You're very lucky."

"Yes, I realize that. Make yourself comfortable while I fix the drinks."

He sat some distance from her, still uncertain how to behave. He found her desirable, but was wary of any emotional involvement in his present circumstances. His thoughts went back to the night Jock had sealed his fate. They made small talk, some of his unease communicating itself to Galina.

"Did you go to the theater a lot in London?"

"No, I'm ashamed to say I didn't. No particular reason; I suppose my old way of life was too erratic. My wife and I enjoyed films more . . ." He was suddenly compelled to add, "I was married, by the way. I'm not any longer, so I'm told. Since I arrived here I've been informed that my wife divorced me."

"She wouldn't come with you to Russia?"

"In fairness, she was never given the chance. But it had stopped being much of a marriage long ago. How about you? Why aren't you married? Or perhaps it would be more polite to say, are you married? I would expect you to be."

"No, I'm not. Like you, I was once. And like you it didn't work out."

After a slight pause Hillsden said, "The one thing I miss is my books. I had to leave them all behind. I've always been a great reader ever since I was a boy. I read everything I could get my hands on. When I first saw you, you reminded me of a favorite book, *Dusky Ruth.* " Seeing that

the title meant nothing to her, he added, "It's a collection of short stories by an English writer long since dead, a master of the form called A. E. Coppard."

"And why did this book remind you of me? Was it about Russia?"

"No, he was a very English writer who did his best work in the thirties . . . I thought of him when I saw you because his heroines were always mysteriously beautiful. I fell in love with them on the page."

Galina colored, staring down into her glass, then surprised him, as once before Inga had surprised him with her guileless honesty. "Would you like to have a relationship?"

Hillsden took his time before he answered. "You mustn't think I was making a pass. I'm not that subtle."

"If you did, I'm not offended."

"My dear," Hillsden said, "didn't it ever occur to you that I'm not good news for somebody as nice as you?"

"Isn't that for me to decide?"

"Why don't we just go on as we are and remain good friends? I need a friend."

"But that's stupid. If we like each other, friendship would never be enough."

Hillsden moved to her and took her face between his hands. "Look, don't think I'm not flattered. You took me unawares, that's all. I'm not used to people wanting to be with me. Of course I want you; I'd be a fool if I didn't." He bent and kissed her on the lips.

"There's nothing wrong in being foolish sometimes," she said, returning his kiss. "One can't be wise all the time. And the woman always makes the final choice."

As she drew him down to her, Hillsden realized he was back in the territory of trust with no maps to guide him.

9

SLOWLY AND PAINSTAKINGLY the dark corners of Mitchell's life were illuminated. On the surface his existence had been a blank sheet of paper, but now his past, once written in invisible ink, responded to the heat of closer scrutiny.

After the barking dog had led the authorities to his secret pied-à-terre they began to strip away the layers of deception. Pearson's patience was finally vindicated: a subsequent search revealed a false compartment in one of the kitchen cabinets. In it they found articles of women's clothing—bras, garter belts and bikini pants—together with a quantity of bizarre literature mostly concerned with lesbian fetishes. Mitchell had also used a Polaroid camera to photograph himself dressed as a woman. He was always alone in these pictures, giving those who had the task of putting together the tawdry puzzle of his life glimpses of a sad misfit. There was some justification in assuming that, like many others drawn to the act of betrayal, he should also betray his own manhood in this manner. Sifting through the material, Pearson was less concerned with the Freudian aspects than with the other implications: anybody so consumed with the need to submerge his own personality was capable of a hundred other treacheries. A cassette of partially exposed but undeveloped microfilm found in another camera was developed, and it revealed that Mitchell had photographed a series of top secret documents. These were later established as being transcripts of radio traffic originating from G.R.U. headquarters in Moscow, much of it in code.

"It doesn't make sense," Pearson said. "Why photograph what you already have a right to see? He handled this stuff; that was his job. It's like robbing your own piggy bank. Who did he steal it for?"

"Perhaps he needed the money to buy tights," Lloyd remarked. "Bloody things cost a fortune, according to my wife."

Pearson chose to ignore this. "Well, it isn't our headache. Special Branch and the MI5 mob can sort that out. But it beats me how this

joker passed through the nets. According to his file he was positively vetted on three occasions."

"He obviously wasn't wearing high heels when they interviewed him."

"You're full of it today, aren't you? Ever thought of entering a talent competition for stand-up comics?"

Despite Whitehall's strenuous efforts to suppress the story, Mitchell's case received intense media coverage: the unmasking of a presumed spy who wore women's underwear was titillating enough, but the added fact that he had been murdered in such a hideous way and that so far the police had not been able to establish how or why the murder had taken place kept the story alive.

Nobody was more disturbed by the new developments than Control. Mitchell's disappearance and the subsequent confirmation that he was the Hyde Park victim left him as perplexed as anybody. By virtue of his position and the fact that within his closed circle Mitchell was assumed to have been in the pay of the Russians, Control could openly demand access to all the available evidence: the matter was no longer the sole concern of MI5. He urgently needed to find out as much as possible. Never one to pass up an opportunity for intrigue, he planted the seed for an official inquiry into MI5's vetting procedures.

Heavily pressed by the Opposition, Bayldon was forced to make a hasty and ill-judged statement to the House. Badly briefed, he allowed himself to be rattled when challenged, playing down Mitchell's importance and describing him as a misguided pervert who had only limited access to top secret material. Since the newspapers had already uncovered Mitchell's rank and position, this was howled down, one Tory backbencher being suspended by the Speaker when he called Bayldon a shabby liar and refused to retract. Even on his own side of the House it was generally thought that the Prime Minister had botched it, and the public interest continued unabated.

It was not Bayldon's week; more was to come. Attending the annual gathering of the Durham miners—historically a necessary pilgrimage to a depressed Mecca for all Labor leaders—he suffered what was described (and Bayldon himself did nothing to discourage being described) as an attempt on his life. All that actually happened was that a deeply disturbed local government official, angered that he had been cheated out of his expected accolade in the discarded honors lists, had lunged at Bayldon armed with nothing more lethal than a letter opener and was

swiftly overpowered. The incident gave the Prime Minister an excuse to intensify his criticism of the police. His press secretary announced that in future he would be accompanied by loyal members of the workers' militia when carrying out public engagements.

A planted leader in one of the tabloids asked:

> Why is it that not only can a spy be openly murdered in a London park, but it now seems that even the Prime Minister is at grave risk from those factions in our society who seek to overthrow our democratic way of life?
>
> It becomes increasingly obvious that our security services have failed to carry out the duties entrusted to them. Constantly compromised by an effete group of privileged men in the past three decades, answerable to no one, not even to Parliament, they now stand accused of further incompetence. The time has come when we must demand drastic changes. We can no longer tolerate a system which allows certain public servants operating outside the law to treat public life as an extension of the prefects' common room. Such a system attracts the unstable, the corrupt, the rogue moles who burrow under and into the very foundations of our most cherished citadels, fails to protect those it was brought into being to protect, and by its incompetence threatens us all.
>
> THE COUNTRY DEMANDS AN ANSWER. THE COUNTRY DEMANDS ACTION.

Naturally ninety percent of the country was not demanding and, in any case, did not get a true answer. Despite heading a government elected on the promise that it would introduce a Freedom of Information Act, Bayldon and his cabinet had swiftly been brought to their cynical senses; too much information, they decided, was injurious to the nation's health and their own survival. In point of fact, a majority of the electorate would cheerfully have voted for less information and a return of the death penalty if given the opportunity. Inner city violence had spread outwards into hitherto quiet market towns in Dorset, Somerset and even as far afield as Cornwall. Sporadic fights took place every Saturday night, work no longer being the curse of the drinking classes. Chief constables remonstrated that their forces were undermanned and hampered by the increased powers of the Militia.

Still baffled by Mitchell's murder, Control thought it expedient to meet with his counterpart from MI5, Sir Oswald Leighton. Whenever they were brought into contact they circled each other warily, like two old alley cats.

"Curious business, this Mitchell affair," Leighton said, with the fastidious smiling hauteur he reserved for those he considered his inferiors.

"I'm always miffed when two and two don't make four." A senior wrangler with a double First in applied sciences, he had been recruited by Churchill during the war to join the team responsible for cracking the Enigma machine. Now on the eve of retirement, and one of the few active survivors of that elite group, he never questioned his own judgments. He liked to have the solutions to life's problems brought to him on a silver salver. "What none of us here can fathom is whose payroll he was on. Certainly not ours."

"Nor ours, either." Control just managed to keep the irritation out of his voice. He knew Leighton's technique in these matters.

"So who else would be interested in G.R.U. traffic? We know there's no love lost between them and the K.G.B., but presumably if Moscow Center wanted chapter and verse they could have achieved better results closer to home."

"Unless . . ." Control began, then trailed off. Despite being on guard, he found that Leighton's attitude discomfitted him. He cracked the knuckles of his left hand.

"Unless what?" Leighton tightened the knot on his Garrick tie.

"I was going to say unless we still have a mole and this was his way of keeping in contact."

"Oh, God, I'm so sick of our lawns being dug up."

"I agree, but knowing our splendid press, it can only be a matter of time before one of the pundits resurrects the theory. I'm amazed it hasn't surfaced already. Has all the traffic been decoded?"

"Yes."

"Anything startling?"

"Not really. Their stuff is as boring as ours, although there was one item that might interest you, Raymond. That chap of yours who defected, Hillsden, he got a mention."

"Really? What was that?" Control registered the minimum interest.

"He's now in Leningrad, apparently, studying at the university there. They regard him as something of a prize, don't they?"

"I can't think why. He was very small fry compared to some that fouled and then fled your nest."

Leighton took this in his usual bland manner. "Yes, I suppose we've always produced a better class of defector. Seems odd they would put local gossip like that in day-to-day traffic, don't you agree? Stuck out like a sore thumb."

"If we understood all their motives, we could retire."

"Anyway, what we have to address ourselves to is the pervert Mitchell. There are so many curious aspects, not the least of which is, Who took him out? A straightforward murder would have made life easier for all of us; it's the secondary factor that raises the big question mark. Had it not been for the dog, we might never have made a positive identification. Since he wasn't working for you or for me, it presupposes there's a third party who bankrolled his exotic tastes."

Control stared past Leighton, having just registered that a new Stubbs had been installed above the fireplace. "Could be the I.R.A., I suppose. They've moved up a notch from kneecapping recently—witness last month's barbaric lynching of that S.A.S. man."

"My dear Raymond, we've considered that exhaustively, but there's no mileage in it for them."

"They killed two policemen."

"Pure chance. Let me put a hypothesis to you, and bear with me for a moment: that it is the present government's intention to bring about a Marxist society."

This took Control by surprise. "Well, it's no secret that Bayldon's cabinet is predominantly left-wing, with more hardliners than we've had before."

"And?"

"Obviously they're keen to reverse as much of the previous Tory legislation as they can. 'Twas ever thus."

"Nothing more than that? Just the mixture as before? What we've had ever since 'forty-five, yah-boo politics?"

"More concentrated, perhaps."

"You haven't really answered me, and I can't believe that you of all people, Ray, would fail to see the writing on the wall."

Leighton's abbreviation of his Christian name nettled Control, but again he stifled his annoyance. "I think we both know the score in our respective areas"—for a brief moment he was tempted to reciprocate and call him "Ossie," except that it would be descending to Leighton's level—"but if you detect danger signs that have so far escaped me, then of course you are right to share them. What writing would I have missed?"

"The word 'militia' to start with. How do you read that?" He did not wait for Control's reply. "Shades of the Blackshirts, wouldn't you say? Seems to me they're already being given too much rope. The commissioner and I are not at all happy about the way they're developing."

"Well, the P.M. was obviously shaken by that incident up at Durham, and I think those closest to him were looking for scapegoats. Who better than the police and the security forces?"

"Be a bad show," Leighton said in his usual understated way, "if they got too powerful. Private armies are never good news. Once they're let out of the pen they're difficult to fence in again." He had a sheep farm in Monmouthshire and was inclined to introduce such similes. "I think that between us we should watch it closely. There are enough loonies around without putting them into paramilitary uniforms. I'd certainly resist any suggestion that they take over any aspect of security."

"My own view is that Bayldon is having a difficult job keeping a balance. He inherited a great many problems not of his making."

"Exactly. That's my point: Bayldon is treading water in shark-infested seas. Somebody might burst his water wings, and then where would we be? I thought we should put our heads together against such an eventuality and have a contingency plan. Decide which arses to kick and which to kiss. We might need to help reclaim the middle ground."

For some reason he's testing me, Control thought, immediately back on his guard. "You're offering me guilt by conjecture. One shouldn't underestimate Bayldon's capacity to resist."

"Aren't you forgetting that he only came to power secondhand? He can hardly claim to be there as the result of the popular vote. He didn't ride to Downing Street through cheering crowds; he came in through the side entrance. Nor does he have to honor a manifesto. His elevation suggested a coup to some people. And don't misunderstand me; I'm playing devil's advocate. One can't ignore the fact that since moving into Downing Street he's packed, or been *made* to pack, the Cabinet with the far Left. I'm reading smoke signals that some of the older natives are getting decidedly restless—*uneasy* would be the better word."

"Yes, but we have to stand aside from all that, do we not?" Control answered. There was no way he was going to give even a tacit blessing to Leighton's innuendo. "We are not at the moment favorite sons. Once our masters detect a whiff of criticism, they can chop us off at the knees."

"Don't I know it. Let me ask you this and then I'll shut up: What if the P.M., despite his many and admired qualities, was to be outmaneuvered, outgunned, and had to relinquish the star part? Where would that put us? Who d'you think would step into his shoes? And would they still fit?"

"I think you're just running around shouting 'Fire' before there's any smoke."

Leighton gave a thin smile, like a judge forced to teach a young barrister court etiquette. "I like to know which part of the battlefield I might be fighting on. I've always acted on the principle that we have to protect our politicians from everything except their own excesses."

There was a chill wind blowing as Control left the MI5 building, but the erratic winter sun was tempting enough to make him dismiss his car and walk to Whitehall through St. James's Park; he felt the need for solitary contemplation while he mulled over the meeting with Leighton. Flocks of mallards huddled beneath the bare willows, deprived of their usual tourist pickings. The ice on the lake was as thin as the sugar crust on toffee apples, and as Control skirted the perimeter a Canada goose made an ungainly landing, skidding and spinning as the shock waves crackled the surface.

Despite the repressed anger brought on by Leighton's infuriating air of superiority, Control was not displeased at the way he had handled the meeting. You boxed cleverly, he told himself; he didn't get through your guard. Even so, he did not underestimate a professional like Leighton; they shared a past so complex that it was always a mistake to take things at their face value. That casual mention of Hillsden, for instance: had that been just an item of in-house gossip, a conversational gambit designed to push home old knives, or had Leighton been testing him, probing to see if any nerves were exposed? There were no rules of engagement in the long and cruel war they both waged; every truth was booby-trapped. But perhaps even Leighton was getting careless in his old age, making it slightly too obvious, presenting his convictions as hypotheses. Certainly even by Leighton's standards he had been remarkably indiscreet, handing me some useful ammunition, Control thought. The question now was how and when to make use of it. But that answer would come in the fullness of time; there was never any reason to hurry the inevitable.

After an interval of a week, Waddington fixed an appointment to survey Mrs. van Norden's Amersham house. It turned out to be authentic Georgian, with no trace of stockbroker mock. Waddington was impressed. Although his current job often brought him into close contact with the rich, most of his clients appeared to have cornered the market

in expensive kitsch. By contrast, the van Norden home epitomized discreet elegance. He had only the most rudimentary knowledge of art and period furniture, but as she showed him around the principal rooms it took little to convince him that he was looking at the genuine article. Early on in the tour he found himself thinking of Hillsden; Alec always had some pertinent literary quote for these occasions. Alec would doubtless have reminded him of Hemingway's famous dictum on the rich.

"If I may say so, Mrs. van Norden, you certainly have a lot of possessions worth protecting. I dread to think what your insurance premiums are."

"Do call me 'Pamela,' otherwise it's too boring. I hate our British formality, don't you? This is the room I use most. As you can see, it gives the best view of my nightmare garden."

"Why a nightmare?"

"Do you garden yourself?"

"I've been known to plant the odd window box, but I have the opposite of green fingers. I only have to look at a flower and it withers."

"Likewise. I don't know anything about nature except that you have to fork out all the time to keep it at bay. Despite what everyone says, God never intended the English to have gardens. The moment anything buds we get out-of-season frosts; as soon as the blossom arrives, He sends gale force winds, and during the three days laughingly known as the English summer the whole place is infested with bugs, wasps and other creepies and crawlies. The whole exercise seems absolutely pointless to me, and I can't stand those intrepid female neighbors of mine who are out in all weather weeding and snipping; they must be demented. My gardener is always telling me I should plant more roses, so I forked out, but we had a monsoon and they all looked like anorexic debutantes. Last year the wasps got the plums, the squirrels—or was it the birds?—ate the apples, and the bloody lawn looked like Ethiopia. It costs me a fortune to create an annual desert."

She delivered this monologue nonstop while Waddington examined the windows with a professional eye.

"Georgian windows are lovely, but they do present a problem."

"Darling, everything I touch is a problem." Waddington noticed that she sometimes affected the exaggerated voice of an actress. "Actually, I don't give a flying fart for material things. If I get ripped off and they steal the televisions, so what? But I hate the idea of being bound and gagged or worse. According to all reports, the average villain today would just as soon rape or kill you as look at you."

"Do you have a panic button?"

"No."

"I think that's essential."

"Well, I'm sure you'll take care of me. Where would I have it?"

"Ideally it should be by the side of your bed."

"Why didn't anybody tell me these things? Well, let's go look."

She led him upstairs, and he was taken into the principal bedroom. Everything was white: bleached white oak flooring covered with white scatter rugs, a white king-size bed, white chaise lounge, white television, even a bookcase with every volume bound in white vellum. The only splash of color was an enormous modern abstract hanging over the fireplace.

"I'd recommend a panic button here within easy reach," Waddington said. "It would be monitored twenty-four hours a day."

"You mean if I pressed it you'd come running?"

"Somebody would. Our computer would alert the local police."

"Big Brother would be watching me?"

"It's all technology, I'm afraid. But we at Breakproof like to feel that we still maintain the human touch. . . . Speaking of which, may I say I love the way you've done this room?"

"Well, after the divorce, I thought: let's whitewash everything, Pamela."

They continued the tour of the house with Waddington making further suggestions. "If you decide to go along with any of this, I should warn you that our stuff doesn't come cheap."

"Darling—sorry, I tend to call everybody darling—I'm not shopping at Oxfam for a chastity belt. If you tell me I should have it, then that's good enough. I just want to sleep soundly."

"Right. . . . Well, first thing in the morning I'll have my office type up a complete list of everything we've discussed. Then, if you okay it, we'll put the work in hand immediately; I'll mark it urgent. And thank you very much for the business."

"Do you have to rush?"

"Now, you mean?"

"Yes. Do you have other appointments?"

"No."

"Would you like to stay and have dinner?"

"That's very kind of you, Mrs. van Norden, but I'm sure that's inconvenient."

"I wouldn't ask you if it was. And do stop calling me that."

"No, listen, I don't want to put you to any trouble."

"Darling, I'm not going anywhere near the kitchen myself. I can only just find it, let alone use it. Bending over a hot stove is not one of my talents, thank God. The cook's Mexican, but we don't mention that because she hasn't got a work permit. Do you like spicy food?"

"Yes."

"Then that's settled: you'll stay. After all, you've come all this way; I can't send you away hungry. Let's have a drink. Come into the game room and fix us both something. What's your poison?"

"Well, since we're eating Mexican, do you have any tequila to get into training?"

"Of course."

He followed her into a room the furnishing of which appeared to have been lifted intact from a Ralph Lauren catalogue, complete with an elaborate bar, pool table and various pinball machines.

"You be the bartender," Pamela said.

This is all very pleasant, but where is it leading? Waddington thought. There was something a shade too anxious about the lady. Why would somebody like her want to spend an evening with the likes of me? It can't be that I've suddenly become the Sundance Kid in my middle age. In the space of a few short hours I seem to have traveled south of all previous borders. Why did I suggest tequila? It'll blow my head off on an empty stomach. Or have I become too jaded and cynical? Maybe she's just being polite and hospitable. Give her the benefit of the doubt, Waddington, and accept graciously.

As he fixed the drinks, Pamela picked up a house phone and gave instructions to the kitchen—speaking, he noted, in fluent Spanish. Then they sank into deep armchairs and chatted as the tequila swiftly reached his toes.

"Pity we have to live like this these days," Waddington observed.

"How d'you mean?"

"Locks on all the windows, death rays, panic buttons. When I was a kid we never locked the front door. My mother used to keep the key on a string through the letter box. If a neighbor wanted to borrow a cup of sugar, she just let herself in. Nobody got ripped off, as I remember."

"Did people actually *borrow* cups of sugar?" Pamela seemed genuinely amazed by this social revelation.

"Oh, sure. Does that date me?"

"Where was this?"

"I was brought up in Birmingham, but I imagine it was pretty general."

"Sounds like another world."

"It was."

He wished she hadn't crossed her legs; that and the tequila gave him a sudden rush of blood to the head.

"Can I ask you something," he blurted, "if you don't think it's too personal? How come your ex let you divorce him? Didn't he go for these simple pleasures of everyday countryfolk?"

"I wasn't his first, and I'm sure I won't be his last. Who knows why anybody really breaks up? Perhaps I wore him out," she added, getting up to replenish their glasses. "He caught me on the rebound, and I liked his after-shave. Let me ask you the same question: how did Mrs. Waddington allow you to escape?"

"With relief, I think. All work and no play made me a very dull boy."

"I can't believe that. Did you cheat on her?"

"I strayed once or twice." God, he thought, why did I get onto that? He sipped at the second glass of tequila like a bird taking water.

"I suppose in your line of work, getting to meet new people every day, temptation gets put in your way?"

"Not really. It isn't every day I walk into a setup like this. Usually my sales talk is directed at monosyllabic Arabs or Jewish widows, and if that sounds faintly prejudiced, I guess it is."

"What made you choose this job?"

"A small detail known as staying alive. I wasn't always doing this."

"What did you do before?"

"I was in electronics," Waddington answered quickly, "but, like a lot of us, the bottom dropped out of that. It was a British firm that didn't keep up with the times; those clever little Japanese cornered the market and I got shoved onto the rubbish heap."

Pamela stared at him in a manner he found increasingly disconcerting. "Listen," she said finally, "don't think me rude, but I'm going upstairs to have a bath and change. I've been in these clothes all day. Just make yourself at home. Do you play pinball?"

"Not for a long time."

"My ex was obsessed, as you may have noticed. Come to think of it, that was another reason why we called it a day. He was always trying for the *Guinness Book of Records* and never came to bed." She paused by the doorway, catching him putting his glass down. "Would you like

to freshen up too? We do have more than one bathroom—seven, to be exact. How about trying a Jacuzzi? You said you'd never had one."

"You serious?"

"Of course."

"Yes, okay, why not?"

She led him upstairs and into what had obviously been her ex-husband's wing, since the décor was decidedly masculine. The bathroom was vast, and the bath itself was big enough to hold an entire football team.

"Christ!" Waddington exclaimed. "Going back to my deprived childhood once again, they'd have called this a public bath."

"Hans built everything big. Too bad he wasn't built that way himself. Look, this is how you work it. Make sure you fill it enough to cover all the jets, then press this. But don't soap yourself until it's switched off; otherwise the whole thing clogs up. Got it?"

"I think I can manage that."

She collected an armful of towels and threw them down by the side of the bath.

"Enjoy," she said in the manner of an American waitress, and left him to his own devices.

Waddington surveyed his coming destiny. Well, he thought, the Captain wouldn't approve—"Fraternizing with the customers is off limits"—but what the hell? He reached out and turned on the taps, which appeared to be made of solid gold. Piping hot water gushed out, and he quickly added more cold, then fumbled for the plug. Shedding his clothes, he waited for the water to reach the required level; then, his head still fuzzy from the tequila, he dipped a toe in the water, found it bearable, turned off the taps, and stepped in. He pressed the knob Pamela had indicated and nearly slid under as half a dozen powerful jets hit him from as many angles. Any prior reservations he might have felt immediately left him; he lay back feeling decidedly hedonistic. The surging water had an alarmingly erotic effect, and again he wondered about his hostess. She was a one-off as far as he was concerned; he had never come across anybody like her. Either he had stumbled across a genuinely liberated woman, or else he was dealing with the genus nymphomaniac. In the old days with the Firm caution would have been needed, but with the water soothing all muscles but one, caution was pushed to one side. Some time later—he had lost track of time, having dozed off—Pamela's voice startled him. Opening his eyes, he found her

standing by the side of the bath enveloped in a large toweling gown.

"How is it?"

"Terrific." He rejected any coy gestures and just lay there, exposed.

"Dinner's going to be delayed at least another hour because Cook insists on doing something special. Can you last out?"

"I think I can manage."

"Would you like me to join you?"

"Join me?"

"That's what I said."

There was no reasonable answer he could think of, but he attempted a feeble joke. "Are you looking for a discount? I have to tell you my boss doesn't give any."

She stared him straight in the eye while slipping out of her robe. Naked, she seemed totally unreal. She had that even, all-over tan that only the very young or the very rich seem to achieve.

"Look, I'm sure I'm being incredibly gauche for a man of my age, or maybe I'm hallucinating, but why me?"

Instead of replying she got into the bath and sat facing him. The turbulent water immediately clustered her breasts with bubbles.

"Don't you hate conventions?" Pamela said, sliding further under the water. "Most people waste half their lives wondering whether they are doing the right, the sensible thing. Such a bore. Relax. You look terrified. I'm not going to attack you."

"What if *I* attack *you*?"

"I guess I'll have to take my chances. After all, you haven't installed a panic button yet. Haven't you done this before?"

"Yes, but not in these circumstances."

"Didn't your nanny ever bathe you? I've always been told that little boys get their first inkling of what it's all about from bathtime with Nanny. True or false?"

"I wouldn't know; I never had a nanny." Even as he said it, Hillsden came into his mind. He remembered that he and Alec had been discussing the results of Caroline's autopsy, and that young Rotherby, always the one to flaunt his superior upbringing, had tried to score off Alec. He couldn't remember why the subject of nannies had come up, but he remembered Alec giving the same reply. It was incongruous to think of that now; yet somehow the memory sobered him.

"Does it bring back unhappy memories or something?" Pamela asked. She twined her legs round his.

"No, I wouldn't say that. It was just a smaller bath—in a Spanish hotel, if you must know—and we flooded the place."

" 'We' being the wife?"

"No."

"She didn't go in for water sports?"

"Pamela, I think before this goes any further you and I ought to establish a few ground rules. I'm enjoying this—who wouldn't?—and I'm sure I'll enjoy dinner, but—call me old-fashioned—I still like the thrill of the chase. Not that I don't find you highly desirable; that much is staring you in the face, as you've doubtless observed. You might be sharing my bath, but you're out of my league. I don't earn enough even to heat this Jacuzzi. I live on a modest salary, plus commission, less alimony. I may not have had a nanny to guide my upbringing, but I did learn early on that men who live off women are known as pimps."

"What's that got to do with it?"

"Everything."

"Aren't we both free agents?"

"Yes, all right, up to a point. I came to sell you a burglar alarm, for Christ's sake! I didn't expect to end up sharing your ex-husband's over-sized hot tub with his naked ex-wife. Curiously enough, that is not in our sales manual. Maybe I should switch jobs and start selling Jacuzzis, maybe I've lost my true vocation, who knows? All I'm trying to say is that I'm astounded, amazed, flattered, and for the moment out of my depth."

"Fine. No problem."

"Now you're offended. I didn't mean it like that."

"No, everything you say is very sensible."

"You *are* offended, I can tell."

"If I was really offended, you wouldn't get dinner."

She switched off the Jacuzzi and stepped out of the bath. Her wet body was even more dazzling, and it occurred to him that if women didn't have breasts they would be less lethal.

"Come downstairs when you're ready."

She left the bathroom. Who the hell would believe that scene? Waddington thought. What are you afraid of—hidden cameras, blackmail, all the paraphernalia that used to condition your every waking hour? Single-handedly you have just blown the entire *Playboy* ethic.

He remonstrated with himself all the time he was dressing, silently cursing his inability to shed the last skin of his old life.

Dinner was a muted affair, given what had gone before. They made conversation, even shared a few laughs when he told anecdotes about some of his more difficult customers, but he departed as he had arrived, the salesman, promising to put her requirements into effect, thanking her for her hospitality as though they had never shared anything more than a formal relationship.

"I'm sorry," he said.

"What is there to be sorry about?"

"I guess I was pretty crass earlier on. If so, forgive me. I would like to see you again, but on my terms and my home ground. That is, if you still want to see me."

"Then I'll wait to hear from you out of office hours."

Arriving home, Waddington was greeted by the neighbor's cat proudly carrying a small rodent in its mouth.

"You evil bastard," Waddington shouted, aiming a kick at it. The cat retreated slowly, staring at him with the superior air that felines reserve for those who fail to appreciate their unique qualities.

The moment he entered the house he was conscious that something was different. There was nothing out of place, yet a sixth sense convinced him the house had been violated in his absence. Searching every room, he found nothing untoward. He had two telephones, one in the kitchen and an extension in his bedroom. Knowing what to look for, he took both instruments apart, but again drew a blank. Then he turned his attention to the answering machine, and it was there that he located the bug. He left it in position and carefully replaced the casing, then poured himself a drink and sat down to consider the implications. Imperceptibly mementoes of his old existence were creeping back. He had never set much store by coincidence, but pondering this latest development he sensed a pattern emerging. For some reason someone was tracking him, and he needed to find out why.

10

FROM TIME TO time and in return for various privileges accorded him, Hillsden was expected to give his analysis of intelligence reports originating from Soviet agents in the West—a task he readily embraced since it gave him an inside track enabling him to keep abreast with what was happening in England. He was often compelled to conceal his surprise at the extent of Soviet penetration into every corner of Western political and commercial circles; their thoroughness was impressive, and he began to appreciate how often the Firm had been duped in the past, how skilfully they had been deflected into concentrating their efforts away from the main danger areas. He now began to suspect that some of the major spy scandals had been deliberately engineered in order to divert attention from a more potent army of subverters, carefully positioned and concealed: self-styled "moderate" general secretaries of trade unions, organizers of minority pressure groups, citizens of irreproachable character who were nevertheless ideally placed to foment trouble and dissent. Historically the K.G.B. had abandoned a frontal attack on the British Parliament; card-carrying members of the British Communist Party seldom stood for election, for Moscow had long since concluded that the real power lay outside Parliament, taking their lead from the civil service, which had always controlled the pace of events no matter which of the two main political parties held office. Even so, various backbenchers on both sides of the House frequently cropped up in the reports—fellow travelers who were usually to be found in trade missions visiting Eastern bloc countries.

His memory having been well schooled over the years, Hillsden was able to store and cross-index certain items from the reports, building a composite picture of who was in place and where. In most cases the true identities were hidden for operational reasons, but he was able to establish that there were sleepers in many of the major seats of learning and communication, in the BBC and ITV companies, in provincial universities as well as Oxbridge, and of course firmly based in a multitude of

local governments. Recruitment was an ongoing priority, any failures being ruthlessly weeded out; on at least two occasions he saw evidence of actual eliminations. Gradually he formed a mental map of an England networked with cells operating outside the democratic process, but always using democratic means to subvert the majority will. There were gaps in the network, for he was unable to detect any signs of subversion in the higher echelons of the armed forces or the police, though several police watch committees were shown to be controlled by political activists. He derived a certain cynical amusement from the fact that Moscow made little use of the old guard of the Labor Party, regarding them as useless reactionaries. These revelations brought home the urgency of his own situation, convincing him that he must put his plan into operation as soon as possible.

In offering his interpretations to his G.R.U. masters Hillsden was always careful never to reveal that he knew the full extent of the role being played by Control. Because Lockfield's duplicity had neither formed part of his original debriefing nor been broached since, he was confident that Abramov had no inkling that Jock Calder had told all before his death. He had gone over the whole sequence of events many times in the intervening two years, but even now he found it difficult to come to terms with the fact that he had bought his alien brand of freedom only by killing a man. In the country he inhabited there were convenient phrases for what he had done—Moscow Center called it "wet business"; the Firm's vocabulary had it down as "expedient demise," abbreviated to three innocuous letters, X.P.D.—but there was nothing innocuous about the recurring nightmares that left him drained and sweating. Hillsden knew he would never expunge that memory: killing Jock had avenged Caroline's murder, but had brought no peace of mind; nor had it removed the architect of his present situation. Control was still in power.

He used these sessions with Abramov to exercise old skills, searching for any chinks in the armor of Soviet penetration that he could use for his own ends, updating his manuscript whenever he could positively identify individuals. Not surprisingly, none of the traffic ever mentioned Bayldon; his name surfaced only once, during a lighthearted exchange about British television programs. It was standard G.R.U. and K.G.B. practice to monitor Western television output, particularly programs with political content and newsreel material critical of Soviet policy or intentions. Abramov confessed that he was baffled by a popular BBC

television series called *Yes, Prime Minister.* The tapes were sent over in the diplomatic pouch and screened, but the humor did not travel well.

"How can they show the government in such a poor light, Alexi? The man who plays the Prime Minister is humiliated every week by this civil servant character."

"That's the whole idea. It's a comedy."

"But subversive."

"Yes, thank God."

"But it must surely have a profoundly negative effect on the population."

"I don't think so. They lap it up."

"But there are even physical similarities with Bayldon."

"Yes, I suppose there are, now that you mention it."

"They are quite happy to be shown that a Prime Minister can be manipulated in this fashion?"

"Oh, yes, we like to have our cynicism about politicians confirmed. It's what keeps the British vaguely sane."

"A dangerous game. Once people cease to fear their leaders, rot sets in."

"But you have your own brands of humor. You Russians are not prudish; you have sex jokes, political jokes. I've seen examples in your underground press."

"Exactly! It is not *official* humor. It doesn't go out on state television. Nor do we allow pornography to be openly shown."

"Oh, come off it!" Hillsden remonstrated. "Don't tell me you're still living in the same Russia as the merchant's daughter in Chekhov's story. If you recall, she refused to look out of the window because there were naked horses in the streets."

"No, this is not so. Pornography is a manifestation of Western bourgeois degeneracy."

"Then why do you have a name for it? *Samizdat,* isn't that right?"

"That is used only to describe foreign material smuggled into our country by subversive elements."

It was during one of these relaxed sessions when the vodka had mellowed them both that Hillsden felt confident enough to test Abramov's reaction to the next stage of his plan. He approached the subject circumspectly, hoping that he could plant the idea in such a way that Abramov would believe it was his own.

"What impresses me, Victor," he began, "and I was never really

conscious of it until I arrived here, is the way in which you go about things."

"Things? What things?" Abramov's speech was slurred; his capacity for vodka was impressive, but Hillsden felt he had the edge.

"Your capacity for planning long-term strategy and sitting on it until exactly the right moment."

"Yes, we're good at that. When the revolution started we used to have five-year plans, but they were never long enough to achieve anything, so we learned to be more patient."

"We don't have that sort of mentality."

"No?"

"No. But let's be fair; British intelligence can be very good. It was very good during the war, better than yours, and, although we shared it when we became allies, Stalin ignored most of what we told you, which proved costly on several occasions."

"Is that the truth?"

"Sure. The difference is that you have an overall world plan, whereas we don't. It's hit and miss most of the time. Our Foreign Office needs firecrackers up its arse. Since the war they've reverted to their old sloth; they don't rate us professionals—we don't have the right accents and didn't go to the right schools. That television program you don't understand—believe me, it's very accurate. The permanent civil servants call the tune; they can run rings around the average minister, and the reason we get up their noses and they do their best to screw us is that they can't control us. So they do the next best thing; they sit on our advice until it's too late. Even when the evidence is staring them in the face they deliberately misread it—witness the Falklands. We told them what was going to happen weeks ahead of the invasion. Did they listen?"

Hillsden poured more vodka. He had his listener's full attention now; Abramov liked nothing better than stories about Western incompetence and Soviet superiority.

"The truth is, Victor, today you are the masters, the originators; we are late reactors. It's the human factor; we don't breed people like you; we still recruit from the old-boy network—a friend of a friend of a friend, regardless of whether they have any real feel for the job in hand. The best you can say of them is that they're patriotic amateurs—fourth-division material playing in the top league. During the war, yes, things were better. Because of the need to survive, class barriers were lowered

and proles worked alongside university types as equals. But that didn't last. Come V.J. Day the old guard started to close ranks again."

"But they did recruit you, Alexi."

"I was in the game from the start, learning our trade the hard way, in the army, like you. They must have been delighted I came over; it proved their point, don't you see? I wasn't one of them."

"And now you are one of us, the best, among the elite. And if we're talking about perfection, there is only one perfect spy, and that is the spy who is never caught. How good it is to have these talks, to speak the same language. . . . How are your studies, by the way?"

"Coming along."

"Being at the University has made life more interesting, yes?"

"Definitely."

"I was right to take care of that, to push you. What of your little Galina?"

"She's fine."

"Your type, I think. Better than the one I chose for you before?"

"You sly bastard! What don't you know?"

"Very little."

Hillsden saw his chance: by now Abramov was well tanked and relaxed. "Okay, let me test you. What d'you know about a man called Kiprenski?"

Abramov squinted over his vodka glass. "Kiprenski? The name strikes a bell."

"He's a ballet critic."

"Ah, yes, I recall now."

"And a homosexual."

Abramov waved his glass. "No, it's not allowed to be a homosexual in Russia, Alexi. You know that."

"How stupid of me! I should have remembered. Forgive me."

"That only happens in the degenerate West."

"I sit corrected."

"What d'you want to know about him?"

"The other night Galina and I went to the theater and I met him. He was with a 'friend,' a British tourist."

"So?"

"A somewhat odd couple."

"Explain."

"Well, this critic, who obviously is not gay since he's an upright Soviet

citizen, seemed to be very familiar with this tourist—who could well be gay, since the degenerate British have a lower standard of morals. And it occurred to me that possibly we could make use of him."

"How?"

"Didn't you tell me to think as you do? So I found out which hotel he's at and made a point of bumping into him there."

"That could be dangerous, to be seen with a man like that. Did he know who you are?"

"I think so, but I had a good reason for taking the risk. I discovered he works in the London Passport Office, quite a senior rank, with particular responsibility for vetting applications from aliens. Now assuming I'm right, assuming he and this Kiprenski are a twosome despite its being forbidden, then he might be suitable material for blackmail. It would be useful, would it not, for us to run somebody in such a position?"

"What gives you the idea we would ever blackmail innocent tourists?"

Hillsden returned Abramov's grin. "Obviously that's just a wicked lie invented by our gutter press."

"Which hotel is he staying at?"

"The Evopeiskaya."

"For how long?"

"Until the end of the week. So if we move fast, and you provide me with the necessary, I could work on him. It would have more impact coming from me and give me a chance to dust off my old technique."

Abramov considered the proposition for a few moments, then nodded. "Yes. Why not?"

Two days later Hillsden was summoned to Abramov's office. "That matter you mentioned the other day . . . I hate to admit it, but you were right. It appears that there are Russian citizens who still indulge in forbidden practices. Very regrettable." He pushed half a dozen photographs across the desk. They showed Frampton and Kiprenski engaged in sexual intercourse and had obviously been taken by a hidden camera. Hillsden did not linger over them.

"I think maybe you should test his reactions to these. It's surprising how such photographs concentrate the mind. Tried and trusted methods are still the quickest, and since we don't have unlimited time I suggest you contact him today. He is in the hotel right now. I have had him kept there on a pretext, though he is unaware of the true reason. When you

get there simply produce your G.R.U. identity card to the man at the desk. He has already been told to cooperate."

On the way to the Evopeiskaya Hillsden thought, I wonder if I can go through with this? Do I have the resolve to intimidate an innocent? He found the unfortunate Frampton in the lobby trying to sort out disputed items on his bill.

Hillsden approached him. "Can I be of any help?"

"Oh, thank you. I don't understand what is wrong. Something to do with my travelers checks. My Russian isn't good enough, I'm afraid."

"Let me try."

Hillsden palmed his identity card and flashed it at the hotel official without Frampton's being aware of the action. In colloquial Russian he said, "I'll deal with this now. There is no further need for you to be involved."

The official bowed and Hillsden walked Frampton away from the desk. "I told him I will take care of everything. They always make a fuss when hard currency is involved."

"Thank you. I was getting worried. Lucky you came along when you did."

"Ah, well, I have a little influence. Do you have time for a chat?"

"That would be nice," Frampton said, "but I couldn't make it today. I have things planned. Unless you'd like to have a drink here?"

"I don't think that would be a good idea. As you realize, I have certain privileges that give me access to confidential information. You see, I didn't come to your rescue by accident. You seem to have run foul of the authorities, and I thought I would like to help."

"I thought everything was sorted out?"

"I wasn't referring to what just happened, but to something more important."

Frampton's expression changed. "How d'you mean?"

"Apparently you've broken some of their laws."

"But I've done nothing—not that I know of, anyway." His attempt at defiance carried no conviction.

"You formed a certain relationship, I believe. One has to be extra careful about one's choice of friends in this country. Believe me, you need my help. Better to deal with me than with the secret police."

"Police? Why would the police be interested in me?"

"Don't raise your voice. Just be calm. We can't discuss it here. Just trust me and come with me."

122

"To do that I have to cancel an appointment."

"Then cancel it. I'll wait here for you."

Frampton stared at him with a bloodless, pinched face, then went to a telephone. On his return Hillsden obtained a taxi and they drove to his apartment but did not go inside. Instead, Hillsden suggested they walk in the nearby park. "Just to be on the safe side. They have a habit of bugging rooms."

"Why would they bug your room?"

"Because they leave nothing to chance."

"Tell me what I've done. I've been on holiday, that's all."

"And how have you spent your time?" Hillsden asked.

"Sight-seeing, visiting museums, the theater."

"With the friend I met the other evening?"

"Yes."

They stopped and sat on a park bench. Hillsden produced the packet of photographs. "Perhaps your choice of a friend was not a wise decision." He handed the packet to Frampton. "I think you should see these, John," deliberately using his given name for the first time.

Frampton withdrew the photographs slowly and stared down at them, his face suddenly transformed.

"Oh, God!" he whispered. "Oh, dear God!"

"Now do you see what I mean?" Hillsden took back the envelope.

"What will happen to me?"

"That depends. The reason I wanted to have this talk was to put a suggestion to you. Because you're a fellow countryman, I interceded on your behalf and persuaded the secret police to let me deal with the matter. Obviously if these photographs got back to England and found their way into the wrong hands, you would lose your job—or worse. Equally, should you not go along with what I am going to suggest, your Russian friend will be punished." Even as he pushed fear into Frampton, Hillsden thought how easy it was to descend to this level, employing the same techniques blackmailers had always used. Yet the distaste he felt for what he was doing was stifled by his own needs; oppressors could always justify the means. "On the other hand, there is an escape route for both of you. In return for your performing a few minor tasks when you get home, I can guarantee that neither of you will be exposed. Debts of this nature always have to be repaid, don't they?"

Frampton nodded.

"You have a sensitive position in a government office, one you've

worked hard for with a good pension at the end of it. . . . It would be a pity to jeopardize all that." He paused, studying Frampton's face; the man seemed close to tears, and again Hillsden forced himself to elbow aside conscience. Softening his voice, he continued: "It's possible that in the future somebody may contact you and ask you to do certain favors in return for keeping your escapades here secret."

"What sort of favors?"

"I've no idea. You may never be called upon, for all I know. But they want to take out an insurance policy on you." Hillsden waited, letting this sink in. "For the moment all that will be required is for you to relay a message when you get back to London."

"A message?"

"Yes. Nothing complicated. Something you can easily learn by heart. That's not much to ask, is it?"

"Why should I trust them to keep their side of the bargain?"

"I don't know why. Perhaps because you have no choice."

"What happens to the photographs?"

"This particular set? Nothing. You can have them for all I care. The negatives are another matter. They are the insurance policy." He offered the packet again, and Frampton accepted it. "So the choice is up to you. Take a message or else face the probability of public disgrace. Do you have a family?"

Frampton nodded.

"You wouldn't want to bring this on them, surely?"

"It wasn't what you think," Frampton blurted, fingering the packet. "These only show one side of it." Now that he knew the price he had to pay, there was a hint of defiance in his voice. "But I don't suppose you understand my kind of love."

"You could be right at that," Hillsden said, rising from the park bench. "It's a dangerous game, love, whichever way you play it. Most of us are betrayed in the end."

11

HAD IT NOT been for the telephone call, Waddington would have thought it a normal Easter holiday weekend: the yearly carnage on the motorways, air traffic controllers on a work slowdown throughout Europe, the cross-Channel ferries on strike (with the usual protestations that the timing and inconvenience to the public were purely coincidental), and of course riots and killings in the birthplace of Christ.

He walked back from his local pub on Good Friday, having enjoyed a plowman's lunch and a pint of draught beer. His mood was reflective. Days like this made him strangely disoriented; they felt like Sundays, which he had always loathed, being nonreligious. When at home on Sundays during his marriage it had been his habit to get breakfast and take it to his wife in bed. Now he found it curious that he remembered those lazy occasions, when more often than not they had made love, with greater clarity than the rest of the time they had spent together. It was difficult to apportion blame or pinpoint the exact moment when any relationship failed, but in his own case he had no doubt that the Firm had been the cause and the effect. As with Alec's marriage, the deceits that were part and parcel of the job had rotted the very fabric of his marriage, just as termites burrowed unseen in the foundations of a house. Perhaps ordinary adultery would have been easier to conceal. He thought of their early years together with something approaching pain, punishing himself in retrospect for acts of indifference.

Inevitably, the predatory male mind being what it was, side by side with remembered regrets came thoughts of more recent events. Did he want to repeat the whole process over again, entering another person's life just because the old phallus dictated the momentary pleasure? He was aware of the sexual threat that Pamela posed, and though he had so far resisted contacting her again, he carried an image of her like emotional excess luggage. Alone at night he tried to analyze why he had not succumbed to her obvious charms at first bidding. After all, her body was the stuff chauvinistic dreams were made on, so what had held

him back? Was it merely a reluctance to become involved again, or had darker instincts surfaced?

These inconclusive thoughts occupied him as he walked home along old Beaconsfield High Street, an oasis of architectural calm that so far had escaped the ravages of the property speculators and that never failed to reveal new pleasures. For once the weather had exceeded seasonal expectations; a profusion of early cherry blossom topped mellow brick walls, window-boxed daffodils and narcissus graced the Georgian façades, and with the absence of traffic the whole street had a picture postcard quality.

The mood was shattered when once again he was greeted on his doorstep by the neighbor's cat, this time proudly carrying a half-eaten thrush and uttering those curious little cries that advertise a kill.

"You murdering sod! Don't you know it's a holy day?" Waddington said.

Inside the house he took a can of beer from the fridge, then switched on the television, flicking through the channels in a search for something to hold his interest. He found an old black-and-white Katharine Hepburn movie and settled down in an armchair. Only then did he notice the warning light blinking on his telephone answering machine. It was the first time it had been activated since his discovery of the bug. Waddington stared at it over the rim of his beer glass. Whoever was keeping tabs on him would presumably be ahead of the game. There was always the chance that the bug had been installed on the Captain's instructions; Waddington wouldn't put it past him since the machine was the property of Breakproof, every employee having one on loan, the Captain insisting they be on call twenty-four hours a day. The crafty old bugger was manic enough to have thought up something like that.

Waddington finished his beer before going to the machine. He switched the control to the answer-play mode and waited for the tape to rewind. After a pause, "You don't know me," a male voice said, "but I've just returned from a holiday abroad and I have a message for you from a friend." The words were blurted out as though the caller were under stress. "I was told not to trust it to the post, but to give it to you in person. So can you meet me? I will be in Harrods food hall on Tuesday at twelve-thirty. Look for somebody carrying the current issue of *Country Life*." The line went dead.

Waddington rewound the tape and played the message again. He could not place the voice, although he detected remains of a cockney

accent in some of the vowels. What friends do I have living abroad? he thought, pouring himself a second beer. And in any case, why contact me in such mysterious fashion? He eliminated the possibility of some elaborate joke; April Fool's Day had passed, and in any case none of the Captain's staff possessed that sort of imagination, their humor being confined to schoolboy smut and tiresome anecdotes about their Sloane Ranger girlfriends. Equally, it was hardly the sort of joke the Captain would play; he was too straitlaced for that. Could it be merely a boring hoax in the same category as an obscene phone call, some anonymous twit passing the time over the holiday weekend? He sipped his drink and pondered the mystery. A certain unease seeped into his consciousness. Various strands were looping together. Were they all unrelated, a series of coincidences, or did they add up to something yet to be revealed? He thought back to the luncheon with Keating, coming as it had out of the blue, yet forcing him back into the past, then the discovery that the house was bugged, and now this. Even the entry of the randy Pamela into his life now seemed loosely connected, or was he becoming paranoiac? One thing was certain: he was not the only recipient of the anonymous message. Whoever was monitoring his calls would have the same information. In turn that could mean that the message was meant to trap him. But trap him for what?

Katharine Hepburn and Cary Grant were struggling with a leopard as he took the problem back to his armchair. Who from his past would want to go to such complicated lengths? *I've just returned from a holiday abroad,* the voice had said, *and I have a message for you from a friend.* Life in the Firm had never been conducive to normal friendships, and since the break-up of his marriage he had not formed any new relationships, nor had he kept up with the old. Keating had been his only recent contact with that past shadowy world. He sat in the darkening room with a sense of foreboding. It seemed to him then, just before the effect of the beer closed his eyes, that possibly the only certainty left in the world was Hepburn's ageless beauty.

As Waddington pondered, an American Airlines flight from New York was just landing in Antigua, West Indies. Among the horde of white-faced tourists making their way across the hot tarmac toward the arrivals building was a man whose fame had been recorded in the deathless prose of the *Hollywood Reporter* over the past three decades. Born Mischa Rabonovich in Warsaw, he had changed his name to Mike

Raven shortly after emigrating to the United States. He had spent the first ten years in Chicago, establishing himself within the large Polish community there and gaining employment in the Marshall Field store. A diligent man, he quickly embraced the American work ethic and was promoted from the sales floor to the position of head buyer for the shoe department, and used the experience to build his own contacts. When he had saved enough capital he gave notice and opened his own shop, selling a range of cheap imported footwear that undercut the competition. Within three years he had a chain of ten shops scattered around the poorer districts of Chicago. Never one to neglect an opportunity for social advancement, he joined the local tent of Variety Club on the introduction of one of his major suppliers. It was in such company that he first became aware of the richer pickings to be made in the film industry. He listened and learned fast. For a comparatively modest sum he bought the film rights of a wildly salacious novel prior to publication, and the gamble paid off: it got onto the bestseller lists and three of the major studios were in the running to buy him out. Raven hired a lawyer and parted with the rights only on the condition that he be hired as executive producer, a title originally invented by Hollywood to pacify the egos of those who had money but no talent. Raven's lawyer also secured him a percentage of the profits. Since the subsequent film turned the basic dross into glossy dross, Raven found himself not only rich, but also accepted as a man who could pick a winner. He was given a three-picture deal, a suite of offices on the studio lot, purchased the obligatory mansion in Bel Air, was quickly trapped into marrying his secretary, a girl of headstrong qualities, and went from strength to strength, having learned the first time around that messages are strictly for Western Union. Four marriages and some score of films later, he was now a member of the Hollywood establishment—not on the A List, to be sure, but nevertheless a player. He had a true instinct for corporate necrophilia and knew where the important bodies were buried.

Raven's last wife had been the pick of the quartet. Sadly, she had died on the operating table a few months before his trip to Antigua. The purpose of his visit was to meet with two tax lawyers who needed to wash one of their client's undisclosed funds. Disgruntled that he had not been given V.I.P. treatment on the crowded flight and suffering from dyspepsia and dehydration, he made slow progress through the wall of heat. A long line had already formed at the two passport desks and the local immigration officers performed their duties in slow motion. When

after a delay of some twenty minutes he obtained his luggage, he was then required to open his suitcase. "Nothing. I got nothing to declare. No liquor, no cigarettes, no gifts, zilch."

"Open," the customs officer said, unimpressed.

Sweat dripped from Raven's brow onto his clean shirts as he complied. The customs man made a thorough search and came up with a small white vial.

"Be careful with that," Raven said.

The cap was unscrewed, revealing that the vial was filled with a greyish dust. The customs man sniffed at it.

"What is this?"

"Well, it ain't drugs, if that's what you're thinking." Raven glanced around, then lowered his voice. "If you must know, it's my late wife's ashes. We used to come to these islands for our holidays, and she expressed a wish that I scatter her ashes here—a sort of sentimental gesture, you might say."

The customs man looked dubious and seemed about to tip the ashes into his palm.

"If you lose any, I'm gonna sue you." Raven barked. "Have some respect for the dead."

Raven's tone, and the fact that the customs man was out of his depth, persuaded him to give Raven the benefit of the doubt. The cap was screwed back on the vial and returned to him.

Outside the heat pushed against him like an angry, restraining hand. After an argument about the price he secured a taxi and was driven off to his hotel.

In contrast to many of the hotels dotted around the island, Curtain Bluff had been an oasis of luxurious calm for twenty-five years, and Raven was greeted as an old friend by the long-serving staff. He was quickly shown to his suite, where high ceilings and revolving fans cooled the marble floors.

"I'm meant to be meeting a couple of guys here. D'you know if they've arrived?"

"What names, Mr. Raven?"

Raven consulted his bulging Filofax. "Ruddock and Grunwald."

"Oh, yes, they got in last night. I daresay they're on the beach. I'll have them paged and tell them you're here. Can I get you anything?"

"A Jack Daniel's on the rocks, and make it a double."

Raven unpacked his suitcase, putting aside several copies of the

screenplay he hoped to hype. The vial containing his wife's ashes he placed in the room safe.

Having changed into casual clothes, he sat on the balcony and waited for his drink to arrive. All the suites overlooked the east beach where the surf pounded continuously. As though alerted of his occupancy by some mysterious radar, small, cheeky birds fluttered fearlessly across his balcony in their quest for tidbits. Far out to sea a four-master made stately progress. Raven nursed his drink, grateful for a chance to relax and collect his thoughts. The sweat dried on him in the sea breeze and, as often happened when he was away from Hollywood, he wondered why he did not give up the rat race. The castaway syndrome of island living always beckoned on the first day, but he knew himself too well. Cut off from his battery of phones, denied the trade papers, left out of the day-to-day in-fighting, he would soon be stir crazy.

When eventually the two lawyers showed up, Raven was disconcerted to find that they were both in their twenties. Youth in general made him ill at ease; youth allied to business deals positively alarmed him.

They were equally thrown by the fact that Raven immediately launched into a somewhat maudlin account of his wife's recent demise. "My late bride and I used to come here every year. A sort of annual honeymoon."

They winced.

"Matter of fact, I've got a duty to perform this trip. I brought her ashes with me. She always wanted this to be her last port of call."

"Gee, that's really nice," Ruddock said.

Grunwald said, "Where are you going to—" He searched for the appropriate words. "That is, how d'you go about that, sir?"

"I thought down there on the beach," Raven said, unaware that the two young men were having difficulty keeping a straight face. "Perhaps you'd both care to witness the ceremony? I thought I'd do it tomorrow morning before breakfast."

"Our privilege," Ruddock replied after the briefest of pauses. "Right, Bob?"

"Wouldn't miss it."

"I appreciate that," Raven said. "Okay, let's get down to business. Have you two done your homework?"

Ruddock assumed the role of spokesman. "We've prepared this memo for you to look over. Basically there are certain advantages for our client setting up a corporation on this island. No income tax and

a ten-year honeymoon on profits. But naturally he would want certain safeguards built in."

"What line of business is he in?"

"He'd prefer to keep that confidential, sir, but I can assure you he's a man of substance and that the necessary funds are available."

"Do you have a budget figure yet?" Grunwald interjected.

"I've got a guesstimate," Raven said, using the normal film industry parlance to denote that he was keeping all options open. "I can give you the below-the-line, but the above-the-line depends on which stars we eventually cast."

"You have a director, though?"

"Yeah. I've got Zev Winter on hold."

"You'll have to forgive me," Ruddock said. "I'm not a great film buff. He's good, is he?"

"He made *Terminal Rider,*" Raven said, as though that settled the matter. The two lawyers looked blank. "Took in nearly thirty-eight million in rentals."

"It was a profit maker, in other words?"

"You bet your ass. Only cost seven." Raven went to the spare twin bed where the scripts were laid out and gave them each one. "This is the latest draft of the screenplay. Still wants a dialogue polish, but I got somebody lined up for that. No point in wasting money until we cast it. Like when we cast it, whoever plays the lead is going to want changes. Or his fucking analyst is going to want changes. We're getting screwed by talent. Suddenly they're all Warren Beattys."

"As far as our client is concerned," Ruddock said, "you could shoot the New York telephone directory. All he's interested in is the bottom line. In return for providing the financing—subject to normal guarantees, naturally—he wants to come out in first position on the gross until double negative, then split the rest seventy-thirty in his favor. You make the deals to fit in with that. No creative bookkeeping and we countersign all checks."

"Oh, and by the way," Grunwald chimed in, "once the final budget's been agreed that's it. Any overage comes out of your fee."

Raven made no comment, but his brain was already working like a calculator. The terms were tougher than he had anticipated, but he could work around them. If he had to wait for double negative before he saw any piece of the gross, he would pad his own fee up front and steal from a dozen different items in the budget. These two guys might

think themselves smart, but they'd have to get up very early in the morning to put one across on him. He knew fifty-eight ways of skinning any cat.

"How does that sit with you, sir?" Ruddock asked.

"I can live with it. It ain't chopped chicken liver, but I'm a realist, gentlemen. One thing you should know, whether you read the script or not: we've got a sequence in there that has to be shot in Russia. How does that grab you?"

"I don't see any problem. I take it the script isn't anti-Russian?"

"No, just a love story. Do yourselves a favor—read it."

After another short discussion about the casting Raven had in mind, the meeting broke up. Arrangements were made for them to meet on the beach the following morning. After a meal and before turning in, Raven checked that the ashes were still in the room safe, took a laxative and put in an alarm call. A cool sea breeze penetrated the mosquito netting, but it was still too hot for sleep and he lay naked on top of the bed, studying the memo they had left with him, his eyes going straight to the fine print: it took a con man to know one. Whoever had drawn up the document had done his homework, but Raven spotted a couple of loopholes he could covertly exploit. He read it twice before fatigue and the sound of the surf closed his eyes.

As arranged, Raven met the two lawyers on the empty beach; though he was irritated that they were both wearing tennis clothes; it seemed irreverent for the occasion. They all walked barefoot across the damp sand to the water's edge while crabs scuttled for the safety of their overnight holes. Blackened coconuts, looking from a distance like severed human heads, rolled backwards and forwards in the spumed waves. All too late it occurred to Raven that perhaps he should have prepared a few words to mark the occasion. He dimly remembered snatches of dialogue from a funeral scene in one of his films, but felt incapable of quoting them. The vial of ashes clutched in his hand, he hesitated at the water's edge, then was forced to retreat as a large wave crashed on the beach. Stumbling, he lost his footing and dropped the vial. Grunwald rushed forward and retrieved it before it washed out to sea, and the scene took on some of the elements of farce.

Ruddock helped Raven to his feet and brushed the wet sand off his back. "We both had a look at the script," he said in desperation, "and we enjoyed it, didn't we, Bob?"

"Yeah, got some good stuff in it. I'm no expert on these things, of

course, but I liked it." After wiping the vial dry, he handed it back to Raven.

"My late bride was my best critic," Raven said, "and that script was the last thing she read. She said, 'Daddy, you've got to go with this one. Run with it.' "

"Well, a woman's instinct is not to be ignored."

"She was a lovely lady." He unscrewed the vial and approached closer to the water's edge. "I wish I had the right words for this occasion, gentlemen; but not being a religious man, you'll have to excuse me."

"I'm sure your bride would understand," Ruddock said helpfully.

Raven poured the ashes into his cupped palm and prepared to do the deed, but his pudgy arms hardly extended over the tideline, and it was obvious to Ruddock and Grunwald that the symbolic event was courting tragedy.

"Perhaps if you stood on those rocks," Ruddock suggested. But he was too late. Raven's pitching arm had not been put to any major test other than the signing of checks, and as he made a feeble gesture skywards a sudden gust of wind blew off the sea and returned the ashes back at him. He staggered drunkenly as the gritty remains of Mrs. Raven filmed his face and clothes.

"Jesus!" he shouted, turning in agony. "I got 'em in my eye!"

"Don't rub it," Ruddock said. "Let's go back to your room and get some drops." Grunwald, whose powers of resistance were minimal, fought a losing battle with hysteria. He produced a handkerchief as though about to offer it to the stricken Raven, but instead clapped it over his mouth. Neither of them could look at each other as they helped Raven up the sandy incline.

The damage repaired, Raven recovered some of his customary chutzpah over breakfast, even to the extent of making a mild joke at his dead wife's expense. "She was always the clinging type, my bride."

"I wouldn't feel too badly," Ruddock said. "It's the thought that counts."

"You're right. So let's talk turkey. I've done all my deals on a handshake; that's the way I operate. You legal boys usually want to make a meal of it, but I'm ready to sign a heads of agreement and get the show rolling. Just give me your top figure and I'll work toward it."

It was a ploy he had often used in the past: get the other side to commit to a price, then make sure that he padded the budget so that it came out just under their maximum.

133

"I think," Ruddock said, spooning an overripe papaya, "our client would prefer to have sight of *your* budget first, then decide whether it's too rich for him. That's how we've been briefed."

His first bluff called, Raven tried his alternative. "Well, tell him he's gonna lose it if he pussyfoots around. I got Warner hungry for this script, but I've been holding them off. Can't you give me his name?"

"No disrespect, sir, but our instructions preclude that."

They're fronting for Mafia money, Raven thought, having over the years learned to smell out laundry deals. So what? Everybody had an obligation to screw the I.R.S. if they could get away with it; it was virtually written into the Constitution.

"When you think you can come up with a final budget?" Grunwald asked.

"I got my people standing by. Soon as we get through here, I'll get them working on it. Too bad we can't finalize it now."

"Yes," Ruddock said, "but none of us wants to make a mistake, do we?"

They left immediately after breakfast, but before catching a flight to New York they called London from the airport to give a progress report to their client.

"I wouldn't say our Hollywood friend is somebody I'd buy a second-hand Chevrolet from; but when he agrees to your terms—as I'm certain he will—I think we've built in sufficient safeguards to protect you all the way, sir."

"Fine. Sounds like you did a good job. Keep me posted."

"Rely on it, Mr. Keating," Ruddock said.

Adopting a fatalistic attitude, Waddington made no attempt to cover his tracks when he set out for Harrods on the appointed day; he calculated that whoever else was aware of the arrangement would be in position inside the food halls before he arrived and that any complicated subterfuge on his part would be a waste of time. He entered Harrods well before half past twelve, choosing the side doors nearest to the cosmetics department. A demonstration of the latest rejuvenating cream was in progress, and he edged his way past a crowd of blue-rinsed matrons intent on sampling one more elixir that promised to retard the ravages of time.

The plan Waddington had decided upon was not to make immediate contact with the messenger, but merely to observe him at a distance in

the first instance. He made a couple of small purchases for appearance's sake, noting any faces that he saw more than once, then began a casual circuit of the various halls, cursing the stupidity of his unknown caller for choosing such a vague rendezvous. The lunch hour had brought in hordes of shoppers from neighboring offices, and in places the crush made his task impossible. After ten minutes he had failed to spot any likely suspect and was inclined to believe that it was a hoax after all. It was then, through a gap in the crowd, that he caught sight of an anxious face standing by the bread counter. At first glance there was nothing out of the ordinary about the man; in fact the very reverse. He seemed to epitomize the average: average height and build, average two-piece suit, neat collar and tie, suggesting somebody in a sedentary occupation. Before the crowd obscured him again Waddington saw that he was holding a copy of *Country Life*. Even at a distance he could make out the cover photograph—a large hare—which he had already checked was the one on the current issue. Convinced by this and by the fact that the face above the magazine was pinched and anxious, Waddington made no abrupt move but, keeping the man in view, eased his way to another vantage point. He had to assume that both of them were under surveillance. Now he changed direction again, this time walking straight for the man to give the impression that he was about to make contact, all the time watching for any untoward movement in the crowd. At the last moment he veered to one side, and his efforts were rewarded: two men suddenly elbowed a passage through the shoppers and with obvious intent bore down on the scared messenger. Then things happened very quickly. The two men were impeded by a stout old party laden with parcels whom they sent crashing to the floor, scattering her groceries. A bowler-hatted man of military bearing reacted, blocking their progress and remonstrating with them for their loutish behavior. The two men attempted to push him aside, but he was made of sterner stuff and a scuffle started. Two security guards appeared and helped tackle the assailants; in the struggle several glass stands were overturned and jagged shards of glass flew in all directions. Displays of cookies and iced cakes collapsed, and to his horror Waddington saw one of the security guards stagger backwards and fall, a sudden spurt of blood staining a large wedding cake with the word "Congratulations" piped on it. Women shoppers were screaming and fighting to reach the nearest exit as alarm bells were activated. In the mêlée the panicked messenger made good his escape, pushing through the crush close to Waddington, close

enough for him to grab at the man's arm as he passed, spinning him around. The messenger struck out blindly, hitting not Waddington, but an elderly man in the face and smashing his John Lennon spectacles. The copy of *Country Life* dropped at Waddington's feet and he bent to retrieve it. Off balance, he was knocked to one side, rolling over several times to avoid being trampled on. When he picked himself up the messenger had disappeared and the food hall was emptying. The security guard lay in a pool of blood and white cake, for all the world like a seal killed on the ice. The fight with the two hit men seemed to be continuing in another part of the hall, for he could hear shouting in the distance. Now two policemen ran in, one pausing by the fallen guard, the other heading toward the noise of the fracas.

Waddington made his own escape, still clutching the magazine. He left by the Brompton Road exit, scanning the street in both directions, but the pavements were crowded with the curious and the scared—word of trouble always traveled fast—and he could not spot any trace of the messenger. A police car bringing reinforcements screamed to a halt, and Waddington took advantage of the stalled traffic to dodge across the road and into a café. He selected an empty table near the window so that he could observe any developments.

"What's happening over there?" his waitress asked as she took his order.

"Seems to be something going on at Harrods."

"Lot of police. Hope it's not another bomb. D'you want a pastry with your coffee?"

"No, thank you."

"You can't have coffee on its own."

"Well, bring me a croissant."

"We're out of croissants." Even the possibility of a bomb could not keep a note of satisfaction out of her voice as she imparted this news.

"Okay, *you* choose something—a Danish, anything."

He watched other police cars arriving, then realized he was still holding the magazine. Flicking through it, he came across a single sheet of lined notepaper tucked inside the center pages. Written on it in neat script were some seemingly unrelated words suggesting a list of reminders.

Lenin
James/Aspern papers

136

Imperative
No contact wine

Waddington stared at the list while buttering his Danish, totally baffled;
nothing made immediate sense. A flake of fresh pastry fell onto the note,
staining one corner. The only certainties were that now he knew the call
had been genuine, that his telephone calls were being monitored, and
that somebody had been anxious to get to the courier before he did. The
man had obviously been scared off and was unlikely to contact him
again. Sipping his espresso, he studied the list again, trying to decide
whether the words represented a code. He jotted down all the capitals—
L-J-A-I-N—but could make nothing out of them: the solving of acros-
tics had never been his strong point. The only item that seemed to be
intelligible was the reference to *The Aspern Papers*. Although his literary
education had been nothing like as catholic as Alec's, he had studied the
Henry James novel as part of an English course at college. The interven-
ing years had dimmed his memory of the plot. He lingered over his
coffee until, in the best tradition of British café society, his waitress made
it obvious that he was outstaying his welcome. A bunch of suburban
matrons were already queuing for lunch, all chattering like linnets about
the Harrods incident. Waddington waited in the doorway of the café
until he spotted a passing taxi, then dashed out to flag it down. As an
extra precaution he did not return to the Breakproof offices, but instead
had the taxi drop him off in Kensington High Street. From there he went
into the Royal Garden Hotel and called his secretary from one of the
public phones.

"If our fearless Captain asks where I am, tell him I'm chasing new
business out of town."

That done, he took another taxi and retrieved his car from the under-
ground garage at Marble Arch. But before going home he made a second
detour and stopped at the local bookshop.

"*The Aspern Papers*? You should find it in the Penguin rack, under
'classics.' "

Waddington searched as directed. "No, it doesn't seem to be here."

"Oh dear, has she gone again?" the proprietor said. He was a middle-
aged queen, sometimes given to fits of temperament and very choosy as
to who he was nice to. "Can't keep everything in stock all the time. Very
popular these days, our Mrs. James. She's having quite a little surge.
Shall I order it for you?"

"Yes, if you would. How long will that take?"

"I don't write horoscopes, dear. Depends whether I've paid my fucking wholesaler's bill this month. I'll try for the end of the week, but I can't promise."

"I don't suppose you remember the plot, do you?" Waddington asked.

"Can't read her, dear, never could. Boring as watching paint dry."

Waddington knew better than to pursue the subject. "Well, do your best."

The chewed head of a mouse greeted him on the doorstep when he arrived home. He kicked it into a flowerbed before examining the front door: he had used the old trick of fixing a hair in place before leaving that morning. It was still intact.

Once inside, he searched his own bookshelves on the chance that he might have a copy. He found a dog-eared paperback of *Washington Square,* but no *Aspern Papers.* Frustrated, he poured himself a large malt whisky and drank it neat while waiting for the bath to fill. Immersed, he soaked until his skin started to wrinkle, trying to fathom the significance of the note and to recall the plot of the elusive novel. He could vaguely recall that it was concerned with a missing manuscript. Michael Redgrave had once dramatized it, and although he had seen the production, he could remember little except Redgrave's performance and the fact that it was set in Venice. Was that a clue? Venice. Do I know anybody living there? Somebody called James, perhaps? Nobody that came readily to mind. I knew a Jim Bishop once, but he died years ago. What else was there? Lenin. Try word association. Russia, revolution, Highgate cemetery—no, wrong, it's Karl Marx who is buried there— Moscow, Red Square, the tomb? Why doesn't my brain work any more? he thought as he reached for a towel and stepped out of the now tepid bath. He said them again, staring at his reflection in the mirror, willing something to prompt his memory. Of course there was always the chance that the note had no connection with the telephone call. Perhaps it was just an innocent shopping list, left in the magazine by accident. Except for the word *Lenin,* which touched a chord.

Clad in a dressing gown, Waddington went downstairs and started to prepare some spaghetti (his only accomplishment in the culinary arts), opened a bottle of reasonable Chablis and was reminded of the time when the Firm had used the wine trade as a front. They had stocked only plonk, but at least he and Alec had managed to help themselves to a few crates before the bloody stuff reverted to vinegar. He poured

a tin of ready-made tomato sauce over the slightly overcooked spaghetti and recalled with nostalgia the meals his ex-wife had put before him. Twisting his fork into the sticky concoction, he wondered how she was finding rural life, and this train of thought led him back to Pamela. Maybe, since the house is bugged, I ought to reconsider her offer to move in, he mused. It would have definite advantages in many ways, and certainly I'd eat better.

Looking up at a slight sound, he found the cat staring in at the kitchen window. The animal's mouth opened as it gave a plaintive, unheard cry. "Piss off, you murderer," Waddington shouted. Suddenly his cooking revolted him and he scraped the remains into the sink before retiring into the sitting room to draw the curtains and switch on the television. He looked for that day's newspaper to see if there was anything worth watching. It was then that his eye went to the copy of *Country Life* again; for the first time he noticed a small white subscription label pasted on the back cover. He picked it up; the label, although torn at one corner, had a name and address printed on it that were still legible: *J. H. Frampton, 194 Cranmer Road, Forest Gate, London E7G 4QP.*

Waddington stared at it, unable to believe his luck. Nobody but an amateur would have overlooked such a damning clue. Wait, though, he cautioned himself. Don't celebrate too soon. What if by finding this you are drawn further into a trap? Think it through before you jump. He sat down to consider new options, while outside the cat hunted smaller prey.

12

"NOW, THERE'S A funny thing," Pearson said, munching on a takeout pizza crust, then wincing; he had bitten on a dodgy filling, and the pain shot up his cheek to behind his right eye. He had already canceled two dental appointments; there never seemed to be time for body mainte-

nance, and as the years advanced he frequently chided himself for the neglect. If it was my car, he often thought, I wouldn't hesitate to have a rebore and antirust treatment.

"I've got to get this bloody tooth fixed," he said to Lloyd.

"How about trying a thread tied to the doorknob? My granny used to swear by that. Of course, she wrecked a number of doors."

"Yes, and Sherlock Holmes solved all his murders with a magnifying glass."

"What did you start to say, Chief?" Lloyd asked. "You said something was funny."

"Did I?" Pearson tossed the rest of the pizza toward the wastebasket. It fell short, and as he bent to retrieve it his kneecap creaked. "And don't get me any more of those inedible Frisbees. I think I've been chewing on the wrong tooth where Mitchell's concerned—sorry, I've got dentists on the brain at the moment. We took it as given, did we not, that he must have been a K.G.B. plant, a classic case of infiltration into a very sensitive area that always presents an attractive target to them? A strange little character, given to some quirky ways of self-amusement, if not self-abuse—witness Exhibit A, certain items of women's underwear—who suddenly gets himself blown apart by a sophisticated bomb in Hyde Park."

"But not before he's been shot," Lloyd interjected.

"Exactly. No discernible motive and no trace of the killer. Subsequently, and purely by luck, we discover his hideaway, which gives us a little more to go on. Exhibit B, a radio, miniature camera and a codebook—the *Reader's Digest* do-it-yourself kit for spies, right?"

Lloyd nodded.

"Now then, you would think, would you not, given the hysteria that normally surfaces whenever G.C.H.Q. is involved, and given the fact that Mitchell was patently not a Boy Scout spotting train numbers but had to be collecting highly secret information for somebody, that our friends in MI5—and, indeed, in MI6, for that matter—would be shitting themselves? Instead, it could be eleven o'clock on Armistice Day. Apart from you and me, not a mouse is stirring. All is quiet. That's what puzzles me."

Staring at Lloyd, he gently moved his tongue against the offending tooth, masochistically testing his tolerance.

"How come the awkward questions have stopped being asked in Parliament? By rights it should be obvious cannon fodder for a dispir-

ited Opposition. Why no embarrassing documentaries on television, no investigative journalists sniffing around? Mr. Mitchell has somehow become a nonevent. Why?" Suddenly he picked up a phone and buzzed somebody in the outer office. "Sarah? Oh, Lucy, sorry, do me a favor. Get hold of the yellow pages, look up "D" for dentists and pick one, any one, within half a mile of here. Tell them it's an emergency and get me an appointment. . . . Now, as soon as possible. Ring me back when you've fixed it."

Lloyd said, "It's certainly odd."

"Odd it certainly is, my dear Watson. Didn't Holmes suffer from toothache?"

"He played the violin and took opium, that's all I remember."

"I'm beginning to detect the whiff of corruption in high places. What makes me think that?" Lloyd was silent. "Ask me."

"What makes you think that?"

"Pain has a way of concentrating the mind, and I was up all night with this bloody tooth. If—and notice I stress the word *if*—Moscow planted him, why did they use somebody handling their own traffic? Doesn't add up—not much mileage in stealing from yourself, is there? *Unless* you need to know how that material is being interpreted at this end. Perhaps the whole exercise was to feed *dis*information. How does that strike you?"

"Plausible."

"But not watertight. If that had been the case, then all he had to do was decode it and pass it over. No need to smuggle anything out. He could go home at night, feed the dog and put on his bra and panties with nobody the wiser. But that isn't what he did. He took elaborate precautions to conceal his true persona. It was only by chance that man's best friend led him to us. So that must lead us to the conclusion that he was also feeding the same information to somebody *else,* presumably somebody who didn't normally have access to it *or didn't want to reveal that he had access to it.* Subtle difference. Then if you take it one step further, take it to a logical end, Mitchell's secret task was to translate coded phony information but give his unknown contact the real stuff."

"You should have a toothache more often," Lloyd said, impressed.

Pearson massaged his reddened cheek with the back of his hand. "Oh, I'm not there yet, but I've got a gut instinct I'm on the right track. And I act on the principle of never trusting anybody."

"Not even me?" Lloyd sounded hurt.

"Never trust anybody who has the power to alter your life. You shouldn't trust me blindly."

Lloyd was bewildered now. "How d'you mean?"

"Because we've never been put to the test. Would I save you from a burning building, or would I save myself? We don't know, do we? I'm kidding. I'd probably throw you a fire extinguisher. What I'm really saying is that the human mind is capable of being bent every which way, so never take anything for granted. Let me give you an example of how the criminal mind really works. Way back when I was in the C.I.D. we were after a forger. He was passing brilliant ten-pound notes—the old large variety, you wouldn't have seen any, before your time. The genuine articles were beautifully engraved on top-quality paper, real works of art, not the Monopoly money we handle these days. The counterfeits were works of art, too; they needed a real expert to detect them. They kept turning up for about two years, always in the same area, one at a time. We finally nabbed him by chance; his house caught fire and we found all the gear. Know what? He was a master engraver in his own right, and it turned out it took him a week to forge a single tenner. If he'd been legit and followed his trade, he could have made fifty quid a week, but instead he made just ten. That's the criminal mind."

"Yeah, fascinating," Lloyd said, "but what's that got to do with trusting you? You've worried me now. I thought we were talking about Mitchell."

"We are, we are, but all we've done so far is skim the surface. We know a bit more about him now than when he first landed on Hogg's table, but we don't know what made him tick. Or who he was ticking for." He broke off and clapped a hand to his cheek. "Christ, this sodding tooth!" He turned away from Lloyd until the pain streaking toward his eye subsided. "Terrorism isn't just bombs, Lloyd, old son. Not just blowing innocents to pieces or opening their skulls with a sniper's dumdum bullet. There's another variety, perhaps the worst kind, whereby you don't kill them outright but do it slowly, take away their power to think and act for themselves. Ever been behind the Iron Curtain? I have. Of course, that's not a term used much these days—not fashionable. We have to go along with the pretense that things are getting better in Warsaw, Prague, Budapest. We're meant to forget things like the Gulag; it's give-them-the benefit-of-the-doubt time. Just like there was once a fan club for Mussolini because he made the trains run on time. But it's all bullshit, a bit of mind bending."

"You've never come out with all that before."

"Haven't I? Well, maybe I'm getting more bloody-minded and reactionary in my old age. You think it couldn't happen here? It already has, because we British are so slow on the uptake. Both of our glorious political parties have been playing dirty for years. Turn up any carpet in Whitehall and you'll find hidden Tory dirt and hidden Labor dirt mixed together. Indistinguishable."

The phone rang and Pearson picked it up. "Good girl. Remind me to put some champagne behind your ears one of these nights. Give me his name and address." He wrote the details on a pad, tore off the page and replaced the receiver.

"I've got an appointment around the corner in ten minutes' time. Walk with me."

They left the office together, Pearson remaining silent until they were out in the street.

"Who do I think killed Mitchell? My guess is that somebody on our side arranged it, some dirty tricks operation; hence the deathly silence. I can smell it."

"When you say 'somebody on our side,' who are you thinking of?"

"Could be any one of ten outfits. There are wheels within wheels within wheels in the espionage game. What was it that joker wrote?"

"Which joker?"

"That old age pensioner, Peter Wright, who lives in Tasmania and wrote his memoirs. He admitted that in his day they burgled and bugged their way across London. He should have added 'buggered' for some of them."

"But casual bugging was made illegal. The Secretary of State has to give his authority now."

Pearson gave Lloyd a pitying look. "Providing the Secretary isn't looking to get even with somebody who's crossed him. Going back to Mitchell, quite a few people would be interested in a cipher clerk at G.C.H.Q. handling Russian traffic while he was alive. What we have to find out is who wanted him dead. What secret died with him? So in the interests of pushing things along faster, I'm inclined to think we should start looking for another mole burrowed in high places. Dirty opponents require dirty tactics. It's time we committed a few professional fouls ourselves."

He glanced at the address on the piece of paper as they turned the

corner. "I have a conspiracy theory for most things that happen to and around us. I believe in Manchurian candidates."

They arrived outside the dentist's surgery and Pearson studied the nameplate by the door. "I want Dr. Amid. Yes, here we are."

"Sure you don't want me to come in and hold your hand?"

"I'm past cowardice. I'll see you back at the office. Mull my theory over and pick holes in it."

Pearson went inside. The receptionist showed him into the waiting room, where the only other occupants were a woman and a small boy fighting back tears. Pearson smiled sympathetically but got no response from the child.

"This lady has very kindly said you can go ahead of her son. Dr. Amid will be ready in a minute."

"Thank you."

"Are you having your treatment done on the National Health?"

"I can never remember my number, but don't worry, I'll pay cash. Right now, the way I feel, I might make over the deed of my house." He sat down opposite the small boy and winked encouragement, again drawing no response. "Very kind of you to let me go first. Don't worry: dentists don't hurt these days." Tears formed in the boy's eyes as he looked away.

A moment later Pearson was called into the surgery. He sat in the chair, rinsed his mouth, and leaned back. Dr. Amid was a slight man of indeterminate age, assisted by a young Asian nurse.

"Now, then, Mr. Pearson, isn't it? What seems to be the trouble, sir?"

"I would like you to take a gun and remove this tooth."

"Oh, we don't go in for such drastic measures. Let us have a look."

Dr. Amid probed around the sensitive area. Pearson bore the examination with fortitude. "Yes, yes. Well, Mr. Pearson, we don't seem to have taken great care with our teeth, do we? It is a shocking sight, your mouth. How long since you last paid a visit to a dentist?"

"My work keeps me very busy."

"Not a good excuse, sir, if you don't mind my saying. But I think we can do something. This is painful, yes?"

"Yes."

Dr. Amid spoke softly to the nurse, and she prepared an injection.

"What is your work, sir?"

"I'm a security officer."

"A valuable contribution, I am sure, to our troubled society, but you

should be more secure about your teeth. This won't hurt; you will just feel a little sting."

He gave the injection expertly. "Now, what I am doing is to remove the old filling and see what is under. It might be that what we find is not happiness. It might mean that I must ask you to come again and I will have to perform a root canal. This is a dying tooth, oh yes. We must work quickly."

Dr. Amid had the high-speed drill in his hand, and once the injection had taken hold he commenced the exploratory work. Pearson braced himself for pain that never arrived. Gradually he relaxed his grip on the arms of the chair, and it was while Dr. Amid worked with delicate skill that his thoughts returned to Mitchell. If he was right, he would need to extract the truth with the same delicate touch, working perilously close to the nerve ends of the corrupt world it was his duty to protect.

Corruption was second nature to General Geichenko: throughout his early life he had been conditioned to find it in every aspect of human behavior; without it the system would have collapsed. Now he was in a position to root it out and get even. He never missed an opportunity to pay off old scores, reserving his special energies for acts of revenge against the K.G.B. Just as the German High Command had always despised the S.S., so Geichenko, an army man, nurtured a hatred of his father's executioners. Nothing gave him greater pleasure than to sabotage their efforts in the operational field, which was why he derived such satisfaction from the way in which their British plan, once the K.G.B.'s brightest achievement, was now floundering.

"The arrogant bastards can't make it out," he boasted to Abramov, whom he treated as a confidant. "They thought they had it made there. All sewn up. Very soon, if they don't get results, heads will begin to roll. We're going to see a few exiles leaving Moscow."

In appearance the general was not unlike that fine Austrian actor Oscar Homolka, who always portrayed Russians in Hollywood spy dramas, but he had none of Homolka's natural charm. Some men emerge from long years of deprivation and the constant proximity of death with their character changed; some achieve a kind of saintliness; others stumble from the darkness with their sense of reality forever distorted; others still are mad with much heart. But some, like Geichenko, remain sane and survive on the adrenaline of hatred, spending

the rest of their scarred and truncated lives hunting down those they consider responsible.

Abramov knew some of this but was astute enough never to probe his superior. The general did not welcome inquiries about his past; nor, unless roaring drunk, did he ever volunteer such information, and Abramov retained scant recollection of such occasions for the simple reason that he had usually passed out, being no match for the general's capacity to absorb alcohol.

By skillful maneuvering Geichenko had brought Hillsden under G.R.U. control, knowing full well that his K.G.B. counterparts in Moscow Center responsible for running London would suffer as a result. The center had always considered London its exclusive territory and felt that Hillsden's past connection with Caroline Oates gave it a prior claim to him. Geichenko had spiked their guns. Likewise, he was entirely satisfied with his protégé's handling of the final episode in the Hillsden affair. Abramov had displayed a positively Machiavellian skill in the way he had disposed of the man known as "Jock" Calder. Geichenko could not have done better himself, which was the highest praise he could bestow. To have convinced Hillsden that he was justified in killing Calder was a masterstroke, and the beauty of it was that should questions be asked at some later date, the department would be in the clear: the liability of Calder removed, Hillsden bound forever by guilt and their own hands spotless.

Now, again due to Abramov's skills, they were poised to bring off an even bigger coup.

It took Waddington the best part of a week to decide on his next move. Since the episode in Harrods, he had taken certain basic precautions: varying his normal routine by leaving the car in the garage and traveling to work by train; at lunchtime making a point of joining some of the other salesmen (previously he had avoided social contacts); on two occasions, instead of returning home, checking into cheap commercial hotels. When in his own house he slept in the spare bedroom, the entry to which he booby-trapped. Renewing an old underworld connection, he obtained a gun that he kept loaded by his bed. On the pretext that his nonexistent wife was receiving obscene phone calls, he had his telephone number changed. Now, as far as he knew, only the Breakproof switchboard had the new one, which narrowed the field. He felt he was in harness again as he began to shape more subtle plans. Calling on a

favor still owed from his time in the Firm, he contacted a friend, Commander Pearson, and had Frampton checked out. The word came back swiftly: no previous record, nothing known.

Waddington's bookseller duly produced a copy of *The Aspern Papers,* and he reread it, confirming that the plot concerned a missing manuscript. Gradually the scrambled clues in Frampton's note began to assume a shape. He tried them in a different order. If "Lenin" equaled Russia equaled the location and the James novel established the existence of a manuscript, then the next word "imperative," could either denote urgency or be linked to the final clue, "no contact wine." Was it "imperative do not contact wine"? The inclusion of "wine" stymied him for a long time, though later he reviled himself for being so dim. He woke one morning after a long, wounding dream about the old days, and the possible answer was miraculously there. He could not believe his own stupidity. When he and Alec had been together, their cover had been a bogus wine company. It was only now that the possible truth entered his consciousness. More than anything else it was the literary association that convinced him he was on the right track. It would be typical of Alec to have included the Henry James gambit.

In all probability the four clues had merely been set down to remind Frampton what he had been charged to deliver in more detail. Taking it step by step: (a) Alec was in Lenin's homeland; (b) there was a manuscript in existence; and (c) it was *imperative that nobody in the Firm be contacted.* Well, I'm no longer in the Firm, Waddington thought, and I'm certainly not about to contact anybody there. How and why the as yet unknown Frampton had been chosen as the messenger boy remained to be discovered. Somehow, despite the risks (and it was obvious from what had taken place in Harrods that risks were present), Frampton had to be tracked down and made to give the full story. Waddington considered the options, then made a decision.

He rang Pamela. "I want to apologize for my previous crass behavior. Either I'm going through the male menopause or else I'm deficient in vitamin E, but I really feel very badly about the other night."

"Apology accepted." Her voice still had a chill in it.

"Can I make belated amends and give you dinner? I promise I'll only eat humble pie. How are you fixed this week?"

"I might have an evening free."

"How about Friday?"

"Let me check." It was fully three minutes before she returned to the

phone, and it was obvious that she was extracting her full pound of flesh.

"That seems okay," she said without undue enthusiasm. "I'm coming up to town on Friday to have my hair done."

"Friday it is, then. Where would you like me to pick you up?"

"Why don't you meet me in the Ritz bar at around seven-thirty?"

"The Ritz at seven-thirty. Terrific. You'll recognize me," Waddington said, trying to thaw her. "I'll be the one wearing sackcloth and ashes."

He had taken the first calculated risk. Despite his previous misgivings about becoming involved with somebody of Pamela's undoubted wealth, in weighing the alternatives he had convinced himself that her setup in the country gave him a greater degree of day-to-day security—always assuming that she allowed him to move in and become involved. That crack about vitamin E wasn't too far from the truth, he thought; he had the feeling that Pamela was out of his league sexually as well as financially. Brush up on your charm, he told himself as he mapped out the next moves.

On Friday evening he made sure he arrived at the Ritz ahead of time, ordered a Perrier and lime and had a bottle of Montrachet put on ice. Pamela proved reasonably punctual for a woman entitled to score Brownie points. Rising to greet her, Waddington had to admit that she had more to offer than a secure haven of rest. Recalling the body beneath the smooth lines of her expensive silk dress, he wondered why he had ever hesitated.

"I like the old Ritz," she said as a waiter greeted her as a familiar. "It's never lowered its standards, unlike some places. As a matter of fact, I lost my virginity within these gilded walls."

Well, we're off to a good start, Waddington thought, raising his glass to her.

"Is that something you want to elaborate on?"

"Not really. It was a friend of my father's. I suppose I made the running; I was bored not knowing what one had to expect and thought I'd get it over with with somebody who knew the ropes. He didn't, as a matter of fact; the whole thing was a disaster." She surveyed the bar while she talked, never looking straight at Waddington, giving the impression that if something better came into her line of sight she might dump him. "Where are you taking me to eat?"

"I've made a reservation at a little place I like called Veronica's near Notting Hill Gate."

"Good food?"

"I think so. Sort of superior French bistro, and very intimate."

"Is 'intimate' going to be the operative word?"

"The choice is yours," Waddington said, playing her game but feeling foolish as he did so. It had been a long time since he had seriously set out to charm. I sound like Caesar Romero in a late-night movie, he thought. One half of his mind was concentrated on the real reason for dating Pamela; the other was wondering how good she would be in bed. Some outwardly sexy women proved a disappointment, only too content to let the man lavish his attentions on a statue.

"So that's the name of the game tonight, is it?" she said. "An intimate dinner, followed by what—jolly romps in the Jacuzzi?"

"Again, up to you. I'm here to be forgiven or rejected. Either way I'll try to give you a pleasant evening."

"I'm not often put down like that."

"I can believe it."

"Nor do I go in for one-night stands."

"Not my style, either."

"So, if we're going to start over again, it's as well to know the house rules."

"My feelings exactly. There is one thing in my favor." Waddington grinned since the atmosphere was now less tense. "I may not be able to keep you in caviar, but I'll make sure the security system works."

They had a second glass of wine before leaving for the restaurant. Waddington was about to ask for a taxi when the doorman handed him the keys to a Jaguar XJS V12 parked on a double yellow line outside the entrance.

"That's why I always choose this place to meet people," Pamela said as they headed down Piccadilly toward Hyde Park Corner. "They always take care of me. I think if I ever got clamped I would lie down in the gutter and die."

The smell of new leather combined with her perfume had an erotic effect on Waddington, who was beginning to relax and enjoy himself. Once out of the park and finding a clear stretch of the Bayswater Road, he put his foot down.

"Ever driven one of these before?"

"Sadly, no."

"Perhaps you should start getting used to it," Pamela said enigmatically.

To his relief she immediately warmed to the atmosphere at Veronica's. As usual, apart from their own reserved table, the small restaurant was full; it was one of those places that commanded a faithful clientele.

It wasn't until halfway through the meal that Waddington angled the conversation away from the mundane to the particular. "You mentioned house rules earlier. Are there a whole bunch of them?"

She shook her head. "No lifelong vows, no cheating while it lasts, and no smoking in the bedroom. I pay all the household bills, which I'd do anyway, so that shouldn't make you feel like a pimp, and you spend as much of your hard-earned money as you please bringing me flowers. How does that sound?"

"Okay. Assuming you don't change your mind by the end of dinner, let me ask you one thing. Why me?"

"Oh, come on, let's not be too modest."

"I'm serious. Girls like you haven't crossed my path too often, and certainly not for a long time."

"Let's just say I've had it with rich men."

"Does that mean you want to try slumming?"

"God! What did your ex do to you?"

"I guess she didn't exactly do much to boost my confidence, and you have to believe I've never had a very good line in chat."

"I intimidate you?"

"I wouldn't put it quite as strongly as that, but you certainly take— took—me by surprise."

"Well, that adds to the excitement, doesn't it? Maybe *you'll* surprise *me*. Would you rather I came straight out with it and talked like a character in one of those raunchy novels? I can if you want—anything that turns you on. Most of them are written by women these days, wouldn't you know?"

The dialogue was interrupted by the proprietress enquiring whether they'd enjoyed their meal.

"Couldn't be bettered," Waddington said.

"Would you like to see the desserts?"

"Just coffee," Pamela said. "Black, please."

"How about you, sir?"

"The same, thank you."

When Veronica was out of earshot Waddington said, "Does coffee keep you awake?"

"I hope so."

The die was cast now, and it was curious to think that if all his conjectures were correct it was Alec who indirectly had provided the fillip to get him into Pamela's bed. Was it fortuitous that so many new elements had entered his life at roughly the same time, and all of them seeming to have connections with the Firm? First the lunch with Keating, then Frampton's message and, swimming tantalizingly in the middle, the slightly alarming Pamela. There were still questions to be answered, his own safety to take care of and problems to be solved, but for the moment the one uppermost in his thoughts was sitting opposite him.

"It's not you," Hillsden said. "Please don't think that. I'm just going through a bad patch. Never happened before."

Although common sense dictated it was stupid to expect an early response to the message entrusted to Frampton, he had become increasingly uneasy, and his disquiet carried over into the relationship with Galina. He found himself impotent for the first time in his life.

"Then it must be me."

"No, I promise. I couldn't wish for anybody more attractive."

"Except—"

Humiliation made him reply more sharply than he intended. "I've told you, it's not you. Just be patient with me. It'll pass."

"I don't mind."

"But *I* mind."

"What I meant was, it isn't the end of the world. Why do you attach so much importance to it?"

"Because it's insulting to you."

"Only if I take it that way, and I don't."

"No? Well, you're very special."

"Tell me what's worrying you. Perhaps I can help."

Hillsden stroked her bare back, tracing a pattern to the base of her spine. "Probably just a wave of remorse for a misspent life."

He swung his legs over the side of the bed. How could he confess the real reasons? Already, even at this early stage, the spirochete of deceit had burrowed into their affair, following the old pattern, and it was all his own doing. In recent weeks he had alternated between states of moroseness and irritability, moods that reminded him of those times in his life when he had attempted to give up smoking.

"I know how difficult it must be for you," Galina said. "Don't think I don't."

"Do you? How d'you know that?"

"Because. Why don't you talk more about it? Don't you trust me? I love you."

He looked at her open, guileless face; it was like receiving a declaration of love from a stranger. "I've got out of the habit of trusting people."

"That's not very kind."

"No, and I didn't mean to say it like that." He kissed her. "Am I worth the effort to love?"

"I think so."

"Why can't the whole business of living be simpler? I wish I had a belief in something. I know a man—" He stopped and corrected himself, suddenly recalling that Belfrage had been murdered. "I knew a man in England who asked me just that. 'What d'you believe in?' he said. And I remember how I answered. I said I believed in evil—good, old-fashioned evil."

Galina stared back at him.

"That isn't much to write home about, is it, after over fifty years?"

"I don't think you mean it."

"Well, I daresay it's difficult for you to understand." Not for the first time Hillsden had to stifle a desperate need to confide in her, to lay himself bare, to destroy her innocence. He wished he had an old diary that he could point to and say, "That was the day when I committed my first betrayal; that's when peace of mind ended." But there was no one date to point to: deceit covered a lifetime, fogging the day-to-day incidentals. He had drifted into betrayal just as some men drift into adultery or alcoholism. It had been simply a way of earning a living in the beginning, not unlike being in a bank, taking home a regular salary—routine stuff, a means of paying off the mortgage. One did not take any exams for a career in MI6; indeed, he was still amazed at how casually his recruitment had come about. He remembered his first meeting with old Dinnsbury—owl-faced, shortsighted Dinnsbury, who had brought to mind memories of a childhood literary hero, Billy Bunter. The way in which that initial interview had been conducted was not unlike that of a vicar asking a prospective bridegroom whether he had the right mental attitude toward holy matrimony. So oblique had it been that for the most part he had had little inkling of what Dinnsbury was

152

talking about. It had gradually became apparent that he was being asked to join a club, the rules and working of which had never been set down on paper and the membership of which would remain largely unknown. How could one explain such a beginning to any outsider? Would any innocent like Galina readily accept that you could live in the closest married intimacy, share the same toilet and bed year in and year out, and yet remain a stranger? Women could sometimes excuse and forgive physical betrayal, but what salve could they use to heal the wounds brought about by an unknown adversary? Spying left no telltale lipstick smears on the adulterous face across the breakfast table.

"Is the reason you don't confide in me that you're still not sure I wouldn't betray you?" Galina said.

Hillsden shook his head. "There's nothing left to betray," he said, lying to her yet again. "I'm safe now," he said, as though one could ever be safe in the world he inhabited.

"Why the sudden change of heart?" Control asked.

"I've no idea, unless of course he found my charms irresistible. There's always that vague possibility," Pamela replied with just a hint of resentment.

"My dear girl, that goes without saying. Well, I'm delighted; it makes our task that much easier."

"You mean *my* task, don't you, since I'm the one sleeping with him?"

"Don't pick me up on words. I have a lot on my plate at the moment. These are trying times. One of your earlier conquests is not proving as pliable as I had hoped. Plus other matters."

"Such as?"

"Nothing you can help with."

He prevented Pamela's pressing him further by abruptly reverting to the original subject. "Do you think one of the reasons why he decided to move in was because he discovered his phone was bugged? He spotted it and changed his number, you know."

"No, he's never mentioned it, and it's hardly something I'd ask him."

"All calls from your house are being monitored, naturally. He was a smart operator. Don't underestimate him."

"Perhaps he still is. You've never fully explained why you got rid of him," Pamela said.

"Surely it's obvious. He and Hillsden were very close, too close for comfort, and he was never convinced about Hillsden's sudden defection.

For a time, until I blocked it, he tried to follow the trail. We know he contacted Hillsden's wife. The main reason I sicced you onto him is that I want to be doubly sure he isn't still nosing around."

"You have such a charming way of putting things."

"Don't be so touchy, my dear; it's just an expression."

Control walked to the shuttered, curtained window as though listening for something. He's uneasy tonight; it's out of character, Pamela thought.

"There is another reason why I wanted to see you," he said finally. "I may have to ask you to take a trip abroad."

"Where?"

"At the moment it looks like Prague. I'm awaiting confirmation."

"Why Prague?"

"To meet somebody."

"Who?"

"It's better you don't know in advance. But when I've made the arrangements you'll be contacted on arrival and be given certain verbal instructions to bring back to me. I can't use the regular channel. Make sure you go a roundabout route, not direct. Paris never arouses suspicion where women are concerned, does it?"

"Doesn't it?"

"Don't women like you go there to buy the latest fashions, frocks and the like? Why are you smiling?"

"I never knew you were such a student of feminine wiles. But if you don't mind my correcting you, nobody talks about 'frocks' these days; that's practically Victorian."

Control's mouth tightened; he did not like to be caught out on details. "Well, I'm sure you can concoct some plausible story for your new boyfriend, using the right terminology."

"Question: why send me now? I thought my current assignment was urgent."

There was a slight pause; then Control said, "Because you're one of the few people I can rely on absolutely."

It was the first time he had ever allowed her to see that his scheme of things had cracks in it. Suddenly he seemed normal. Men who played with toy soldiers, like those who kept tattered teddy bears on their beds, had always made her uneasy.

A week later Pamela had cause to respect the way Control worked. Her morning post contained an invitation to attend the Yves St.-Laurent

collection in Paris the following Tuesday, together with a slip confirming a reservation for a suite at the George V.

"Darling," she said to Waddington over breakfast in bed, "do you think you can live without me for a few days?"

"If forced to. Why?"

"Well, not that you'd understand, but I can't pass this up." She waved the invitation in front of his bleary eyes. "These are gold dust, like front-row seats for the finals at Wimbledon."

Waddington peered at the embossed card. "Wonderful."

"Can you read it? I know you can't focus in the mornings."

"Yes, it's an invitation to spend a lot of money on something you don't need."

"One has to keep up with fashion. Skirts are going to be much higher next season."

"Ah, I'm all for that."

"Will you miss me?"

"As an egg would miss its shell; I shall fall apart."

"No, seriously."

"Seriously, I shall miss you, but bear the loss with fortitude. No, I'll be fine. I have a lot on in the next week."

"Just tell Maria what you want to eat everyday and she'll fix it."

"Leave a phrasebook, then, because I can't understand a word she says."

"And use the Jaguar. I've had it insured for you to drive."

"God! Greater love hath no woman than that she lay down her Jaguar."

While shaving that morning with the gold-plated razor Pamela had given him, Waddington began to think how he could now advance his own plans; during Pamela's absence in Paris he would move to track down Frampton. He had been waiting for just such an opportunity. Even so, he had not been idle but had already carefully pinpointed Frampton's address on the map and examined a variety of routes before deciding which one he would take.

On the day Pamela departed he kept to his normal schedule, driving to the railway station and parking in the station car park. On his return that evening he telephoned Pamela at the George V and told her he thought he was coming down with flu and would be taking a couple of stiff whiskies and aspirin.

"Not only to stave off the cold but also to make sure I get a good

night's sleep without you, darling. Otherwise I shall be rattling around in our enormous bed."

"It's nice to be missed," Pamela said. "Take care of yourself and sleep late. Can you take the day off from work?"

"What a good idea."

He had dinner and before retiring told Maria he was not to be disturbed in the morning. Once in the bedroom he did not undress but instead watched television. When the late news finished he waited another hour, then switched off the newly installed burglar alarm and let himself out through the kitchen. In addition to the Jaguar, Pamela also possessed a small Fiat Uno, and this was the vehicle he had elected to use. He drove on the orbital M25 motorway, leaving the car at Waltham Abbey on the northeast outskirts of London. There he checked into a small motel, paying cash in advance for his room and requesting a wake-up call.

The following morning Waddington was on the road again before seven, dodging most of the commuter traffic by taking a back route through Epping Forest until he reached Wanstead. From there he had everything committed to memory.

Cranmer Road, the destination he sought, had been named after one of the martyred bishops burned at the stake during the reign of Bloody Mary. The roads that ran parallel to it were likewise terraced memorials to the victims of that past religious persecution: Latimer, Lorne, Tilney, Ridley. They all opened at the north end onto the scrub wasteland of Wanstead Flats, an expanse of grass, neither park nor pasture, dotted with a few sparse plantations of dying trees. In prewar days there had been a bandstand where on Sundays brass bands played to genteel audiences sitting in hired deck chairs; there had also been a pond on which paddleboats plied. Generations of small boys had played cricket and football there, and it had also served as a trysting place for desperate precursors of the permissive age, for after dark the plantations provided cold sanctuary. The Flats had seen violence, too, during the thirties, when Sir Oswald Mosley marched his blackshirted legions through the East End to confront the Jewish community. Pitched battles had taken place, broken up by charges from mounted police armed with long staves who bloodied anybody in their path.

These days the thin grass was trampled by different feet. A second generation of postwar immigrants now claimed it as their own; turbaned Sikhs played hockey, and sad veiled women, far from home and sun-

shine, took solitary walks over the urban desert of the gravel dunes.

As Waddington drove around the perimeter of the Flats he saw a detachment of the workers' militia drilling. They had cropped heads and wore paramilitary uniforms. This glimpse of an Orwellian scenario contrasted sharply with the orderly row of terraced houses as he reached Ridley Road, where some residences abutted the walls of a cemetery harboring the crumbling mausoleums of Victorian aldermen. He selected a local pub, noted the name and location, then parked his car close to a post office, where he felt he could be reasonably sure of finding a set of directories and an unvandalized public phone.

He was in luck. There was only a single Frampton listed, and the address tallied with the one he had memorized. The telephone was an up-to-date model requiring a plastic phonecard to operate it rather than coins. He purchased one and inserted it.

Again his luck held: Frampton answered after a couple of rings.

"Mr. Frampton?"

"Yes?"

"I'm a *Country Life* reader who frequents Harrods. I'm close by and I think it would be useful if you and I met." He could hear the sound of a man's voice shouting in the background.

"Nothing, Father," he heard Frampton say. "It's a call for me." He spoke softly into the receiver: "I can't see you now."

"You have to. I know where you live, and if you don't agree to meet me I'll come calling at your house."

"No, please," Frampton whispered. "Don't do that. I can't see you today; I was just about to leave for work."

"You just got sick, didn't you? Too sick to go to work today. You can think of some excuse. I shall wait for you in the saloon bar of the George at opening time. If you don't turn up, expect a visit. Understood? Just be there if you know what's good for you." He hung up before Frampton could make any further protest.

Needing to kill time until the pub opened, he returned to his car and drove to Cranmer Road. There were signs of urban decay: in the front garden of one house a rusting motorbike with both wheels missing propped against a bow window; moth-eaten privet hedges, graffiti on a blank wall, plastic garbage bags spilling their contents onto the pavement. He slowed down as he approached Frampton's house. There was a National Front poster pasted inside the downstairs front window; the paintwork was in better condition than its immediate neighbor and the

garden was tidier, but otherwise it was indistinguishable from the others in the row. He noticed a metal sign attached to the gate which read NO HAWKERS, NO CIRCULARS. Driving on, he found the sad high street which, like so many others, was devoid of any individual character, merely a series of garish shopfronts plastered with sale notices, a plethora of junk-food establishments, and uninviting ethnic restaurants, cut-rate chemists and betting shops.

He drove on, depressed, until he found a sandwich bar where he could get a snack and what passed in England for a cup of coffee, served in a plastic cup too hot to hold.

Waddington arrived at the George ten minutes before the doors opened and positioned himself in the car park so that he had a good view of the entrance. It was another twenty minutes before Frampton appeared on foot. He allowed his quarry to go into the saloon bar before getting out of the car and following him.

He found Frampton sitting in one of the booths. Now that Waddington had a closer look at him, he saw it was a face that had fear etched into it as surely as coal dust impregnates a miner's features. He walked to the booth and sat down. A noisy darts match was already in progress; this and the deafening sounds of a jukebox and a pinball machine ensured that their conversation could not be overheard.

"I'm glad you decided to show up. Can I get you a drink?"

"I don't want a drink. I'm not stopping."

"You'll go when I let you go. Have a drink; it will calm you. What's your tipple, beer or something stronger?"

"A small whisky, then," Frampton said, sinking back defeated on the ripped leather seat of the booth.

"Good. That's better."

As Waddington returned from the bar with their drinks, one of the darts hit the wire and flew off the board, landing close to their table. Frampton jumped, spilling some of his whisky.

"My, my, we *are* jumpy." Waddington retrieved the dart and handed it back to the player. "What are we nervous about?"

"I don't want to be involved in this."

"It's a bit late to say that."

"Who are you?"

"I'm the one you phoned. Why else would I be here?"

"Who were those other two men in Harrods?"

"Your guess is as good as mine. Not friends of either of us, that's for

sure. But let's not worry about them for the moment. Give me the message you were to deliver."

"I do worry about them. Can't you understand? I don't want to be involved."

Waddington ignored the plea. "First of all, who gave you the message?"

"How do I know you're not the police? You could be a blackmailer for all I know."

"Let's just say I'm another sort of policeman, one who doesn't have to account for his actions. And don't raise your voice. Just keep calm and take it step by step. You met somebody abroad. Where?"

"I was just on holiday."

"Where?"

"Leningrad."

How dim of me, Waddington thought. Of course "Lenin" in the message had been used as an abbreviation. "Good. And you met somebody?"

Frampton nodded. He could hardly hold his whisky glass.

"Whom did you meet?"

"A stranger."

"Did you get his name?"

"All I had to do was contact you and give you a message from him. He promised I would be left alone after that. He made a definite promise."

"Well, I can't be responsible for other people's promises. Who was he, a Russian?"

Frampton shook his head.

"Who, then? Come on, let's get this over quickly."

"I've never been in trouble before."

"What makes you think you're in trouble now?"

"Those men. They scared me. Why were they there?"

"That's a mystery I haven't solved yet," Waddington said, easing the pressure now, using the gentler voice of the experienced interrogator. "I'm the only one you have to worry about. I'm on your side if you tell me the truth. I'm here to protect you."

"Protect me from whom?"

"Other interested parties. But so far I'm the only one who could have traced you. Just get to the point, give me the message and tell me who sent it."

Frampton put his glass down and gripped the edge of the beer-stained table. He leant closer to Waddington as the darts game reached a climax. "Will I be left alone when I've told you?"

"I'll leave you alone. I can't vouch for anybody else."

"And you swear you're not one of them?"

"Them?" Waddington said, and irritation at the delay hardened his voice again.

Frampton's face was close to him as he whispered the word, and Waddington caught his bad breath. "A spy."

"No, I'm not. Let me make it easier for you. This stranger, did his name begin with 'H'?"

Frampton nodded.

"Good. We're making progress at last. Now, what message did he give you for me?"

"That he had a manuscript he had to get to you, but that he couldn't risk sending it by any normal route."

"What sort of manuscript? Did you see it?"

"No. Something he'd written himself. He said it was for your eyes only because it told the truth and you'd know what use to make of it."

"Is that all?"

"No. There was one other thing. He said to tell you everything was out of control."

"Out of control?"

"Yes."

"You're sure those were the exact words he used?"

"Yes, I swear."

"And how was I to contact him? Did he give you an address?"

"Yes, but you were not to write to him."

"Understood. Give it to me."

"Flat eighteen, Ninety-eight Ligovsky Prospect."

"Ninety-eight Ligovsky." Waddington committed it to memory. "That's in Leningrad, I take it?"

Frampton nodded and swallowed the remains of his whisky.

"Well, that wasn't too painful, was it?" Waddington got to his feet. "I meant what I said. As long as you don't tell any of that to another living soul, you won't be bothered by me any more."

Some color had come back to Frampton's cheeks, but whether it was caused by the whisky or by relief that the ordeal was over there was no means of telling.

"What about my friend?" Frampton asked.

Waddington had started to leave, and turned back, puzzled. "Your friend?"

"Yes, will he be safe too, now that I've kept my side of the bargain?"

Since Waddington had no idea what this referred to, he answered, "Neither of you will be bothered as far as I'm concerned. Just forget you ever saw me."

As he left the bar one of the darts players shouted, "Go for a treble six, Mike, and you've got him!" as though most problems in life could be solved by one well-placed arrow in the dark.

13

ON HER SECOND day in Paris, Pamela was still waiting for the expected contact to be made. Then shortly after breakfast the front desk informed her that an envelope had been delivered. She had it brought up to her suite and did not open it until she was alone. Inside was an unsigned typewritten note on a plain sheet of paper. The note said:

> Change of plan. Leave today for Marseille. A room is reserved for you at the Sofitel Vieux Port. Again wait there until contacted. Ring your lodger and say some old friends have invited you to drive down to the south with them for a few days.

Pamela burned the note, flushing the ashes down the lavatory, then asked the concierge to book her on the three o'clock Air Inter flight. When this had been confirmed she rang Waddington, but he had already gone to work. Rather than leave a message at his office, she scribbled a contrite letter on hotel stationery, using the names of some dead friends of her parents, to explain the new arrangements posting this

express delivery when she checked out. Before having an early lunch she took the added precaution of going to the Yves St.-Laurent salon and making a purchase.

The Air Inter flight was short but alarmingly turbulent; she was relieved to be on firm ground again, smelling the distinctive scent of Provence—that strange, heady mixture of petrol, ozone and the fragrance of flowers. Marseille was a city she knew only from films. The hotel selected for her was well situated, and from the windows of her penthouse suite she had a bird's-eye view of the old port bristling with the masts of yachts and fishing boats. There was no message waiting for her, so she took a shower and ordered a bottle of *blanc de blanc* from room service. It all seemed a far cry from Amersham, and she realized how much she missed the adrenaline of the old days when she and Günther had moved across the world, leaving havoc in their wake. A sense of the past pressed in on her.

It was dark before the call came, a message from the front desk to say a car was waiting outside. As she walked through the crowded lobby she was again reminded of the past; it was at times like this, setting out toward the unknown, that she came alive.

The driver of the Citroën waiting for her had a vaguely Slavic appearance. He greeted her in French but made no reply to her inquiry about their destination. Had she been more familiar with her surroundings, she would have recognized that she was being taken by a complicated route that eventually led them to the immigrant areas around the Porte d'Aix and the rue St-Barbe. The car pulled up outside a small shuttered *tabac.* The driver got out and opened the passenger door for her, indicating an unlit alleyway to one side of the shop. She took a few steps toward it, then turned back to ask in French, "Will you wait for me?" but the car was already making a U-turn.

Walking slowly down the middle of the alley, she was convinced that she had been led into a trap and silently cursed her own stupidity. What had Günther always told her? Never go anywhere without making sure you have an escape route. At any moment she expected to hear the sound, like a cushion being punched, of a silenced revolver. But it didn't come. She had taken only a few steps when a door in the wall on her left opened and a man's voice said in softly accented English: "Please come in."

It wasn't until the door closed behind her that a light was switched on and she saw the man for the first time. He was tall and good-looking

and, unlike some tall men, made no attempt to reduce his height but held himself with military bearing.

"I hope," the stranger said, "that the sudden change of venue did not inconvenience you?"

"No. I do what I'm told."

"Of course. Don't we all? We travel too far, too quickly and too often," he added cryptically. Then, "Excuse me, but I have to search you."

She remained passive while he carried out a body search clinically, with an expertise she recognized from her own past. While his hands probed her body she took stock of her surroundings. She was in what appeared to be a storeroom; boxes of Gauloise and Badois were stacked against two of the walls.

"Thank you," the man said when he finished the search.

"Do I get to do the same to you?"

He smiled thinly. "I'll save you the trouble. I am armed. Come this way, please." He led the way through another door to an all-purpose room she assumed was the living quarters of whoever owned the shop. It was poorly furnished and was divided into three areas: kitchen, bedroom and shower. The air was stale, a sour combination of cigarette smoke and garlic.

"I apologize for the surroundings," the man said. "Take the best chair."

There was only one bare overhead bulb to provide illumination, and as the man moved to offer her a battered armchair his head brushed against the bulb, causing it to swing to and fro. His features seemed to come and go, now fully exposed, now half in shadow.

"Are we going to be introduced?" Pamela asked. "You presumably know who I am. How about telling me who you are?"

The man smiled. "You're quite right. I do know who you are." He drew up a kitchen chair and sat opposite her at the table. Now that she got a better look at him, it seemed to Pamela that he was too pale to be a native of Marseille. She found the glacial quality of his smile disconcerting.

"I know, for example," the man continued, "that you have recently been reactivated, and that you come with excellent credentials. So let's leave the question of who I am, and just say that we are both professionals working for the same end result. What we have to discuss tonight concerns your people and mine. An unfortunate gap in communications

has come about between those I work for and London. It is a situation we are here to rectify."

As he spoke Pamela tried to place his accent.

"Certain decisions have been taken at a level far beyond your and my humble status."

"I don't believe your status is humble," Pamela interrupted. "Nor does Control deal with juniors. That's why I'm here."

"May I continue?" he said without change of expression. "It is our job to make sure these decisions are set in motion. We are to coordinate the process of discrediting someone, doing it in such a way that the evidence we plant can never be traced back, and that it has irrevocable effect."

"Who?"

"Somebody you once knew intimately, I believe."

For some reason Pamela blurted, "Hillsden?"

The man shook his head. "Now, that's interesting. Why would you think it was him, of all people?"

Flushing, embarrassed at her involuntary reaction, Pamela said, "I don't know. Perhaps he's been in my mind in recent weeks." That will get back to Control, she thought, and what did he impress upon me? Forget Hillsden; don't mention his name. I blurted that out like a novice.

"I must ask him if his ears have been burning," the man said. "I'm sure he'd be flattered. . . . No, you're a long way off the mark. The person concerned is your current Prime Minister." He paused to let this sink in. "Does that surprise you?"

"Yes. Yes, it does. Everybody went to a lot of trouble to put him where he is. I thought he was—"

"Firmly in place? Oh, we would all do well to remember that nobody is secure when the stakes are that high. He hasn't been keeping his side of the bargain, and we can't afford to wait forever. The cloak of *glasnost* is just that—a chance for us to make up lost ground. Diplomatically certain cosmetic advances have been made, but there is no military version of *glasnost*. We still have to continue the invisible war, the only important war."

Pamela nodded, only now recovering from the double shock of her own mistake and the revelation that Bayldon was the target.

"The reason you are here to take back the first stage of the scenario

we have devised is that a vital link in the chain between Moscow and London was recently broken when Mitchell was eliminated."

She looked blank. "Mitchell?"

"Ah, well, if that means nothing to you, don't worry about it. My mistake for assuming you know more than you do. I'm sure Control had a reason for withholding his identity from you. I would prefer you not to repeat my reference to him."

Pamela felt they were even now: his mention of this Mitchell canceled out her gaffe about Hillsden.

"Because of Bayldon's position we have to be exceedingly clever. Since we are not dealing with small fry, we have to fox him into a corner from which there is no escape."

"You mean *box* him in, I think," Pamela said.

"Do I? Thank you. We must discredit him not only in the eyes of his party, but also in the eyes of the British public. It needs a great deal of ingenuity since we'll only have one chance."

"A Watergate operation?"

"Something like that. Except in this case it won't be by his own hand, like Nixon, though it has been decided to use the Americans in the beginning. As you know they have an absurd mania for revealing all."

"Isn't that true of your country now? Aren't you all for truth now?"

"And what is my country?"

Pamela suddenly flared. "Look, if you want to play games, fine. I know you're Russian; otherwise I wouldn't have been sent here. You said you were going to treat me as an equal, so don't insult me, and don't feel you have to charm me. We're both here to do a job of work."

"Good. Very good. You have spirit."

"And don't patronize me either."

"My apologies. May I continue? The initial rumors will be leaked at the United Nations. We'll let others do most of our work for us so that our hands stay clean. Such a useful organization, the United Nations, for disseminating lies; there's nothing our friends in the Third World like better than a chance to besmirch the hands that feed them." Again the smile without warmth. "Such a corrupt society, America, and yet so obvious about it. One must protect corruption more carefully than innocence." He broke off. "They were supposed to leave some liquid refreshment for us. Can you see any?"

They looked around. "Perhaps in the kitchen," Pamela said.

The man got up to search and produced an opened bottle of *vin*

ordinaire. "This seems to be it." He rinsed two coffee bowls under the cold tap and poured the wine. "I'm sure we're both used to better, but cheers. Did I say that with the correct British intonation?"

"Perfect," Pamela said. "If you ever get to England, you should apply for an Equity card." They both drank. The man grimaced, but smacked his lips.

"Where did you learn your English?"

"At university."

"Which one?"

"What an inquisitive girl you are," he said in a way that dismissed the question. "If we can stay with the main topic. . . . The plan, then, is to plant the first rumor in America. I have no doubt it will find its way back across the Atlantic quicker than your Concorde. Bayldon was put into Downing Street to implement a timetable, but rashly he has not kept to it. Now, although certain cosmetic improvements have taken place between the two big power blocs, we need to accelerate the pace of change in your backward country, so he must be replaced by somebody more reliable."

"Why not assassinate him? I doubt whether the nation would go into mourning."

"Too crude. It was considered but rejected. It might have the reverse effect. No, this plan is more subtle. You know, of course, that he is married to a rich American, and as I am sure you are aware the British have never forgotten that another ambitious American woman toppled their beloved King Edward VIII. We thought it would be amusing to use his wife as the means of destroying him. A variation on the campaign directed against Madame Pompidou in 'sixty-eight, but which failed, like the French Revolution. A number of scurrilous stories will be put into circulation about the rich Mrs. Bayldon, all of them without foundation but sufficiently titillating to ensure that they are widely repeated. There seems nothing your fellow countrymen like better than the destruction of a reputation, especially if it is brought about by some sexual aberration . . . Is that the right word, 'aberration'?"

"Yes."

"We have some excellent rumormongers in all the right places. That is why America is the obvious ground in which to sow the seeds; the freedom of their press and their greasy legal system combine to make the perfect compost heap for germinating lies. And once they have flowered they will condition public opinion to accept what comes after."

"And what does come after?"

"She is, you recall, second-generation Irish American. It will come out that she has covertly donated considerable sums to the I.R.A. through NORAID. These funds will be shown to have originated from a secret bank account that she keeps in the Cayman Islands."

"Does she have such an account?"

The naïveté of her question made the man smile. "She will have. She will have," he repeated. "Photostats of the checks, bearing her genuine signature, will find their way to Fleet Street—"

"Wapping," Pamela interjected.

"What does that mean?"

"Fleet Street has moved."

"This is so? Well, once again I thank you for correcting my ignorance. So the British newspapers will come into possession of these photostats. Other copies will be sent to certain members of the Opposition. But in addition we will also make sure that sufficient supplies of arms and explosives reach the I.R.A. to enable them to mount a new campaign on the British mainland. Sleeper units are already in position and will be activated when we judge the time is ripe. The main target on this occasion will be one of the royal residences." He paused and finished his wine to let his words sink in. "I think, don't you, that the revelation of Mrs. Bayldon's criminal duplicity combined with such a terrorist outrage will ensure that her husband is removed from office. And the beauty of it is that we don't get the blame. Our Irish friends can have all the credit. We're not greedy."

"Very ingenious."

"It appeals to you, yes?"

"Oh, I like it. You say her signature will be genuine? How will that be done?"

"Don't worry; that's the least of our problems."

"But she'll deny all knowledge."

"Of course, who wouldn't? We are talking about half a million dollars. Anybody who conceals such a sum from the tax authorities is unlikely to plead guilty. But who will believe her? I promise you the mud will stick, and coupled with the parallel I.R.A. campaign your Right Honorable Mr. Bayldon will be finished, never to rise again. Then he can be replaced with somebody more amenable to our wishes."

"Has the replacement been selected in advance?" Pamela asked.

"Oh, yes."

"Who?"

"All in good time. Your immediate job is to report this to your Control. Describe the plan and confirm it has already been set in motion: the phony bank account has been opened, and the first rumors will be in circulation this week."

"That's it? Nothing else?"

"Well, if you like you can also tell him I am impressed with you—and I am not always impressed with the way your people operate." He pushed charm across the table like a croupier awarding a winner. "Perhaps next time we meet we can get to know each other better?"

When Pamela made no response, he produced a small beeper from his pocket and pressed it three times. "The car will be here shortly to take you back to your hotel. Fly home tomorrow on the first available plane."

"Where do you return to?"

"Home, like you. We're both going home."

"You don't take chances, do you? The strong silent type," Pamela added with a touch of bitchiness.

"Not the first time around, no. Shall we finish the wine while we wait?"

When she shook her head, he drained the bottle into his bowl. "Funny you mentioned Hillsden earlier," he said casually. "I know him well. Perhaps not as intimately as you, naturally, but well enough. If you wish, I could give him a message from you."

Pamela thought quickly, again remembering Control's warning and scenting a trap. "I don't think he ever knew my name."

"But I'm sure he remembers your face, or even more than your face."

The obvious sexual innuendo annoyed her. "Does he enjoy his new surroundings?"

"No complaints that I know of. He has a girl now whom he lives with."

"Good for him. And you're pleased with him?"

"Oh, yes. An honorable spy. He's rendered excellent service to us."

His beeper sounded, and he rose to his feet. "Until the pleasure of our next meeting," he said, taking one of her hands and brushing his lips against it. "Let me go first and make sure it's all clear." He switched the light off and she followed him through the storeroom to the alleyway door. The same car and driver were waiting outside. She got in and was driven away.

Abramov watched the car out of sight, then closed the door and walked off in the opposite direction.

14

MAJOR HUGH WOODLEY, D.S.O., was up and about at his usual early hour before the rest of his household was stirring, showering and shaving in the cold water he preferred. In his middle forties, he kept himself in good trim and was often taken for somebody ten years younger. Women thought him attractive, but studying his early-morning face in the bathroom mirror he wished he had more definite features, a touch of grey at the temples, anything to get away from the nickname "Young" Woodley that had stuck with him ever since prep school when he had been cast in the title role of the play of the same name. He had tried a moustache, but it had proved a sparse comic affair, like something stuck on for amateur theatricals, and had been hated by his wife. He had entered the army straight from university and had been commissioned in the Grenadiers, following family tradition. After serving several tours in Germany and Northern Ireland he had applied for a transfer into the Special Air Service. He now commanded an operational troop of the Counter Revolutionary Warfare Squadron. This was the term normally used by the press, but within the S.A.S. they were referred to as the Special Projects Team.

It was common knowledge in army circles that the existence of the S.A.S. was now viewed with a jaundiced eye by many of Bayldon's cabinet, and shortly after becoming Prime Minister he had ordered a committee of inquiry to investigate its methods of operation with a view to bringing in stricter controls, using an incident that had taken place during the previous administration's time in office as justification. "We cannot allow this highly specialized section of the armed forces to operate with disregard for the normal rules of engagement. I refer, of course, to the 'shoot to kill' policy that has been applied in the past and that my government is determined shall never be applied again. We want no repetition of Gibraltar."

There were cries of "Traitor!" and "Shame!" from the Tory benches, but Bayldon shouted down his opponents since he was playing to his own gallery. The mention of Gibraltar was a reference to an incident

that had provoked violent and prolonged debate at the time; members of an S.A.S. unit had shot and killed three unarmed I.R.A. terrorists on active service. Bayldon had used it more to appease certain of his ministers than from personal conviction. The recommendations of the committee, which were never made public, were not implemented since the Prime Minister was cynically conscious that any restrictions put upon such a highly trained force might one day work against his own safety needs. He never lost sight of the fact that in reaching for power one had constantly to guard against the enemies within. Fortuitously, shortly after the committee handed in its findings, the S.A.S. had successfully taken out a Libyan terrorist squad attempting to assassinate the Israeli ambassador in London. Woodley had been in command of the troop involved, and the ensuing international approbation had given Bayldon the excuse he needed to shelve the report.

For all that, Woodley was first and foremost a soldier prepared to serve the national interest regardless of whoever occupied 10 Downing Street, somebody who relished the role assigned to him, but like many of his colleagues he was increasingly disturbed by certain developments, in particular the setting up of the workers' militia. The S.A.S. had always enjoyed close collaboration with the regular police, but the emergence of a second force with paramilitary ambitions seemed to him a dangerous experiment.

That morning, after he had completed his toilet and activated his bowels with two cups of strong espresso, Woodley dressed in civilian clothes but did not neglect to wear a concealed shoulder holster in which he placed a loaded Browning Hi-power. Then, after exercising his two Dobermans, he drove away in a specially-strengthened Range Rover that among other refinements had bulletproof glass and tires.

His destination was Chobham Common, a long way from his Cotswold home. This barren piece of the Green Belt lies between stockbroker Woking and stockbroker Wentworth, dissected by the M3 motorway. In spring the gorse blossoms and bracken fronds push upward through the acid soil, but most summers the landscape blackens, scarred by fires started by careless picnickers, giving whole sections the look of a petrified forest. Certain parts of it are used by the army as a tank testing ground, and at night it is a lonely, even sinister area frequented only by lovers with something to conceal who satisfy their passions in locked cars parked off the roadway to the distant accompani-

ment of gunfire from the army range. From its high points on a clear day one can see planes rising every few minutes from Heathrow.

Woodley's route took him past the old Denham film studios, long since demolished and now a shopping complex, then on through the outskirts of Slough, where groups of small immigrant children were being shepherded to school, to Datchet and the boundaries of Windsor Castle, then following the road that ran alongside the Thames until he branched off up the hill to the small hamlet of Englefield Green. There he picked up the main road into Virginia Water, passing close to Fort Belvedere, the last British home of Edward VIII, until he reached Sunningdale. He was forced to slow down by a line of commuter traffic waiting at the railway level crossing. As soon as he could, he took a left onto a secondary road and accelerated through the undulating country-side. Early-morning mist still clung in pockets over the Common, and he narrowly avoided an urbanized fox loping home to its lair.

Reaching the midway high point, Woodley swung the Range Rover off the road into one of the parking areas that afforded him a clear view of the road in both directions. He could hear the continuous roar from the nearby motorway and counted himself lucky that he did not belong to the nine-to-five rat race. Despite the traffic he had still made good time. Taking advantage of this, he rolled a crude cigarette from a packet of rice paper and loose tobacco, his concession to a habit he refused to break and that filled his children with despair. All around him were the charred remains of small conifers and birches, stark memorials to past conflagrations and reminding him of First World War photographs of no-man's-land. A large crow flapped away as he struck a match to light the ragged end of his homemade cigarette.

A few minutes later he saw another car approaching. It slowed down as it neared the parking lot, then drove straight past and disappeared. Woodley waited, and soon the same car returned from the opposite direction, this time bumping over the uneven ground to park a short distance from him. Commander Pearson got out and looked around before walking to the Range Rover.

"You make me feel like I'm back in the vice squad, Hugh, arranging to meet here," was his opening remark after they had greeted each other warmly.

"Really?"

"This is prime country for a bit of you know what. There was a famous case some years ago when two young coppers spotted something

naughty going on in a closed car. Oral sex, I believe it's called now, though we had another name for it. Turned out to be an engaged couple, and they pleaded not guilty. The newspapers had a field day reporting the trial, because they brought the car into court and the defense counsel made the two coppers assume the same position as the prosecution alleged the accused had taken up on the back seat. Then the defense proved the cops could not have seen what they said they had seen because the windows were misted over. Case dismissed with costs. Made legal history, that one, to say nothing of what it did to the two young policemen. Had a sad ending, though. The couple never got married after all that."

Pearson breathed in the air. "God, it's a relief to get out of the office once in a while and take in some pure lead poisoning from the motorway. You're looking good, Hugh."

"I don't want to hear that. Just tell me I've aged."

"Were you surprised to hear from me again?"

"Pleasantly surprised."

The two had first met in Belfast on a clandestine operation during one of Woodley's tours and had hit it off from the beginning. It was one of those friendships that did not depend on everyday contact.

"Good of you to see me at such short notice," Pearson said.

"I was glad you called. I get bored when I'm on leave. Seeing as you didn't invite me to lunch at the Ritz on your generous expense account, I take it that whatever you wanted to talk about is off the record."

"What expense account? Yes, I've got a problem. And excuse me if I occasionally dribble; not senility—not quite anyway—the canteen tea has finally done my teeth in. I've been spending most of my spare time at the dentist lately, and last week he fitted a temporary bridge—a bridge too far in my case. Now where shall I begin? How long have you got, by the way?"

"I'm all yours. All I'm missing, happily, is a shopping expedition with Mary."

"Do you rate coincidences?" Pearson asked, jumping straight in.

"I don't ignore them."

"Me neither. Hunches, they say, have hanged more men than fingerprints. Recently two or three apparently unrelated incidents seem to share a common factor when examined more closely. Do you remember the case of a man called Hillsden a few years back? He was MI6 and linked to the murder of a Foreign Office type. Subsequently he defected and surfaced in Moscow."

"Rings a bell, yes."

"Well, a couple of days ago I was contacted by another ex-MI6 officer whom I've known on and off. Always struck me as straight and reliable; otherwise I wouldn't waste your time. Name of Waddington. Ever come across him?"

Woodley shook his head.

"He bent my ear with a bizarre story that this Hillsden, who's in Leningrad now, had got a coded message to him via a tourist—who Waddington believes was an innocent carrier. The message, when decoded, apparently revealed that our chum Hillsden has written his memoirs and wants to smuggle them back here."

"Ah! another *Spycatcher*?"

"Maybe. Waddington once worked alongside Hillsden and is convinced that his defection was a frame-up. Now in the ordinary course of events I'd take that with a double dose of salts, except that I'm currently trying to solve the death of a cipher clerk from G.C.H.Q., and there are aspects of the case that point to the possibility that he was murdered by or on the orders of our own security boys. I'm talking about the Hyde Park do at Christmas, when two policemen bought it as well."

"Oh, that. Yes, very nasty."

"Somebody went to a lot of trouble to try to destroy the evidence, and we only got a break by pure chance."

"Remind me."

Pearson sketched in the salient details of Mitchell's sad life and untimely end. "I'm convinced he wasn't killed by the I.R.A. or by any of the known terrorist groups; nor do I believe that it was a K.G.B. job. That leaves us with somebody closer to home. Now then, if you tag on Waddington's story, that Hillsden was trapped by a dirty tricks operation, perhaps certain pieces start to dovetail."

"Go back to something," Woodley said. "This tourist, the one who brought the message, is he kosher or a plant?"

"Waddington is convinced he's clean—shit scared, but clean."

"And Waddington's also convinced he's right about Hillsden?"

"He swears that Hillsden was well and truly screwed because he'd stumbled on the existence of a supermole."

"Oh, we're back to that, are we?"

"It doesn't go away."

"Did he say who his money's on?"

"No, but he believes Hillsden knows—hence the memoirs."

"That's strong beer, and a lot of people have tried to swallow it without success."

"Hugh, nothing in this game surprises me any more. Look, I don't have to remind you that for years now, ever since the Cambridge Four hit the headlines, a whole cottage industry has sprung up. At least a dozen books have appeared, some from so-called experts, some from ambitious journalists with no particular qualifications, some from ex-members of the Firm—all jumping on the supermole bandwagon. There are conflicting views in nearly every case, and no real evidence has been produced, but somewhere along the line there could be buried a truth that so far nobody has disinterred. Why pretend that the establishment lives and abides by the Queensberry Rules? They don't. The number of files that disappear whenever one tries to follow through would make a scrap paper merchant rich overnight."

"So what's your bottom line?"

"I can't discount the supermole theory entirely. Stranger things have happened. After all, if I had come to you a few years ago and said that one of the Cambridge spies, probably the most lethal, had been a re-spected member of society, working in Windsor Castle and Buckingham Palace as Keeper of the Queen's Pictures, you'd have driven away convinced you'd been dealing with a lunatic. Maybe the only person who might have settled the issue one way or the other was Philby, but if he knew the secret he took it with him to the grave. And don't forget that the K.G.B. had Philby lined up to take over the top job. If it hadn't been for Maclean and Burgess panicking, they'd have succeeded; as it was they came bloody close."

"What if the whole thing is a K.G.B. sting?"

"Yes, that was my immediate reaction, but Waddington argued that if this was the case the Russians could publish it themselves and there'd be no need for Hillsden to go to such lengths."

"Unless they wanted to make it look more authentic."

"Except that if they do have a supermole still in place, they're hardly likely to make us a gift of him."

"True," Woodley said. "I'm just being devil's advocate. Have you thought what you'd do with the information in the event it passes the tests?"

"No."

Woodley rolled another of his highly combustible cigarettes. "Can I make you one?"

"Why not? I'm already living dangerously."

"Why is Waddington ex-MI6?"

"Made redundant in the Bayldon economy purge."

"Except those boys never retire, do they?"

"Any more than your mob ever fade away. Where would the letters column in *The Times* be without regular contributions from 'Disgusted Brigadier of Harrow'? You'll be writing them one day."

"Thanks a lot. Sorry to press you, but you're not the type to buy gossip off the streets. What's his present occupation?"

"He works for a private security outfit."

"That's suspect for a start."

"Yes, he admitted as much, though not in the way you mean. He said it was a rip-off operation. The main reason why I believe him is that I knew Hillsden."

"Ah! Now you're getting to me. Why didn't you say so sooner?"

"Like Waddington, I never reckoned Hillsden to be what they said he was. For one thing he came from a different background, there were no public school connections, he certainly wasn't gay and he never hunted with the pack."

"That proves nothing. Next question: why was he singled out for redundancy?"

"You'd have made a good policeman, Hugh. I've given you the official reason, but maybe he probed too deeply into sensitive areas, like Hillsden."

"Got a chip on his shoulder, then?"

"Yes, probably. Who hasn't?"

"So if he has an ax to grind, maybe he's set the whole thing up just to get even."

Both men glanced up as a helicopter crossed the sky.

"Again can't be ruled out; it's a murky world he once inhabited."

"Records can be doctored."

"Well, I'm not infallible when it comes to judging character," Pearson said, "but I'd give Waddington a clean bill of health. See, from the moment Hillsden disappeared he smelled a rat and tried to follow it through, but was told to lay off by Lockfield himself. Subsequently he got the chop. His contention is that the two things were not coincidental. He's convinced Hillsden was onto something big. Even so, I wouldn't be wasting your time or mine with hearsay, if it wasn't for the fact that

both Hillsden and the dead cipher clerk point me in the same direction. That's the hunch, and I'm going along with it."

Woodley handed him the manufactured cigarette. "Careful how you light it. Sometimes the end drops off. I've burned at least six pairs of trousers."

Pearson took a drag and choked. "God, what do you put in these things?"

"State secret."

"You have to admit there have been some odd developments since Bayldon came to power. Curious, don't you agree, that the only outfit to be given an increased budget in the last review was Lockfield's. Why single him out?"

"Jesus," Woodley said, "are you really telling me you think Downing Street is directly involved?" He glanced up as the helicopter returned, this time making a lower approach above them. "A lot of overhead activity—must be a golf tournament on at Wentworth. They shuttle in the top brass to avoid the traffic."

"Yes," Pearson said, "except he's been circling, not landing. My teeth may be rotting, but I've still got twenty-twenty vision. . . . Not that it's much good when you're fumbling around in the dark. Have you still got a purpose in life, Hugh?"

Woodley was still shielding his eyes and staring up at the helicopter. "Purpose?"

"Yes. What keeps you going? What stops you taking a nice well-paid directorship in the City? With your record and background they'd jump at you. Why do you stay on the firing line?"

"Why do *you*? Because we don't know any different."

"I used to enjoy it. Always wanted to be a copper, solving crimes. Once upon a time it was cut and dried: you knew who the villains were, what they'd done, what they might do, even how they'd do it. Breaking and entering, loitering with intent, a bit of assault and battery, a murder now and then, usually a family job—all nice clean stuff, uncomplicated, never too difficult to solve. The ones we caught were all little men, pathetic cases most of them, nothing special, just lost causes. I've known some of them to throw a brick through the window on Christmas Eve, then stand there and wait for the Black Maria to turn up and take them in. They couldn't wait to get back inside—three meals a day, a bed, four walls around them and the company of their own kind. It was life. Now it's all different. Now the real murderers are among us, and I don't enjoy

it any more. Sometimes I get the feeling that I'm peeling off layer after layer of a dung heap and I'm never going to get to the bottom." Pearson stopped, suddenly conscious that he was pontificating. "Hey, thanks for listening. I didn't mean to waste your time."

"You haven't. I wish I could be of more help."

"Just talking it out helped. If you come across anything, you know where to reach me. Give my regards to Mary."

As they left the helicopter drifted sideways across the grey sky like a watchful buzzard.

15

FEW PEOPLE AT Marseille airport paid any attention to the elderly Arab woman slowly wandering around the departure lounge. She was dressed in a billowing black gown that denied her feminity, and her features were largely obscured by a headdress made of the same black material. A keen observer might have spotted that she was wearing a pair of modern sneakers instead of the traditional sandals, but otherwise there was nothing unusual about her. She blended in with a variety of other ethnic types: Algerians, returning Anglo-Saxon holidaymakers florid and peeling from overexposure to the Mediterranean sun, the odd priest, a party of German hikers, native French students, a boisterous group of young Scandinavians loaded down with knapsacks and carrying home the radiance of summer, seasoned businessmen easily distinguished by their briefcases and air of studied superiority.

Like the majority of air travelers all of them circled restlessly, as though some collective inner fear compelled them to savor their last moments on firm ground. Having passed the perfunctory security checks, they were now privileged captives, compelled, until their planes departed, to live in limbo, for they had crossed the frontier that sepa-

rated them from everyday existence. In these last moments many were also infected with the urge to spend their remaining currency in the duty-free shops, buying expensive trinkets that in the ordinary course of events they would have hesitated to acquire.

There being no direct flight to London until the afternoon, Pamela had booked herself on the first Swissair to Geneva after confirming that she would arrive in time to make a connecting flight to Heathrow. Now, having purchased a glossy fashion magazine, she sat observing her fellow passengers. Through the sound-baffled windows glinting with the rising Midi sun she heard the muted roar of jet engines. She too had a spasmodic fear of flying. Not for the first time the thought struck her that they were all too conscious that once in the air they would have no further control over their lives, that for the duration of the flight their destinies would rest with a pilot they would never meet face to face who would be handling many tons of complicated metal and machinery that mysteriously defied the laws of gravity. Pamela had always been a keen reader of horoscopes; invariably she turned to the relevant page whenever she purchased a new magazine, but it had occurred to her that what mattered when flying was not one's own horoscope, but the pilot's.

The elderly Arab woman passed in front of her several times, making a tour of the duty-free shops. She walked with measured steps, lingering before a window full of cameras, transistors and other electronic toys before finally deciding to enter the perfume shop. Despite their outward drabness the westernized Arabs were now the nouveau riche, Pamela thought, traveling first class with the excess baggage of their affluence, monopolizing the gambling tables, visiting the smart clinics in Harley Street, raping the showcases at Asprey's and Harrods, or colonizing the home counties on a prodigious scale as they reversed the role history had previously allotted them. Choosing to ignore her own wealth and the fact that she had been brought up by doting, well-heeled parents, Pamela had little time for the oil-rich expatriates. At such times she felt an even greater affinity with the P.L.O.; wealth allied to vulgarity offended her, no matter where it had been acquired. On a nonselective, nonracist basis she also had an equal loathing of the *Tatler* types who peacocked around in the Royal Enclosure at Ascot.

The elderly Arab woman did not emerge from the perfume shop until the second call for boarding. She came out carrying a plastic shopping bag and with head lowered surrendered her ticket at the departure door and walked across the tarmac to the waiting plane. She was traveling

on an economy ticket and once on board was directed to the last row of seats at the rear of the aircraft close to the toilets. She refused the stewardess's offer to stow her shopping bag in the overhead racks, clutching it to her bosom.

Pamela had been assigned a window seat in the front, first-class cabin. Ignoring the businessman next to her, she fastened her seat belt and settled down to read a copy of French *Vogue*. Engrossed in the latest dictates of Chanel et al., she did not look up from her magazine when a final passenger boarded: a bulky young man in a well-cut suit who took the only remaining first-class seat two rows ahead of her.

The doors were secured and the aircraft taxied out to the runway. After a short wait it was cleared for takeoff and rose toward the morning sun, its initial course taking it out over the sea, climbing to a third of its cruising height before turning back on a heading for its destination.

As soon as the seat belt sign had been extinguished, the young man got up and made for the toilets at the rear of the aircraft. There he allowed the elderly Arab woman, still carrying her shopping bag, to precede him. While the stewardesses began to take orders for complimentary drinks the man stood waiting in a position that effectively blocked the view of the toilet door.

A few minutes later the elderly Arab woman emerged—except that she was no longer elderly. Minus the black gown, stripped of her grey wig and dressed in jeans and a leather jacket, she was revealed as a young woman in her twenties. She stood with her back to the cabin and handed the young man a mini Uzi automatic with spare magazines and an H & K P7 9-mm revolver from the shopping bag. She was armed with a Beretta 92F, and the pockets of her jacket were stuffed with plastic explosive and the necessary detonators. The weapons and explosives had been given to her by an accomplice in the duty-free shop after she had passed through the security check.

The young man walked to the front of the aircraft, holding the Uzi straight down and close to his right leg, the P7 in his pocket. A priest was sitting in one of the aisle seats, and as the young man passed he dropped the P7 into the cleric's lap. The girl remained where she was. At this point none of the other passengers had noted her changed appearance. The young man edged past the stewardess serving drinks, excusing himself politely, and continued through the first-class cabin to the cockpit door, his movements so casual that none of the passengers paid any attention. The cockpit door was unlocked, and he went straight

through, bringing the Uzi up as he entered and pushing it against the pilot's neck.

"From now onwards do exactly as I tell you," he said in French. "Inform air traffic control that your aircraft has been taken over by Action Direct and that you are changing course and proceeding to Cyprus. When you have done that, tell the passengers of this development and warn them not to make any stupid moves. They and the cabin staff are to remain seated with their seat belts fastened. I am not alone. I have two comrades in the cabin, like me fully armed, and explosive charges have already been placed and primed in the rear toilet. If you or anybody else attempts to disobey my orders, we will blow up the aircraft. Later you will relay our demands to your government. For the moment that is all. Plug me in a set of phones." While adjusting them he kept the gun against the pilot's neck.

The pilot gave his call sign to air traffic control and alerted the authorities of the hijack. He was asked to repeat the message. After a pause the controller accepted it as authentic and gave him a fresh course heading and permission to climb to 12,000 feet. The copilot punched the new headings into the computer.

"You will now maintain radio silence."

"I can't do that," the pilot said flatly. Both he and his copilot were Swiss nationals and had done their compulsory military service. The pilot had also been trained in antiterrorist psychology and was fully aware that it was vital to give rational replies to all the hijackers' demands, especially at the outset when the adrenaline was pumping. "I have to stay in contact to receive regular clearances. This is very congested airspace, and I'm sure you don't want a midair collision."

"Okay," the young man replied, "but don't try anything clever. What is the flight time to Cyprus?"

"Just under two hours in normal conditions."

"Do you have enough fuel?"

"Yes. But you realize we shall have to get permission to land there. They might refuse. We can't stay up forever."

"How long?"

"Three and a half hours maximum."

The controller's voice crackled in the headphones, giving a further change of course and a new height. When this had been acknowledged the voice asked, "What else can you tell us?"

The young man pushed the barrel of the Uzi into the back of the pilot's neck.

"Nothing else."

"How many are they?" the voice asked.

"I am not able to tell you that. Have you alerted Cyprus?"

"That is under way. Are there any casualties?"

"Not that I know of."

"Good. We are keeping this channel open; all other aircraft have been told to change frequencies."

"Roger."

"Good luck."

"Thank you."

"You did that very well," the young man said. "Just keep it that way. Now inform the passengers."

In the cabin Pamela looked up from her magazine as the pilot's calm voice made the announcement. Listening to the news, she shared the common shock. The man sitting next to her gripped her arm and moaned "Oh, God, no!" Further down the cabin a woman screamed in disbelief and a child cried out, but for the most part the news was received in silence.

When the announcement ended, the bogus priest, gun in hand, came to the front of the cabin and addressed them.

"Everybody will remain in their seats with their seat belts fastened. That includes the cabin staff. If you do what we say, no one will get hurt. Keep quiet, don't make any sudden movements, do nothing. Explosive charges have already been placed on the aircraft. We will collect all the passports." He spoke in English first, then repeated the warning in German and French, but it was difficult to pinpoint his true nationality.

Now the girl worked her way through the aircraft taking the passports.

"Mine is in my briefcase in the overhead rack," the businessman whispered to Pamela. "What do I do?"

The bogus priest immediately stepped up to him and pistol-whipped him across the head. Blood from the wound spattered Pamela's skirt.

"You weren't listening, were you? I told you not to speak."

That's a bad sign so early in the game, Pamela thought. He's jumpy. He's the one to watch. She remembered how tense she had always been when she and Günther went out on a mission. The first moments were always the worst. Even so, the bogus priest's reaction betrayed that he was on a short fuse. Moving cautiously, the businessman's head lolling on her shoulder, she carefully opened her handbag and took out her own passport. When the girl reached her she handed it across the injured

man. She met the girl's eyes and took a chance: "His is in his briefcase in the rack," she said softly.

The girl made no reply but opened the rack and took down the briefcase. Opening it, she held it upside down and emptied it onto the floor, then bent to extract the passport from the scattered contents: a bulging Filofax, travelers checks, a copy of a raunchy magazine, an electric razor, pens and pencils and a leather photo frame containing a colored snapshot of two small children. She kicked these to one side and moved on. Blood from the businessman's wound dripped steadily on to the central armrest. As the aircraft climbed to the permitted cruising height he became a dead weight on Pamela's shoulder, but for the moment she judged it unwise to make any move to help him.

She sensed the plane had changed course. Twisting her head slowly, one eye always on the bogus priest, she glanced out of the window, but it was difficult to guess where they were heading. Through a break in the clouds she saw the sea below and the thin glinting wake, like a snail's trail, of a steamer. Then, as the plane's shadow traveled across thick cloud, she judged their direction to be southeast. Her feeling of shock and disbelief was receding, to be replaced by anger. How can this happen to me? she thought. The irony of the situation was not lost on her. She had long been familiar with the techniques of hijacking; at one time she and Günther had been trained for a unit of the Red Army Faction targeted on a Lufthansa Jumbo carrying several top-ranking NATO officers. At the last moment, with the unit in position at Rome airport, the plane had been diverted because of fog and the operation had been aborted. Even so, she well remembered what they had been taught. It was important to disorient the victims as quickly as possible: separate the men from the women, break up family groups, commit one violent act very quickly after the seizure of the plane, give no information, show no emotion, if necessary be prepared to kill at random. Alone among the hundred or so other passengers, she was in a position to gauge the future sequence of events. She knew the usual passport routine. They would be sorted into nationalities; then, depending on the terrorists' aims, certain groups would be isolated. Holders of American and Israeli papers were usually the prime targets, assuming that the hijackers were from one of the Arab organizations, although in this case the fact that they had selected a Swiss aircraft puzzled her. The Swiss were an odd choice, unless there was somebody on the passenger roster they were particularly interested in. The fact that she was a woman, Gentile, and

had British papers meant that the odds were minimally in her favor. The vital thing was to keep a low profile and do nothing to draw attention to herself. She hoped to God nobody would attempt heroics at this stage, setting off a chain reaction that could only bring disaster.

While Pamela was pondering these and other aspects of the situation, the door to the cockpit opened. From where she was sitting the angle was too acute for her to see the third terrorist, who Pamela presumed must be the leader. Unseen, he issued a command in German to the priest, ordering him to take over in the cockpit. They crossed in the narrow space between the toilet and the galley, and it was only now, as the young man came into her view and stood surveying the sea of frightened faces, that the shock of recognition was shared between them. Although he was slimmer than the last time they had met and both age and artifice had worked subtle changes on his features, there was no mistaking the face that stared at her. Irrationally, another image from the past flashed into her mind: she was suddenly reminded of the classic introduction to Harry Lime in the film *The Third Man*. Perhaps the comparison was justified, for there was more than a passing resemblance between the remembered screen image of the actor and the terrorist now confronting her. Fate had reunited her at 29,000 feet with the Fat Boy.

16

WHOEVER THEY WERE, Pearson was to say afterwards, they did a messy job, almost as if they didn't care.

"Very messy," he remarked to Lloyd. "Like you and me squashing a cockroach. Casual and messy. I've handled a few of these in my time, and pleasant they are not."

Frampton's house had been entered from the rear, a downstairs toilet window having been smashed. None of the neighbors reported hearing

any sound of the break-in, though this was not unusual. There was no local Crimewatch organized, and Frampton senior was anything but popular, having made no secret of his political and racist views. The crime was only discovered when young Frampton's office reported his phone out of order after making repeated attempts to find out why he had been absent from work for five days. Getting no answer, the telephone engineers who made the service call raised the alarm, having discovered the broken window. The overworked local police had responded an hour later, and the first grisly sight of what was inside the house fell to two officers of a mobile patrol car, one of whom was a policewoman.

They found Frampton senior in the living room with most of his brains splattered over the screen of the television set. It was still on, and the cabinet was hot to the touch. He had been shot at point-blank range in the back of the head, and the force of the impact had thrown him into the fireplace. Soot and ashes were mixed to a paste with his blood. There were no other signs of disturbance, though the budgerigar was stiff at the bottom of its cage.

Making a preliminary search of the rest of the house they came upon the real horror. As they mounted the stairs to the upper floor they became aware of the stench of death, and their noses led them to the younger Frampton's bedroom. Nothing in the policewoman's training had prepared her for the sight that greeted her. Frampton's partially clothed body was lying face upwards on the blood-soaked bed, with both arms tied to the brass bedstead. His bare chest was a mass of small burns such as could have been made by a lighted cigarette. One ear had been completely severed, and it was subsequently discovered that he had been emasculated. The room itself had been totally wrecked. Papers, ornaments, pictures, his record collection and books lay smashed and thrown to one side. The clothes from his wardrobe had been taken apart; even the heels of his shoes had been removed. The sides of the mattress had been slashed, and the cheap horsehair stuffing, stiffened in places with his congealed blood, bulged from the gashes as though the material formed part of his own mutilated body. It was as if a maniac had been let loose in a toy shop, and that what lay on the bed was not human, but a broken doll.

The policewoman retreated to vomit on the landing. Her partner took her downstairs into the fresh air, and she sagged against the patrol car while he radioed for assistance. By now a small group of curious onlook-

ers had gathered, some of the faces bright with morbid expectation. In quick response to the urgent summons, other police quickly arrived and by nightfall a mobile incident room had been set up in the street and the murder house isolated. A forensic team made a detailed examination of the bodies before they were bagged and taken away for autopsy. The front and rear gardens were combed for clues and every resident of the street questioned. Apart from conjecture, nothing of substance came to light. Newspaper reporters and television crews swarmed into the area, and though kept at a distance and given nothing but the bare facts by the Detective Chief Superintendent in charge of the investigation, treated their readers and viewers to lurid hearsay descriptions of the crime. Having gleaned from all-too-willing neighbors that there had always been bad blood between father and son, some of the reports concentrated on this aspect, one even going so far as to quote a "reliable source": CRAZED FATHER KILLS SON IN FAMILY BLOODBATH, screamed the headline the next morning.

Domestic murders, however hideous, seldom involved Pearson, and in the ordinary course of events it is doubtful whether he would have more than glanced at the story. But the name of the two victims nudged something in his memory. Being methodical in all things he followed up.

On the afternoon of the day after the discovery Waddington was in the office typing up an estimate when his employer sent for him.

"What's going on, Waddington?" was the Captain's opening remark.

"Going on, sir?"

"Yes. Don't play the innocent with me. I've just had a call from a Commander Pearson at Scotland Yard who's anxious to interview you. What's it all about?"

"I've no idea."

"My relations with the police have always been top-hole. I deal with them direct at the highest level, as one would expect with a firm of this standing. I have a reputation to maintain which I do not want sullied by underlings. Why would a Commander Pearson wish to see you?"

"I've already told you, I've no idea."

"I hope you're not lying, Waddington. Lying is something that I will not tolerate. If subsequently I find your denial is false, it will be instant dismissal."

"When does he want to see me?" Waddington said, cutting through the threats.

"As soon as possible."

"Then am I allowed to go?"

"Provided you make up the lost time, yes."

"Did the gentleman say where I was to meet him?"

"New Scotland Yard, of course. I shall expect a full explanation on your return."

"Thank you, sir."

Waddington took a taxi to the Yard. A pass had already been left for him at the door, and he was shown up to Pearson's office.

"You dropped me in it," Waddington said the moment he entered the room.

"Oh, sorry about that. Couldn't think of any other way to contact you, and something's come up that I felt merited urgency. I also thought it vital that we meet on safe ground. I'm told my office is safe—as far as anything is safe these days."

"Was it something about Hillsden?"

"Yes and no. Tell me again, what was the name of the courier, the one you had to meet in Harrods?"

"Frampton."

"You're quite sure?"

"Yes."

"Have you seen the papers?"

"Not today. I had an appointment early this morning before they arrived."

Pearson picked up a copy of the *Sun* from his desk and swiveled it round so that Waddington could see the headline. "Read that. Is that our man?"

Waddington studied the story, taking in the salient details. "Jesus!" he said. "Yes, yes, it is."

"Positive?"

"No question. Same address." His mouth had suddenly gone dry, and he found it difficult to speak.

"They don't have the full story. Just as well because the true facts will turn your stomach. Whoever did him in didn't do it neatly. He was tortured before they killed him. Tortured in a very nasty way. He got the Abelard treatment."

"Abelard?"

"And Heloise. Didn't you ever read that story?" Waddington shook his head. "They cut his balls off, to say nothing of his ear. The young policewoman who was first on the scene is on sick leave seeing a shrink.

186

People imagine we're all hard-boiled Philip Marlowe types. We're not. We're just garbage men these days, picking up every kind of human debris. Ever seen a motorway crash? When you've taken your first dead child out of a family hatchback squashed to the thickness of a plank, you don't need to rent horror videos."

Pearson had walked to the window while getting this speech off his chest, as though anxious not to let Waddington see his face.

"Could it have been the father, as this report hints?"

"Not from our evidence," Pearson said, turning back, composed again. "The old man had the back of his head blown off, but since they didn't find any trace of a weapon it doesn't suggest a self-inflicted wound. They'd both been dead five days. Did you see him again after that first visit?"

"No."

"No contact whatsoever?"

"None."

"When you met him in the pub, could you have been recognized?"

"It's always possible."

"The two men at Harrods that day—did you get a good look at them?"

"No. It all happened too quickly."

"Well, adding it all up, it sure as hell doesn't suggest coincidence, does it? What you have to worry about is how much they got out of him before they killed him. From what they did to him he must have talked, the poor bastard."

"How d'you know there was more than one?"

"I don't. Just a guess on my part. Has the look of a team job. How safe are you these days?"

"Safe?"

"Yes, where d'you live?"

"I'm staying with a friend right now."

"In London?"

"No, in the country."

"Look," Pearson said, "you're in the middle of something whether you like it or not. Maybe Frampton told his killers more than he told you, or maybe there was no more to tell. Either way you have to be next on the list. Now, if it was me, I'd want to do more than just change the locks on the doors. These characters are not your average housebreak-

ers. I might be able to arrange for you to stay at one of our safe houses. Unofficially, of course, and I can't promise. You married?"

"Divorced."

"Children?"

"No."

"That's a plus. Any current attachments?"

"I'm living with a woman."

"Serious?"

"I don't know yet. It's early days."

"Does she know any of this?"

"No way, but she'd certainly find it odd if I suddenly disappeared."

"She'd find it even odder if you ended up like Frampton. If you want my advice, I wouldn't be too visible right now. Do you have any friends you can trust? What about ex-colleagues? For all we know, given your Hillsden connection, it could be in house. Did you think of that?"

"Yes." Waddington glanced down at the newspaper again. "Listen, I'm grateful for the offer, but I think I'll take my chances elsewhere for the moment. You mentioned Hillsden. Does that mean you believe my original story?"

Pearson did not answer at once. He seemed to be choosing his response with care. "Put it this way: you came to me and I listened. I went further, discussed it with somebody just to talk things out, testing the water, so to speak. Leveling with you, until this happened I was in two minds. It's not my usual line of country. What little I knew of Alec Hillsden I liked. You worked with him and you liked him too—enough to go out on a limb for him against all the evidence. Now this, a definite connection. It adds up. So you can count me in. In what way I don't rightly know. But let's not make it public, eh? We both have to do a lot more thinking before we make the next move. Let me know where you hole up and use this number"—he scribbled it down on a piece of scrap paper—"that's my direct private line. Not even the wife has that, so don't abuse it. If I don't answer, keep trying until I do. And don't speak to anybody else in this building. One last thing: don't walk out of here. I'll get you a Q car and have them drop you off somewhere."

Pearson was as good as his word, and Waddington left from the rear of the Yard in an unmarked police car. He had no intention of returning to face the Captain; that reunion would have to wait. He asked the police driver to take him to Euston Station. There he joined the crush of commuters and dived into the Underground, catching the first train that

came in and strap-hanging his way through a dozen stops before alighting. Above ground again he went into the first pub he came to, ordered a double scotch and sat with his back to the wall in a corner concealed from the doorway. Downing his drink, he attempted to sort out his thoughts, relieved that her current absence meant he could delay having to deal with the Pamela situation. The first name that had come to mind in Pearson's office when asked to think of a funkhole had been Keating. He answered most of the basic criteria: out of the game, but not entirely divorced from it, somebody who knew the ropes; the luncheon had established that much. But how much should he tell Keating, if anything? He would need to concoct some plausible reason to justify turning up out of the blue.

He left the pub and went in search of a phone booth. Keating's butler answered, and after a pause he was put through.

"Bill, how goes it? Glad you rang. Coincidence, because I was going to give you a bell tomorrow. Must be mental telepathy."

The warmth of Keating's greeting surprised and fazed Waddington momentarily. "Really? How odd."

"So when can we meet? Got your diary handy?"

"Not with me. . . . In actual fact, the reason I'm ringing is to ask a favor," Waddington said, plunging.

"Go ahead."

"I'm in a spot of bother and I need somewhere to go."

"Like here, you mean?"

"That was the idea, but I'd quite understand if it's impossible."

"Got the wife's lawyers on your tail?"

"Something like that."

"No problem. We've got spare rooms—ten, to be exact. You want to come now?"

"In a word, yes."

"See you in a little while, then. I'll be here."

Walking away from the phone booth in search of a taxi, Waddington felt he had made the right choice. The beauty of somebody like Keating, somebody from the Firm, was that they knew how to live with the unexpected.

17

WHILE WADDINGTON WAS on his way to Keating's house, the first sparse details of the hijack were released, including a statement from the Swiss government that so far the terrorists' demands were not known. This was a deliberate piece of misinformation since the authorities were already in possession of the Fat Boy's conditions, namely the release of three members of the French Red Brigade currently being held in Swiss jails, together with a ransom of ten million Swiss francs. Urgent negotiations were under way between the Swiss and the Cypriots, who were currently refusing to allow the plane to land.

The Swiss already had their own premier Hostage Rescue Unit force—the Zurich "Enzian" unit—airborne. Also on board were trained negotiators and a full medical team including surgeons, together with government officials carrying the ransom. In addition, requests for backup forces had been made to the British, Israeli and Turkish governments, and these had immediately put H.R.U. teams on full alert. Within an hour of receiving the request, the Turkish unit, known as the Jandara Suicide Commandos, was on its way to Cyprus. Intelligence forces throughout Europe were monitoring all radio traffic to and from the jet, feeding everything back to Komissar, the West German computer system used to keep track of all terrorist activity. Constantly updated, the computer analyzed the options, dealing out poker hands. The three jailed terrorists had been taken under armed guard to Zurich airport, and a jet was standing by to transport them should the situation demand it.

Back in England, S.A.S. Headquarters at Hereford had kept MI6 fully posted as a matter of routine, and when Control returned to his office that afternoon the reports were on his desk. Included among them was the passenger list for the Swiss airliner. He scanned it to see how many British nationals were on board. As he went down the list the name *van Norden, Mrs. P.,* leaped out at him from the page. He checked where the flight had originated just in case the name was coincidental,

but the combination of Marseille and her name left no room for doubt: somehow the unthinkable had happened.

Using his hot line, he immediately contacted Hereford for the latest information and was told that the plane had still not landed. The Swiss were putting pressure on the Cypriot authorities to relent, but time was running out.

"The last report from the cockpit was that there was only fuel enough for a further twenty minutes' flying time."

"When was that logged?"

"Seven minutes ago."

"How many terrorists on board—has that been established?"

"Not definitely. It's believed there are three."

"What's the Swiss attitude?"

"Wait and see. The Turks have got an H.R.U. team on the island and the airborne Swiss unit now have the plane in sight, plus the Yanks have scrambled three fighters from the Sixth Fleet. You've got the passenger list, I take it?"

"Yes," Control said.

"We make it that there are eighteen British subjects on board. Anybody of particular interest to you?"

"No," Control answered quickly, "but keep me fully posted."

"Will do."

"Has your help been asked for?"

"We've got a troop ready to go if needed."

"Have the French come up with anything, seeing as Action Direct is responsible?"

"Nothing that we know of so far."

"Curious choice, Marseille."

"Yes. Still, share and share alike. Makes a change. Things have been too quiet recently."

"It can never be too quiet," Control said acidly before hanging up. Incredible, he thought. The odds of Pamela choosing to fly on that plane were equivalent to winning the Irish Sweepstake lottery outright. And from Marseille of all places! It just went to prove that in the world he inhabited it was not the obvious that one had to guard against, but the long arm of chance. And there was nothing he could do about it; like the Swiss he could only wait and see. Would Moscow pick up on it? he wondered. Not that they could influence matters; the only people in control for the time being were the actual hijackers.

He ran his finger down the list of passengers again rather like a disappointed beneficiary studying a will in the hope that he misread it the first time.

"It's no use you threatening me," the Captain said to the Fat Boy. They had been stacked and circling for the last ten minutes while he had made repeated and increasingly urgent calls to the control tower. "I happen to be on your side right now. You heard me: they've got the runway blocked off and we only have another eleven minutes' fuel."

"Do we have any other options?"

"One. There's a military airport in the Turkish sector we could just make, but I doubt if they'll help us down. I'll have to fly clean, go straight in first time on a visual approach. It's now or never, so make up your mind."

The Fat Boy hesitated a second. "Do it. Go in."

"You'd better strap yourself in the spare seat. It's likely to be a dodgy landing. And please don't say anything else until we're down—that is, *if* we get down."

As the Fat Boy harnessed himself into the third seat, the Captain was already altering course, taking the plane into a gentle banking turn as he began the descent. The escorting American fighters tucked themselves in behind him, above and below. The voice of one of the American pilots crackled in his headphones, asking his intentions, but the Captain ignored him, concentrating on giving concise orders to the First Officer.

"Give me twenty flap."

"Twenty flap on."

"Igniters."

"Igniters on."

"Tell the cabin crew and passengers to take up positions for an emergency landing."

The First Officer made the announcement.

"Call it out," the Captain said.

"Three thousand. Speed two six zero."

The First Officer's knuckles whitened over the throttles. The plane leveled out, the engines biting into a layer of cloud.

"Two thousand. Speed two ten zero."

"If I've got it right, when we get through this cloud it should be straight ahead. Reduce throttle."

"Fifteen hundred. Steady at one eight zero."

The Fat Boy twisted in his seat to see past the Captain as the cloud finally thinned out and they were once again in clear sky. He could make out nothing of the terrain ahead.

"One sixty, one fifty-five at one thousand. Still at twenty flap."

"Landing gear."

The First Officer activated the switch and there was a whine of hydraulics as the undercarriage locked into position. Then the aircraft began to drop at a faster rate as the Captain lined it up on the distant runway.

"Speed one forty. Three degrees nose up."

Now the Fat Boy could make out figures on the ground, and cars like Dinky toys. There were some swimming pools, scattered squares of bright blue among the counterpane of brown and green. Every now and again the sun reflected back from glass, as though someone was flashing danger signals.

"Six hundred."

They were on the final approach now, and the engines took on a different note.

"Five . . . four . . . three."

Through the narrow windscreen the Fat Boy could see activity ahead: half a dozen vehicles streaming out from the main cluster of buildings toward the runway; figures running; the ground rushing up to meet them, the last half mile eaten up at an alarming speed, the aircraft rocking in the currents of hot air as the Captain made subtle movements with the stick. Tensed in the cabin, bracing herself and the injured businessman against the landing impact, Pamela prayed for the first time in years.

"One hundred . . . fifty . . ."

The first yards of tarmac disappeared under the nose, and then the Fat Boy felt a sudden lurch as the wheels touched down and locked hot rubber onto hotter tarmac. It was a perfect three-point landing, and in the cabin the terrified passengers cheered their first piece of luck.

The First Officer slammed the protesting engines into reverse thrust for the specified time, then pushed the throttles back. A sort of quietness engulfed the aircraft as the brakes were applied and it slowed to taxiing speed and slewed off the runway into a parking bay before coming to a complete stop.

"Kill engines."

The American fighters screamed over them, and then there was a magic silence.

The Captain turned his head to the Fat Boy. "Over to you once again," he said, and reached for a packet of cigarettes.

"You did a good job," the Fat Boy said, "but now that we're down don't try to be a hero. Do anything smart and I'll blow your friend's head off." He pointed the Uzi at the First Officer before releasing his harness and going back into the cabin.

"I'll have one, too," the First Officer said when they were alone. He found he was shaking and drenched in sweat.

"You gave up."

"I just started again. Thank God these bloody gauges aren't dead accurate. If I believed them, we ran out of fuel five minutes ago. By the way, Skipper, that was an ace fucking landing."

"Yes, to use your own words, it fucking was," the Captain said, savoring a lungful of injurious tars in the sure knowledge that over the past few hours he had already shortened his life.

"Wives are a recurring sickness, like malaria," Keating said in his most expansive mood. "One feels perfectly well, and then suddenly, out of the blue, the temperature rises. We're never safe, old man."

As Waddington might have guessed, Keating's house complemented the man and was of equal Falstaffian proportions—a large detached mansion set well back from the road in an area noted for its exclusivity. On arrival he had spotted two remote-controlled video cameras positioned to survey the front gates and garden. There was also an alarm bell bearing the name of Breakproof's main competitor fitted high on the wall.

He had decided to feel his way cautiously where Keating was concerned and for the time being stick to the story that he was the victim of a marital dispute.

"What about your own wife—will she mind me being here?"

"We're in this together, as it happens. Mine has flipped, I think, so we've come to an arrangement to put some air between us for a while. Lots of air. D'you think we ever learn from our sexual mistakes?"

"Probably not." Certainly not if a Pamela van Norden enters our lives, Waddington thought.

"It's a bloody fraud to say that 'In the dark all cats are grey.' If I'm going to exist by a maxim, I prefer good old La Rochefoucauld. Ever read him?"

"No, I confess I haven't."

"He told it like it is: a few good fucks interspersed with long periods of purgatory—though he tarted it up, of course, in the usual French fashion, but that's what he was talking about. Still, we mustn't be too hard on the dear creatures; the occasional fever clears the blood, and they can be delectable in small doses. Now then, let's get you organized. I've had my man put you in the guest suite. You'll need a house key, and I'll explain how the alarm works, though I don't suppose that will faze you."

"It really is very generous of you."

"Glad of the company. Are you still working for that boring character you told me about?"

"Yes, for the moment, but it's only a matter of time before I quit." Even as he said this his mind moved to Pamela again. My God, I've learned to love how the other half live quickly enough, he thought, protestations about pimps notwithstanding. I seem to have struck it rich twice in a row. But given the situation he would need to sever connections with the wearisome Captain; life at Breakproof could no longer be considered safe. Pamela was a more difficult equation to solve. He was torn between the necessity of taking himself out of circulation and the urge to see her again. "I've been intending to make a move for some time, but I must find something else first before I give the Captain the finger. I sampled the breadline before, and it isn't much fun. But obviously I can't abuse your hospitality for any length of time."

"Don't worry about it; the invitation's open-ended. As it happens, we could help each other out. We might have renewed acquaintance at just the right time. If you hadn't rung me, I was just about to contact you and proposition you."

"Really? What about?"

"Remember I mentioned that I dabble in films? Well, I've got too many irons in the fire right now, and it's too much like hard work keeping tabs on all of them. The film industry's an even murkier world than the one we both used to inhabit, and it's been in my mind for some time now to find a reliable partner who can watch the inmates while they run the asylum. It seems to me the time is ripe for you to step into those shoes."

Listening to this, Waddington wondered whether Keating was to be believed, or was he the type who invented favors on the spur of the moment merely to show that he could?

"Very flattering of you, but I know nothing about films. I'd probably be a disaster."

"It's just another surveillance job, old chap. Piece of cake to somebody like you. You won't be dealing with a bunch of Mensa graduates. From what I've seen so far, the majority of them are just self-employed villains with artistic pretensions, out to screw anybody who's fool enough to pick up the tab. They give you a lot of crap about 'creative freedom,' but all they're really talking about is 'creative bookkeeping.' "

"But surely I'd need some experience. I couldn't just jump in at the deep end."

"Why not? Most of them do."

"What sort of film is it?"

"Don't ask me. Here." He picked up a bound copy of the script from his desk. "Judge for yourself."

Waddington glanced at the title page. "What does this picture of a raven signify?"

"That's the producer's name. Old-time Hollywood type who's managed to stay afloat making schlock for schlocks, but his films do well and that's all I'm interested in. I'm told this one is above average for him, and for the first time he's making it away from California. Says the unions are killing him out there."

"So he's making it here?"

"Yes, the interiors will be shot at Shepperton, and the locations in Europe, with one sequence in Russia. At one time he wanted to film the entire thing there, but I squashed that. Too much of an unknown quantity."

"Russia? That's unusual, isn't it?"

"From what I've heard Raven jumps on every new bandwagon, so he's stolen half the plot of *Ninotchka* and brought it up to date. Western boy meets Russian girl in *glasnost* time. Very original. Listen, maybe he's right."

"Whereabouts will they be shooting in Russia?"

"Leningrad, I think. They tried for Moscow, but didn't grease the right palms or something."

"Interesting," Waddington said. "I'll certainly read the script, and if you're serious about taking me on, providing I feel I can make a contribution, I'd like to take you up on it."

"Just an idea. It's got to be a mite better than playing death of a salesman."

196

"Too true. Well, thanks. What can I say?"

"Always more gracious to receive than to give, chum."

"Is that La Rochefoucauld?"

"No, that's Keating, pure Keating."

Thirteen hours after it had landed the hijacked jet still stood on the same spot at the end of the runway. Requests to have it towed to another location had been refused by the Fat Boy. His only concessions had been to permit food and water to be brought aboard and to release a mother and her two children, both of whom had become dehydrated by the intense heat; the Turkish military authorities had refused demands for the plane to be refueled, and there was no air-conditioning. The front exit door had been opened for short periods, but by now the atmosphere inside the cabin was fetid. The hostages were still strapped in their seats, but as Pamela had predicted, they had been separated into ethnic groups; though she had been isolated at the rear of the cabin, the other seventeen with British passports were in the front section. The only three Israelis had been gagged and bound and placed close to the midway emergency exit. The hostages had the feeling that they had all been sealed in a tunnel, the terrorists having pulled the blinds on all the windows. From time to time the injured businessman regained consciousness and could be heard moaning.

Beyond the ring of searchlights illuminating the aircraft, the Turkish H.R.U. had set up perimeter security around the entire area and were prepared for an immediate assault should the position deteriorate at any time. Reconnaissance and sniper teams were positioned as close to the plane as possible, armed with AR-15 rifles fitted with laser target illumination systems. One member of the unit, dressed as a canteen worker, had taken the food and drink out to the plane, but on the Fat Boy's instructions the provisions had been left at the foot of the portable staircase and had been retrieved by a male hostage while the girl terrorist, wearing a hood, stood to one side of the open door with her gun trained on him. She had been photographed, but no positive identification had been possible. The Zurich H.R.U. team had landed at the island's commercial airport and been rushed to the scene. Their chief negotiator, a psychiatrist, was in the control tower and in contact with the plane, but so far the Fat Boy had refused to talk to anyone directly, using the pilot to relay his responses. To stall for time he had been told that the Swiss were flying the three jailed terrorists to the island. This

was untrue. The Turkish authorities had insisted that any rescue attempt would be carried out only by their own commandos. In addition they were adamant that the hijackers' demands not be met. Urgent and at times acrimonious discussions were taking place between the Swiss, Cypriot and Turkish governments, and the British, French and Israelis were being kept fully informed. The media had already started converging on the scene.

From the time she and the Fat Boy had come face to face, Pamela had been conscious of the innumerable necessary evils of which her life was made up. In the ordinary course of events she would not have questioned his inalienable right to use terror as a weapon in the world revolution they all sought, but the fact that she was now personally involved presented new and perhaps insoluble problems. During the long, stifling hours since the plane had landed she'd had ample time to consider all the probabilities. There was a remote possibility that the hijackers' demands would be met and that she, along with the other hostages, would eventually be released. But attitudes toward such acts of terrorism had hardened in recent years, and she had no doubt that assault plans were in hand and that the chance of a bargain being struck was at best dubious. Equally, she had no illusions about the Fat Boy; he would not hesitate to kill if the operation went wrong or if he felt it imperative to regain the initiative. So far, apart from their moment of mutual recognition, he had not approached her. Most of the time he had been in the cockpit, leaving the other two to deal with the passengers and flight crew. From experience she knew that as every hour passed without progress being made the team's tolerance would be strained. The bogus priest had already demonstrated that he was on a short fuse, and the girl remained an unknown quantity. If forced to abort the mission, they would have allowed for a final solution. They had no faith in anything but death.

Pamela was in an aisle seat, and by inclining her head an inch at a time she obtained a partial view down the cabin. Only the emergency lights were burning, and her line of vision was restricted, but as she looked now the cockpit door opened and the Fat Boy was briefly silhouetted against the dying sky. She saw that he was allowing the pilot to use the forward toilet; while he stood guard the girl went past to take his place in the cockpit. They were obviously working to prearranged procedures, as Pamela would have expected. When the pilot emerged and returned to his seat the Fat Boy closed the cockpit door and walked

the length of the cabin. He paused by the three Israelis as though selecting them for something in the future, then walked on, coming at last to Pamela.

"You," he said to her in French, "unfasten your belt and come with me."

Pamela did as she was told, rubbing her cramped legs, while the hostages closest to her averted their eyes. The Fat Boy motioned her toward the rear of the cabin with his revolver. There he opened the toilet door and pushed her inside. They stood close together in the cramped space, and he spoke softly in the remembered sibilant voice.

"You've given me an extra problem—one I could have done without." She caught the scent of garlic on his breath. Like her, he was sweating from the intense heat.

"Yes. It's unfortunate for both of us."

"Why were you on this particular plane?"

"I was doing a job. I had to make a contact in Marseille."

"Word was that you'd retired."

"I was out of it for a time. Now they've decided to use me again."

He stared at her. "You know that I can't show you any obvious favors."

Pamela nodded. The feeling had not yet returned to her legs, and suddenly she sagged towards him. "Can I just splash my face with water?"

"Go ahead." He waited until she had finished. "Did you hear what I said?"

"Yes."

"If they're prepared to trade, I can make some small concessions. That could include you. Could," he repeated, "but no guarantees. If they don't—" He left the sentence unfinished.

"What are you asking for?" she whispered.

"The release of three comrades held in Switzerland and a safe passage out of here."

"Where to?"

"You don't have to know. If you're still alive, you'll read about it."

"Are they stalling?"

"Of course. What else?"

"I'm sorry," Pamela said.

"Well, you've been lucky this far. Maybe your luck will hold."

"Please," she said, "before I go back, let me use the john."

"Okay, but be careful what you touch. This place is wired."

He eased his bulk out of the entrance and allowed her to pull the door closed. When she emerged he loudly ordered her to return to her seat and watched until she had refastened her safety belt. Again none of the hostages looked at her. The Fat Boy returned to take over in the cockpit, pausing midway down the cabin to contemplate the three Israelis.

Once back in the cockpit he called the control tower. "I'm giving you one more hour to show goodwill. I make it one-fifteen. In exactly one hour we will shoot a hostage."

The negotiator's voice remained calm. "There is no need for that. We're making progress. How are conditions on board? Do you want more food sent out?"

"I want results. You can begin by refueling the plane. Otherwise you're going to pick up a dead Jew from the tarmac."

"I give you my word we're doing all we can. The three men flew out from Switzerland ten minutes ago. We expect them to arrive just over two hours from now. Obviously they can't land here while your plane is blocking the runway."

"I'll agree to it being moved once it's been refueled."

"All right, I'll see what I can do. Please be patient. I am having to consult with more than one authority."

"One hour," the Fat Boy said before cutting the connection.

In the control tower the negotiator relayed the latest threat. Several alternative plans had been deliberated exhaustively throughout the long day. If all else failed, the Swiss government was prepared to authorize a direct assault on the plane, but only as a last resort. Their scheme was to use a variation of the technique employed during the successful rescue of a Lufthansa 737 at Mogadishu. On that occasion a unit of West Germany's Grenzschutzgruppe 9 had started diversionary fires in front of the hijacked aircraft, relying on this distraction to make the terrorists congregate in the cockpit where they could be more easily picked off. On the other hand, the Turkish commander had put forward an imaginative and original plan. His scheme was first to show goodwill by allowing the plane to be refueled. During this operation key members of his assault team would be left in position below the wings. The second phase would be to tow the plane to another part of the airport where he would already have positioned the remainder of his force. This would gain valuable time and convince the terrorists that their other demands would also be met. To convince them further, when the next lot of food

was delivered it would also include half the ransom money, with the promise that the remaining half would accompany the released prisoners.

"There is no way we will agree," the Swiss representative said. "My government has made that abundantly clear. It is out of the question."

"Please let me finish!" the Turkish commander shouted. "I am aware of that. Three of my men, suitably dressed and disguised, will take the place of the prisoners. They will be driven in a bus to within sight of the cockpit and revealed to the terrorists. At that distance and in poor light the terrorists will not be able to tell the difference. Only then will we put our final conditions to them. One: If any of the hostages is harmed in any way, the prisoners will be shot before their eyes; two: All the hostages, including the stewardesses, are to be freed; only then will the prisoners be allowed to board; three: the refueled plane will be allowed to take off."

"The plan is not feasible," the Swiss representative remonstrated. "We cannot allow this."

"Those are our conditions. I did not say they would all be carried out. During the evacuation of the hostages my assault team will have attached explosive charges to the emergency exit doors on both sides of the aircraft. Ladders will also be in position. As my three decoy prisoners reach the head of the stairway, the order will be given to explode the charges and force an entry using stun grenades. Provided there have been no prior killings, we will attempt to take them alive, but if necessary we will take them out."

There was a long silence when he had finished. Finally the Swiss officer nodded. "It might work," he said finally. "It's never been tried before and it might just work. It's certainly the best we've come up with."

"Are we agreed, then? We put it into effect, yes?"

The Swiss officer was not to be won over so easily. "I shall have to refer back to my superiors."

"Please do, but let us hurry, shall we?" The Turk turned to the negotiator. "In the meantime, I suggest you keep them talking. Begin by telling them that we believe we have permission to refuel. Every minute gained is valuable. I will start to brief my team."

By nature Control was not fitted to be a passive player; throughout his career he had always been the instigator of plots, and although the

fortuitous circumstances of the hijack could hardly be described as a counterplot the effect was the same. His concern for Pamela's possible fate was minimal; she would have to take her chances. The all-important factor was to reestablish a safe contact with Abramov and receive instructions. The inexplicable assassination of Mitchell had shaken him badly; this further setback meant that his fresh initiative was stymied. He had to believe that Pamela's presence on this particular flight was pure chance, the joker dealt at random like the three-card trick employed by pavement hustlers; at the same time he could never dismiss the thought that darker forces had played their part. In the long, cruel war he had joined so many years before, nobody fought cleanly. He detested failure; failure was a weakness, something he pushed to the back of his mind, just as he ignored the evening pain from the arthritic fingers of his left hand.

The irony of it all was that until now he had never put a foot wrong. Moscow could not fault the way in which he had shoehorned Bayldon into Downing Street against all the odds, and the planning of Hillsden's defection had been a masterstroke. This is what made the present situation intolerable. There was something too coincidental about recent events; it had been difficult enough to arrange Pamela's meeting with Abramov—taking a chance that in the normal course of events he would never have contemplated. Moscow had needed a lot of persuasion to agree to it, and if it now proved to have been a waste of time there was no predicting what their reaction would be. Control was aware that they were already losing confidence in his ability to deliver: Bayldon was his man, and Bayldon was not performing as promised; Bayldon had proved a tactical liability. There was no point in telling Moscow Center that the British system did not operate like the Kremlin, that Prime Ministers could not be overturned easily. Having lost face over Afghanistan, with their African ventures not performing as planned and the Middle East too volatile, the old guard in the Kremlin needed a diversion in order to counter the changes *glasnost* had brought about. No matter what small internal freedoms were being introduced, their sights were still fixed on Fortress Britain. If the Americans could be convinced that the British were unreliable, they would pull out; once that happened, the whole concept of NATO would collapse. To bring this about they needed a climate of uncertainty, the very thing Bayldon had been put in office to achieve.

But now the necessary removal of Bayldon was being threatened by a hijack engineered by some crackpot group. It really was too galling.

The principal negotiators were almost as exhausted as the hostages in the sweltering plane. After further and often acrimonious exchanges, the Swiss had reluctantly given their consent to the Turkish commander's plan, pressure having been brought to bear on them by the Israeli government. The exact procedures having been decided, there was another dialogue with the Fat Boy, and following a simulated show of reluctance they agreed to let the plane be refueled. Stage one began with two crack marksmen from the Turkish unit being taken out to the aircraft on the refueling tanker, hidden under blankets in the driver's cabin and exiting from the blind side of the vehicle while the genuine tanker driver and his assistant connected the hoses. They were now in position under the belly of the aircraft. The Fat Boy had monitored the operation from the cockpit, checking the gauges as each tank was filled.

In the blackened-out cabin, the hostages remained ignorant of what was happening outside, though Pamela, catching the girl and the bogus priest exchanging a look, guessed that something was developing. Once the refueling had been completed to the Fat Boy's satisfaction, he again spoke to the chief negotiator and was told that in order for the plane carrying the prisoners to land the hijacked airliner would have to clear the runway. He closely questioned the Captain about the necessity of such a maneuver, then insisted that they taxi under their own power rather than be towed. In addition, he gave explicit instructions that the first installment of the ransom money and extra supplies be delivered before the aircraft moved. They were to be brought out to the plane on an open truck. This would be driven into position at the forward cabin door and the supplies and money were to be placed halfway up the portable stairway. The driver would then withdraw and two of the hostages would be allowed to retrieve the food and the ransom.

"Let them know," the Fat Boy told the pilot, "that if these instructions are not carried out exactly they will be responsible for the consequences."

He came back into the front cabin and indicated that the girl should put her hood on. Watching through the door window, he waited until the truck had driven off again before opening the door, then moved down the cabin and selected two male passengers at random.

"Get up, both of you." Now he spoke in English.

They struggled to release their safety belts with cramped hands. The Fat Boy motioned them toward the exit door. "Go outside and fetch the food."

Both men obeyed, walking unsteadily as the blood returned to their legs, the girl covering them all the way with her automatic. They brought some of the food inside, then returned for the rest. On the second trip the younger of the two suddenly jumped the last half dozen steps and made a run for it. He had gone only a few yards when the girl opened fire, cutting him down accurately with a spray burst. The bullets spun him around, and he appeared to dance a parody of the Twist, executing a zigzag pattern before crumpling to the tarmac.

Smoke from the girl's gun drifted back into the cabin, filling the already fetid atmosphere with the smell of explosive. The hostages cowered in their seats. Although none had witnessed the actual killing, they were well aware that something horrendous had happened.

The package containing the ransom money was still on the steps. "Get it!" the Fat Boy shouted to the other man. "And don't try what your friend did." He pushed the terrified man out of the aircraft again. Once he had returned, the exit door was closed and the Fat Boy took the package from him and went back into the cockpit.

"I warned them," the Fat Boy said. "I did warn them." He opened the package to assure himself that it contained half the ransom money.

"Is he dead?" the Captain asked.

"Who cares?"

"Can I radio them to pick him up?"

"No, not yet. I want them to understand I mean what I say."

"They'll take you now." The Captain found the courage to speak out. "Now you've made sure they'll take you."

"You think so?"

"Unfortunately for the rest of us, yes, I think so."

"I'm not interested in your opinion."

The Fat Boy looked out of the cockpit window, but his view was restricted. An icicle of doubt entered his mind. The instincts that had kept him one step ahead of his hunters for over a decade came into play. He had always made it a trademark to act unpredictably, and now he took an immediate decision.

"Start your engines and prepare for takeoff."

"Takeoff? We're supposed to clear the runway."

The Fat Boy pushed his revolver against the copilot's temple. "Do as I say or else you'll be flying this plane alone."

"But take off to where?"

"I'll tell you when we're in the air."

At first those in the control tower found nothing odd in what was happening, believing that the plane would now move to a parking bay as agreed. It wasn't until the plane slewed round and the sound of full power reached them that they got an inkling of what was happening. The two marksmen concealed under the belly of the plane were suddenly exposed, spread-eagled and deafened as the plane left them and began its takeoff run. The hot blast from the jets rolled them over like pieces of paper caught in a whirlwind. Powerless to act, the onlookers in the control tower could only stand horrified and amazed as the plane lifted off and climbed steeply into the night sky. All airborne military aircraft were immediately warned and tracking stations throughout the Mediterranean alerted.

"What's my flight plan?" the pilot asked as they leveled off.

"Libya."

"I'll have to lodge it with air traffic control."

"You lodge nothing."

"It's required procedure under international safety regulations."

"I make the regulations," the Fat Boy said. "Safety doesn't come into it. When I'm ready I'll speak to Libya. Just set course and keep to it."

In the control tower violent arguments and counterarguments were taking place, the Turkish commander remaining adamant that his plan would have worked.

"What about the dead man on the runway? Earlier you said that if any of the hostages were harmed you would move in immediately."

"Once all my men were in position. That's what I said. And the crucial factor was the plane supposedly bringing the prisoners. For my plan to succeed all the elements had to come together. I cannot be held responsible for events beyond my control."

Pressed back into her seat as the plane banked and climbed steeply, Pamela had no illusions: something had gone wrong with the Fat Boy's plans, and she knew him only too well; once denied he was twice as dangerous.

18

IT WASN'T UNTIL he got to Paris and was inside the Russian embassy that Abramov learned that Pamela was on the stricken plane. With his usual thoroughness he double-checked, telephoning the airline's hot line and posing as an anxious relative. Like Control, he had little concern for her welfare; he too was angered that the long arm of coincidence had reached out and delayed, possibly wrecked, the timetable Moscow had laid down. His next call was to Geichenko, and he knew what to expect.

"What d'you mean, she was on the fucking plane? How come?"

"I don't know. I wasn't responsible for her travel arrangements, General. Presumably London made them."

"London! London is useless shit! We can't trust London with anything."

"It was just pure chance, General."

"There is no such thing as chance."

"No, General."

"Where is the fucking plane now?"

"It took off again, and we just had a report that it's landed in Libya, General."

"I want you back here!" Geichenko shouted, and the line to Paris went dead.

Traffic between Moscow and Libya, on the other hand, was extremely busy during the next few hours.

Until he awoke late in yet another strange bed and read the morning papers over breakfast, Waddington was likewise ignorant of Pamela's involvement in the distant drama. Preoccupied with his own problem, he had first scanned the inside pages for any follow-up on Frampton's murder before turning back to the main story. The only photograph accompanying the text was that of the Swiss captain, most of the space being taken up with a fanciful eyewitness account of the way in which he had brought the plane down safely in Cyprus seconds before his fuel

ran out. The story also stated that there were a number of Britons on board, and it was while Waddington was idly scanning the passenger list that Pamela's name leaped out at him. Stunned, he read it twice, hoping his early-morning vagueness had misled him. It seemed unlikely there could be two people with the same unusual name, and Pamela *had* been in the south of France. The fact that she should have caught a plane originating in Marseille rather than Nice was odd, but not all that odd; the rich moved around. He obtained the emergency number for enquiries for the latest update, and the Swissair spokesman confirmed that a Mrs. P. van Norden had been on the passenger list.

Bathing and dressing hurriedly, Waddington went downstairs in search of Keating, finding his host at his desk in the paneled library.

"Slept well, I trust?"

"Like a top. Have you seen the papers?"

"I glanced at them. Why?"

"There's been a hijack."

"That, yes. Now I suppose we're in for a spate of them. Once one succeeds, others imitate."

"I know somebody who's on the plane."

"God, how awful! It's my nightmare to be involved in one of those things."

"Everybody's . . . the point is, I can't believe this. My entire world seems to be falling apart recently. . . . It happens to be the woman I'm currently having an affair with. Can you believe that? She was just on a holiday in the south of France."

"You need a drink?"

"No, it's too early. There's nothing one can do; that's the worst part."

"Well, if it's any comfort, statistically the odds are in favor of your lady; they seldom harm women and children—even *their* twisted minds take some account of public reaction. Once they kill they usually lose out. It's not much, but it's something to cling on to. Is this the lady who broke up the marraige?"

Waddington hesitated before replying. "No, and I haven't been honest with you. It is true my marriage has broken up, but that was some time ago; this particular affair started afterwards. . . . Maybe I will have that drink."

"I'll join you. What time is it? Oh, it's gone eleven. A Bloody Mary goes down well at this hour."

He busied himself expertly at a small bar while Waddington unbur-

dened himself. "I seem to have become involved at one remove with something from our joint past, and I guess I can't trade on your hospitality without telling you about it."

"My dear chum, whatever you tell me won't go any further."

"Well, it might have to. When you've heard it you might change your mind. It concerns Hillsden."

Keating handed him a beaker of lethal proportions. "If I've overdone it, I'll add some more tomato juice. You say it's concerned with Hillsden? You don't mean the hijack, do you? What are we talking about?"

"No, that's something else to add to my worries. . . . I was sitting at home minding my own business when I got a phone message on my answering machine. No idea who it was; he didn't give a name. Just said he had to deliver something from a friend he'd met abroad, and would I meet him in the food hall at Harrods. I thought it was a gag at first—and then I found out my phone was bugged. That set me thinking."

"And he didn't give a name?"

"No, nothing. Sounded scared. I was intrigued, naturally, adding two and two together. I kept the appointment, went to Harrods as per the arrangement, though I guessed something wasn't quite kosher, so I played it very low profile. Just as well, because a couple of heavies also kept the appointment. You might have read about it. They stabbed one of the Harrods security guards; there was a piece in the papers."

"That was the same thing?"

"Yes."

"Did you ever find out who you were supposed to meet?"

"No, he sensibly did a bunk when the trouble started. I got a quick look at him—he was a total stranger—but he did leave something behind which I picked up. A magazine."

Keating raised an eyebrow.

"Oh, I should have mentioned that he said he'd be carrying a copy of *Country Life* so that I could recognize him. He dropped it when he ran and I picked it up."

"Significant?" Keating asked.

"Not in itself, but there was a note tucked inside. Sort of a shopping list, which meant nothing at first, but seeing what had happened at Harrods I stayed with it and worked out that the list must be some sort of code. Well, not a code, exactly; it was too amateur for that, the kind of thing you jot down to remind yourself of something you have to do."

"Did it mention Hillsden?"

"Oh, God, no. Then I got a break. The messenger had stupidly left his name and address on the magazine, and I tracked him down. He lives—lived—on the other side of London."

"Why do you say 'lived'?"

Waddington paused and took a choking swig of his Bloody Mary. When he recovered he said: "The man I eventually came face to face with was called Frampton."

The name produced no noticeable effect on Keating.

"You obviously don't study the tabloids very closely."

"I don't take them, and in any case I only read the financial pages."

"Frampton and his father were taken out. The father had his head blown off, and his son, the one I met, was tortured and mutilated."

"Jesus Christ!"

"That's why I sought sanctuary with you, and I apologize for that cock-and-bull story about a difficult time with the wife."

"Don't worry. I understand. Have you told anybody else?"

"Not officially. I contacted an old mate I know at the Yard, somebody I could trust, and he was the one who advised me to go to earth for a while."

"Good advice." Keating stared at him before speaking again. "You say you tracked down this Frampton?"

"Yes, I met with him finally. God knows how he got chosen by Hillsden as a messenger boy; the poor devil was scared shitless."

"He'd met Hillsden?"

Waddington nodded. "In Leningrad, while he was on holiday."

"And what was the message?"

Perhaps the unaccustomed vodka so early in the day had weakened Waddington's normal caution, or perhaps the added complication of Pamela had thrown him, but having revealed most of the story he now went on to complete it. "Well, according to this Frampton, Alec"—he slipped easily into the use of Hillsden's Christian name—"has written his memoirs and wants to get them out. Now that could bear out what I've always thought—that Alec was set up, that he knew too much, and that now he wants to blow it sky high. It holds up, in my opinion."

"Why are you so sure?"

"Somebody out there thinks the manuscript is worth killing for. So you see what trouble I've brought into your house? If what he told me

is true, I'm back in the game whether I like it or not, and bad news as far as you're concerned."

"Forget that. You came to the right place."

"If you want me to go—"

"My dear chum, *mia casa,* et cetera. It's a problem, but not insurmountable. I'm equally concerned about your girlfriend. What's her name?"

"Pamela. Pamela van Norden."

"Is she Dutch?"

"No, that was her married name. She's divorced," Waddington said, suddenly wondering if they would ever make love again.

"We must hope for the best."

There was a smear of tomato juice on Keating's lower lip, and as he pulled himself out of his chair and went to the desk he seemed larger than ever, ballooned within his single-breasted suit like a fat man drawn by a child. "You know what I've been thinking?" he said.

"What?"

Keating picked up another copy of the film script and waved it. "Leningrad, right? Perhaps the unspeakable Mr. Raven has done us a favor . . ."

Conjecturing about her future sex life was not one of Pamela's priorities at that moment. Like the rest of the hostages she had scarcely slept for the past forty-eight hours. Fear and fatigue had reduced most of them to crumpled heaps. Apart from a few sandwiches and canned drinks, none of them had had much sustenance since the original departure from Marseille, and the food brought on board when they landed in Libya had proved inedible to most. Personal hygiene was a thing of the past, and for most of the hostages disorientation was complete: they could not remember life before the hijack.

In the cockpit the Captain and his copilot slept while the Fat Boy continued his dialogue with the Libyans. He argued a dozen scenarios, sometimes screaming in rage when his propositions were rejected. If he was exhausted, he showed little sign. One of the differences that had particularly enraged him was a demand for payment if the plane was again to be refueled. The Fat Boy had made a rare slip by telling them he had half the ransom money on board, and this factor, more than the fate of the hostages, had become the major issue. The Libyans were playing a double game and stalling for time, neither rejecting his de-

mands outright nor agreeing to them. In the past year, faced with a growing crisis in their economy, they had been attempting to repair their image with the West, while at the same time covertly continuing to train and support several terrorist organizations. Basically their policy had not changed; it was merely presented to the world in a different guise. Hence opinion within the governing ranks was sharply divided: one faction favored giving the Fat Boy every assistance; the other was for storming the plane and thus enhancing their image in the West. There was also a third group pressing for freeing the plane but allowing the three terrorists to escape. The Colonel remained uncharacteristically passive through all these sessions and so far had not come down in favor of any of the options. His only positive act had been to place all the Libyan armed forces on a war alert in case the American Sixth Fleet mounted a rescue attack. There had been considerable air activity picked up on Libyan radar, and on two occasions Libyan fighters had been scrambled to investigate invasions of their airspace.

Back in Cyprus, with the Turkish plan having been thwarted, the Swiss were urgently considering their own military options. Once they established the second destination of the plane, they made use of all available intelligence and studied the feasibility of an Entebbe-type assault, requesting help from Israel's Sayaret Matkal unit, which specialized in desert operations. Spy planes from the Sixth Fleet had provided photoreconnaissance pinpointing the exact location of the hijacked airliner, but the White House had so far refused to be drawn further into the conflict. The new President had been in office for less than a year and had his own domestic problems; he was not inclined to risk offending the OPEC bloc and possibly provoking another oil crisis. But he too had a problem with the hawks and doves in his cabinet and was being pressured by the Jewish lobby. The big question mark all the would-be rescuers faced was the unpredictability of the Libyans and the very real fear that any assault would inevitably put the hostages at risk.

World media sought to make as much capital out of the incident as possible, for sadly it is a quirk of human nature to be both fascinated and horrified by such crises. Only the families directly involved knew that anguish was not a spectator sport manufactured to sell newspapers and fill television screens.

"What this country needs is a kick up the arse," Pearson said out of the blue.

"The question is, whose arse?" Lloyd observed.

"If we knew the answer to that, we would have the secret of semieternal life."

At that moment Pearson's private phone rang. He hesitated before lifting the receiver. Listening, he said, "Oh, yes. Will you hold a second? Lloyd, get me the Mitchell file, will you?" He waited until Lloyd had left the room before resuming the telephone conversation. "Waddington, you still there? Or I should say, where are you?"

"As you advised, tucked away out of sight. Any developments?"

"No. All blanks so far. It's being treated as a racist killing."

"Racist?"

"Yes. Apparently the old man held most of his neighbors in contempt. Made no secret of it. Practically everybody in the street is a possible suspect."

"Do you believe that?"

"No, but it's keeping the C.I.D. boys busy. How's your own situation?"

"Well, I'm okay at the moment, but obviously it's not a long-term solution."

"Do you have a number you can give me?"

"Yes. Like yours, it's not for general circulation."

"Understood." Pearson reached for a ballpoint pen, which naturally was dry. "Hold on. Whatever happened to the old-fashioned fountain pen?" He grabbed a pencil, and the lead immediately broke. "Shit! Tell it to me and I'll remember."

Waddington did so and Pearson went on. "I'll be in touch the moment anything breaks. I'm following up a few things that might dovetail. Meantime, keep your head down."

"You don't have any inside gen on the hijack, do you?"

"Only that it's still in Libya. No further killings reported."

"Thank God for that. I've a particular reason for asking. I know somebody on board—one of the hostages, in fact—so I'd be grateful for any news. It will probably come through to you first."

"That's tough. I'm sorry. Give me his name."

"Her. It's a Mrs. van Norden. Pamela van Norden. She's British; that was her married name."

"I'll find out what I can." Pearson hung up and went into the next office, silently repeating the number until he found a usable pen. Returning, he found Lloyd leafing through the Mitchell file.

"Anything new?"

"Not new exactly, but I've just spotted something in his diary we missed before."

"What?"

"There are two entries a month apart, the last one for the day we found him." He pointed and handed the file to Pearson. "Admittedly on their own they don't mean much."

Pearson studied the entries. "'PP'? Could mean anything." He turned the pages. "He's got others. Here. 'MD' on this page, 'TSB' here. People always jot down initials and abbreviations; I do it myself."

"I agree," Lloyd said, "except that if you turn back a few months to January, he's written 'Peter Pan.' "

"How did you spend your childhood? Didn't you ever go to *Peter Pan*? Traditional Christmas outing, and they always run it into the New Year. All that means is that he went to see it."

"Except," Lloyd repeated, "where did they find what remained of him? In Hyde Park, right?"

"Yes."

"And we know he didn't die there. He was shot and then put there."

"So?"

"What's just across the park in Kensington Gardens?"

"More grass."

"The Peter Pan statue."

"Okay, what does that prove, apart from having the same initials?"

"Well, there's a proximity."

Pearson lit a cigarette, already losing interest but trying to be patient. "Go on."

"Hypothesis: at certain intervals he met somebody by the statue, and on that last occasion that somebody killed him."

"Brilliant. Why didn't I think of that?"

"Don't take the piss. I'm only trying."

"You mean he arranged to meet a fellow transvestite to swap underwear and the other guy didn't like what he brought, so first of all he shot him, then carried him across the park to the Round Pond and planted a sophisticated bomb under him? Who are we looking for, Captain Hook? You're one of the Lost Boys, Alan, living in Never-Never Land, or else you've been drinking too much canteen tea. Come on!"

"I wasn't suggesting that."

"So what *were* you suggesting?"

"I don't know yet. I just think it's a possible connection."

"Good. Well, you follow it through. Put on short trousers, take a skip rope and stake it out. When they arrest you for child molesting, don't depend on me to stand bail," Pearson said and walked out of the room.

There was a Russian military mission permanently stationed in Tripoli, composed mostly of G.R.U. personnel, the senior officer of which had conveyed Geichenko's extreme views on the conduct of the hijack. The Colonel had been left in no doubt about the Kremlin's attitude. It did not suit Moscow's plans for the Middle East to become even more volatile; it was too close to their own borders and ethnic problems.

Even in the face of such pressures, the Colonel still played his usual poker game, disinclined to give something for nothing. He enjoyed horse trading and was holding out for a badly needed arms deal in return for compliance with Moscow's wishes. The Kremlin, in turn, had no intention of leaving the field open for the Americans to step in and grab all the glory for a successful rescue. The Russian ambassador to the United Nations had been instructed to put down an emergency resolution in the Security Council condemning all such terrorist acts; in London, Bonn and Paris other diplomatic moves were under way to assure the Western powers that Russia had no intention of taking unilateral action. But since the game was being played at different levels, at the same time the Kremlin was circulating another version, letting it be known that if the American Sixth Fleet moved Russian intervention was inevitable. None of the participants was fooled by such maneuvers.

These developments suited Bayldon's purpose: he was quite content to let the Russians handle it, for Britain still had no diplomatic relations with the Colonel's regime. He made a token statement denouncing the hijack and expressing sympathy for the victims and privately ordered the S.A.S. unit to stand down.

Eventually, having satisfied his own ego and having reached an understanding on the arms deal, the Colonel stated his terms. In return for the terrorists parting with the major share of the ransom money, the Libyans would mount a dummy assault on the plane under cover of darkness and guarantee that no serious harm would befall the hostages. The terrorists would then be spirited away and the plane allowed to be flown back to Switzerland. This solution again demonstrated the Colonel's flair for unpredictable behavior—cynically presented and cynically agreed to. He would thus show his new humanitarian face to the world

while keeping faith with the terrorists and pocketing his share of the spoils. It was generally felt that in the relief of the rescue operation, the killing of the hostage in Cyprus would soon be forgotten—as in time proved correct.

There was one last stall while the Fat Boy held out for a larger slice of the ransom money, but he knew better than irrevocably to antagonize the Colonel, who had long been his principal paymaster.

Elite units of the Libyan army duly mounted the rescue operation, and the full drama was filmed for world consumption. The task force used stun grenades and dummy ammunition to create the maximum noise and confusion without loss of life. Although a dozen of the hostages received superficial wounds during the scrambled evacuation and two small children suffered damage to their hearing, the bogus mission gave the impression of great daring and efficiency. The Fat Boy and his two companions were shown being taken away, but later bulletins about their subsequent fate were deliberately vague. The Swiss were allowed to bring in a relief flight crew, and once the plane had been certified as airworthy it made the journey home, again with full media coverage. All in all the Colonel achieved a notable propaganda coup at no cost.

The episode concluded, Geichenko turned his attention to more pressing issues. "Operation Medusa," targeted on Bayldon's wife, had already been set in motion, and it was vital that London be kept fully in the picture. Further delays in the long-term strategy could not be tolerated: the fledgling American President was just as hawkish as his predecessor, and despite a mounting budget deficit there were no signs that he or Congress intended to cut U.S. arms expenditures. A new bomber with a dramatically reduced radar profile, currently beyond the resources of the Russians to counter, had recently been unveiled. It was imperative that Bayldon be toppled so that the disintegration of NATO could be hastened. The line of direct communication with London having been broken with the murder of Mitchell, it was vital to mend the link as soon as possible.

Pamela arrived back at Heathrow with the other British hostages to find the airport awash with television crews and reporters, all anxious to reduce a human nightmare to soap opera proportions. At the first opportunity she dodged into the nearest toilet and remained there until she judged it safe to emerge; she knew the dangers of exposure and had no wish to have her face plastered all over the front pages. There was no

question of contacting Control; it would be up to him to signal the time and place of their next meeting. She hired a chauffeur-driven car at the airport and drove to her country home, rehearsing a version of the events to relate to Waddington.

Much to her surprise, he was not there to greet her. Instead she was given a message by her staff that he had been called away on business and hoped to contact her shortly. He sent love and was overjoyed that she was home safe and sound. Having prepared herself, she was slightly put out by his absence, but, exhausted by the recent ordeal, she took to her bed and slept around the clock.

Watching the television coverage of the hostages' return, Waddington was perturbed not to spot Pamela among them. He again telephoned her house and was relieved to be told that she had arrived safely but was not taking any calls. He left word that he had rung, but carefully omitted giving his own number. He was faced with a delicate situation where Pamela was concerned; he was anxious to see her again, but didn't know how or when, and he was unwilling to involve her in a dangerous situation.

In Leningrad, denied his own culture and friends and prey to the fear that at any moment the existence of his manuscript would be discovered, Hillsden had by now convinced himself that Frampton had failed to make contact with Waddington. What had once seemed a reasonably viable scheme now assumed the form of a nightmare.

Normally he and Abramov met regularly once a month when Hillsden delivered his reports on the London traffic. For some reason, which he now regarded as sinister, Abramov had missed a month, so it was in a mood of fearful uncertainty that he got a telephone call from Moscow one morning when Galina was out of the apartment.

"I called you to say good-bye, Alec," Abramov said. "We won't be seeing each other for a while."

"Why is that?" Hillsden kept his voice steady, though a nerve in his right leg went into spasm, and he put a hand on his thigh to try to control it.

"I have been posted to London, and leave tonight."

"Earlier than you expected."

"Yes. It's good news."

"For you."

"I will send you some of your favorite brand of cigarettes in the

diplomatic pouch. Or anything else you think of. Just let my office know and they'll forward the request."

"Thank you."

"Just one thing you can tell me. Where is the store of Marks and Spencer?"

"*The* store? There's more than one; they're all over London. Your nearest branch would be in Kensington High Street, close to your embassy."

"I must note this. Say again, please."

"Kensington High Street."

"Got it. Well, I shall miss seeing you, Alec."

"Likewise. Have a good trip."

"Oh, by the way, I nearly forgot. There was some news from London that concerns you."

Now it comes, Hillsden thought, and braced himself for the worst. "What was that?"

"That man you met here, the English tourist."

Hillsden's immediate reaction was to jump on it quickly, rather than pretend he had forgotten the name. "Frampton, you mean?"

"That's right. The strangest thing . . . apparently he was murdered. Some reports suggest that his father killed him and then took his own life. Very Grand Guignol, from all accounts."

He's playing with me, Hillsden thought; he's concocted this story to trap me. "Well, I'm told the majority of murders are domestic. . . . So my well-intentioned efforts to recruit him proved a waste. Pity. He might have served a useful purpose."

"It was worth a try, Alec. Everything is worth a try. Anyway, my friend, I thought you'd be interested. Keep well."

"You, too. Bon voyage."

Hillsden put down the phone still uncertain whether Abramov had been testing him. He searched the apartment for his hoarded copies of *The Times,* hoping he might learn more details of the murder, but could find no mention of it. That was not peculiar; *The Times* never devoted much space to crimes of that sort. Only scandals in high places merited its full attention. He sat down in the kitchen and tried to think it through. If Abramov had merely related the truth, it was still too much of a coincidence that Frampton had come to a sticky end so soon after their encounter, and it left the big question mark: had he managed to get word to Waddington before being murdered?

He remained motionless, the virus of doubt coursing through his veins, thinking how everything could be made into a plot. How conveniently they had agreed to his request to live in Leningrad. Hadn't it been Abramov who had suggested enrolling at the university? What if he had instructed Galina to seek him out? Sex was one of the most potent weapons in the armory of subversion. I've used it myself in the past, he thought; I even used it on the pathetic Frampton. Then again, how quickly Abramov had agreed to the blackmail ploy; had it all been too easy, too pat, something he should have spotted?

Consumed by these dark thoughts, it was with the fear of betrayal uppermost in his mind that he greeted Galina on her return.

"Anything wrong, darling?"

"No."

She came to him, put her arms around him and kissed him. "You want to hear some good news?"

"Why not?" Gently he disengaged himself from her embrace.

"Remember what you said the other day?"

"Which day was that?"

"When we made love and you felt sorry for yourself?"

"Oh, that day. Don't you mean when we *didn't* make love? What did I say?"

"You blamed yourself."

He had no idea where the conversation was leading, except that it fed his suspicions.

"You didn't need to," Galina continued breathlessly, her face flushed with a kind of happiness he had not seen for a long time. "Because I'm going to have your child. I'm in the third month; the doctor confirmed it today. That's where I've been. I didn't tell you before in case it was a mistake." She searched his face. "Are you pleased?"

Hillsden stared back at her, unable to take it in.

"Are you?"

"I'm pleased if that's what you want."

"You have to want it too. Don't you want it?"

He answered slowly, "My dear, it's not a question of want. Want is something you think about beforehand. I never thought of starting a family at my age."

Her mask of happiness slipped. "Are you saying you'd rather I got rid of it?" Hillsden paused for too long. "I could; there's still time. I

don't want to make more trouble for you. Is it you feel trapped, is that it? I didn't set out to trap you; it just happened."

"No, it's not that. I was trapped long before this." The words were out of his mouth before he could stop them. Seeing disappointment flood into her face, he gathered her to him and kissed her. "You've never made trouble for me, and I wouldn't let you get rid of a child we'd made. It *is* good news, very good news. I just have to get used to it."

"Didn't you ever get a girl pregnant before?"

Hillsden shook his head. "Believe it or not, no, but I guess it was a matter of luck rather than of good judgment." An image of Caroline swam before his eyes: Caroline in Austria, in the last days before she went back into East Berlin. Then reverse blackmail had been constantly in his mind: the man trapping the woman, getting her with child in order to hold her.

"Shall we have a drink?" Galina was asking.

"Should you?"

She burst out laughing, the tension suddenly dispersed. "How funny you are, you men. Immediately you become protective. Nothing's going to happen because we have a few drinks to celebrate. . . . You are truly pleased?"

"Yes," he said, cradling her face on his shoulder so that she could not see his expression. "You see, the trouble is that I've only been trained to recognize hate. Love always takes me by surprise."

19

BAYLDON COULD NEVER walk past the array of portraits of previous occupants lining the staircase of 10 Downing Street without a tremor of satisfaction. Being Prime Minister, surrounded by the hand-picked team of his private office, all of whom had a vested interest in keeping him

sweet, had proved a heady experience. The times when he gave some thought to the manner in which he had been elevated were spaced further and further apart. Conveniently, he had developed amnesia where that part of his life was concerned.

The mechanics of modern government being so complicated, those at the top of the pyramid are invariably isolated from the truth, hearing and believing only what their conceit wants them to hear and believe. This was certainly the case with Bayldon. There was safety as well as power in having arrived, for one could always evoke the democratic ethos to stifle the small voice of conscience. Yet in recent weeks, beginning with the meeting with Control, even Bayldon had become aware that there were rumblings of discontent within the ranks. A score or so of his backbenchers and one member of the Cabinet had abstained on a vital vote. This had given transient cheer to the demoralized Tory ranks—which in itself did not bother him, but he took the revolt as a direct challenge to his authority. It was no secret that the dissenters had been led by Deacon, who was still smarting at being denied a major ministry. Not that he feared Deacon—the man still did not command sufficient support within the National Executive Council to constitute any real threat—but his arrogance so matched his own as to be a constant source of irritation.

"Is there any way," Bayldon asked the Home Secretary, "that we can find out whether Deacon has been meddling in matters of security?"

"Meddling? How d'you mean?"

"Does he have any contact with Lockfield, for example?" Bayldon asked the question with studied casualness.

"Why Lockfield in particular?"

"I don't know. It just occurred to me that our friend Deacon seems to have an inside track on certain subjects. His intelligence is alarmingly accurate, and the papers always give him so much space."

"He keeps his ear to the ground, to be sure, and of course the papers like nothing better than a homemade vendetta."

"I don't mind admitting, Richard, that he's a bloody thorn in my side."

"Promote him."

"I did offer him something, as you know, but he had the nerve to turn it down. Said he'd only accept one of three jobs, one of which happened to be yours. Didn't I tell you at the time?"

"No."

"I thought I did."

"He had a bloody nerve."

"Just an eye for the main chance, like us all. Might be worth our while to dig a little around his patch. Perhaps you know of somebody reliable who could keep a closer watch on his activities."

"Tricky."

"Why tricky?"

"We could be rumbled."

"Oh, we mustn't be rumbled. I rely on you to ensure that. Something very discreet. You'll find a way if you put your mind to it. Things are going so smoothly; it would be a pity if Deacon rocked the boat. He's getting too big for his boots."

"He's always been an arrogant bastard."

"Well, see what you can come up with. Never know when it might come in useful. You wanted to see me about something, I believe?"

"Yes." The Home Secretary hesitated.

"Not about the militia, I hope. I know you received a deputation from the Chief Constables."

"No, I dealt with that. I don't quite know how to put this to you, and I don't want you to think that I'm just carrying gossip."

"I enjoy good gossip, as long as it's not about me," Bayldon said.

"It doesn't concern you personally, but it is very close to home."

Again the Home Secretary hesitated, and Bayldon got impatient.

"Tell me, then!"

"I've received a report from MI5 in Belfast that certain rumors are freely circulating about your wife."

"What sort of rumors?"

"Obviously without foundation, but potentially highly dangerous."

"Richard, just give it to me straight."

"The story is that she has secretly donated large sums to the I.R.A. through NORAID."

"Balls."

"Okay, I agree, no truth in it whatsoever; nevertheless, good ammunition to use against you if it got into the wrong hands. They appear to have some evidence."

"What evidence could they have?"

"Photostats of checks with your wife's signature on them."

"I don't know why you bother to repeat such crap. They couldn't possibly be genuine; they're obviously forgeries."

"Toby, don't attack me. I didn't invent the story; I'm merely bringing it to your attention."

"Can you seriously believe that Linda would do such a crazy thing?"

"Of course not, but you wouldn't thank me for ignoring such a report. I have to protect you; that's part of my job. The rumors appear to have originated in New York."

"That doesn't surprise me. The Yanks are capable of anything."

"Granted the checks are forgeries, what happens if they surface here?"

"Presumably they're drawn on a bank, yes?"

"Yes."

"We get the chairman of the bank to issue a sworn statement that they're fakes. End of story?"

"Except," the Home Secretary said, "it's not a British bank. It's in the Cayman Islands."

"So what's the difference? Get *that* bank to disown it."

"You're forgetting something, aren't you? We brought back exchange controls. . . . No British subject is allowed to have a foreign account; we've made it a criminal offense."

"I know that!"

"Mud sticks."

"Don't give me that. Linda doesn't have a foreign bank account."

"Difficult to prove, though. There might be a lot of people who wouldn't give her the benefit of the doubt."

"Nobody would print it, and if they did we'd slap such a writ on them they'd wish they never had."

"They might accept it. They don't exactly shy away from printing libels or defending them. Linda would have to go into the dock. Hardly dignified for the Prime Minister's wife. They'd have to throw everything at her." He met Bayldon's outraged stare without flinching. "I'm just being devil's advocate, Toby. Whoever started the rumor dotted the *i*'s."

"What's that supposed to mean?"

"It's been put together very skillfully. Linda's second-generation Irish American. NORAID is one of the main sources of I.R.A. funds. They could make a lot of waves with those two facts, plus the forged checks."

Bayldon recovered his composure. "Has anybody seen the checks?"

"Not the actual ones. But MI5 has received photostats."

"How much are they for?"

"Half a million dollars."

"And the signatures?"

"I'm told they're very good, Toby, not amateur efforts."

Bayldon paced the room. "It's a plot."

"Yes, obviously."

"Well, get the police working on it."

"Is that wise? I'd suggest we leave it with MI5 for the moment. Right now it's confined to Belfast; there's always a chance it won't cross the water. If we open it up, the possibility of a leak is much stronger."

"Jesus Christ!"

"The other piece of information I have is that the security forces in Northern Ireland are certain that a large shipment of arms for the I.R.A. has slipped through the net. They got the tip-off from one of their undercover men, but before he could tell them where, he was executed. In the wrong hands, it could all be made to add up."

"So what do we do?" Bayldon demanded.

"Sit tight for the time being. See what develops."

"Do I tell Linda?"

"I wouldn't, if I were you. There's no point, unless events force you to."

"You're probably right. And here I was thinking that Deacon was my only problem." Then Bayldon added, almost as an aside, "I trust Linda. She wanted this even more than me."

When the meeting ended, the Home Secretary gave more thought to this remark than to anything else they had discussed.

Abramov enjoyed his first weeks in London. He had, of course, entered the country under a false name. His passport stated that he was Oleg Besedin, a director of the State Publishing House in Moscow and a professor of English at Kiev University. Deliberately he was not traveling with diplomatic status, Geichenko having decided that the familiar ploy of using trade delegations to mask covert activities had been dangerously overworked. In the more relaxed atmosphere of *glasnost* reciprocated by Bayldon's government it was felt that a private citizen with distinguished credentials could move about with more freedom. This notwithstanding, within the embassy he outranked the resident G.R.U. officer and, if required, could avail himself of all embassy facilities. The calculated risk was thought worth taking.

Abramov was ostensibly charged with setting up an Anglo-Soviet publishing house capable of challenging the American and Australian

conglomerates. Booked into the Park Lane Hilton, he occupied a carefully chosen corner suite and for the first few days behaved like an average tourist, visiting bookshops and museums and avoiding all contact with the embassy. Then, working to a prearranged plan, he rang the first secretary and requested an appointment with the ambassador. This was an elementary test to establish whether his phone calls were being monitored. If he was subsequently tailed, a second plan would be put into operation. He took a taxi for his appointment with the ambassador, and though he expected his visit to be noted by MI5 or Special Branch, he could detect no sign of undue surveillance. The ambassador thoroughly briefed him on the current London situation and in turn received his own instructions. A series of meetings with leading British publishers had been set up in advance, and Abramov had come armed with genuine commercial proposals to put to them, since his cover was not without substance. The carrot he was empowered to offer was that if the joint venture became a reality, the Soviet government was prepared to accept what had hitherto always proved a stumbling block: the payment to foreign authors of their royalties in hard currency.

The ambassador hosted a reception at the embassy that was attended by most of the leading publishers and literary agents, together with a number of well-known authors and executives from the Writers' Guild. Some came out of curiosity, thrilled at the chance to step inside the embassy, but the majority went because they welcomed what could possibly be a major breakthrough for their lists and clients. Abramov gave a short speech, addressing himself to the central theme of closer ties between the two literary communities and stressing that if a deal could be consummated there would be no censorship of the material. "Though obviously you should not expect large sales, if the books you send us are hostile," he told them with great charm, adding, "except for Stalin—you can write what you like about our great butcher." His impeccable English relieved the British contingent from the normal boredom of having to listen to everything twice through an interpreter, and he impressed his guests with his grasp of the fundamentals. The evening was accounted a major step forward, and he scored a personal success. Before his guests departed a working party agreed to meet in a few days' time and he received numerous invitations to dine out.

Abramov followed this with a series of meetings with individual publishers and agents, collating all the points discussed and promising to come up with a summary from which the working party could draw

up an agreement. "I shall stay as long as it takes," he told his hosts. "I have no wish to go back empty-handed."

Only when he was confident that his day-to-day movements were not being too closely scrutinized did he set about making contact with Pamela. During one of his many meetings with literary agents, he asked if he could use a spare office while drawing up a legitimate publishing contract. He used the occasion to phone Pamela at her unlisted number and to assure her that despite the hiccup brought about by her delay in reporting back to Control, Operation Medusa was on course and the second stage was to be put into action the following week.

Neither Pamela nor Control had any inkling that during the final stages of the hijack Geichenko had revised his strategy; he had struck his own private bargain with the Colonel while negotiating the terms that ended the incident. Medusa had been conceived by the K.G.B. but he had penetrated the team responsible at Moscow Center, subsequently using Abramov's Marseille rendezvous with Pamela to give London the impression that it was his show. He was content to let it run its course; if it worked, all well and good, but at the same time he had set in motion a final solution to the British problem. Abramov had been instructed to play it straight, but to start laying a few traps and to make his own contacts. It was important to establish that the K.G.B. had no real grasp of the situation, and ultimately to discredit them. Geichenko was confident that he possessed all the necessary ingredients to bring this about.

In due course Pamela reported their conversation to Control.

"In future he insists we use a dead-letter drop."

"Did he nominate one?"

"Yes."

"Which?"

She told him.

"Why there?"

"He said it was conveniently near the embassy."

"Well, be extra careful."

Control lit one of his rare cigarettes, a sure sign that he was edgy, then switched the conversation abruptly to Waddington, asking for an update.

"I haven't seen him since I returned."

"Why not? You told me he'd moved in."

"He had, but he wasn't there when I got back."

"So where is he?"

"I've yet to discover, but I'm working on it."

"He's made no attempt to contact you?"

"He's phoned, but he never leaves a number where I can reach him. I checked with the outfit he worked for, but apparently he handed in his notice and they have no idea where he went."

"How about his house?"

"Empty. He hasn't been near it."

"Well, don't let up. I want to know soonest."

"I said I'm working on it. Leave it to me. I'll find him," Pamela replied with more confidence than she felt. Control scared her.

20

BAYLDON WAS IN a panic. Although his wife did not have an account in the Cayman Islands, he was well aware that, relying on her American origins, she had never declared the existence of a Swiss numbered account to anybody but himself. "I can always plead ignorance if it ever came out," she had told him when the new regulations were passed. "After all, Daddy set it up for me long before your stupid rules were thought of."

"The laws of the land may be stupid, in your opinion, but they're there to be obeyed."

"Well, there's no way I'm going to close the account, so it's a waste of time talking about it. It's my nest egg."

As soon as he learned of the existence of the plot Bayldon had questioned her again. "You do realize, don't you, that if anything did come out it would reflect very badly on me? The Swiss code of secrecy can be broken these days. It's never admitted, but it has happened with Mafia funds and laundered drug money. Zurich has been very cooperative lately."

"Sometimes I think this job has softened your brain, Toby. What has my little savings account got to do with the Mafia and drugs?"

"I'd hardly describe it as little. When we married your father settled three million dollars on you."

"You think that's a fortune?"

"To most people, yes."

"Of course, you've never had money; all you've ever had is a talent for spending other people's."

"Thank you."

Bayldon could not make up his mind to tell her the whole truth. If, as he prayed, the rumor died a natural death, he would have scared and antagonized her for nothing, and their relationship was delicate enough as it was. Since he had come to power she had made few friends outside her own circle and was quite openly critical of most of his cabinet, describing them as "the second-rate in pursuit of the third-rate." On the other hand, should his efforts to stifle the rumor fail, it would be impossible to avoid some very awkward questions. Her gibe about money had gone home: he had always relied heavily on her personal income to fund his ambitions, and she had never forgiven him for choosing the wrong party.

"If only you'd had the sense to join the Tories we might have been able to lead a normal life."

"What d'you call 'normal'?"

"Well, it certainly isn't playing hostess to a lot of trade union officials and their dowdy wives."

"Do you imagine I'd have got to Downing Street if I was a Conservative? I'd still be on the back benches. I thought you Americans were so anticlass. Well, class still counts for everything here, and that's what we're out to correct."

"Bully for you."

Thus the argument went back and forth while Bayldon searched for a way in which to warn her of impending events. He derived no comfort when he discussed the situation with Control.

"You're on the firing line, Toby. You poked your head over the parapet a long time ago; you must expect to draw fire."

"But this whole thing is a complete fabrication."

"I believe you, but it would be foolish to expect others to take the same attitude. Many a good man has suffered because his wife shot him in the foot. It's the very stuff that scandal is made of."

"I don't want to hear that. I want something done, and done quickly."

"We're working on it night and day, Toby. Everybody has your best interests at heart, but scotching rumors isn't the same as tracing an electrical fault. The wires lead everywhere. I hate to put it this way, but you're quite certain there is no substance to the story?"

"My wife has assured me she does not have an account in the Cayman Islands."

"Then you've no worry on that score. And naturally her sympathies are not with the I.R.A.?"

"How could they be?"

"No, of course not. Even so, it might be worth checking with the C.I.A. whether any of her family has opposite views. The professional Irish in America are often more rabid than the genuine article. If there is any distant connection, we ought to be forewarned. I'm told that in Disneyland on St. Patrick's Day they color everything green. Even the bagels," he added inconsequentially.

Bayldon swept this piece of folklore aside. "I don't trust the C.I.A. For all we know, they set the whole thing up. There's every indication that the rumor was first planted at the United Nations."

"Perhaps we're running ahead," Control said, "allowing ourselves to be panicked for no good cause. Put it this way: were we out to frame somebody, we'd play the same game. Dream up something that's close enough to be possible, add a few trimmings that sound authentic, and then sit back to await results."

"Is that meant to be reassuring? It seems to me you're taking it all very casually on my behalf. I'd remind you that if I'm damaged in the process it will hardly further the cause."

"Did I give that impression? If I did, it was not intentional. I'm convinced there is no truth to these terrible allegations. After all, I have your word for it, and that's good enough for me. However, I doubt whether you'd thank me if I pushed you into a public denial too soon in the day. One should never deny anything, true or false, until it's absolutely necessary. If political history has proved nothing else, it's proved that time and time again."

"I've given considerable thought to our problem," Keating announced over breakfast, helping himself to a generous portion of scrambled eggs and smoked salmon, "and I think I've refined it." He reached into the basket of hot toast cut into identical triangles. "In the beginning was the

word. The solution came to me last night. The script, the screenplay." He paused for effect, and Waddington waited. "They'll be taking at least forty copies into Russia, when you count all the artists and members of the unit, so it becomes a simple matter of arithmetic."

"Arithmetic?"

"Yes, forty in and thirty-nine out. D'you follow me? It shouldn't be beyond the wit of yours truly to make a swap: Hillsden's manuscript inside the cover of my script."

"How d'you mean, *you'll* make the swap?"

"Exactly that."

"You'll go to Leningrad yourself?"

"I'm entitled, chum. More so than the dreaded Raven. I'm the money man, remember? I foot the bill, and there's nothing your average Communist likes better than the man with the bankroll—especially when it's hard currency."

"I never thought of you going."

"But isn't that the answer?"

"Yes, if you're prepared to risk it."

"What risk? I've got a valid visa, I've even got a credit as executive producer. No problem."

"The problem will be making contact with Alec."

"I've even thought of that. Did you read the script?"

"Yes. I don't pretend to have understood it. It seemed very technical to me."

"Well, in the Leningrad sequence we need a certain number of extras to play British tourists. They have to look authentic. Can't have the screen full of Mongolian faces above Berman suits. My location manager will ask the authorities for permission to use the real thing. We'll get in touch with him privately and suggest that he apply."

"If you say so."

"It's another world, chum, the film business. I've learned that. They seem to have amazing chutzpah, these film types—never take no for an answer, barge in where angels fear to tread."

"Okay, I believe you. But assuming that part of it works, you've still got to bring it out. They could search you."

"Don't forget I won't be traveling alone, and the rest of the crew will be carrying their copies of the genuine article. There's safety in numbers. In addition, and most important, the local Gestapo will be familiar with the script. Before they gave permission and provided the facilities, it had

to be submitted and approved. That's the beauty of it—prior approval, like clearing Customs before you arrive. No, as I see it, the area of risk doesn't lie there, but with Hillsden himself."

"Why with Alec?"

"He's got to be persuaded to part with it, hasn't he?"

"I don't follow you," Waddington said.

"What's the *Good Housekeeping* guarantee I give him in exchange? Put yourself in his shoes. He sent word to you some months ago. Since then, silence. He has no way of telling whether or not you ever got the message. Has he been betrayed? Are they just sweating him? By now he's anxious, very anxious, waiting for that knock on the door we all fear. Then I turn up out of the blue. Who am I? Is it a trick? Does he even remember me from the old days? Or if he does, why should he trust me?" Keating extracted a sliver of smoked salmon from between his teeth and positioned it carefully on the side of his plate. "It's one thing for me to ask for it, quite another for him to admit it exists, or to part with it. I'll need to go armed with something more than my pretty face."

"Some kind of password, you mean?"

"Exactly. You're not eating a very hearty breakfast."

"I am for me. Orange juice and a stale bagel are my usual welcome to the day."

"I can't function unless I'm stoked up. So what d'you think?"

"It really ought to be one of those trick questions the Resistance used in the war. Like how many runs did Len Hutton score when he slaughtered the Aussies. . . . Or . . . something only I would know, so that it ties in with me."

"Did he have a pet?"

"What? Sorry, I don't come to very quickly in the mornings."

"A pet."

"Yes. Yes, he did. He had a cat when he was married to Margot. A neutered tom."

"What was it called?"

"Wait a tick. He told me he took the name from a favorite book of his . . . MacDonald? No. Mactavish?"

"Macavity?" Keating asked.

"Say that again."

"Macavity."

"Is that from a book?"

"Yes. Eliot's *Old Possum's Book of Practical Cats.* Macavity was a mystery cat."

"That's it! I remember now. Alec always used to say, 'That bloody cat's a mystery.' There's your password."

Keating shook his head. "Not sufficient in itself. It needs something else, again something personal from you that you could put in a hand-written note. Didn't you and he operate from a bogus wine merchant's at one time?"

"Yes."

"What sort of stuff did you pretend to sell?"

"Piss mostly."

"Remember any particular brand?"

"There was a Romanian red we used to flog if any genuine customer wandered in by mistake. Cheap and nasty, would rot your guts if you drank more than two glasses of it, called 'Castle'—not Château, mind you!—'Castle Draz,' but we referred to it as Dracula."

"That combined with the cat should do it. Give me a note to take."

Waddington looked dubious. "I'm not too sure about the wisdom of that."

"I think we need it."

"Wasn't the Firm's motto 'Never commit anything to paper'?"

"Special circumstances. I'll only have one shot at it, remember. Just something short and sweet but in your own style."

"Okay, if you think so. When do you go?"

"The advance unit's already there. I travel with the main group in two days' time. By the way, while I'm gone take advantage of my absence and have the girlfriend over. I'm sure you both need to comfort each other."

"Are you serious?"

"I'm always serious about sex," Keating said, taking another helping of buttered toast. "Sex and food."

Unaware of these developments, Hillsden was still coming to terms with Galina's news. The prospect of becoming a father for the first time filled him with both dread and a kind of wonder. He remembered moments in his past life, with Margot, with Caroline, when the possibility of a child had been skirted but never resolved. Never promiscuous, for certain periods in his life he had been celibate—not always from choice but because in the field he had had no choice. Equally, he had been constrained by the chains of romanticism, a romanticism often born of literary associations; just as whole lives are shaped by a single childhood experience, his view of women had been taken, rose-hued, from the

231

books he had read in his formative years. There had always been an element of eroticism in the descriptions of his favorite heroines: in print they never changed, but could be returned to or conjured up during those nights when sleep evaded him. Age could never destroy their beauty; their responses remained constant. Even now, some forty years after first discovering Hemingway's youthful paean, he could not reread the description of Catherine's death in *A Farewell to Arms* without a profound sense of personal loss. Sometimes, as in Caroline's case, the fiction overlapped his own anguish, blurring the reality.

Now, with Galina carrying his child, he was torn between the moral dilemma and the wider issue of his secret manuscript. If the pages hidden within the lining of his overcoat were ever made public, as his wife she would inevitably be guilty by association, and he had no illusions about how she would be treated.

He allowed Galina to see none of this, treating her with new tenderness, becoming oversolicitous in his efforts to conceal his true feelings.

"I'm not ill," she said. "I'm just pregnant. I never felt better. Don't worry over me so much."

"I can't help myself. Does it irritate you, darling?"

"No, but you should see yourself. You're like an old hen."

"You mean an old cock. Well, that's for sure."

"The baby's not suddenly going to appear; I've got five months yet. There's plenty of time before you have to worry."

"How d'you mean, worry? What will happen then?"

"Nothing. About getting me to the hospital on time, things like that."

"Oh, I see."

He found himself unusually tongue-tied, unable to broach the subject of marriage openly, tackling it obliquely. A lifetime of deceit had not prepared him for honesty in matters of the heart. "Did you know that Spartan women had a ceremony of spanking unmarried men once a year?"

"Spank?"

"Smacking them. They were regarded as undesirables."

"Really? Why?"

"I suppose because they refused to accept the obligations of marriage—making a home, having children. They were considered traitors to their sex."

"It sounds very drastic, darling."

"I wouldn't want to risk you having to go to such lengths," he said, keeping the joke going. "To say nothing of the indignity."

"Is that your real worry?" she said. "That you have to marry me?"

"I'm an obsolete model. I still believe children shouldn't be born bastards." Even as he said it, he was conscious that it was not a very elegant proposal. "And yes, if you're going to have my child, I want to marry you."

"Are you sure? I don't want you to feel there is no way out."

Hillsden was now committed to whatever happened: the embryo she carried would decide both their futures. He could hardly believe that he had needed to travel so far from home to find a kind of love he had never experienced before, but as he pressed his face against her soft swollen belly a great wave of relief swept over him, and his tears dampened the fabric of her blouse.

"Is that what you want?"

"Yes," she said.

"It won't be easy, will it? I shall be a very ancient father. There's going to come a time when you'll both be on your own. Have you thought of that?"

"Don't talk about that, not now."

"It has to be faced, though."

"All I want to know is, are you sure, are you happy?"

"I'm very sure."

She tasted the salt on his cheeks as they kissed.

"Do you know yet whether it's a boy or a girl? Have they told you?"

"No. What would you like to have?"

"Aren't men supposed to want girls? I don't mind. I'll be happy with whatever you give me."

"Just so long as it's healthy," she said. "with ten fingers and ten toes. That's what my mother used to say."

Hillsden frowned. "What will she think? What d'you suppose your parents will say? Do they know about the baby?"

Galina shook her head.

"Do they even know about us?"

"They know I'm living with you."

"Will they be angry about the baby and about you marrying somebody like me?"

"Why should they? I love you."

"But—"

"No buts. They'll be happy if I'm happy. And I'm happy—very happy."

"You'll have to make all the arrangements. I've no idea how one gets

233

married in Russia. I've only seen Russian weddings on films—priests wearing golden crowns, like something out of *Ivan the Terrible*—but I'll go through with it if that's what you want."

"That's Russian Orthodox. We don't have to do that."

"We don't?"

"No. We get married simply, no problem."

"The sooner the better, then. I'll leave it all to you. Hey! A thought just struck me. Do I have to have a best man?"

"Best man?"

"Yes, in England the bridegroom usually chooses his oldest friend. The best man takes care of the bridesmaids and the ring. I don't have any friends here except you."

She kissed him again. "What a worrier you are. We don't need best friends; we have each other. Isn't that enough?"

"Yes," Hillsden said, "it's enough for me, more than I deserve."

21

THE SECOND STAGE of Operation Medusa began with a bomb placed in the Royal Mews at Buckingham Palace, causing extensive damage to the stables housing the state ceremonial carriages, though miraculously there was no loss of life. The explosive device, smuggled into the premises in a bale of hay, had been placed and activated by one of the grooms prior to going off duty. At the time the Queen was boarding an aircraft of the Royal Flight in Newcastle, where she had launched a new destroyer. Her plane was ordered to divert to an R.A.F. base in Norfolk, where an armed escort was provided for her journey to Sandringham. There, shortly before the royal party arrived, a second, larger explosion was triggered, destroying much of the staff quarters and inflicting numerous casualties. Seven fire brigades were deployed to contain the

subsequent blaze. The seriously wounded were ferried by R.A.F. helicopters to hospitals in nearby King's Lynn, and in addition to a massive police presence a company of the S.A.S. was flown in to provide extra security. Despite being advised to divert yet again, the Queen insisted on completing her journey to inspect the damage to one of her favorite homes and later visited the injured in hospital before taking another plane to Heathrow and thence to Windsor. The garrison there had been supplemented by a second S.A.S. unit. Bayldon and the Home Secretary were waiting to receive her at Heathrow and accompanied her to the castle. They outlined the measures already taken and obtained her approval for contingency plans. During this audience news was received that three of the Sandringham casualties had died. Most scheduled television programs were interrupted and replaced by extended news bulletins. Police forces throughout the country having been put on full alert, all other royal residences and principal government buildings were now being guarded by troops and tanks. More than the Birmingham pub outrages and the Brighton bomb that had killed members of the Thatcher administration, the incidents provoked widespread and immediate public outrage. Gangs of youths attacked known Irish neighborhoods in Liverpool and Glasgow, and Molotov cocktails were thrown at the Irish embassy in the capital, mounted riot police being needed to disperse the large crowds. In Northern Ireland members of the outlawed Ulster Defense Force carried out a number of sectarian murders; the Falls area of Belfast was subjected to a night of retaliatory terror, by the end of which the death toll had risen to thirty-four, the highest since Bloody Sunday.

The BBC and ITV switchboards were jammed by viewers demanding drastic retribution, the majority calling for a state of war to be declared. In Dublin, the Irish cabinet met in emergency session, later issuing a statement expressing their revulsion at these terrorist attacks and promising a stringent crackdown on all known I.R.A. suspects. This did little to appease the British public, and when the newspapers appeared the following morning they all carried front page articles strongly critical of Whitehall's security measures, many of them pointing out that it was only by a miracle that the monarch had escaped injury. The *Telegraph,* in a two-page editorial, stated that the Secretary of State for Northern Ireland should resign and be replaced by a military commander empowered to conduct a shoot-to-kill policy against terrorist elements.

"Enough is enough," the editorial stated in bold type.

There must be no further hesitation; the gloves must come off. The British people have suffered these outrages with fortitude for too long. These latest outrages against the royal family and their servants cannot and will not be tolerated by loyal subjects of the Crown. While we must avoid a policy of revenge, the perpetrators of terrorist acts must be ruthlessly hunted down, and if the authorities are not prepared to take the necessary measures, it will be difficult to contain the anger of the people. Not since 1939 has the country been faced with such a threat to national security. We did not shrink from the task in those dark days, and we must not shrink now. England expects the government to do its duty.

Immediately after his return from Windsor, Bayldon presided over a full cabinet meeting to discuss the crisis, and it was with relief as much as with honor that the Northern Ireland Secretary duly tendered his resignation. It was later announced that he would not be replaced; instead the Prime Minister would assume direct responsibility for Northern Ireland, and in future all security matters would be directed by Downing Street. The armed forces in Northern Ireland were to be increased by an additional ten thousand troops, and a bill to strengthen the existing provisions of the Prevention of Terrorism Act 1988 was to be rushed through Parliament. This was to include the reintroduction of the death penalty.

Bayldon hoped these draconian decisions would stifle the mounting criticism of his administration, but they played right into Control's hands; Operation Medusa was working as planned. By now Bayldon was aware that photostats of the forged checks were in the hands of the press. Earlier on the day the bomb attacks took place he had met at breakfast with the editors of the national newspapers and asked for their voluntary agreement to withhold publication of the story. The Attorney General had also been present at the meeting. After a heated discussion the editors had reluctantly given an undertaking to sit on the news for a further forty-eight hours on condition that Downing Street issue a full statement from Mrs. Bayldon refuting the allegations and backed by a full disclosure of her assets.

As soon as the Cabinet dispersed, Bayldon again met with the editors, ostensibly to brief them on the measures he intended to announce in Parliament the following day. As on the previous occasion he took the precaution of having the Attorney General present.

"You do realize, Prime Minister," the editor of one of the tabloids interrupted, "that today's events make it increasingly difficult for us to withhold publication of the other matter."

"I don't see any connection between the two."

"The connection, sir, is plain enough. The suspect checks are made out to NORAID."

"As I have repeatedly stated, the checks are forgeries."

"With respect, sir, that remains to be proved."

"Are you saying you are not prepared to take my word for it?"

"I'm saying, and my colleagues agree, that the proper place to test that is in the courts. It's our business to print the news, not to conceal it."

"How can you describe it as news? The news, for God's sake, is yesterday's hideous outrages. We are on the brink of civil war, and all you're worried about is a malicious slur on my wife's character."

"The trouble is, Prime Minister," a second editor chimed in, "the timing appears to be unhappily coincidental—too coincidental to ignore. In the circumstances a leak is almost inevitable."

"Is that meant to be a threat, Bob?" Bayldon said, employing the man's first name in an effort to sound reasonable despite the provocation.

The editor did not back off. "No, merely a statement of fact, human nature being what it is."

While they argued, events were overtaking them. The latest issue of *Private Eye* was on the newsstands carrying an item, couched in the magazine's familiar prep school journalese, that was quickly seized upon and translated by the rest of the media.

Lord Gnome reports that all men (and women for that matter) are not created equal in our egalitarian paradise. There appears to be one law for our masters and mistresses and one for the rest of us. Despite elaborate efforts at the highest level to conceal the matter, friends tell me that the NORAID funds for the brave freedom fighters who are doing much to clear the slums in our inner cities have recently been swelled by a massive contribution from a well-wisher living not a thousand miles from Downing Street. Our popular Prime Minister is expected to comment on the matter in the near future. We await his statement eagerly and understand that it will be issued from a bank in the Cayman Islands.

In Parliament that afternoon a supplementary question was put to Bayldon by a Tory front-bench spokesman, asking when the House could expect his statement referred to in a well-known political journal.

"I would like to assure my Right Honorable Friend the Prime Minister, that we on this side of the House feel deeply for him in this hour

237

of national and personal crisis." The emphasis was on the word "personal."

All Bayldon could manage when he got to his feet to respond was, "I thank my Honorable Friend, the Member for Slocombe, for his expression of sympathy. I am sure he speaks for this entire House in supporting the Cabinet's resolve never to submit to terrorism. I shall keep my Right Honorable Friend, the Leader of the Opposition, fully informed of all developments."

There was much waving of Order papers and cries of "Answer" from the Opposition benches, but Bayldon refused to be drawn further and shortly afterwards left the Commons to return to Downing Street. Under heavy escort he drove through the large crowd gathered in Whitehall and was somewhat mollified to find himself being cheered. Control was waiting for him in the private apartments.

"You've seen *Private Eye,* I take it?"

"Yes. They appear to be well informed," Control said.

"How?"

"Their sources have always been good."

"Well, get them to reveal their source."

"Easier said than done. It means going through the courts."

"I wasn't suggesting the courts. Surely it can't be beyond your resources to find out by other means."

"Dangerous. If it went wrong, it would merely strengthen the case against your wife."

"Don't keep talking as if there *was* a case. There is no case to answer. My wife is entirely innocent."

"But not above suspicion. Circumstantial evidence has hanged many a man. The most damaging element is the timing. It couldn't have broken at a worse moment. These latest I.R.A. bombings have worked against you. Countries have gone to war for less."

"You don't have to tell me that. So what do I do?"

"It very much looks as though you'll both have to brazen it out and face the music."

"That's bloody easy for you to say. You're not in my shoes. I want every available stop pulled out. Get the bloody checks and destroy them. I don't care how you do it, just do it; that's what you're paid for—to protect me."

"I can't protect you against rumors. And if the checks are forgeries, then they can be forged again."

"So are you saying *nothing* can be done? Next you'll be suggesting that my wife go on television and do a crying act like Nixon and his dog!" He went to the window and looked down into Downing Street, where television crews stood about in groups. "What you don't seem to realize is that though she is totally in the clear as far as this filthy campaign is concerned, there are aspects of her affairs that we don't wish to be aired in public. Once the bloody media scent a scandal they're like foxhounds; they won't be satisfied until they have a corpse."

Control used a more conciliatory, almost fatherly tone. "What other aspects are there? I need to know if I'm to help."

Bayldon hesitated. "It's never been a secret that Linda has private means. Her old man left her comfortably off."

Control waited, betraying nothing on his face.

"Until this business came up, I was in the dark myself about some of her affairs. . . . She now tells me that she does have money overseas. Not in the Cayman Islands, I hasten to add."

"Where?"

"The traditional place. Switzerland." Bayldon bit on the words.

"A numbered account, you mean?"

"Yes. I suppose, being American, she thought our laws didn't apply."

"Hardly a defense," Control murmured. "You see, if I can be devil's advocate for a moment, even if the Swiss thing never surfaces, the rest of the case, though I accept there's no basis for it, is fairly damning from an outsider's viewpoint. We can't ignore that the I.R.A. have tightened matters a notch. By actually attacking the Monarch they've lit a fuse which won't be snuffed out easily. If you add to that the connection—however tenuous—between your wife and NORAID, you're looking at trouble. Better she'd had an affair with a toy boy in the postroom; you could weather that and come out relatively unscathed. But the Queen's life has been threatened; there's real anger outside, you can feel it, and it won't go away easily."

Bayldon had listened to this without interruption. "You mean it could conceivably bring us down?"

"There is that possibility."

"Well, I've acted swiftly where the I.R.A. is concerned. Apart from going into the Republic itself, I've ordered the gloves off. The next terrorist we arrest is going to hang. Perhaps that will take the heat off."

"You're confusing two issues."

"Jesus Christ, you're a big help! What's the point of having a secret

239

service if you can't even solve a simple problem like a forged check? I know how the C.I.A. would handle this. They wouldn't hesitate if the President's wife was being framed."

"Wouldn't they? They didn't save Nixon, and they didn't come clean about Oswald. You have to live in the real world. The name of the game is power."

"Well, isn't that what we're talking about—staying in power? You sound as though we're on our way out."

"Not me," Control said evenly. "I don't have a wife. It's your neck, not mine."

"Whose house is this?" Pamela asked, looking around Keating's splendid library.

"An old friend's," Waddington replied casually. "As you can see, he did rather better for himself than I did."

"But why are you living here? I got back after my horrendous experience expecting to find you at home, and you were nowhere to be seen. And if not with me, why not in your own place? Have you gone off me?"

"No, of course not. I could explain, but it might sound too farfetched, so don't ask me."

"I don't know that I care for that."

"While you were away, I got involved in a situation I need to sort out."

"Does that mean your ex-wife is on your tail?"

"You're warm," Waddington lied. "I just needed to go to earth for a bit, and I didn't want to involve you."

"Darling, wives don't bother me. Are you behind with the alimony, is that it? Because if so I can bail you out."

"I told you before, I don't sponge off women."

"Only men, it seems. You'll have me thinking you're AC/DC if you're not careful. However, if you insist on being a man of mystery I guess I'll have to live with it."

"I'm much more concerned about you. What a terrifying experience. Come to bed and tell me."

They went upstairs to Waddington's suite and Pamela examined the paintings while she undressed. "He has taste as well as money, your friend. Where did he make it?"

"He dabbles in a number of things, all of which pay off. He's investing in a film at the moment."

240

"A man of many talents. Who's this?" She pointed to a framed photograph of a woman on the dressing table. "This yours or his?"

"His."

"He's married, then?"

"Several times. You don't give up, do you? Come here." Pamela walked naked to the bed and threw the Ralph Lauren duvet to one side as Waddington drew her down to him. "If you have to know, his name's Keating. Does that satisfy you?"

"I'm hoping this will satisfy me," she said, employing a technique that from past experience she knew he could not resist.

"What did you think of on the plane? Did you think of me at all?"

"I wondered if we'd ever make love again, yes. But most of the time you're just numb, too terrified to move. We were made to stay strapped in. They pistol-whipped the man sitting next to me. Have you ever noticed how slowly time passes when you're flying, even on an ordinary trip? Well, every minute during the hijack seemed like a week."

"You poor darling. Did they do anything to you?"

His questions stopped as her mouth closed over him again. Waddington lay back and for the next half hour forgot Frampton had ever existed. There was a new urgency to Pamela's lovemaking, a kind of frenzy that he took to be a reaction to the events she had endured. He had never known a woman so uninhibited; she heightened his own pleasure, goading him on with obscenities, prolonging the final spasm that left them both drained.

"There's something special, isn't there, about doing it in a strange bed?" Pamela said when she returned from the bathroom. "Hotels do that to me. I always get very randy in hotels; even before I unpack I want to fuck. Do you feel like that?"

"Not the hotels I usually stay in—and I don't usually share rooms with anybody like you."

She wrapped herself in an enormous bathrobe and snuggled up to him. Waddington slid his hand inside the robe and stroked her breast, which was cold from the shower.

"What am I going to do about you?" Pamela said. "Is this it from now on, me having to come to you?"

"Just for a while, until I get things sorted out."

"Can't you tell me anything about it?"

Pamela thought of how many times she had played the same role, probing in the aftermath of lovemaking when men were at their most

241

vulnerable, using all the tricks in her repertoire, cold-bloodedly picking their brains, while often her feelings were nearer hatred than love. Some were a pushover; others like Waddington knew all the countermoves and could block her checkmates.

"It's a boring mess I got mixed up in by pure accident."

"You're not a wanted man, are you?"

"Only by you, I hope. No, nothing as dramatic as that. It's something I have to work out for myself. Maybe when it's over I'll tell you."

We'll have to know before then, Pamela thought as he nestled his head in her neck and his eyes closed.

Pearson was somebody else who had not been sleeping in his own bed. He had his hands full and had not been home in a week. Everybody was on his neck. The latest I.R.A. campaign, his team agreed, was a proper bastard. All leave had been canceled, and they were working around the clock, snatching a few hours' rest on the premises. Although they had roped in nearly a hundred possible suspects from all over the country and were holding them under the stringent new laws, nothing material had come to light. The only real lead they had was the missing royal groom. If he and the rest of the I.R.A. Active Service Unit were still in the country, they had to be found quickly. It had been established that the explosive used was of Czechoslovakian origin, probably part of the huge Libyan shipment Pearson knew had been smuggled into Eire some months before. That proved both something and nothing as far as he was concerned. In the wake of the two major terrorist attacks there had been the usual spate of hoax calls, all of which had to be investigated. In two cases the Bomb Squad had carried out controlled explosions of suspect parked cars. The S.A.S. had now taken over the responsibility of guarding all members of the royal family. Despite protests from the Palace, Bayldon had prevailed upon the senior members of the House of Windsor to cancel all public engagements until further notice. He had also ordered positive vetting of all staff who had direct access to the Monarch, and again this had not been received with any enthusiasm. For the first time visas were now required for all Irish citizens before they could enter the British Isles. Supermarkets reported a widespread boycott of Irish produce, and the large Irish population in the major cities was advised to keep a low profile until the furor died down. The Irish government delivered a strong protest to the British Foreign Office condemning these measures, and were abruptly told they would have to

live with them. Many of the convicted hardliners in Belfast's Maze Prison began a hunger strike, which impressed nobody in Whitehall. Off the record the prison authorities were told to let them starve to death if necessary.

"This is just the beginning," Pearson volunteered to the Police Commissioner.

"You think so."

"I'm bloody certain. They've been on the front pages of the world for the past week, just what they like. 'Breathing the pure oxygen of publicity'—isn't that the phrase?"

"What's your guess, then?"

"Well—and it *is* only a guess—the royals are now pretty well sealed off, so they'll try for something equally spectacular, but further afield. My hunch would be a senior member of the government."

"All the Cabinet are covered."

"They still have to move about. A car bomb is the most likely."

"Who would be the prime target, d'you think?"

"Well, the jackpot would be the Prime Minister. Since he brought back the death penalty he must be number one on their hit list. I suggest he use one of my men to drive his armored car, plus police and S.A.S. backup."

"Okay, I'll put that to him at tomorrow's meeting," the Commissioner said. "What's your view about the other business, just between these four walls?"

"What's that, sir?"

"The stories going around about his wife."

"I haven't seen the news or read the papers in days. What stories are those?"

"Well, if you don't know, so much the better."

When he left the meeting Pearson tackled other members of his unit. "Tell me what I've missed about Bayldon's wife."

They told him.

"Has Downing Street reacted?"

"Not really, not so far. There have been questions asked in the House, but so far only *Private Eye* has actually dared to print it."

At that moment a report came in that Harrods was being evacuated for the fourth time in five days, and Bayldon's dilemma took a backseat. Since no chances were taken any more, the entire Knightsbridge area was sealed off, creating a traffic snarl that stretched back to the Heath-

row exit on the motorway, causing Keating to miss his flight to Leningrad. Sniffer dogs were sent in, one of them creating a minor crisis when it peed on a rare oriental carpet. A crude incendiary device was eventually discovered and quickly rendered harmless. The search took over two hours, during which time Harrods calculated they lost half a million pounds in sales.

It was while this diversion was taking place that the third bomb Pearson had predicted was exploded. It seemed to typify the I.R.A.'s total disregard for the sanctity of innocent lives in the furtherance of their campaign, but in actual fact was carried out by a two-man East German team, both under the age of twenty-three, who had entered the country a week before. The materials for their mission had been smuggled into their own embassy many months previously in the diplomatic pouch. Fully aware that by now all the royal residences would be unapproachable, they had targeted Madame Tussaud's waxworks, visited by thousands of tourists every year and famous not only for its Chamber of Horrors but also for the replicas of the entire royal family. Knowing that security would be strict and that any shopping bags would be searched, the devices they carried had been ingeniously constructed. The main charge was concealed in a large hollowed-out guidebook of London, carried quite openly. Two smaller incendiary devices capable of producing intense heat within seconds were hidden inside bizarre cuddly toys such as could be purchased in any tourist gift shop. These too were carried openly and passed the security check without challenge. All three were programmed to be triggered by a radio signal.

Operating from a car hired at Gatwick Airport, the team parked it legitimately at a meter in the Baker Street area just before 8:30 A.M. They then joined the usual line that formed before opening time every day, deliberately distanced from each other and avoiding any eye contact. When the doors opened they bought tickets and wandered around the exhibition looking for suitable locations. They were working to strict limits, since it was vital that they place the devices and be off the premises before 10:30 A.M. so they could return to their car before the permitted parking time expired. The plan was to drive straight to Heathrow and catch the first available flight to Paris.

In the room housing the royal replicas, the first terrorist bent down to tie a loose shoelace, placing the guidebook on the floor so that he had both hands free. Before straightening up he gently pushed the book under a plinth, then walked away casually. Meanwhile, his companion

had left his cuddly teddy bear in one of the toilets, then left the building. The first man carried his toy, a Mickey Mouse, into the chamber displaying other Disney waxworks. Carefully choosing his moment, he left it propped against one of the exhibits. He then left the building and rejoined his companion at the parked car. Only sixteen minutes had elapsed. At approximately 10:19 a small boy discovered the abandoned bear in the toilet and claimed it as his own, carrying it back to his parents. They took it from him and went in search of a member of the staff to hand it in as lost property.

At 10:22, using a specially programmed miniaturized radio, the terrorists activated timed detonators on all three devices before speeding off on the West Way.

All three bombs exploded at 10:35. The main charge caused enormous carnage in the royal chamber, which was crowded with a party of old age pensioners who had traveled down from Liverpool, eighteen of whom were killed outright, with double that number seriously injured. The parents of the small boy were still on their way to hand in the teddy bear when it ignited, and the subsequent fire engulfed the whole family. In the Disney room the second incendiary bomb started another intense blaze. Although the staff made valiant attempts to contain the fires, they swiftly got out of control. There was widespread panic and confusion as acrid smoke blotted out the standby lighting system. Molten wax added to the nightmare as people rushed to escape; many fell and were trampled on by those pushing from behind. Although the London Fire Brigade and the emergency services were on the scene within fifteen minutes, the fires were not easily contained. A score of ambulances ferried the injured to adjacent hospitals, where surgical teams battled to save as many lives as possible. A nearby church was used as a makeshift mortuary, and by midafternoon, when the chief fire officer confirmed that all the bodies had been removed, the death toll had reached fifty-four, including eleven children.

The two terrorists boarded their flight to Paris without hindrance, having returned the rental car and disposed of the miniature radio in a wastebin. This was subsequently retrieved by a female Pakistani cleaner who gave it to her small son. Since it did not function normally, he later swapped it with a friend for a balsawood glider.

Stranded, Keating fumed in the gloom of Helsinki airport. Having missed the British Airways flight to Leningrad, he and his small party—

one of the featured actresses and the costume designer—had been forced to take Finnair and travel coach. On arrival in Finland the aircraft had been taken out of service because the reverse thrust on the jet engines was faulty. This meant that there was no connecting flight to Leningrad until the following day. Conscious that he ought to live up to his position as financier, Keating attempted to charter a private jet, but without success. There was nothing else for it; they were condemned to spend a night in a Helsinki hotel. Organizing taxis—he needed two because the actress was traveling with enough luggage for a world cruise—he took them to the Intercontinental Strand, which proved to be a new and curiously anonymous piece of architecture built round an atrium festooned with pink marble columns that reminded him of not particularly engaging Arabian nights. The lifts were made of glass and climbed inside the atrium for eight floors, giving him vertigo. He was ushered to an equally bland, anonymous room that was nevertheless functional, with good plumbing and the statutory array of free shampoos, plastic shower caps and gels that nowadays personify universal hotel life. He raided the minibar, poured himself a double gin of dubious parentage, then telephoned his office to let them know his whereabouts. After taking a bath he went downstairs and met the two women in the bar, which was connected, open plan, with the only restaurant.

"We can't possibly eat in the hotel," Keating said, his initial annoyance gradually fading as he consumed his second martini. "Let's venture out and explore. I'll ask the desk if there's a decent Russian restaurant in town—get you conditioned for what's in store. What d'you say? Are you both game?"

"Sounds good to me," Jennifer, the costume designer, replied. She was immensely chic, having decided at an early age that since her looks were unlikely to prove her fortune she would compensate by dressing eccentrically. She turned to the young actress. "Yes, Vanessa?"

Vanessa was of a breed that is determined not to be impressed by anything. She had recently made a stir in a West End play, becoming overnight and for a very short period—the play having flopped—a large fish in a small pond. Snapped up by the film company, she now behaved as though at any given moment hordes of photographers would descend and ask her to pose, which was not the case. Little did she know that she had been cast not for her histrionic talents, but because the director was a tit man and she happened to be extraordinarily well endowed. She sipped her glass of white wine with studied boredom, hoping that by

being enigmatic she would intrigue Keating. With the predatory cunning that had taken many of her kind to the top, she had an instinct for zeroing in on money. "As long as I don't have to eat reindeer. I'm into organic food. Red meat is a turn-off."

"Does your diet exclude caviar?" Keating said. "That's as organic as you're going to get in Russia." He excused himself and went to the desk to inquire about restaurants and to make a reservation.

Jennifer stared after him through her state-of-the-art bifocals. "As producers go he's rather cozy, don't you think?"

"He's not really the producer; he's just putting up the money."

"That's producing, honey."

"Have you worked for our director before?"

"Once."

"How was he?"

"Well, he's talented, but an evil bastard. Likes to have one whipping boy—or girl—on every film. He totally destroyed Charlotte Baron when we did *Love Feast* last year. Had her in hysterics every day."

Vanessa's mouth went down at the corners. "Well, he'd better not try it with me."

"Haven't you met him yet?"

"Yes, when I auditioned for him, but he was on his best behavior then, all sweetness and light because they were desperate to have me. I got so many offers after the play, but I settled for this because I thought it would be a change of pace."

"Did you meet our Mr. Raven as well?"

"He's the old American, right?"

"Yes."

"Gross. He breathed stale cigar breath all over me. All he was interested in was whether I'd do the bed scenes nude."

"And will you?"

"Not unless it's a closed set. I've got no hang-ups about stripping; it's just that I think all that leg-over acting is terribly old hat. It's about as sexy as a baby's open grave."

Keating had been directed to a place called The Troika on the concierge's recommendation. A taxi was summoned and they departed into the damp night.

The Troika proved to have an agreeable atmosphere, which was somewhat destroyed by the presence of a large party of Japanese who laughed immoderately throughout their meal.

"Oh, gross," Vanessa exclaimed, using her favorite word again as she studied the menu. "See this? It says, 'Bear, when available.'"

"Speciality of the house," Keating said. He selected salted cucumber with honey and yogurt as an appetizer, followed by spicy reindeer steak. Jennifer followed his choice.

"How can you?"

"Very tasty."

Vanessa ordered a plate of vegetables and lectured them both on the toxic qualities of red meat. "Carnivorous animals have a short bowel, whereas we have yards and yards of it, which means we don't get rid of waste quickly enough."

"Do we have to discuss this over dinner?" Jennifer asked.

"I'm just telling you. Practically everything we eat is adulterated." She produced a small vial and swallowed a variety of vitamin capsules with her Russian mineral water, which, she complained, tasted of iron.

Vanessa's vapid and exclusively self-congratulatory chatter throughout the meal, combined with the noisy explosions of the Japanese at the adjoining table, made Keating's head ache. "You're going to starve in Leningrad," he observed, switching his attention to Jennifer, whom he had decided to try to make.

"I read somewhere that Finland has the highest suicide rate in Europe," Vanessa continued, "and I can well understand why. I'd jump off the nearest building if I had to eat bear in semidarkness."

It was with thoughts of Vanessa's murder rather than of his own suicide that Keating ferried them back to the hotel. It wasn't until he tuned in to the CNN English television news broadcasts that he learned of the Madame Tussaud attack, now being officially attributed to the I.R.A., though this had been denied by a Sinn Fein spokesman. Bayldon appeared during the bulletin, speaking directly from Downing Street and promising that the perpetrators would be ruthlessly tracked down. He looked haggard, mouthing the familiar platitudes parrot fashion and promising swift retribution. This was followed by interviews with relatives of the victims, the reporters revealing, as usual, an appalling lack of sensitivity, seemingly more concerned with furthering their own personality cults than with any consideration for the feelings of the bereaved. Nowadays, Keating thought, tragedy is a glorious excuse for a media jamboree, a chance to extract the last ounce of human misery.

It was dark when the waiter brought his breakfast the next morning, and still dark when they took off on the last leg to Russia. Staring out

of the aircraft window, Keating looked down on the snowy wastes below: a landscape of innocence, with the shadow of the jet passing over it like a huge bird of prey.

The Cabinet, hitherto a placid beast, now showed signs of resisting Bayldon's efforts to manipulate it. In the wake of the hideous slaughter at Madame Tussaud's and with the tide of public opinion turning against the government, old antagonisms resurfaced, now with an underlying menace.

It began with the foreign secretary saying, "Toby, I didn't, you didn't, none of us entered Parliament in order to perpetuate an alibi society. We all know that accountability is a bloody nuisance, but it also happens to be a fact of political life. The public—and by the public of course I mean the truffle hounds in the papers and on television—are demanding answers."

"I thought we *were* giving them answers, Wilfred," Bayldon replied. "Surely the steps we've taken during the past few days are draconian enough to satisfy even the most rabid Tory voter, let alone our own. After all, we have gone against the wishes of the party conference— though not against the unions—and brought back hanging for terrorist offenses. Are you suggesting we regress further and bring back the rack and Iron Maiden?"

"I don't want this minuted, but you know perfectly well what I'm talking about."

"What *are* you talking about? We're here to discuss antiterrorist measures, surely? Isn't that the only item on the agenda, or am I wrong?"

The foreign secretary looked around the table for support. "I think," he said finally, when no one came to his immediate aid, "I have to employ some verbal brutality, Toby. Your wife's reluctance to deny certain rumors has become a major liability to the credibility of this government."

Bayldon did not blink. "I hope we're not going to conduct this meeting on a level of personal abuse. I fail to see what my wife has to do with the present crisis."

"Well, let somebody else speak up. I'm not going to be made the scapegoat for a view generally held."

Certain faces around the long table avoided Bayldon's eyes. He settled on the Home Secretary. "You'd all agree, wouldn't you, Richard, that

like all free citizens my wife has a right to privacy? Just because she is my wife she's an obvious target for cranks and fanatics. I take it that Wilfred, in his usual diplomatic manner, is referring to certain unsubstantiated items in a magazine that has a long history—for which it has frequently and deservedly paid a high price—of printing libels."

"Yes. Unfortunately, the particular magazine in question also has a long history of being hideously accurate on many occasions. Of course, if your better half has been libeled, then she has recourse in law."

"She would hardly stoop to dignify such monstrous lies."

"She might have no alternative," the Home Secretary said, shuffling his papers, "if she's to scotch them once and for all. The longer the charges remain unanswered, the more it damages your own authority. The events of the past few days make it imperative for her to act."

"She is already in touch with her legal advisers and has every intention of issuing a statement."

"Just a statement?" somebody at the end of the table said. "Will that be sufficient? Why doesn't she issue a writ?"

"If you must know, my wife is inclined to treat the whole thing as a joke in bad taste. Now, can we move on and discuss the vital business of the day, please? I intend to fly to Dublin tomorrow to hold urgent discussions. At the same time my wife has agreed to visit Belfast, which should go some way toward allaying criticism of her and showing where her loyalties lie. Personally, I think it's very courageous of her under the circumstances. I shall join her there after Dublin to boost the morale of the security forces. I've arranged full media coverage; there's no point in making a gesture if it goes unnoticed. Unless I can obtain firm assurances that the Irish government is prepared to cooperate fully, further and much tougher sanctions will be applied. I've listed them for you. As you can see, I propose that all imports of dairy produce, meat and manufactured goods be blocked."

"And Guinness, presumably?" the minister for agriculture chipped in.

Bayldon ignored this. "The assets of Irish banks and companies in this country will also be frozen, and Irish citizens will no longer be eligible for National Assistance. Does anybody have any problems with these measures?"

Again it was the foreign secretary who spoke first. "We'll have problems with Washington. They can't afford to ignore the Irish lobby, and in my view, if we really bring the shutters down, the collection boxes

will be rattled and NORAID"—he dropped his voice on the word—
"will be the main beneficiary. So it's to be hoped that your Dublin
mission succeeds."

"Do you have a better alternative?"

"It might be appropriate if I flew to New York and addressed the
United Nations. I could do some useful buttering-up behind the scenes."

"No, I don't think so. I want you here minding the shop." Bayldon
had no intention of letting the foreign secretary steal any of his thunder.

When the meeting broke up, several of the senior members of the
Cabinet retired next door to Number II, where, behind closed doors,
they voiced their misgivings. It was a guarded exchange, since none of
them wanted to reveal his hand too early in the game. If Bayldon was
to go and refused to leave quietly, he might have to be pushed. This
raised the question of who would replace him, and every man present
had ambitions in that direction. Nobody actually mentioned a palace
revolution in so many words, but the thought was in everybody's mind.

"Tricky situation," the chancellor said. "We don't want to stir up the
Yanks and provoke another run on the pound."

"There definitely seems to be a cover-up of one sort or another. If
she's entirely innocent, she should come out and say so."

"Especially since the Americans have always had this extraordinary
attitude about open government," the Home Secretary murmured.
"You'd have thought that would have rubbed off on her. They have a
mania for baring their breasts in public."

"Perhaps you should rephrase that in her case, Dick."

"We know she's got money. After all, she hardly gives the impression
she gets her clothes at Oxfam. I've always thought the way she dresses
is inappropriate for somebody in her position. Remember what she
turned up in for the last day of the party conference? That didn't go
down well with the rank and file. That sort of ostentation provokes envy,
and envy loses votes."

"What's the latest poll?"

"We're holding steady, but Toby's own rating has dropped five
points."

"Well, he should take note. Not that popularity is worth tuppence.
I've never courted popularity," the foreign secretary said. "One must
just do one's duty as one sees it."

Nobody commented on that.

"Well, we'll just have to wait and see, then. Let's hope Toby doesn't

push too hard in Dublin. I've got serious doubts about excluding the Irish. For one thing, half the building sites in the country will grind to a halt."

"Is there anything we can do?" the chancellor asked. When nobody else volunteered a solution, he walked to the window overlooking the parade ground. "We have to take the long-term view, in my opinion. What matters is not personalities, but the party." He turned back to face the others. "Not that I'm advocating a change; I wouldn't like anybody to get that impression. I just think it would be sensible to have a contingency plan—" After the briefest of pauses he smiled at the Home Secretary. "And by the way, Dick, it would be appreciated if you didn't make an entry in the diary we all know you're keeping as insurance for your old age. Give it a miss on this occasion."

Control was also concerned at the pace of events. Bayldon's refusal to be panicked necessitated a change of plan. Using the safe house, he met with Pamela again, instructing her to bring Abramov up to date on recent developments. Then he questioned her about Waddington.

"Something happened while I was away; he's no longer living with me, nor at his own home. Instead, he's moved into a friend's house. Says he has to lie low."

"Did he say why?"

"No, he refuses to be drawn. I've tried everything I can without being too obvious."

"Who's the friend?"

"Somebody called Keating."

"Keating?"

"Yes."

"You're sure?"

She nodded. "Does the name mean anything to you?"

Control's face did not betray him. "No. Have you met the friend?"

Pamela shook her head. "He's abroad, apparently."

Cracking his knuckles twice, Control moved around the small room. "Keep everything normal. When have you next arranged to meet him?"

"Tomorrow night."

"What time?"

"Eight. I'm having dinner there."

"Don't keep the appointment."

"You mean cancel it?"

"No, let him think you're coming. Are there staff in the house?"

"A butler and a cook."

"Any dogs?"

"I haven't seen any. There seems to be a very sophisticated security system."

"Give me the address."

Pamela wrote it down. "What are you going to do?"

"I haven't quite decided yet, but it could well be that your affair is over."

Pamela knew better than to ask more questions, and shortly afterwards she left the house. Control stayed on, waiting for his next visitor.

Owing to staff shortages, there was no restaurant car on the train Deacon boarded on his return from Leicester. He accepted this as yet another of life's miseries, just as he was resigned to the fact that there were no longer any first-class carriages: the government had recently abolished such divisions, at the same time raising the general level of fares—a political example of what the French, in slang, called *à cheval*, astride the two worlds of socialism and commerce.

The grimed compartment where Deacon finally secured a seat was awash with spent beer cans, and though a sign read "No Smoking," the floor was littered with butts. He kept his briefcase on his knees. Most of his fellow passengers shared the appearance of displaced persons, the scene evoking memories of those old movies, so popular immediately after the war, when the hero attempted to cross the frontier into safety. From time to time during the slow journey announcements were made over the loudspeaker system, supposedly to tell passengers the name of the next stop, but the voice was distorted and the information given in what appeared to be an unknown language.

The train finally reached London nearly an hour late. Deacon walked swiftly to the barrier, noting that a group of the Militia were lounging by the closed newsstand. They carried short truncheons—a new development, he noted—and he was aware that they recognized him. The length of the line at the taxi rank suggested he would have a long wait, and he was about to make for the Underground station when he was approached by a middle-aged man who addressed him with a pronounced cockney accent.

"Looking for a taxi, governor?"

"Yes, I was, but it seems a forlorn hope."

"Very few of them about. How far are you going, governor?"

"Holland Park."

"I could accommodate that," the man said.

"Are you a taxi driver?"

"Yes, but at this time of night I pick and choose—look for gents like yourself, don't risk the slag and getting a knife stuck in me ribs at the end of the journey. I'm not on the rank; I'm parked round the corner, so if you'd like to follow me . . ."

Grateful for his good fortune, Deacon was led away. The man took him to a side street where an ordinary London taxi was parked and opened the passenger door. Deacon got in, but they had gone only a few hundred yards when he noticed that the man had not activated his meter. He leaned forward and attempted to slide the glass partition, but it refused to budge. He rapped on it. "Your meter isn't on."

The driver made no sign he had heard and Deacon shouted the same message in a louder voice. Again he got no reaction. It was then that he became aware that they were heading in the wrong direction for Holland Park, going south instead of west. He banged on the glass with his signet ring.

"Where the hell are you taking me? This isn't the right way. I want Holland Park."

There was no response; if anything, the driver seemed to accelerate, leaving the main roads and taking a back-street route. Finally he pulled up inside what appeared to be a builder's yard and they drove straight into a garage. The moment the cab stopped Deacon attempted to get out, but both passenger doors had been locked. Only now did the driver open the glass partition and speak to him.

"I apologize for that, sir. Please don't be alarmed. Acting under orders."

"I demand to be let out."

"You will be, sir. Let me just explain first."

"You'd better. I'll see you lose your license for this, believe me. I have your number."

"I doubt that, sir. This cab is a phony, just used for special purposes." He produced an identity card, holding it up so that Deacon could read it, which showed him to be a member of MI6.

"The boss wanted to see you privately, sir. This was considered the best way of doing it. I do apologize once again."

Only slightly mollified, Deacon said, "Your boss will have to do more than apologize."

"We'll see you safe home when you've had your meeting." The man released the locks and got out of the cab, coming around to open Deacon's door. "If you'll follow me, sir." He led the way through the rear of the garage into the adjoining house. They passed through a kitchen and a small hallway; then Deacon was ushered into a sitting room.

"My dear Colin," Control said, greeting him with a whisky in his hand, "please forgive my man abducting you like that. These are desperate times and one has to resort to unconventional means. A small peace offering." He offered the whisky, but Deacon did not take it.

"What the bloody hell do you think you're playing at, Lockfield?" The use of the surname was deliberately offensive.

"I'm not playing at anything, I assure you. Please take this; I'm sure you can do with it. I also have some ham sandwiches if you're peckish after your journey; I understand there was no restaurant car on the train."

Control nodded to the cab driver to retire, and Deacon finally accepted the whisky with ill grace.

"Would you care for a sandwich?"

"I'd like an explanation first of all."

"Yes, of course, but please sit down."

Deacon sat but refused the proffered plate of sandwiches. Control took one for himself, eating it delicately as he continued.

"I know you look upon the activities of my department with a jaundiced eye, and perhaps we do overstep the mark on occasion, but only in the national interest. I can assure you that I have a very valid reason for bringing you here tonight. Perhaps when you've heard me out, you'll appreciate the reason for secrecy."

Deacon made no response, but the redness above his collar was beginning to fade.

"You recall that when we last met at Winfield House I said I would contact you at some point. At that time I had certain, but unsubstantiated, evidence of subversion. Since then events have moved somewhat faster than I feared. I believe that I can now produce evidence to prove my case, if you are prepared to listen. I brought you here for that reason, to put you in the picture."

"Why me?"

"Isn't it obvious? You stand apart from the rest. Because of that, because you haven't been tainted, you command widespread trust and respect."

"I don't know about 'widespread.' I do have a certain following in the party and in the country," Deacon answered, unable to resist such flatteries. He took his first sip of whisky. "You say you have evidence?"

"Perhaps not the sort of evidence that would stand up in a court of law, but in the nature of my trade—reliable. I have to consider the significance of every related incident. Isolated they would not convey much, but when added together they produce an ugly hypothesis. If I'm right—and I believe I am—the time could come when extreme measures might have to be employed to correct a dangerous situation. In which case the country would need a strong man, a man of principle, a man such as yourself, to take over the reins."

"What you are talking about is sedition."

"No, I hope not."

"I think so. However you care to disguise it, the word is sedition."

"I am merely stating that somebody would have to be the instrument to restore a constitutional government."

"Well, we've always lacked a written constitution, more's the pity, but leaving that aside, I would remind you that every member of the Commons was properly, democratically elected."

"It's the current leadership I'm concerned with. Correct me if I'm wrong," Control said, taking a second sandwich, "but as I understand it Bayldon's cabinet hardly represents the will of the people. He came to power by default, committed to head a caretaker coalition, did he not?"

"Are we now getting down to personalities, naming names?"

"It is personalities, not governments, that run countries these days, is it not?" Control countered blandly. "Collective responsibility is merely a public relations palliative designed to fool us."

"So what is this 'evidence' you have to offer?"

"Some of it must be obvious to you. Your speeches both inside and outside the House make it abundantly clear that you are utterly opposed to much that is going on."

"I've made no secret of the fact that I consider there has been a betrayal of our socialist revolution."

"Exactly. So if you became convinced, as I have become convinced, that what you have worked for all your political life is being systematically corrupted, and that if the situation is allowed to continue unchallenged there is a danger of moving towards a fascist state, would you act or would you remain silent? How would you see your duty?"

"I would still have to act within the democratic process."

"Yes. Of course, Hitler came to power by the democratic process."

"Do I have your word that this isn't a replay of the Wilson plot drummed up by your outfit?"

"You have my word."

"Well, then, if I was ever totally convinced of the necessity, I would agree to play a role, but there could be no question of a coup," Deacon said after a pause. His neck was becoming flushed again, but not from anger this time, Control thought. He's taken the bait, as I knew he would.

"Understood. We must always vote our masters out of office—unless, of course, circumstances force them to resign."

"You have something to show me, presumably? Documented evidence?"

"Oh, yes." Control took out a file from his briefcase. "For your eyes only. There is no other copy. Read it." He handed the file to Deacon. "And for goodness' sake have a sandwich while you're reading. I firmly believe one should never receive bad news on an empty stomach."

Waddington answered the door himself with a welcoming smile already in place. It wasn't Pamela who greeted him, however, but two men he had never seen before. With a skill he just had time to register he was pinioned against the wall by one of them while the second taped his mouth and hands. He was then frog-marched to a waiting car and bundled into the backseat. There he was pushed to the floor and held there by both men. The car immediately pulled away, driving at a steady, unhurried speed for what Waddington judged to be some twenty minutes. None of the men spoke during the journey.

When the car stopped he heard the driver get out and open a door. Only then did his other two captors pull him upright and manhandle him out. He was taken through a door set into a wall; beyond was a small courtyard. The driver had a further door open to receive him, and within fifteen seconds from leaving the car he was inside, having had no chance to pinpoint a landmark.

The interior of the building was garish, and Waddington got the immediate impression that it had been previously occupied by squatters heavily into the drug scene. Makeshift wiring crisscrossed walls painted in psychedelic colors. Facing him in the entrance hall was an enormous homemade birthday card collage made up of cuttings from magazines,

across which had been written HAPPY HAPPY BIRTHDAY LUCY WITH THE LOVELY TITS. He was pushed past this into an enormous room that had obviously once been an artist's studio. The only cathedral-sized window had been blacked out. A circle of decaying Victorian armchairs, all sporting wounds of horsehair, was grouped in front of a fireplace that had the charred remains of a stuffed animal in the grate. A bare bulb on a shadeless standard lamp provided scant illumination. Four apple boxes, scarred with cigarette burns and spilled drinks, served as a coffee table. But perhaps the most bizarre aspect of the room was the crudely executed imitations of famous paintings that occupied three of the walls: Waddington had time to take in a pseudo-Picasso clown and a Degas nude before he was pushed down onto one of the armchairs, the legs of which immediately gave way beneath him. The tape expert now took a jackknife and slit Waddington's suit, dissecting the cloth with the expertise of a chef skinning a rabbit. Flinging the pieces to one side, he then trussed Waddington's hands and feet. Then he and his silent companion left the room, extinguishing the light and locking the door after them.

Waddington wriggled upright, but the broken chair now gave way completely and he slid sideways to the floor, as helpless as a chicken in the market. In the darkness, seminaked, he concentrated on stopping his body from shaking, but some of the muscles were in spasm. The suddenness and ruthlessness of the abduction had left him in shock. The stale smell of marijuana permeated the room, and he was sure that his first impression had been correct. Wherever he was, the place was semiderelict and had probably been used by dropouts until put to its present use as a prison for him. But by whom, and for what?

Now, as he rolled his body backwards and forwards over the rough floor planks in an effort to keep some circulation flowing, he tried to bring reason into play. He went back over the events of the past two days since Keating had left, checking his every movement. Apart from Pamela and the staff, who else knew of his whereabouts? He had never left the house and had made no phone calls other than to Pearson and Pamela. It was inconceivable that either of them had had anything to do with this. Tracing further back, remembering that his home phone had been bugged, reliving the episode with Frampton in Harrods and the man's subsequent murder, he realized he had been marked from the start. Whoever was behind his own situation was also looking for leads back to Hillsden. Did that point to the Firm? Again he could not bring himself to believe the inconceivable. Am I being too bloody naïve? he

thought. Just because Alec and I played it straight, why do I assume that everybody else is straight?

The darkness, fear and physical pain now spreading to his limbs intensified his concentration. He willed himself to recall the layout of the room, rolling himself past the apple boxes in what he hoped was the direction of the electric fire. Twice he blundered into other objects until his cheek touched the cold metal of the fire. Inch by inch he edged himself into position, seeking to get his bound hands against something sharp enough to sever the tape. The effort exhausted him, and he lay still, listening to the thumping of his heart before commencing to rub his wrists against the electrical element. He persisted with this for a period, then had a better idea. If he could turn on the fire, maybe he could burn his way through the tape. With his fingertips he found the cord connecting the fire to the wall outlet and slowly jackknifed his way along it until he touched the plug, only to find that it was unconnected. The effort had cost him dear; he was drenched in sweat. After a rest he made another supreme effort, and though he managed to lift the plug, he did not have sufficient strength to insert it into the outlet. It was then that he realized he lacked the necessary control to stop himself pissing. For a few seconds the urine warmed his cramped legs, but he was consumed with a spasm of self-disgust and rolled clear of the puddle.

Thus Waddington spent the first night, sleeping fitfully, racked with pain that woke him in the throes of a recurring nightmare. He had no means of telling whether his captors were still in the building; the only sounds he could discern were distant traffic. He lay there unable to calculate the passing of the hours, giving himself mental and small physical exercises to try to keep alert, in the sure knowledge that once they felt he had been softened up his captors would return. He recited limericks, then forced himself to remember Beatles song titles, the stars of old films—anything to pass the time. Somewhat to his surprise, he experienced no hunger pangs, but he became increasingly desperate for something to drink. At times during what he took to be the second day he started to hallucinate, sometimes laughing out loud, sometimes crying as he lay in his own filth.

In actual fact his captors left him for over two days before they returned at night. He was semiconscious when they took him into a squalid bathroom, the mirrors of which were smeared with graffiti and symbols that to Waddington seemed part of the continuing nightmare. He was plunged into alternate hot and cold baths. The cold water

seemed an unexpected bonus, for he was past the point where pain had any significance and he managed to swallow some water before the ordeal was over. They left him in the empty bath, and it was only now that they brought him a small quantity of food and fed it to him, a mouthful at a time, between questions. If he refused to answer, the food was withheld—kept tantalizingly in sight, but withheld. His interrogator sat behind him on the toilet seat, so that Waddington could not see his face, and at first the disembodied voice was gentle and the questions seemingly innocuous. It was the standard technique, and he recognized it as such, his mind working in two directions at once.

Why make things hard on yourself? Just give us the answers and you'll be out of all this.

What answers?

You know the answers we want.

Tell me who you are first.

You're a smart man. You know you're here as long as it takes. Why hold out?

I've been out of the game for years. What could I know?

You've been in touch with people.

What people?

You tell us.

I don't understand the question.

Try.

What people?

Let me help you. You met a man called Frampton.

No.

Oh, yes. Try harder. Why? Why did you meet him?

I don't know anybody called Frampton.

What did he tell you?

I don't know him.

What did he tell you?

The repetition, drip, drip, like water, the old Manchurian method.

Do you know what happened to Frampton?

Who's Frampton?

Frampton found it difficult to remember your name, too. He had to be persuaded.

Why would he remember me?

After persuasion he found his tongue. My friend persuaded him. He's not as gentle as me.

The two men swapped places, always extinguishing the light when they changed over. The second man played it differently; he was the nasty one. Again, standard technique used by security forces the world over, including our own, Waddington thought. He was shivering uncontrollably from the cold long before the end of the first session. No more food was offered.

Would you like to know how we made Frampton talk?

Why answer? He would be told anyway.

He was a homo. Are you a homo?

The use of such an old-fashioned word dated the man.

Know how you persuade homos to talk? You stick things up their arses. But not what they're used to. Not sexy things, but things that hurt. Afterwards he told us about your friend Hillsden. The one who ran away.

Can I have a drink?

Why should I give you favors when you're not cooperating? Tell me about Hillsden first.

Nothing to tell.

Don't make me lose patience with you.

The cold-water tap was turned on. When the water was up to Waddington's neck, a hand behind him pushed his head under. He was held there, unable to struggle free, until his lungs were bursting.

Just a reminder of where you are. Next time I won't let you come up.

The hand put pressure on his head.

We were talking about Hillsden. He contacted you.

No.

Again his head was pressed under the water. He was half conscious when released.

He contacted you through Frampton. Frampton brought you a message. What was it?

Just news of an old friend.

That's better. You're trying now. What news?

Waddington struggled to frame words that would satisfy, but a great tiredness was sweeping over him.

Come on, try harder. What news?

Told me Hillsden was in Leningrad.

We know that. You're stalling again. What else?

The man's voice seemed farther and farther away, coming to Waddington as though from a tunnel, and even his own voice, weaker now, was disembodied. He wondered who had once told him that drowning was

a peaceful death, and if it was true. He hoped it was, and that it would bring an end to the ordeal.

Nothing else, he tried to say, his cracked lips moving, but no words came out.

Then he lost consciousness.

22

"TRYN-TRAVA," RAVEN said, airing one of the few Russian expressions he had picked up since arriving in Leningrad. He sat opposite Keating in the film's production office, arguing over the latest budget. A plate of *zakuski* was between them on the table, for the meeting had been going on for three hours. Nothing, not even mounting annoyance, ever stopped Keating from taking frequent nourishment, and he punctuated his questions between mouthfuls of red and black caviar globbed onto halves of boiled eggs.

"What's that supposed to mean?" he asked.

"It makes no difference. Who cares? Why bother?" Raven translated.

"*I* care! I come here expecting to find everything going smoothly, and you tell me this location's going to cost an extra fifteen grand. That makes a hell of a difference in my book."

"The rate of exchange went against us," Raven said. "It was ever thus." He enjoyed the financial in-fighting that always went with a film; he was on his own ground talking numbers and percentages. The creative decisions confused him; there was always some smartass director giving him pear-shaped answers that he couldn't challenge.

"What's this item here?"

Raven consulted his own copy of the budget. He knew by heart where all the bodies were buried, having made sure that he was cushioned against everything except acts of God, and the insurance policy would

take care of that. He had even taken out insurance against the leading man catching AIDS, since he had a reputation for humping anything that walked. "What page you looking at?"

"Thirteen. 'Allowance for No Meal Break.' What sort of double talk is that? We feed them, don't we? You've already got a fortune down for unit catering on the previous page."

"That's normal."

"What's normal about it?"

"See, when you call them early, which we have to do because it gets dark early, you're outside their normal hours. So even though you provide breakfast, you also have to give them a 'No Breakfast Allowance.' "

"You mean you have to pay them for a meal they're not supposed to have had when they've just had it?"

"You got it."

"Jesus!"

"What else bothers you?"

"Everything bothers me."

"We're getting great stuff on the screen. The dailies are terrific."

"Listen, I wasn't born yesterday. This reads like a work of fiction to me, and if there's one thing that gets my dander up it's being taken for a ride. I know you're stealing from me, but just don't get too greedy or I might pull the plug. Leningrad isn't Beverly Hills."

"You can say that again. How's the hotel? How's your room?"

"It's somewhere to sleep," Keating said. "What are you shooting today?"

"Outside the university."

"I'll go take a look."

His car and interpreter were waiting for him. He was driven to the location site and stared with grave misgivings at the size of the unit—British, Russian and a sprinkling of Americans—he was payrolling. As with most people who are unfamiliar with the way films get made, Keating had the immediate impression that only half a dozen people around the camera were actually working. Everybody else appeared to be enjoying a holiday: the actors lounging in their canvas chairs attended by sycophants, and a great mass of anonymous technicians standing about. He felt a sense of isolation, for nobody paid him any attention, money and art seldom being compatible. Only Vanessa, the

young actress he had traveled with, made the effort to recognize him, and naturally she had a complaint.

"Oh, I'm so glad to see you. Can you do something about my hotel room?"

"What's wrong with it?"

"I don't have a bathroom."

"Use mine," Keating said, thinking, maybe I can get laid and retrieve something out of this expensive jamboree.

"Oh, I couldn't do that."

"Why not? Come to my room when you've finished shooting. What's happening here?"

"They're lining up a track shot."

"How's it going, d'you think?"

"Slow, but then filming's always slow."

"You can say that again."

"I was in makeup at six, but they haven't used me yet. Which reminds me, I'd better get my face fixed; I'm in the shot after this."

"What's wrong with your face? Looks okay to me," Keating said in what passed for a compliment.

There was a sudden flurry of activity. The first assistant shouted for quiet, the instruction being repeated several times in Russian by his local counterpart. Two of the actors sauntered to their marks followed by a wardrobe assistant and hairdressing. The continuity girl approached them, script in hand, and heard their lines. Some fifty feet of metal track had been laid immediately in front of the main entrance to the university and now, after further cries for complete silence, the first request having been ignored by most of the onlookers, the actors took up their positions and proceeded to rehearse. It took six attempts before the bearded director pronounced himself satisfied.

"Final checks," the first assistant shouted. "And get those people further back." The filming was being watched by a large crowd, mostly university students.

"Are we ready?"

"No. We've lost the sun." The cinematographer stared at the sky through a piece of smoked glass. "Be another three minutes."

"Don't relax. Hold your positions. Just waiting for the light," the first assistant relayed, but as far as Keating could see, everybody did relax. The director sat down in his chair and put his head in his hands as though suddenly bowed down with grief.

"Fuck the weather," he groaned. "Why don't I ever make pictures in fucking Bermuda?"

"Want a cup of tea, governor?" the ever-solicitous prop man asked.

"Why not? I suppose a blow job is out of the question?" This got a dutiful laugh from those around him. "How long, Harry?"

"Difficult to say," replied the cinematographer, who also sat down. "Take a look. There are about six layers of cloud up there. I think the wind's shifted."

It was during this lull that Hillsden and Galina came out of the university building and lingered with the other spectators, standing on the edge of the crowd close to where the director was sitting.

"What's happening?" Hillsden asked a fellow student.

"It's a British film company."

"British?"

"So I'm told."

"What are they making?"

"No idea. They don't seem to be making anything at the moment."

Hillsden watched as a portly man walked over to the director. Something about the man was familiar, although Alec could not immediately place him.

"What's the holdup?" Keating said within earshot.

"Weather. The light's gone dead on us."

Keating stared up into the sky. "Doesn't look any different to me."

"Sun," the cinematographer said. "We started the sequence in full sun. It has to match."

"Isn't it exciting?" Galina said. "Find out what sort of film it is."

Hillsden stopped a passing technician. "Can you tell us what you're making?"

"A comedy, so I'm told, but I could be wrong," the man said, intent on an errand.

Hearing an English voice, Keating swiveled in his chair, and before Hillsden walked away their eyes fixed briefly. He and Galina had gone some twenty yards when the first assistant ran after them. "Excuse me, sir."

Hillsden turned.

"Sorry to bother you, but as you can see we're making a film here, a feature film, and we have a sequence coming up that requires some real English tourists. Would I be right in thinking you're English?"

"Yes," Hillsden said guardedly.

"My producer over there wondered if you'd be prepared to take part—with payment naturally."

"No, I don't think so."

"You wouldn't have to do anything special, just be in the crowd. We want it to look authentic, see?"

"Thank you, but no."

"Well, would you at least have a talk with Mr. Keating?"

"Who is Mr. Keating?"

"The gentleman sitting over there. He was the one who suggested it. Would you, please?"

"Keating, you said?"

"That's right."

Hillsden hesitated again before turning to Galina. "Wait here a second, dear. I'll just go and be polite." The name Keating had touched off a memory he could not immediately place.

Keating rose from the chair to greet him. For once his voice did not boom. "How kind of you. Sorry to be a nuisance. It is Alec, isn't it?"

Hillsden stared at him.

"Alec Hillsden?"

"Yes."

"Remember me?" He extended a pudgy hand, but Hillsden did not take it. "We worked for the same outfit once. When Dinnsbury was around."

"Did we?"

"Yes. Look, dear fellow, I didn't mean to embarrass you, but when I heard an English voice and recognized you, I felt at the very least I ought to say hello for old times' sake. Is that the wife with you?"

"Soon to be."

"She's Russian, is she?"

"Yes."

"Good-looking girl. So you've settled in here?"

"More or less."

There was a pause before Keating said, "Did my man ask you if you'd care to take part?"

"Yes."

"How d'you feel about that? Might be fun for you—and for your wife, for that matter."

"I don't think that would be a good idea. I have a certain amount of leeway in what I'm allowed to do, but they don't encourage me to

publicize myself. Also, it might not do your film any good if I was spotted in the crowd."

"Understood. Well, would it be wrong for me to ask you to have a drink or a meal?"

Certain details were surfacing for Hillsden. He dimly recalled a slimmer, less aggressively confident Keating from their shared past. They had never been close, though he remembered that Dinnsbury had thought well of Keating and had mentioned him several times. For some reason he could not immediately recall, he had the notion that Keating had left the Firm abruptly.

"No, I'm sure a drink wouldn't compromise either of us."

"I'm being very rude, keeping you from your wife. Why don't you both stay for a while and watch them get this shot—if they ever get this shot, that is. Please ask her to join us. I'll get you some chairs."

Hillsden beckoned Galina over, and after he had introduced her Keating escorted them to a vantage point and had chairs brought. "Filming, I've discovered to my cost," he said, "is ninety percent inertia."

As he said this a shaft of sunlight appeared and the unit was galvanized into action. The shot got under way, but the director wasn't satisfied and announced he wanted to go again. Halfway through the second take the sun went in and the take was aborted.

"Oh, Christ!" the leading actor shouted. "That was going great." The hairdresser went over to him and brushed a few strands into place.

"Don't relax, nobody relax, we'll go straightaway when the currant bun does us a favor."

"What is currant bun?" Galina whispered.

"Cockney rhyming slang for the sun," Hillsden told her. Galina appeared none the wiser.

"How long?" the director enquired. He paced up and down, swinging his viewfinder in agitated fashion.

The cinematographer peered up into the turbulent skies. "Can't say, governor. There might be a short break when that cloud has passed over."

"I might pass over myself before then."

During the wait Keating made small talk with a purpose. "Are you enjoying life here?"

"It has its compensations," Hillsden said. He took Galina's hand. "This is the main one. Galina's expecting our first child."

"Congratulations."

The exchange was cut short as the first assistant shouted for quiet once more. The actors and camera crew took up their positions, but this time the leading man fluffed his lines.

"Sorry. Sorry, Zev. It's these bloody long waits between takes. You lose concentration."

"Some of us don't," the director replied, baring his teeth in a parody of a smile. "Okay, first marks, let's go."

"He needs a touch-up," the makeup man said, advancing with his box of tricks. When the actor's face had been repaired the shot was attempted yet again, this time with success.

"Make that the print. Check your gate."

"What are they checking?" Galina asked.

"Something known as 'hair in the gate,' " Keating told her. "The gate is part of the camera, and for reasons I've been unable to fathom, being of simple mind, hairs get trapped in it with depressing regularity. When that happens they do it all over again, so keep your fingers crossed." He turned to Hillsden. "We never really worked together, did we, in the old days? But I seem to remember we had a mutual buddy . . . what was his name? Waddington, was it?"

The sudden mention of Waddington jolted Hillsden. There was something too casual about Keating, and his instant friendliness struck a false note.

"I knew Waddington, yes."

"Funny old world, isn't it, us bumping into each other like this? Who would have believed it? Both our situations have changed since those days. We both got out of the game in different ways."

This time Hillsden made no response. Hearing Waddington's name had given him a new wariness.

"Would you be free to meet later at my hotel? It might amuse you to swap a few reminiscences."

Hillsden looked at Galina.

"You go," she said. "I can't because I have to write an essay. But you go. It will be a nice change for you."

"What time?" Hillsden asked.

"Shall we say seven? I'm at the Astoria."

"Fine. I'll be there."

"A pleasure to meet you," Keating said to Galina. "When is the baby due?"

"In five months."

"At the rate we're going it'll be born before they finish this film."

In London the forensic boys established that the house had blown up just before one P.M., which, allowing for the time difference in Leningrad, was roughly the moment when Hillsden and Keating were discussing Waddington and the old days. Because everybody was still jittery and there was a permanent alert in operation, the Bomb Squad and Pearson's antiterrorist unit investigated the blast as a matter of routine. After a preliminary examination of the wreckage, which included damage to the two adjoining buildings, Pearson was inclined to the view that the explosion had probably been caused by a domestic gas leak. Officials from the gas board confirmed that the installation was prewar and that they'd had considerable difficulty in gaining access to the premises while it was occupied by squatters; as a result, there had been no maintenance for at least two years. According to their records, an ancient hot-water geyser in the bathroom was the most likely suspect.

Pearson was about to leave the site when a police constable reported finding a body in the garden. "The extraordinary thing is, sir, the body's still in the bath."

Together with other members of the team Pearson went to investigate.

"Seems to confirm what the chaps from the gas board say, Chief."

Lying on its side amid other debris was an old-fashioned cast iron bath, and in it was the seminude body of a man.

"Bloody lethal, those old geysers," one of the party remarked. "My parents used to have one in our house when I was a kid. The wind was always blowing out the pilot light."

Pearson knelt down on the damp grass to have a closer look. The dead man's head was turned away from him. He got a hand under the corpse to turn it over. The head lolled toward him, and he stared dumbfounded at Waddington's death mask. "Oh, God, no!" he exclaimed.

"What is it, governor?" Lloyd said. He, too, peered at the dead man.

"I'll tell you later."

Pearson straightened up and started issuing instructions. "I want nothing touched here. Put a twenty-four-hour guard around this whole area, and make bloody sure nobody tramples all over the place. We've probably done enough damage as it is. I'll make a bet with you: the

explosion didn't kill him. He was dead before it happened. He was drowned."

Pamela had made the drop by the Peter Pan statue on the second Tuesday of the month, as arranged, choosing the lunch hour. She had parked her car at a meter in Hyde Park Square before taking a taxi to the Oxford Street branch of Marks & Spencer, where she purchased a tuna sandwich and a carton of orange juice. Outside the shop she bought the midday edition of the *Standard,* then took a bus back to Lancaster Gate and walked the rest of the way to Kensington Gardens. There she sat on a bench a few yards from the drop and ate her sandwich alongside several other office workers taking their break. She saved her crusts and fed them to the sparrows and pigeons that always gathered for pickings. While drinking her orange juice through the provided straw she opened the newspaper to concentrate on the crossword. From time to time she appeared to use the Marks & Spencer receipt to scribble possible solutions to the clues. At the end of an hour she carefully wiped her mouth on a tissue, then placed the debris, including the receipt, inside the Marks & Spencer bag and dropped it into the litter basket. Then she returned to her car and drove home to Amersham.

Shortly afterwards a member of the embassy staff appeared in the gardens walking a dog. The animal squatted and defacated on the pathway, drawing angry glances from other passersby. The man went to the litter basket, extracted some wastepaper and gathered up the offending turd. To the satisfaction of the onlookers he then went back to place the mess in the basket. While accomplishing this, he skillfully extracted the Marks & Spencer bag and walked away, making a wide detour before returning to the embassy.

"Unquestionably death by drowning," Hogg told Pearson. "In addition, he appears to have been starved."

"Starved?"

"That's what I said. The body was dehydrated and the stomach virtually empty, containing little but bile. There was a sparse volume of matter in the upper and lower bowels, indicating a period of perhaps a week when no food was eaten."

"Starved," Pearson repeated to Lloyd later. "Hogg was convinced he was starved, poor bugger, though starvation didn't kill him, nor did the explosion. I imagine we were meant to think it was just a domestic

accident. Happens frequently: old equipment, a gas leak and Bob's your uncle. But by a freak the blast must have gone outwards, and being in the bath prevented him from being blown to pieces. My guess is that we weren't supposed to have any remains to identify."

"Clever, very clever."

"Except that it went wrong."

"And was it even a gas leak?"

"Hogg is carrying out further tests. He said he'd expect to find traces of gas in the lungs if that was the case, but so far he's drawn a blank."

Pearson chewed on a Mars bar, his lunch for the day, and while talking thumbed through the latest batch of contact sheets of photographs taken in Kensington Gardens. The area around the Peter Pan statue had been kept under twenty-four-hour surveillance.

"How long did Hogg think he'd been dead?" asked Lloyd.

"At least two days. What have we found out about the house?"

"It's been empty for eighteen months. The landlord kicked out the last legitimate tenants and has been trying to get planning permission to knock it down and build an office block. It was occupied by squatters until they were forcibly evicted after a drug raid."

"Well, he'll get his planning permission now," Pearson said drily. "We've got to trace Waddington's last movements, and his girlfriend's. Get onto the staff at this man Keating's house and see what they can tell us."

"You don't mind treading on the C.I.D.'s toes?"

"No." He lingered over a set of contact prints. "Have these blown up." He ringed three of the shots on the contact sheet.

Lloyd came round to the other side of the desk and examined the prints with a magnifying glass. "Found something?"

"Maybe."

Lloyd peered at the marked shots. "Yes, he looks vaguely familiar."

"Somewhere," Pearson said, "there's a link to all these incidents. I feel it in my water, or maybe it's just prostate trouble. Never know at my age."

"Bad as that, is it?"

"Nothing's ever quite what it appears. Mitchell, Frampton, now Waddington. We know there's a link between the last two. Does it join up with Mitchell?"

"Maybe you should take a few extra precautions," Lloyd said.

"Why?"

"If there is a connection, as you suspect, you could be next in line."

"Would you say this is a safe place to talk?" Keating asked. "I'll bow to your superior knowledge on the subject."

He and Hillsden were sitting in a corner of the Astoria bar. There was a general hum of conversation around them from other imbibers.

"This is safer than your room, but if you don't want to risk it perhaps we should take a walk."

"Let's have a couple of drinks first. There's no hurry."

"What got you involved in films?"

"Two things: another way of making money, and a chance to meet some available young crumpet."

"I haven't heard that word in a long time."

Keating looked past him and his expression changed. "Damn, some of the actors have just come in. I don't want to get involved and have to listen to their latest gripes. Let's drink up and take that walk."

They edged by the group at the bar while their backs were turned. "I think perhaps I ought to come clean with you," Keating said when they were safely outside. "I didn't meet you by chance today. It was chance that you came by at that moment, but if you hadn't I knew where to find you."

If he had expected some startled reaction from Hillsden, he was disappointed.

"Did the Firm send you?"

"Good God, no! No, my setup here is on the level. I really am payrolling that circus you saw."

"So who did send you?"

"Waddington. I have a note to you from him—my reference, as it were." He fumbled in a pocket, but Hillsden stopped him.

"Don't show it to me."

"Don't?"

"No. For all I know we're being tailed. Passing notes is not a good idea. Just tell me what's in it."

"You're very trusting."

"I didn't say I trusted you; I said tell me what's in the note."

"He told me you had something for me to take back to England, but that I would need to prove that I came with his blessing. A mystery, like your cat, Macavity." He glanced sideways at Hillsden to see if there

was any reaction. "And that if we had a drink together I should order Castle Dracula."

"That's your safe conduct pass, is it?"

"Waddington thought it would convince you."

"How do I know this information wasn't obtained under duress?"

"You're a cautious bastard. I'm here to help."

"What makes you think I need help?"

"You sent him a message, didn't you? Via some little poof."

"I see you're fond of the old-fashioned terms—crumpet, poof. It's almost as though you're in a time warp."

"Trust me, Hillsden. I'm your only hope."

"Trust isn't a word I use often these days. But for a moment let's believe your story; let's pretend I do have something to give you: how would you set about getting it back to Waddington? There's that to consider first."

"Right now he's staying in my house for his own safety. Your messenger boy was murdered."

It was only now that Hillsden gave any sign that he was capable of being taken by surprise.

"Name of Frampton, right?" Keating said. "Well, they were onto him from the start, and they took him out, along with his father. Does that go any way toward convincing you? I know the ropes as well as you. We come from the same stable, remember? Two of Dinnsbury's thoroughbreds, and we both got the chop. I want to see you get even."

"You didn't answer my question," Hillsden said. "Tell me how."

"I'd take it out personally as one of our film scripts."

They walked on in silence for twenty yards or so before Hillsden finally answered, "I'll think about it."

"You don't like it?"

"I'll think about it."

"D'you have a better idea?"

"What I have is a baby on the way. That changes things. I don't mind signing my own death warrant, but now I have two other people to consider."

"I'm here for another four days," Keating said as they crossed the street and started to retrace their steps back to the hotel. "I have to leave with the rest of the unit if it's to work; there's extra safety in numbers. If you resolve your problem, you know where to find me."

273

23

ALTHOUGH THE POLICE were keeping the file on Waddington's death open, it was not being treated as a murder case. Despite Hogg's report that no trace of gas had been found in the victim's lungs, and the fact that the dead man had once been an MI6 case officer, they could find no conclusive evidence of foul play. Because he had recently divorced his wife and quit his job for no apparent reason, suicide was the favorite theory, one given added credibility in view of the venue he had chosen. Even so, the C.I.D. investigation was thorough; his house was entered and diligently searched. No suicide note was found, but the telephone bug was uncovered, and as a result the police inquiries switched to Century House, where the detective in charge of the case finally achieved a meeting with the Director General.

"Did he ever give any indication of being unstable, Sir Raymond?"

"I wouldn't go as far as that," Control said.

"Why was he dismissed from the service?"

"*Dismissed* is too strong a word. We were required to reduce the complement of officers by the government, and obviously we kept the best we had and let the others go. Waddington was one of those given early retirement."

"Did that upset him?"

"I've no idea."

"And you had no contact with him after that?"

"Not personally."

"We found his phone bugged. Was that on your authority?"

"Superintendent, I don't have such authority. As you must know, only the Home Secretary can approve phone tapping. From time to time we make requests, but the final word is his."

"I apologize. Put it another way, was there any reason why anybody in this building would request a tap?"

"Not to my knowledge."

"Could it have been done *without* your knowledge?"

274

"I have to admit that in the past the rules have been bent, but since I've been Director General any such request has to come through my office. I've been at some pains to avoid a repetition of previous misdemeanors."

"Then could you tell me, sir, whether Mr. Waddington worked in any particularly sensitive areas before he left the service?"

"I think one could say that everything we deal with is sensitive."

"I appreciate that."

"From your line of questioning, Superintendent, am I to take it that this is being treated as a murder inquiry?"

"The death of anybody in unusual circumstances has to take every possibility into account."

"But what is your own opinion?"

"I don't have opinions, sir; I just go by the evidence. The evidence so far would suggest he took his own life, for reasons we have yet to discover."

"His marriage had failed, I believe?"

"Yes."

Control cracked a knuckle. "Excuse me," he said as the Superintendent looked up, startled by the noise. "A very unsocial habit of mine, but I suffer from rheumatism in these fingers. It slightly eases the pain. Yes . . . well, this business, rather like your own, I imagine, is not conducive to a regular home life. The best operatives are usually those without . . . other responsibilities."

"Occupational hazard, sir."

"If it was suicide, he chose the classical Greek method, did he not? Death in the bath, like Socrates."

"Except that he didn't open his wrists, sir," the Superintendent said, scoring a point. There was something in Control's manner that had irritated him from the start. "From what we've been able to piece together, he relied on a gas leak to do the job for him."

"A sad end. I hope you get to the bottom of it. We none of us like unsolved mysteries, do we?"

While this was taking place other members of the investigating teams were interviewing everybody at Breakproof and tracing Waddington's movements during the weeks prior to the tragedy. His ex-wife and Keating's staff were also questioned, but the latter could throw no light on the matter: on the night in question they had been off duty, and since

he was a guest of their absent employer they had not thought it their business to report his disappearance. Through them the police learned of Waddington's association with Pamela. She too was questioned but was able to establish that on that particular night she had made up a bridge four with neighbors in Amersham. Keating was due to be interviewed on his return from Russia.

Using his contacts within the C.I.D., Lloyd was made privy to all this information and, operating on his own, paid a visit to Pamela. She gave him the impression that she was still genuinely distressed by Waddington's horrific death. In turn, Lloyd was impressed by her looks, which distressed him in a different way.

"I can't understand it. We were due to have dinner the following evening."

"Did he ever mention his previous occupation to you?"

"I knew he worked for a security firm. That's how we first met."

"I meant when he was a member of MI6."

"You mean spying?" Her surprise seemed authentic.

"Well, not spying exactly. He was once engaged in counterespionage."

"No. I just took him for what he was—at least, what he told me he was."

"When you last saw him was he worried about anything?"

She shook her head. "He had been worried about me. I was caught up in that recent hijacking. But no, nothing else; he seemed quite happy the last time we saw each other."

"What did he talk about when you were together?"

"Nothing special. Look, we were having an affair; I'm sure you're aware of that. We were both divorced, and we came together because we needed what most people need."

"What is that?"

"Sex, companionship, a shoulder to cry on if necessary."

"It was a recent affair, I take it?"

"Yes. It started a month or so ago."

"And it worked?"

"It worked for me, and it seemed to work for him, too. To save you reading it in the Sunday papers, he was very good in bed."

I'll bet you are too, Lloyd thought. "So on the face of it there was no reason for him to disappear like that?"

"Not that I know of."

276

"You hadn't had a quarrel?"

"No."

"And he never mentioned his previous life to you?"

"He talked about his marriage. We compared notes about our respective failures."

"I was referring to something else," Lloyd said, pressing her. "When he failed to show up for your dinner date, weren't you alarmed?"

"I thought it odd, yes, but I imagined he had some excuse. We weren't chained to each other."

"Why d'you think he wasn't living in his own house? Did he give you any reason?"

"He hinted that he had some personal problem. I assumed his ex-wife was chasing him, or something. A woman scorned can be vindictive, you know," Pamela added with a Giaconda smile.

"So I'm told. Just that? He didn't elaborate?"

"No."

"If I were to tell you that the house he moved to belonged to another ex-member of the security services, would that surprise you?"

"*Are* you telling me that?" Pamela fielded.

"There is a connection, yes."

"As I said, all I knew is that when we first met he was selling burglar alarms. I knew nothing about his past life." She took out a handkerchief and dabbed her eyes. "All this has been a terrible shock, and I've already told all this to the police who came before. We fell in love. That's not so unusual, is it?"

"I'm sorry. I didn't want to upset you, but naturally we're concerned about discovering the true circumstances of his death. Why, for instance, he would suddenly leave comfortable surroundings and, if I may say so, a very attractive woman, and be found days later in the ruins of a derelict house."

"I don't know why. I wish I did."

"You would agree, though, that it appears likely that in the circumstances he had very little reason to take his own life."

"Who knows what goes on inside anybody? I had a friend who blew his brains out just before Sunday lunch with his family."

"Can I ask you one further question? Did he take drugs?"

"I guess that like a lot of people he might have tried them, but he wasn't on anything when he was with me. He drank, but not to excess."

"Well, thank you, you've been most helpful. If you think of anything else, please contact me at this number." He handed her a card.

"Quite a looker," Lloyd said when he reported to Pearson.

"Telling the truth, d'you think?"

"Who knows? A cool bird, if you want my opinion, the sort that might drive a man around the bend. I bet she's red hot in the sack. Fantastic tits."

"How old?"

"Difficult to say. I can never tell. Under thirty, maybe. She had her war paint on when I met her."

They were studying the surveillance photos again.

"We've traced that character." Pearson pointed to the enlargements he had ordered. "Russian embassy trade mission."

"Interesting."

"Yes, look at those two closely. See what he's doing?"

Lloyd examined the prints. "Model citizen, picking up dog turds and depositing offensive material in litter basket."

"Now look at this section. I had it computer-enhanced. What d'you see?"

"Like I said, model citizen. An example to us all."

"Look again; look at his left hand. He puts something in, then takes something out. Or appears to."

"Do we have one after this in sequence?"

"No, unfortunately. That old man feeding the pigeons blocks him out."

Lloyd sorted through the entire batch. Suddenly he stopped. "Jesus! I don't believe it."

"What?"

"There! See that woman sitting on the park bench?" He pointed.

Pearson took a magnifying glass and had a close look. "What about her?"

"That's her; that's the bird I was talking about, Waddington's bit of stuff. Mrs. van Norden."

"You sure?"

"Bloody positive. Were all these taken on the same day?"

"Yes, they're date-stamped."

"What order were they taken in?"

"Go by the negative numbers and you'll get the sequence."

Lloyd arranged the prints, laying them out in a line. "Right, that's

got them in order. In this one she's just leaving the park bench. Then she dumps her trash in the basket and leaves. Seven shots later he appears. That's a bloody coincidence, isn't it? Too much of a coincidence, if you ask me."

"Coincidence isn't proof."

"Okay, okay. But why would somebody like her take a sandwich lunch on a park bench? Claridge's would be more her style."

"Agreed, but not conclusive."

"It sucks."

"What does that mean? I'm not up on your colloquialisms."

"I don't know what it means, either; it just sounds good. All I'm saying is that it's bloody odd that our Russian embassy friend and the lady from Amersham just happen to turn up in the same place on the same day and use the same trash basket. Add that she was Waddington's girlfriend and I think it's another link in the chain you were talking about."

"You're absolutely certain she's one and the same?"

"I just spent over an hour with her. I swear it's her."

Pearson studied the photographs again. "Maybe you're right. Maybe 'link' was the wrong word; perhaps I should have said 'web.' "

They lay side by side in bed, Galina asleep, Hillsden awake, his right hand resting on her swollen belly, his thoughts tracing the long journey that had brought him to this moment of truth in an alien city. He was conscious that everything previous in his life seemed to have been a betrayal of one kind or another; now the choice was between self-betrayal and a denial of love. Slowly and gently he removed his hand and slipped from the bed, padding from the darkened room into the kitchen. There he poured himself a whisky and sat, not drinking it, nursing the glass.

When he had started writing the manuscript he had accepted that once it had been smuggled out, his own fate was sealed. At that time, consumed with a desire to get even—the object had been to bring down the whole pack of cards—what eventually happened to himself had seemed of little consequence. He had never contemplated somebody like Galina entering his life—and beyond Galina, the child she now carried. Russia was changing, but he doubted that the minor relaxations of the old order extended to forgiving the wives of traitors.

He went back to the doorway of the bedroom and stood there, watch-

ing her as she slept. He had an overwhelming desire to wake her, to take the manuscript from its hiding place and share the burden with her. I've only ever cared for three women, he thought, and none of them shared my life entirely. There was always something to hold back—not the ordinary, unimportant lies that were part of most intimate relationships, the ones that protected rather than bruised, but the sustained lies that eventually and inevitably corrupted love. It occurred to him how different his marriage to Margot would have been if he'd ever found the courage to reveal the truth about himself. He wondered, Would I ever have betrayed her with Caroline if Margot, with no justification, had not already believed me unfaithful? In the end the effort of proclaiming a truth while coloring it with a spectrum of lies had finally worn him down.

Galina turned in the bed; the outline of her belly accused him as he stood watching. He had never made another life before; he had only destroyed them. Now, forming in her womb, there was a child that he might never live to see. As if suddenly conscious of what he was thinking, she sat up in bed, her eyes wide open. "What's happened?" she said.

"Nothing. I couldn't sleep."

"Why are you standing there?"

"Just watching you."

"You gave me a fright."

"I didn't mean to. Go back to sleep."

"Aren't you coming back to bed?"

"In a minute." He held up the whisky glass. "I'm a secret midnight drinker. I'll come when I've finished this."

"Have you had second thoughts—is that it?"

"What are you talking about?"

"About us?"

"Second and third thoughts, if you must know."

"About me and the baby?"

He nodded.

"I know I'm no fun for you at the moment, but the doctor said the sickness will disappear and then we can make love again properly."

Hillsden went over and sat on the edge of the bed; he stroked her stomach, feeling the warmth of her body through the thin sheet.

"D'you want to know what I was really thinking?" he said. "I was thinking that we should get married as soon as possible."

She searched his face. "You really mean that? You're not saying it because you feel sorry for me?"

"My darling, the only thing I'm sorry about is that I didn't meet you thirty years ago when I had something better to offer."

As he leaned down to kiss her amazed, vulnerable face he realized that the living rather than the dead had made all the decisions for him.

The bird had flown.

Despite Pearson acting swiftly in conjunction with Special Branch, by the time they reached the house in Amersham Pamela had disappeared without a trace. A warrant for her arrest under the 1991 Official Secrets Act was granted, and security forces at all airports and ports were put on the alert. Her aged parents were interviewed but could offer little except shock and surprise at these developments. They said that since her divorce from van Norden they'd had little contact with her, apart from an occasional visit at Christmas. The central police computer came up with a blank. Nothing was known about her; as a student she had never taken part in any sit-ins or protest movements, she belonged to no political party and she appeared to have no political associations. Her staff and neighbors in Amersham also gave her a dull, clean bill of health. The total picture was of the average rich divorcée enjoying an affluent life on her alimony. It all seemed too good to be true.

"Nobody's that anonymous," Pearson observed to Lloyd, sharing a pot of canteen tea strong enough to skate mice across. "Otherwise the tabloids would go out of business. Show me somebody with no skeletons in their cupboard, and I'll show you a skillful liar. When I was with the Met every rapist we ever caught was a mother's boy—shy, retiring types, the sort that help old ladies across the street and are kind to dumb animals. We manufacture a particular kind of monster in jolly old England. It suits some people to portray us as gentle, law-abiding, tepid-beer-drinking salts of the earth. In reality there's a hidden beast in a good many of our stalwart citizens, ready to bare its fangs at the slightest provocation. No inferiority complex in we British, boyo; arrogance is our religion. Forget the wogs begin at Calais, forget tolerance, love your neighbor and all that pious shit; we don't like anybody, not even ourselves. And since we no longer have an empire to push around we've taken the fight to the holiday beaches."

"Churchill anticipated that, didn't he?" Lloyd remarked.

"Churchill?"

"Yeah. In his speech: 'We shall fight them on the beaches.' "

"What a mind you have, Lloyd. Always a quote for the occasion."

"You sound bitter, Chief."

"Bitter? Of course I'm bitter. Nobody's bringing me arrows of desire any more. That's another quote for you to ponder. Thank your lucky stars you're not still on the beat. When I joined the force way back, there was some respect for the old Bill. Just a couple of us could take care of a Saturday-night punch-up in the local on our own. Nowadays you'd have to go in with a riot squad, and you'd still be lucky not to get a knife in your back. Mind you, this tea will probably get you in any case."

"Changing the subject," Lloyd said, "I see they've applied to the Home Secretary for a deportation order for that Russian trash collector—the one spotted in the park."

"Big deal. And next week the Russians will kick one of ours out of Moscow. It's a game, just a game at that level. But I blame myself; I screwed up on that one."

"How?"

Pearson did not answer immediately. For reasons he could not readily explain even to himself, feelings surfaced that the very nature of his job usually forced him to sublimate. He felt a sense of guilt about Waddington, a nagging suspicion that if he had acted differently the man's life might have been saved.

"Getting old," he said finally. "There were signposts all along the way, and I misread them. It means starting again. Get me everything you can on Hillsden. Waddington was convinced he was framed."

"Framed for the murder of that diplomat?"

"Yes, and the rest. He was onto something, in Waddington's opinion, and they needed to get him out of the way. So see what you can turn up. Let's go out on a limb for this one; we all have to die some time."

Pearson was edging closer, but not close enough. There was no way for him to know that Pamela's disappearance had been engineered by Control. Immediately after Lloyd had interviewed her she had reported to him, using an unlisted number, and had been swiftly smuggled out of the country.

Again contact with Abramov had been broken and Control desperately needed to find an alternative means of communication before it was too late. The confession extracted from Waddington before his death had to be checked and acted upon as soon as possible; there were too many unfriendly ferrets scuttling around for comfort. Equally vital, he had to appease Moscow.

The first necessity was to put Bayldon in the picture, and he requested

an urgent meeting. Bayldon's private office fitted him into a gap between a lunch appointment with the secretary general of the United Nations and a meeting with the chiefs of staff on the defense estimates.

He was greeted with, "I can't spare you very long. I've got a very difficult day."

"You're going to have a more difficult day when you've heard my news."

Ever since Bayldon had weathered the engineered crisis surrounding his wife there had been a marked change in his attitude. With a political astuteness that had surprised Control as much as anybody, he had brilliantly defused the situation in one stroke. On his own initiative he and his wife had paid a flying visit to the troops in Northern Ireland, where, in one of the most vulnerable border towns, with full media coverage, she had announced that she was setting up a million-dollar trust fund for the widows and children of servicemen killed during the terrorist campaign. "I am aware of the rumors that have recently been circulating about me, and it is easy to guess where they originated. They were part of a deliberate campaign to discredit my husband through me, and I hope that in setting up this fund I can make it abundantly clear where my true sentiments lie. I may be an American by birth, but my loyalties are with the British people, and like the Prime Minister, I am utterly opposed to any form of terrorism and support his efforts to combat this cancer in our midst."

If Bayldon had had a hand in writing her speech, he was not letting on. When loaded questions were put to him concerning his wife's wealth, he did not cover up: attack, he had decided, was the best defense. "My wife is well aware that inherited wealth must always pose a moral responsibility, and as a committed socialist she welcomes an opportunity to put it to good use." His popularity in the polls had reached its highest level since he took office.

Thereafter the tabloids dropped the original story, and the attempt at a back-bench revolt led by Deacon fizzled out; in the last analysis, ordinary members were disinclined to rock the boat they sailed in for fear it might capsize and sink them with it. Principles were always on special offer at Westminster.

Bayldon said, "What is it this time? You have a tendency to panic these days, Raymond. You panicked over the affair of my wife, coming to me with a doom-laden scenario which I quickly proved wrong."

"It was hardly wrong of me to warn you."

"But I was the one who found the solution. Money talks in two directions, you know."

"I'm sure we're all greatly relieved that episode is closed," Control said acidly, "but something far more threatening has come up."

"Really? You need my help again, is that it?"

"I need you to realize how serious it is. Serious enough to warrant an XPD without delay."

"Don't talk as though we're solving the *Times* crossword. I haven't a clue what 'XPD' means."

" 'Expedient demise.' "

Bayldon stared at him. There was a long pause. "I don't want to be involved in anything like that. I don't even want to be told about it."

"You can't help being involved. You think the journey you took to get to this office kept your hands clean?"

"All right, spare me the sermon. What is it this time?"

"It concerns Hillsden."

"Hillsden? But he's safely out of the way—at least that's what you've always told me."

"Out of the way, maybe, but no longer safe. Circumstances change, and we have to meet them."

For the first time during the meeting Bayldon faltered. "What circumstances?"

He listened in silence while Control brought him up to date.

"He should have been dealt with once and for all. I said so at the time. A dead man can't write his memoirs." He took out a clean handkerchief and wiped his damp fingers. "So what are you suggesting? That you 'XPD' him, as you put it, by remote control?"

"That's for Moscow to decide, as and when I inform them. But it might not stop at that. There might have to be others. It's possible I was too clever last time."

"I can't believe we're having this conversation. Who are we talking about now?"

"The girl, Pamela . . . Pamela van Norden, as she last called herself," Control said, watching Bayldon's face closely. "Surely you can't have forgotten her? She was always a threat to you, remember? A threat I caused to be removed with some delicacy."

"But you assured me there's no longer anything to connect her to me."

"No material evidence, no. The incriminating photographs from your less-than-distinguished past were all destroyed. But she could open her mouth to save herself."

Bayldon raised the lid of one of the red boxes on his desk as though expecting to find all the answers inside, but there was no one to brief him on this occasion. When next he spoke he was more placatory. "Well, we've survived worse and come through. I'm sure you'll do whatever is necessary. The vital element is that I mustn't be implicated in any way. . . . Did this man Waddington reveal how Hillsden intended to get his manuscript into the country? And to whom?"

"No. Unfortunately, if I can put it this way, his ability to withstand interrogation was higher than we had allowed for."

"Well, push him harder."

"That might be difficult. By now he's sprinkled around the roses in a garden of remembrance."

The Fat Boy was on the move again. Having received instructions, he started his journey from Greece, this time traveling on an American passport; the name, Allen Lyndon Witz, and physical details had been taken from a dead man of his own age and height, an attorney at law who had been born in Phoenix, Arizona. Provided he did not pass through any U.S. immigration check, his papers would stand up in the rest of the world, for he was armed with backup documentation should he ever be challenged, even to the extent of having a voluminous brief concerning international patents. His wallet contained snapshots of a nonexistent wife and daughter, membership in golf and health clubs in Scottsdale, and credit cards, driving license and printed business cards of a law firm that had folded several years previously. He sported a moustache and contact lenses that changed the color of his eyes. As an extra precaution he also wore a corset under a sober, beautifully cut Armani suit. The impression of understated affluence was completed with a button-down Ralph Lauren shirt and a Cartier tank wristwatch.

Flying first to Nice, the Fat Boy remained in transit awaiting a connection to Rome. Although he took elaborate precautions whenever he ventured into unfriendly territory, he was never overly concerned about his safety; few countries wanted to apprehend him on their own soil for fear of revenge attacks. He was probably the most unwanted wanted man on the terrorist list, and he never made the mistake of traveling with anything that could tie him to a particular incident. The

complete professional, perhaps the only chink in his armor had been his womanizing, but in recent years, growing wiser and more aware that one day his luck might run out between the sheets, if not from betrayal from AIDS, he had become celibate.

He had not been to Italy since the days when the Red Brigade had been active. On arrival he found Rome airport disrupted by industrial action: the baggage handlers were on strike and the immigration officials were on a slowdown. Shuffling slowly forward in the long line of disgruntled passengers, he was relieved to find the passport check perfunctory, the immigration officer hardly glancing at his photograph. Once in his rented Fiat he was amazed by the changes that had taken place since his last visit. It was as if every single car in Italy had swarmed into Rome; metal cholesterol clogging its arteries, they were parked, sometimes three abreast, at every conceivable angle, often mounted on the pavements with a disregard for regulations that he could only admire. He had the impression that only the ancient ruins looked clean and preserved; the endless incongruous apartment blocks were stained with neglect, their lower walls defaced with graffiti and posters for pop groups, while the vast edifices marking the Mussolini years had the appearance of an abandoned film set. Waiting in the inevitable traffic jams, he also spotted several swastikas, as though history were about to repeat itself. After taking three wrong turns he eventually found his way to the Aldrovandi Palace Hotel, where a room had been booked for him and paid for in advance. His window overlooked the zoo; he could see half a dozen sad, moth-eaten condors in their giant cage, hunched like lonely old men on the seafront, and beyond it the white rocks of the polar bear enclosure.

The Fat Boy helped himself to half a bottle of indifferent champagne from the minibar and waited for contact to be made. Despite the failure of the hijack he viewed his coming assignment with confidence; he was anxious to restore his reputation. Despising most of his fellow terrorists, he thought of them, in de Gaulle's phrase, as *ces shies-en-lit,* "shit-a-beds." He was truly happy only when he worked alone; then the planning and the risks were solely his to evaluate. His paymasters were invariably generous, and privately he thought of himself as a star soccer player, always prepared to be traded and score for any team that could afford him.

The expected phone call came half an hour later while he was lying fully dressed on top of the bed watching CNN's live satellite news

beamed from America. He was amused by an item about a mass murderer who had just gone to the electric chair; a trio of earnest pundits was debating the morality of capital punishment even when it was meted out to a sadistic dropout who admitted to killing forty-two women. The sanctity of human life did not rate high on the Fat Boy's list of priorities.

A female voice on the telephone said, "Mass for the dead is being held in the church at the Piazza Euclide in half an hour. I hope you'll join me and pay your respects."

He said, "I'll be there."

He left the hotel immediately and drove to the church. It proved to be a monstrous edifice, its rotunda in architectural conflict with the massive squared-off pillars of its grandiose entrance, where students sat on the steps consuming junk food. Dominating the otherwise characterless piazza, it had been erected not only to the glory of God but also to the greater glory of Benito, even though Benito was a nonbeliever. Had it been left alone, the interior was in fact simple and could have been impressive, but it had been glitzed up by some of the grossest paintings the Fat Boy had ever seen. There were seven or eight private chapels, all vying with each other in banal tastelessness. The first, just to the left of the entrance, featured half a dozen large paintings of nubile angels, executed in a flat monotone and resembling centerfolds from a religious version of *Playboy*. Dotted around the perimeter walls were other examples of religious kitsch so brightly colored one could almost see to shave in them. There was also a model of the nativity that contained a plastic infant Jesus and was surmounted by a disproportionately large shooting star picked out in fairground bulbs. None of the altars had candles in front of them; instead there were brass boxes topped with small electric lights that could be activated by the faithful, rather like slot machines. Far from being offended by the vulgarity, the Fat Boy took satisfaction from it: lacking any faith, he was delighted to have his scathing opinion of the Catholic Church confirmed.

Even so, he behaved correctly, genuflecting in front of the main altar, then sitting on a pew at the rear of the church, well away from other penitents, and bowing his head as though in prayer. He remained thus until, five minutes later, Pamela entered and occupied one of the pews in front of him. She did not glance at him or give any sign of recognition, but seeing her again, hatred welled in him; he did not like witnesses to his failures, and the inconclusive hijack still rankled.

He got up to further the charade, placing a coin in one of the brass

boxes and switching on one of the fake candles, mocking the Virgin above the garish altar as he mouthed his own prayer: *Holy Mary, bring us chaos.* Then he went and sat close to Pamela. "I'll do all the talking," he whispered.

Pamela knelt as though in prayer, her head below the level of the pew in front of her, so that she was partially concealed and able to glance sideways at him.

"Are you sure you were not followed?"

Pamela nodded.

"Do you have a safe place where we can talk?"

She nodded again.

"This is what you do. Turn left when you leave here and follow the road around. Walk slowly until I draw up alongside you, then get into my car quickly. I will leave now."

He got up, genuflected again in the center aisle and left. Once in his parked car, he waited until he saw Pamela come out of the church, then slowly drove after her. He caught up with her a few yards further on and she got in.

"Take me the shortest route," he said.

After she had given him the first directions, Pamela said, "Was it a surprise to see me again so soon?"

He made no reply.

"I'll never get over the coincidence that I was on that particular flight. It was scary. I'm sorry it didn't work out as planned for you, but I was glad when it ended."

Her condolences angered him; he lost concentration and was forced to brake sharply as a Mercedes cut in front of him. He swore in Spanish, another indication that he was rattled.

"They drive like maniacs here," Pamela said, reaching to attach her safety belt. "Turn left at the next light and follow the autostrada signs."

"Did you know that Günther is dead?" she said, breaking the silence and referring to her ex-lover, who had first introduced her to the Fat Boy.

"So?"

"Just making conversation. I miss him. He was good."

"But not good enough to stay alive."

"He was unlucky." His attitude forced her to be defensive. "The explosive he was using was unstable."

"He was just another amateur, playing at it. What is this place we're going to?"

"One of Control's safe houses that he uses himself."

"Have you used it before?"

"No, but if you're that uneasy why don't we talk now? I take it you're driving a clean car."

"Just give the directions."

They headed out of Rome in the direction of the airport. The traffic thinned as they gained the autostrada, and eventually they turned off and made for a small village. When she finally pointed out the house, the Fat Boy drove straight past it, continuing for half a mile before he pulled in by a small wood.

"What's wrong?" Pamela asked.

"Everything. You call that safe? Two strangers arriving in a deserted village? What d'you take me for? You think you're still dealing with your dead boyfriend?" He drummed his gloved hands on the steering wheel.

"It was the house I was told to use."

"Fucking amateurs, the lot of you. No wonder London has to call me in every time they want something done properly."

Pamela reached into her handbag for a cigarette, but before she could light it he tore it out of her mouth.

"Don't you know cigarette butts can hang you? How many of the locals smoke British Dunhills, you stupid cow?"

Then, at the sound of a car approaching, he suddenly, alarmingly embraced her, pressing his fat lips to hers, remaining in the clinch until the vehicle had passed.

"Was I supposed to enjoy that?" she asked, wiping her mouth.

He did not answer but put the car into gear and drove on until he came to a small path leading into the wooded area. Once they were out of sight of any passing traffic on the road, he stopped, switched off the engine, got out and walked around until satisfied that the spot was completely safe.

"We'll talk here," he said, returning to the car. "Give me the final details."

"Talk about amateurs. What I've got to tell you could have been said in the church."

"Don't you know the rules? When in Rome, do it my way."

His physical presence at such close proximity in the tiny car repulsed

Pamela. She could still taste the cologne he used, and for no reason it reminded her of moments in her childhood when she had shared an apple with her mother and tasted the scent of her lipstick.

She began to outline her instructions and he let her finish without interruption, only then asking her to repeat one detail. He consulted a small pocket diary.

"The fifteenth is a Saturday."

"That's right. They always hold the last concert of the season on a Saturday."

"You're sure you've left nothing out?"

"I'll go over it again if you like."

"This shop where I get the costume—is it well known?"

"It was one I chose at random, but there are plenty of others; they're all over London. It's not a costume as such, just a funny hat or something like that. The ticket will be given to you in London. They're like gold dust."

The Fat Boy stared straight ahead, appearing to be lost in thought. On Pamela's blind side he extracted something from his jacket pocket and palmed it.

"Does it give you a charge?" she asked.

"What?"

"Killing."

He shrugged. "It pays well." Then, uncharacteristically, though aware that nothing would be lost, he felt the urge to boast. "This one especially. I could retire after this one."

"And will you? Quit while you're ahead? There must come a moment when the luck runs out. The law of averages."

He turned and smiled. "It's like roulette. There's no point in playing red or black. The only kick comes when you play *en plein* on a single number and go for the maximum odds."

"Günther felt the same way. Not that I'm comparing you."

"I'm glad, because there is no comparison. I'm the best," he said, getting out of the car. "Just let me check; then we'll go back." He disappeared from her view, returning after a short interval and seeming to be more relaxed.

"All clear?"

"Yes. Everything's fine." Again there was the unexpected softness. "Do you have a lover now?"

"Not at the moment."

"What a waste. Perhaps if I ever retire you should join me."

The thought revolted her, but caution framed her response. "I wouldn't mind getting out of the game. I don't have your confidence about the future."

"Well, it's something we should both keep in mind. No hard feelings about the hijack?"

"How could there be? It was just kismet."

"Good." He leant towards her, and again she had no time to avoid his kiss. The sheer strength of him forced her lips to open to his, and she felt him pass something into her mouth. Then his hands clamped her jaw shut, holding her in a vicelike grip.

"Swallow," he said. "Swallow."

She tried to struggle free, but it was an uneven contest. Her teeth bit into the capsule, and she tasted the acrid powder. The Fat Boy massaged her throat with one gloved thumb, easing the poison down, and the last image she had was of his smiling face.

When she was dead he removed anything that might identify her from her handbag, then carried her body into the woods as far from the road as possible. Afterward he drove straight to the airport, checked in the rented car, and caught the first available plane to London, where he disposed of her belongings.

24

KEATING SAID, "HAVE you reached a decision? We'll be moving out at the end of the week. If it hadn't been for their endless bureaucracy, we'd have finished yesterday. Just to get an extra lamp is like asking for a lock of Lenin's hair—that and the lousy weather."

Hillsden answered carefully. "I've been weighing all the alternatives. But don't think I'm not grateful for the risk you've taken already."

They were sitting in two folding director's chairs on the fringe of the unit, which was shooting a sequence by one of the bridges. Hillsden broke off as the production manager approached.

"Now what?" Keating asked, seeing the expression on the man's face. He looked mournful at the best of times, his job ensuring that he was regarded as the hatchet man by the crew.

"Slight problem, governor."

"There's no such thing on this bloody film. Okay, give me the bad news."

"Isobel's got the curse."

Isobel was the female star, a comparative newcomer who possessed that priceless asset, far removed from any discernible talent, called a *television rating,* which was the only reason she had been cast.

"What difference does that make?"

"She doesn't work when she's got the curse. It's in her contract."

"I don't believe it. Have you checked?"

The man nodded.

"Offer her more money—anything to get out of this place."

"She won't budge. She says she looks terrible. Bags under her eyes."

"Jesus Christ, that's all we need."

Keating dragged his bulk out of the canvas chair and waddled over to the camera to tackle the director. "I gather we've run out of Tampax."

"Actresses," the director said, but he didn't appear disturbed. It suited his purpose; his own contract would shortly go into overage because of the delays.

"Have you talked to her?"

"Sure."

"And?"

"She does look terrible, and this is meant to be the big love scene when he first gets the hots for her."

"What about the cameraman? You told me he was a genius when you hired him. Can't he do something? Light out her fucking bags?"

"Possibly, except she refuses to be photographed."

"I'll sue the bitch."

"That won't help us right now. Know what the real problem is?"

"There's another one?"

"She isn't getting any."

Keating stared at him, nonplussed. "Any what?"

"Cock. She likes to have a relationship with her leading men. Unfortunately, our leading man hasn't come across."

"Well, why don't you step into his shoes?"

"There are a lot of things I'll do for this film, but I draw the line there. She's a piranha in spades. I'd rather go down on a Russian roadsweeper."

"So shoot something else."

"I haven't got anything else to shoot. She's in every sequence."

"I will not be screwed like this."

"You already have been. Listen, I'm sorry, but I understand from Gerry that she has it in her contract. When it's Tampax time, the lady is a tramp. But talk to her, by all means; maybe you can charm her. I've tried and got nowhere."

"Where's Raven?"

"He went back in the hotel with her."

"So what are we supposed to do in the meantime?"

"Sit it out, I guess."

"On my money."

"What can I say? It's bring-on-the-empty-horses time."

Keating conceded defeat and walked back to Hillsden.

"Trouble?"

"I don't want to talk about it," Keating said. "This business is sick." He stared moodily into space, then took out one of his outsize Havanas and bit off the end. "Want one?"

"No. I might get to like them."

With the cigar alight and glowing Keating seemed to recover. "Alternatives," he said abruptly. "What alternatives?"

"Well, having come this far, I have to trust you. I have to believe that you contacted me with Waddington's blessing. But we're both a long way from home, and there can't be any mistakes. We know things have changed here; there is a degree of . . . not freedom exactly, not as we understand freedom; call it a loosening of the bonds. The domestic animals have been given an extra length of rope when they're allowed out for a walk; they've let a few more Jews go to Israel, and it's no longer a certain trip to the Gulag to suggest that Joe Stalin wasn't Rebecca of Sunnybrook Farm. But so far the K.G.B. hasn't been given *Scouting for Boys* as their standard textbook."

"I'm listening."

"In the beginning I didn't care what happened to me. I had precious

little to live for here; I simply wanted to get even. But since I first tried to contact Waddington my situation has changed. The only alternative I can come up with that protects Galina and my unborn child is to destroy my manuscript and just give you the facts. Assuming I convince you, you can convince Waddington in turn. He'll know what to do with it. I don't know how much he's told you already—or whether in fact he's told you anything."

"All he said was that he believed you'd been framed."

"That's too tame a word for it. Did he give you names?"

"No."

"No names at all?"

"Only yours."

Hillsden was silent for a while. The rich and almost forgotten aroma of Keating's cigar drifted past him, making him reach for a cigarette.

They were interrupted again as the production manager hovered nearby.

"Yes, what is it now, Gerry?"

"Should we wrap for the day?"

"Have I got a choice?"

"Not really."

"So why ask me? Do we know how long she's going to stay in purdah?"

"No, it's never happened to me before."

"Well, go back to the hotel and tell Raven that if he wants to finish this fucking epic he'd better get that bitch working tomorrow; otherwise I'll pull the plug on him."

"Right. I'll tell him. What about the wrap? Shall I dismiss the unit?"

"No, they're getting paid. Why should they enjoy themselves when I'm not?"

Gerry backed away.

"Can you believe this?" Keating said to Hillsden. "That stupid little cunt who Raven persuaded me was the difference between profit and loss is refusing to work because she's got the rag on. I don't know why I got mixed up in this in the first place. I need my head examined."

There was a crudeness to his sudden anger that Hillsden had not seen before.

One of the prop men came up with two glasses of sweet Russian tea. Keating took his without a thank-you. "Go on, tell me the rest."

"What if I was able to convince you that all those endless memoirs,

articles, thinly disguised works of fiction about the Firm being infiltrated at the top level were true? What if, beyond that, I was also able to convince you that the present occupant of Number Ten was put there and run by Moscow Center through Control?"

"Stranger things have happened," Keating said evenly. "The Prince of Wales married Wally Simpson. So convince me."

"First, you have to understand that they had Bayldon on ice for years. Patience, as you know, is one of their hallmarks. When I stumbled too close to the truth, they had to set about disposing of me."

"How did you get close?"

"You have to begin with a murder, the murder of my ex-mistress, a woman called Caroline Oates. At one time she and I and a character named Calder, 'Jock' Calder, were all in the Austrian station. Caroline was the bright one of the trio, bright and committed. It wasn't just a job to her; it was something more, much more. She really had a lifelong hatred of the Bolsheviks. She was onto Bayldon first."

"And told you?"

Hillsden shook his head. "Nothing as simple as that. I wasn't running her; Control was doing so direct from London, using me as the post office when it suited him, and eventually, when he realized his own position was threatened, he betrayed her."

"How?"

"Oh, he was subtle, very subtle. First of all he made sure I was safely out of the way. We'd played into his hands, you see, broken the house rules by sleeping together. That was strictly *verboten* in Control's book. Fiddling the expenses was allowed, but not fornication. Once I had been shipped home he urged her to follow up her leads and sent her back into East Berlin. It was a one-way ticket; he made sure they'd take her there. But what he hadn't allowed for was that Caroline stayed one step ahead. You never met her, did you?"

"No. I knew about her in a roundabout way."

"She was smart, as well as being the love of my life, and she'd so nearly solved all of the puzzle. To be honest, I don't think she suspected Control at that point, but before Moscow Center got her and started working her over she managed to get a vital piece of the puzzle back to England."

"What was that?"

"A very incriminating photograph."

"Of Control?"

"No, I jumped to the same conclusion at first. Not Control. Bayldon and a girl, a girl I once knew—she called herself Wendy then, but that was an alias, probably one of many she used. Had the photograph fallen into the wrong hands, it would have blown fifteen years' meticulous preparations to slide Bayldon into Number Ten Downing Street, don't you see? Any link between him and the girl would have sabotaged the master plan. The photograph was a hot number; people were killed to remove it."

"So how did you discover it?"

" 'Discover' is the wrong word. Bear with me. When Moscow Center had reduced Caroline to a vegetable, she was eventually traded and sent across Checkpoint Charlie in a wheelchair. Once she was home, Control, with his infinite compassion, arranged for her to get the George Medal—not that she would have been able to appreciate the gesture. By then they had tucked her away in a nursing home for terminal cases. They weren't taking any chances. The photograph was there, on her bedside table, just waiting for somebody to spot it."

"Where you found it?"

Hillsden looked away into the distance where the film crew were gathered in groups, passing the time. "No, it wasn't like that. I never saw her again."

"Why not?"

"That's a good question. Maybe it was guilt, maybe it was just plain cowardice, or a combination of both. If I had, things might have been very different. You might say I betrayed her by doing nothing. If I'd ever gone to see her when she came home, she wouldn't be dead and I wouldn't be here. But somebody else paid a visit, not for old times' sake, but to murder her. Somebody from her past, somebody she trusted. He had to murder her because she knew him."

"Who was it?"

"Jock. Our old friend Jock. It's possible—anything's possible—that Caroline betrayed him. . . . They took her apart, mentally and physically, so, poor darling, she couldn't be blamed for that. The K.G.B. got Jock too, but he wasn't made of the same material as Caroline; he did a deal, they turned him, orchestrated a phony death, buried him. Very neat and tidy, right down to a grave in Vienna's central cemetery. But favors have to be repaid. When they realized Caroline still had the photograph, they called in his debt and sent him to England to kill her, which he did most expertly. It's funny how you can live in close proxim-

ity with somebody, share their life, and yet not know them at all."

Keating had listened without expression. Now he said, "You mean, you never took him for a killer?"

"He was a friend, for Christ's sake! Somebody I trusted. We'd shared so much, the three of us. I cried when I got news he was dead."

"How did you find out he killed her?"

"I came here as a prize catch. You see, Control devised a really watertight way of neutralizing me, and I fell for it. I suppose if you're going to jump over a cliff you take a run at it, like a lemming; you don't pause on the brink and look back at what you're leaving. Control persuaded me to go back into the field. 'Back to where it all began,' as he put it. And I jumped. I left my wife, which was no big deal, because our marriage had been a sham for years, and went to earth. The plan I agreed to was for me to become a dropout, which I did. To make it look kosher, I went up north, got myself arrested and deliberately engineered a prison sentence. Came out, drank myself stupid until finally I was picked up again and sent to a home that rehabilitated derelicts, a quasi-religious order down in Devon. While I was there, Moscow ran me down, convinced I was ready to defect, as they were meant to, and spirited me out of the country. I played the role to the hilt, though I say so myself. The deal I had been sold provided for an eventual trade."

"Quite a story," Keating commented, and for the first time he seemed impressed.

"Don't tell *me;* I lived it. But as soon as I was out of the country Control closed the trap. I was set up as the prime suspect for the murder of Sir Charles Belfrage. Remember that case?"

"Yes."

"Dyed-in-the-wool, true-blue Tory, Eton and Cambridge, a pillar of the Establishment, but couldn't keep his fly buttoned. An upright cock has no conscience, as an uncle of mine used to say, even in such exalted circles. I knew him, not socially, but because we often liaised on security matters. As a matter of fact, we met on the day Caroline was murdered; he came with me to the autopsy. That's by the way; the only important thing is that it made me the chief suspect when he was murdered."

"And Jock?"

"They sprang Jock on me halfway through my debriefing. When I got over the initial shock of his resurrection, I was glad of his company. Ostensibly, as the old hand, he was provided as a mentor, to show me

the ropes. We were both given apartments in Moscow, and I took him at face value. You have to remember that at the time I had no reason to suspect him, and he accepted that I'd joined his club."

"So how did you suspect him?"

"Begin to have doubts?" Hillsden answered. He brought his head around and looked Keating in the eyes. "If you're to believe any part of it, I have to tell you everything, regardless of what you'll think of me afterwards. Not that my feelings matter. I'm past caring about myself. I wish to God we had a drink."

"You want to go somewhere else?"

"No, let's finish it now we've got this far. No good leaving at the end of the second act. While we were in Moscow, Jock was very restless; he couldn't understand why they were keeping him there. Like Belfrage, he was a cocksman; he liked getting his nookie regularly, Moscow cramped his style, and he had a luxury pad in Switzerland he was anxious to get back to. So with Abramov's permission and connivance a party was arranged."

"Abramov? Who's he?"

"Didn't I mention him before? He's my G.R.U. guru, assigned to me from day one."

"Sorry, I interrupted you. A party was arranged, you say?"

"Yes. A couple of local girls, some drinks, all of which was very welcome at the time. Pleasant girls, too, not obvious tarts, hand-picked and knew what the score was. We paired off. I got the blonde—her name was Inga—Jock got the brunette, and we were all set to have a good time. In fact at the start I *did* have a good time. Not sex: companionship, talk with a woman for a change. Jock had claimed the only bedroom; he didn't waste time. . . . Then it turned ugly." Hillsden paused as the memory of what had happened in the locked bedroom crowded back. "The other thing I didn't know about Jock was that his sexual tastes were . . . twisted. He could only get his rocks off—sorry, that's an Americanism I learned from him—by inflicting pain." His delivery slowed again as he searched for adequate words to describe the events of that evening. "He used his girl in the same way that destroyed Fatty Arbuckle's career. . . . Do you know what I'm talking about?"

"Fatty who?"

"He was a big film star way back but got involved in a bizarre sex scandal that rocked Hollywood. The legend is that he killed a girl with the help of a champagne bottle. Jock wasn't drinking champagne that

night, but he killed her in the same hideous way. Do I have to spell it out? It had to be hushed up, and Abramov did the necessary. He was very efficient, I have to give him that. The dead girl was removed before you could say 'Molotov.' Or maybe she wasn't dead when they came for her—I'm a bit hazy on that—but she died soon after. My girl was told to say nothing—not that she needed to be told."

"How did Abramov deal with Jock?"

"I'm getting to that. He saw me the next day and asked me to do him a certain favor. It had been decided that Jock had outlived his usefulness. Abramov offered me a trade: in return for filling in the last pieces of the puzzle—giving me the name of Caroline's killer—I was to do their job for them . . ." He paused again, watching Keating closely. "I told you I wouldn't leave anything out."

"You were to kill Jock?"

"Yes. Don't ever believe they haven't got a sense of humor. A 'certain poetic justice' was how Abramov put it."

"Jesus!"

"It was a kind of Sophie's choice."

"How d'you mean?"

"Didn't you ever read the book?"

Keating shook his head.

"Well, no matter. I wasn't prepared to accept Abramov's word for it. I had to have proof; I had to have Jock admit it to my face. That was the only way I could even contemplate it. Again Abramov came up with the answer. He suggested I trick Jock into believing that I'd got him off the hook for the girl's murder. It worked. Gratitude loosens the tongue—gratitude and a bottle of whisky. In the end he gave me the rest of the story . . . told me how, if the plot to put Bayldon into Number Ten was to succeed, they had to have a clean sheet: anybody remotely connected had to be eliminated, which was why Caroline, Glanville and Belfrage were murdered. At the same time the country was being systematically destabilized—strikes, racial conflicts fomented, an orchestrated run on the pound. It was all diabolically clever, and it worked."

Keating nodded. "Yes, it certainly worked."

"I'd already guessed a lot of what Jock told me. After all, I knew *I* hadn't murdered Belfrage or Glanville, and it wasn't that difficult for me to realize that Control had to be the mole, though I had no inkling of his real purpose until much later."

"Bayldon, you mean?"

299

"Yes, that came like a bolt out of the blue. But with Jock my only concern was to learn the truth about Caroline. Even when he finally admitted his guilt, I still didn't think I could go through with my side of the bargain, except for the way he justified himself. To hear him tell it, killing Caroline was like putting an old dog down, an act of charity. He didn't have any remorse; it was just a job to him."

"And that made it possible, did it?"

"Yes. I finally found enough hate."

"How? How did you do it?"

"Is that important?"

"I guess not."

"I said I wouldn't leave anything out. He got drunk, unconscious drunk . . . If he'd ever been aware of me, I might have funked it at the last moment, but like the expression he used about Caroline—'she wasn't there,' he kept saying—he wasn't there, either. He was just an object, and I smothered him with a pillow."

Now Hillsden took a sip of tea, but it was stone cold. "He'd been buried once; now they buried him again, for real. Since then I've lived a privileged, barren life—that is, until I met Galina. There you have it, the whole story."

"Which you committed to paper?"

"Yes."

"A dangerous gamble," Keating said.

"I had nothing to lose at the time. I needed to disgorge it; it was poisoning me. It's a lot to ask, I know, but if I have convinced you and you're prepared to take the risk, Waddington will know what to do. If the situation in Britain is too hairy, tell him to plant it with the C.I.A. The Yanks will be more than happy to make use of it; they're always uneasy about Labor governments, and they'll never be completely sold on *glasnost.*"

Keating thought about this, his manicured fingers drumming on the arm of the chair. "Obviously whatever is done has to be done without directly tying it to you."

"That's all I ask, for Galina's sake."

"Have you destroyed the manuscript already?"

"Not yet. I'll wait until I know you and Waddington have succeeded."

"How will we get word to you?"

"Use the personal column of *The Times*. Just say: 'Caroline arrived home safely.' Put it in three weeks running, in case I miss a delivery."

That night, when Galina was asleep, Hillsden again slipped out of their bed and went into the sitting room. For the first time in years he thought about the home he and his wife had once shared, comparing her taste to the furniture he now lived with. Relating his story to Keating had brought the past into focus. Margot had never been able to resist the mail order bargains, acquiring useless objects, jackdawlike, to feather what he realized had been a lonely nest: a collection of miniature teapots; reproductions of Impressionist masterpieces "exquisitely framed," in the words of the brochure; a set of Apostle spoons; the complete works of Beatrix Potter—poor compensation for the children he had never given her. He looked around the room, but everything here was alien; nobody had chosen the décor, even by mail order; the only personal articles were the dozen or so books he had managed to scavenge and the small vase of flowers Galina daily put on his worktable.

He poured himself a whisky and went into the kitchen to add water to it. Catching sight of himself in a mirror, he paused and studied his face. How old I've become, he thought, fingering the salt-and-pepper beard. It was as if in unburdening himself to Keating he had not shed the past, but instead had hastened the aging process. He was committed now; the secret had been passed on like a baton in a relay race, and now he was relegated to the role of spectator, unable to see the finish line.

As he often did these days when unable to sleep, Hillsden padded to the doorway of their bedroom and stood looking at Galina. She had one arm thrown across her face—as though warding off a blow, he thought—and he could see the outline of her full breasts beneath the sheet. There was so much that he was ignorant of. Would he be equal to the responsibility when the baby came? Would he even be there to see it born? I've never had the care of innocence before, he thought. All I've ever had to protect are the lies that made up my life.

He finished the whisky standing there, then as quietly as possible crept back into the bed beside Galina. She stirred but did not wake. He put his hand on her taut stomach, wanting to share the warmth of the unknown life in her womb. He remembered something from his childhood, something his mother had told him: if you whispered to people when they were asleep, the message entered their dreams. He began to whisper to Galina, willing the words to penetrate her unconscious mind.

"I love you, and we are going to be married tomorrow; then you'll be safe." But even as he whispered the last word the doubts returned, and the last image he carried into sleep was not of Galina, but of Margot; Margot as a young girl on the day of their wedding, when brightness, not fear, had fallen from the air.

25

LLOYD POSED THE question as they took one of their hurried lunches. "So what are we left with?"

"Something that doesn't fit anywhere," Pearson said.

"Like the sweater my wife knitted me last Christmas. Do you suffer from home industries?"

"I suffer from fallen arches, an increasingly weak bladder and the delusion that I'm on top of my job. Whereas in fact we're back to square one. Somebody is one step ahead of us every inch of the way. We have a nice line of corpses and a full stop at the end of them. Pass me the ketchup."

He stared down at his Big Mac. "Why can't I be like all those laughing happy people in the ads who come dancing out of McDonald's hand in hand with all life's problems solved?" He took a bite and chewed on it slowly. "Did it ever occur to you that there was a time when crime did not pay? A time when you could eat an egg without fear, when smoking did not give you cancer but attracted the best girl on the block, when the trains ran on time and schoolteachers did not wear crotch-revealing tight jeans?"

Lloyd shook his head. "You know me, just an innocent abroad."

"The only thing that hasn't changed is graft in high places. I voted Labor at the end of the war, the first time I had a vote. It was the soldiers' vote, you know, that got them in. The rest of the world ex-

pected old Winnie to sweep the board; they just couldn't understand it. Nobody knew Attlee, any more than the Yanks knew Truman, but each in his own way changed things irrevocably. Truman gave the go-ahead for Hiroshima, and Attlee brought in the welfare state. Destroy mankind, on the one hand, but on the other make sure they have free dentures before they're incinerated."

"You really think about these things, don't you?"

"No. If I did, I'd shoot myself. All I think about is retirement. I can't wait to retire to my country estate."

"You've got a country estate? You never told me."

"I have about one eighth of an acre of a foreign field, on the Costa Brava, to be exact, which I purchased some years back in the mistaken belief that I'd spend the twilight of my years watching the sun go down from my terrace while sipping a jar or two of Fundador, only to find that most of the villains we haven't managed to catch have the same idea."

"Yes, and if it's not that it's nuclear fallout, isn't it?" Lloyd asked inconsequentially. He helped himself to some of Pearson's french fries. "So where do we go from here?"

"Don't keep repeating yourself. I don't know where we go from here. We've been led up so many blind alleys, and the walls on either side have been whitewashed. Take Waddington's death. What was he doing in that squatter's hovel? Why would he leave the security of a smart address? Then, surprise, surprise, his girlfriend vanishes without trace before we can get to her. That smacks of a tip-off, doesn't it? Almost as if, in the midst of all the other changes this government has brought to our lives, they've also found time to create a ministry of fear. Terrific book that, by the way; you should read it."

"They've actually published a government book?"

"Christ, you're so illiterate! Graham Greene's thriller. No, I was always inclined to believe Waddington's story, though the poor sod can't add anything to it now. He was convinced that everything led back to his friend, that Hillsden held all the answers."

"He was what—MI6?"

"Yes."

"And last heard of in Leningrad?"

Pearson nodded and pushed the remains of his meal to one side.

"Well, presumably our distinguished friends in Century House still maintain a presence in Leningrad, don't they? Or have they closed shop

since *glasnost* came into being? Can't we ask them to do our work for us and contact Hillsden?"

"You've missed the point. Waddington's theory was that Hillsden knows where the bodies are buried in Century House. If he was right, and we go to them, we show our hand. We've already strayed a long way outside our own manor. We're meant to be antiterrorist, not anti-Establishment."

"Leave it, then, huh?"

"I can't leave it," Pearson said. "I can smell the compost heap."

"This bloke whose house Waddington was staying in—what's his name?"

"Keating."

"Did they come up with anything new on him?"

"An oddball, but clean as far as one can tell. Ex-MI6, but got out years ago and went into business—the usual asset-stripping career that used to guarantee the City boys a knighthood when knighthood was in flower. However, you don't stay biologically white in that game, so we'll put him on the back burner while we make a few more inquiries. Dabbles in films now. He's involved in one at the moment, out of the country; that's why we haven't been able to interview him yet."

"Yeah, I checked on that with his office. He's in Leningrad."

"Say again."

"Leningrad."

Both men looked at each other.

"Now isn't that a coincidence!" Pearson said. "You know something? Occasionally you're worth your keep."

The Russian ambassador to the Court of St. James's gave his full attention to Abramov's instructions. He was under no illusions as to who was master in his house. London was more to his liking than Rome, his previous posting, where the Italian Communist Party had made his life tiresome. The British Communist Party, on the other hand, was unlikely to bother him, being too occupied with the local class struggle to bother with what the Kremlin dictated. The great thing about England, the ambassador had quickly discovered, was that to the majority of people politics generated about as much excitement as the graffiti in a motorway urinal. Only politicians were habitually held spellbound by the activities of other politicians.

"The changes, when they come," Abramov was saying, "will be far-reaching, and you must be ready to capitalize on them."

They were speaking in the embassy's room within a room, continuously swept for bugs and, as far as modern science could make it, impenetrable. Here cipher machines encoded and decoded satellite messages: through them flowed details of British and American operations targeted against the Soviet Union. Access to this inner sanctum was restricted to three members of the embassy staff, including the ambassador, and the resident senior K.G.B. and G.R.U. men.

"Moscow is not well pleased with the rate of progress made in the past. Your own position is under review."

"For what reason?"

"Your social profile is extremely low. You need to be seen more; the name of the game today is how human we are. Most of the people in this building look as though the tailor is still working on their suits. We need to smarten up our act. The Politburo is looking for acceleration, an initiative to regain lost ground."

"Where particularly? I am anxious to be guided."

"There is still fallow ground to be tilled. We've always had the capacity to seduce British intellectuals and gays. Now we must widen the scope of our activities. We shall still maintain our barrage of disinformation, but more subtly, I hope; the Third World is not taken in so easily any longer, and the campaign planting the idea that the Americans deliberately engineered the AIDS epidemic backfired. It was in Africa before America. Now we will concentrate our efforts on the technological front—go after the industrialists, the young City computer wizards—because the next stage of the struggle is going to be economic. In this country there is a strong anti-EEC groundswell, helped along by the mistaken enthusiasm for a Channel tunnel. One can hardly believe the stupidity of the British. For over a thousand years they have relied on that stretch of water to protect them from Europe, and now they build a terrorist paradise. Equally, there is no love lost for the Japanese; that smolders on and could be exploited. We need to gain ten lost years in as many months, and this will be achieved through industrial espionage."

"Where do you think I can be of greatest assistance?"

"Tell our visa department to cut down the waiting time for applicants. Show our face to be smiling, get the tourists flowing. We are now an open society. Intourist is shortly going to launch an advertising cam-

305

paign for Aeroflot; we have to convince the public here that we serve something more than bottled water on our flights. They are also recruiting more attractive cabin crews." Abramov smiled, the first time he had allowed the ambassador to relax.

"What about your own department's activities?" the ambassador asked with some courage. "Are they to change, too?"

"There will still be a subversive presence here, as large as we can get away with, but kept strictly in order. We want no further mass expulsions. In the past there have been too many mistakes. I shall be drafting a different breed. We will always have the edge in long-term planning, and in the final analysis, should it come to a showdown, conventional forces will be the deciding factor."

"I am grateful that you have taken me into your confidence in this manner."

Abramov deflected the flattery with a nod. "Be on your toes."

"Do the changes you envision also embrace our friends here in high places?"

"There will be certain developments, yes. You'll learn of those in due course. The next stage of the plan has been agreed on and will be put into effect shortly. I am only awaiting confirmation that certain elements are in place, and then I shall return home. It would be a mistake for me to be in England when it happens, but we shall be monitoring everything."

He led the way out of the room, passing through the sound-baffled double doors into the real world.

It was strange being married again. Hillsden had a sensation of things lost—lost loves, lost youth, lost England—and the conviction that he had finally turned his back on the past, and in so doing had created another wrong, another victim. He wondered whether he had given Galina safety or future sadness. He sat at their wedding breakfast table, a glass of iced vodka in his hand, observing Galina's happiness, listening with the concentration one gives to a stranger one meets on a long journey. Why do I have this intense distrust of life? he wondered, fingering the simple gold ring she had given him, showing her the face she wanted to see. How does one learn contentment if one is always guilty? Truth has never given real comfort in any human relationship; it's not truth we want but the counterfeit that eases self-doubt.

"You don't have any regrets, do you?" Galina asked suddenly. Her

healthy cheeks were dotted with two identical bright pink spots. He had been surprised that the old wives' tale about pregnant women "glowing" had proved accurate.

"Of course not. What a thing to ask me, today of all days."

"You looked worried just then, Alexi."

"Just my natural look. It comes with age."

"I'm very happy, and I don't care about your age."

"I'm glad." He replenished their drinks, and she dropped juniper berries into their glasses. "To my husband," she said in Russian.

He replied in kind, "To my wife."

"It takes getting used to, saying 'wife' and 'husband.' . . . Does it?" she asked. Sometimes her excellent English, shamingly superior to his Russian, lapsed slightly.

"I suppose. No, not really."

"Do they drink vodka at English weddings?"

"No, they usually drink inferior champagne out of silly glasses that look like eyebaths."

The red patches on her cheeks grew brighter. He leaned across the table and kissed her. "Why me? Why did you choose me?"

"Because I'm a revolutionary. And drunk."

"Oh, that's very flattering."

"No, I meant I'm drunk now. Suddenly."

"Then I shall take you home, Mrs. Hillsden."

"Say that again."

"Which bit?"

"Call me Mrs. Hillsden."

"I think, Mrs. Hillsden, that I shall take you both home. Your child has had enough excitement for one day."

As he helped her out of her chair and gave her his arm as they left the restaurant, it occurred to him that he no longer knew what he meant by "home."

Because of the euphoria Bayldon felt every time he entered 10 Downing Street, it had escaped his notice that a self-important job is invariably one to which, irrationally, importance is attached long after genuinely impressive people have ceased being appointed to it. He had convinced himself that he had turned the corner and that everything was now going his way. The scandal involving his wife had been deflected, the Cabinet was malleable, and despite a media-inspired scare about old age

pensioners being slowly poisoned by sausages—the latest in a long line of food health hazards that had begun in the late eighties—the government was riding high. The Tories (never a party to take Opposition in their stride and since the heady days of the Thatcher era ever more convinced that their direct line to God had been temporarily disconnected) were still conducting bitter postmortems about the cause of their downfall and feeding on their own scars. Mrs. Thatcher had retired from politics, and since there was no longer a House of Lords had been deprived of a peerage, historically the golden handshake former prime ministers awarded themselves. She was now the chairperson of a large chain of supermarkets, and it was her sausages, her critics claimed, that had been responsible for hastening a few geriatrics' progress to the grave.

Never one to shirk stealing from those he had at one time decried, Bayldon had embraced that all-American need to sell yourself and gave weekly presidential press conferences, as well as appearing on television at every opportunity. Using his wife's money, he had also employed the services of an ad agency, instructing them to change his image. In the old days it had been a gentleman's agreement that whenever the Prime Minister was accorded air time his opposite number would be given equal time. Bayldon had changed all that. He had ensured that his own men occupied all the top administrative posts in the BBC, and the corporation no longer operated under the umbrella of a Royal charter but was now controlled by the Ministry of Information. The commercial stations, sold off to the highest bidders in the dying months of the previous government, were subjected to crippling taxation and could now afford only to transmit reruns of forty-year-old American sitcoms and Australian soap operas.

As part of the campaign devised for him by the admen, Bayldon's image started to appear on gigantic hoardings all over the country, alongside a series of catchphrases: THERE WILL BE NO FALLOUT UNDER THIS GOVERNMENT; THE WORST CRIME IS POVERTY; STATUTORY UNEMPLOYMENT IS ABOLISHED; LIVE IN PEACE, NOT IN PIECES. In addition, he made a point of attending football matches whenever they were being televised, and went to the theater, patronizing fringe productions as well as the popular shows since he was well aware of the value of cultivating the quasi-intellectuals. He lent patronage to the leading AIDS charity and went walkabout (though heavily protected) through the annual Notting Hill Carnival to show solidarity with the ethnic

population. Nor did he neglect the need to be a man for all seasons and classes: he was seen at Ascot, the Oval and the Royal Opera House, and he cultivated the City elders. His future engagements included appearances at the Mansion House, the Edinburgh Festival and the last night of the Promenade Concerts.

Concurrent with these calculated moves and sheltered by his private office and numerous acolytes only too anxious to curry favor, Bayldon was progressively distancing himself from Control's influence. There was little or nothing Control could do about this without exposing his hand. He was compelled to wait, fine-tuning the elements in his contingency plan, in the sure knowledge that he would have the last word. Prior to leaving London, Abramov had set up a new go-between to replace Pamela, activating a sleeper in the Foreign Office who was a member of Control's club.

"Do you ever get the feeling," Pearson said, breaking into the radio commercials with his familiar preface, "that the real purpose of life has passed you by?"

The motorway being under repair, they had just navigated their way through a traffic-jammed Maidstone on their way to the coast. A new type of bomb, planted in a department store and thought to be the work of one of the animal rights organizations, had been defused in Dover the day before, and Pearson had been ordered to check it out.

"Look around you, Lloyd. This is Kent, once known as 'the garden of England.' When I was a kid we used to come hop picking here. Now the only thing you could pick up is the remains of takeaway fast food. We've been Americanized without America's vitality." He killed the radio.

"I expect you're right."

"But have you?"

"Have I what?"

"Had that feeling?"

"I forget what you asked me. I was listening to the program. I like phone-in programs; you get to know what the general public is really thinking about."

"What you get is confirmation of the general level of stupidity. Everybody is soaked in half truths, half-baked ideas, thrown at them by fatuous journalists and then spewed out again over the airwaves by idiotic disc jockeys."

"You don't like England, do you?"

"I've gone off it. In every way my life seems to have retrogressed."

"Could be you're not getting it regularly."

"Ha ha. Fat chance."

"I read the other day that even a couple of pints of beer will reduce the sperm count."

"Good. Maybe with any luck the lager louts won't be able to procreate and the race will die out. Let's talk about something more important. That alleged sighting of Rejano, our old friend the Fat Boy—what happened when you questioned the Greek?"

"He insisted he'd seen him in Athens about a month ago, then spotted him again in London."

"Whereabouts in London?"

"Kensington High Street."

"How reliable is the Greek?"

"Difficult to say. He's being held on a drugs charge and is desperate to get on our right side."

"Did he give a description?"

"No longer fat, a credit to Weight Watchers, apparently, well dressed, every inch the City gent."

"Has that been circulated?"

"Yes."

"And nothing further?"

"Not so far."

Pearson thumped the steering wheel. "The worst of it is, we've never had a decent photograph of him. The only ones on file are twenty years old. Has the V.I.P. arrivals list been checked?"

"Yes."

"Are we expecting anybody he might be interested in?"

"Well, not that I could see. . . . There's a state visit of the President of Gambia coming up in two weeks' time, and another Anglo-Irish summit, but on past form neither of those would interest him. Not that you can go by that," Lloyd added. "Just a gun for hire, isn't he? First come, first served, and put your money where your mouth is. He's had a long run."

"Well, tell everybody to keep on top of it, and give the Greek another working over. If Fatso is here, he hasn't come as a tourist, of that we can be sure."

Arriving in Dover, they went to the main police station, where the

defused bomb was still being examined by experts. It proved to be of sophisticated design, a talking teddy bear stuffed with an incendiary device. It had been taken to pieces and laid out for Pearson's inspection. The Bomb Squad major who had handled the delicate task of immobilizing it explained how it worked: "Any child picking it up and pulling the cord to activate the voice wouldn't have had any more bedtime stories. Bloody diabolical."

"How was it spotted?"

"Somebody phoned here with a warning," the local police sergeant answered. "I took the call, as a matter of fact. Not the sort we usually get; that's what makes us suspect a new loony group."

"What was unusual about it?" Pearson asked.

"Woman's voice, for a start. Named the shop but gave no time limit, then said: 'Ask me a riddle and I reply, Cottleston, Cottleston, Cottleston pie.' "

"She said *what*?"

"Yes, it fazed me too, sir. But one of my lads, a young constable new to the force, cracked it. Bloody brilliant, I thought." He paused, enjoying the moment. "*Winnie the Pooh.* Apparently he reads it to his daughter every night. That's where it comes from."

"Well, full marks to your lad."

"Funnily enough, his name's Christopher. Different surname, fortunately—not Robin—otherwise his life wouldn't be worth living now. We evacuated the building and took the dogs straight to the toy department. Happily they found it without much trouble. My guess is, it ties in with one of the animal groups. You know, woman's voice, teddy bear . . ."

Pearson nodded. "Sounds feasible."

"Nice types," the major said. "Still, all's well that ends well in this case."

"Got any leads, Sergeant?"

"No. Wish we had, sir."

"Well, carry out all the normal forensic checks, then let us have the mortal remains when you've finished. I'd like teddy for our Black Museum."

"Bit of a waste of time," Lloyd observed as they set off back to London.

"Stop complaining. You had a day by the sea. It's a funny old world.

Save the animals, but kill the kids and anybody else who gets in your way."

Trundling along the motorway just inside the limit, they came up behind an Opel. They stayed on his tail for half a mile; then Pearson observed, "That joker's got only one brake light and his exhaust muffler's about to fall off. Pull up alongside and tell him to get it fixed."

"Still a traffic cop, eh?" Lloyd accelerated and moved over into the center lane.

"Never leaves you," Pearson said. Since they were in an unmarked car, he propped a notice saying POLICE against the windscreen, then switched on their loudspeaker and picked up a hand microphone.

"You, sir, the driver of the Opel. . . . This is the police. Would you please pull over onto the hard shoulder and stop your vehicle."

He got a brief glimpse of the driver, but then the Opel accelerated away from them.

"Oh, we've got a comedian here. Hit your siren and go after him. Did you get the license number?"

"Yes," Lloyd said, enjoying this unexpected excitement. He gave it to Pearson who passed it to the central computer to be checked. They kept up with the Opel, maintaining, as per regulations, a steady distance between the two cars until word came back on the registration: it was not on the computer.

"What d'you know? We've chanced on a stolen job. Take him."

Lloyd put his foot down and they narrowed the gap, drawing level this time. The Opel swerved toward them, but had to straighten up to avoid hitting a large articulated truck. With practiced skill, Lloyd brought the Sierra alongside and hovered there. As he did so, the driver of the Opel lowered his offside front window. Lloyd saw the glint of the gun barrel and just had time to shout a warning to Pearson before the bullet caught him on the jawline just below his right ear, entering at an angle and ricocheting off the collarbone to shatter the rear window of the Sierra. Pearson grabbed the steering wheel as Lloyd slumped onto him. Some instinct made Lloyd take his foot off the accelerator, but even so Pearson could not control the car; it veered off the carriageway and careened into the crash barrier, finally coming to a stop facing in the opposite direction. The Opel had sped on out of sight by the time Pearson recovered from the impact. He radioed emergency calls for assistance and an ambulance. "Don't take chances, the bastard's armed. He's shot my number two."

There was a first aid kit in the Sierra and Pearson held a sterile pad

pressed tightly against Lloyd's wound until the ambulance team arrived. By then Lloyd had lost a massive amount of blood. Half a dozen police vehicles hurried to the scene and a police helicopter arrived overhead. Traffic on the motorway was diverted and the area was blocked off. Pearson stayed long enough to give the bare details of the incident; then the helicopter landed to lift him back to London. En route he kept in touch with the chase and got a report from the local hospital where Lloyd was undergoing surgery. His chances of survival were not rated highly.

While Pearson was still in the air, news was relayed to him that the Opel had been found abandoned on the outskirts of Bromley. The driver had vanished without a trace.

The sentry at the bottom of St. James's Street stamped his feet with parade-ground precision, momentarily startling Control as he crossed over from Pall Mall on the way to his club, and he remarked how unsuitable modern rifles were for such ceremonial duties; there had been something brutally pleasing about the old Lee-Enfields, especially when fitted with the long First World War bayonets. He remembered watching George VI's funeral procession from a balcony in St. James's; both pavements had been lined with guardsmen, and on a distant shouted command all the heads bowed over reversed rifles in perfect unison, starting at the Palace and continuing up the street to Piccadilly, like a pack of cards slowly falling one by one. It remained one of his most enduring memories. Whatever else the British got wrong, he thought, they had the knack of burying their dead with ceremonial style.

Control nodded to the head porter as he entered the building but was not greeted by name in return: it was an unwritten law that because of his position his identity would not be exposed within the marble halls.

Depositing his topcoat in the bleak cloakroom that still sported the Victorian washbasins and dripping taps he associated with the prep school he had attended as a child, Control washed his hands and smoothed his hair before proceeding to the smoking room, where certain former glories were enshrined, some of them sleeping in the large leather armchairs that made sounds resembling farts when the occupants lifted arthritic limbs from their shiny comfort. His expected companion had not yet arrived, and he took his usual seat by the bookcase, which housed a catholic collection of unreadable donations, the only item of interest being a first edition of *My Secret Life* by the anonymous Walter that had somehow slipped past the library committee. There was a smell

of wax about the entire building, pungently mingling with stale cigar smoke.

Control had originally joined this particular club on the strength of its wine cellar, and the fact that it prided itself on being the dullest club in London, though there were many other contenders for this honor. He had wanted a club where the members did not talk too much and where women, when allowed in as guests, were permitted to occupy only the annex at the back, a room more reminiscent of a ship's bar than of anything remotely feminine. Most of his fellow members shared his background—public school education, politics and the services—and, although the club had its quota of eccentrics and the inevitable infusion of business types since the sixties, it remained an agreeable oasis. It had seen better days, and every year the fees went up; on one occasion a few years previously it had been saved from extinction only by the calculated generosity of a brash industrialist anxious to buy a knighthood. In the past bedrooms had been offered to members who enjoyed the deadening effect of a London weekend, but this, too, had gone the way of all flesh—rising costs, the impossibility of attracting the right staff, and the fact that the rooms themselves resembled nothing so much as prisons decorated by Viollet-le-Duc. Only on one occasion, temporarily dispossessed from his own flat when the bathroom flooded, had Control stayed a night under the club's roof, and the experience had not been one he wished to repeat.

Now, sipping the large gin and dry vermouth brought by the steward on a silver salver, he studied a copy of *Punch,* leaving each cartoon without a smile until he was suddenly aware that the man he was expecting had entered the room.

Andrew Fonthill, an Oxford Blue who had also taken a First in constitutional history, was regarded as a coming man at the Foreign Office. Nothing in his demeanor, dress or accent suggested anything other than an Establishment figure. Perhaps the only external feature that gave rise to comment was the fact that his lips seemed scarcely to move when he spoke. Married, with two somewhat gormless daughters who were often photographed for the society pages of the *Tatler* along with his vapid wife, he exemplified that seemingly inexhaustible stock of courtiers who gravitated around the monarchy and occupied the higher echelons of the civil service. Outwardly such men appeared to have no knowledge of or interest in anything beyond their immediate circle, but in Fonthill's case the urbane façade concealed darker forces at work. His problem had always been a propensity to live beyond his

means, and it was this failing, rather than idealism, that had first suggested his potential usefulness to the Russians. In the pre-Falkland War period, when he was first secretary in Buenos Aires, he had become hopelessly entangled with the French wife of a local banker. The demands she made upon him were not only physical but also monetary, for she had expensive tastes, and he was rapidly plunged into debt. In an effort to extricate himself he had traveled the classic escape route and gambled heavily on the horses.

Such ordinary human situations often end in tragedy of one sort or another, but Fonthill's salvation had come in the guise of a G.R.U. recruiter. He was persuaded that in return for immediate solvency and future financial peace, he could render occasional services. Fonthill never thought of it as a betrayal of his country since he was a man of many conceits and felt he owed it to himself to survive. During the remainder of his stay in Argentina he supplied a certain amount of restricted information to his controller, none of which he judged to be of vital national importance. In this he was probably correct, since, as the Falklands War had demonstrated, Foreign Office know-how was lamentably inaccurate. Long before he finished his tour of duty he eased his way out of his French mistress's bed, bought himself two polo ponies, and returned home to marry his second cousin for no other reason than the fact that she had inherited an estate in Berkshire. Back in London, he settled down to the pursuit of his career and in due course was rewarded with a C.B.E. Thinking the episode behind him, he had all but forgotten the Argentina crisis when he was phoned late one night and a strange voice told him that Sir Raymond Lockfield wished to meet with him and discuss a highly confidential matter.

Thus Fonthill kept the appointment in a disturbed state of mind. He had no idea he was meeting a fellow traveler but assumed that his past was about to be exposed.

The evening began casually, and Fonthill could detect nothing on Control's observations on the international scene that gave cause for concern. Over drinks before dinner he gradually relaxed, and by the time they went into the dining room he had half convinced himself it was a false alarm.

"What day is it?" Control said, studying the menu.

"Wednesday."

"Ah, yes. They always have a decent steak-and-kidney pie on Wednesdays. Or would you prefer the duck?"

"No, the pie sounds excellent."

"You're not into any of these health fads, then? So many people don't eat proper food these days. There's a woman in my office who eats nothing but rabbit fodder. Come to think of it, she's beginning to look like a rabbit. Do you shoot?"

"When I get the chance," Fonthill said.

"I usually go up to a friend's place in Yorkshire. I must get you invited."

"Thank you. I'll look forward to that."

Control wrote out their orders and handed them to the headwaiter. "Burgundy or claret?"

"Whatever you prefer."

"I think the Burgundy if we're both having the pie. Can't give the old digestion too much to cope with. And half a bottle of Fumé for starters, eh?"

"Fine by me."

Control selected the wine and broke bread, placing tiny pieces in his mouth with all the delicacy of a spinster taking the wafer. "What I miss most is not being able to ride any more. Got a gammy hip. Well, that's only part of it. I seem to be riddled with arthritis. You ride, I take it?"

"Yes. I play polo. Keep a couple of ponies."

"Heady stuff. Where—Windsor?"

"Yes, Smith's Lawn."

"I used to like to watch it. There was one particular year, I remember, when the Argentines were wiping the floor with us. You were out there, weren't you?"

"Yes, for a period. . . . That's where I began to play." Fonthill's lips were compressed to the point where they almost disappeared.

"Like adultery, not a sport for old men. One of the compensations of getting older; it's no longer necessary to win every race . . . only the last one."

At that moment their first course was served. Eating his prawn cocktail, Fonthill was left trying to decide whether Lockfield's last remarks had any significance.

"Well, as you might have gathered, I asked you here for a purpose," Control said, his face half concealed by his napkin. "For some time now I've had you on my shopping list."

"That sounds ominous. Is it?" The composure Fonthill had heretofore maintained faded like a holiday tan on the return flight.

"One is always looking for suitable people whose loyalties are in the right place." Control paused as their empty plates were taken away and

the Burgundy brought for his approval. He took another piece of bread before tasting it. When the wine had been poured he raised his glass, and they both savored the wine.

"Drinkable," Control said, "but the whites are not what we excel in here. It's a question of price, of course, like most things in life. The cost of a decent Chablis is ruination. Not that I should be tempted; the acidity goes straight to the old joints."

It was all too casual for Fonthill's liking.

"The P.M. said something to me the other day which I think bears repeating. He said, 'The lights are coming on all over Europe.' You recall the original, of course."

"Indeed. I did my final paper on the start of the First World War."

"True, do you think?"

"Well, there's certainly been a thaw; I wouldn't put it any stronger than that. But any relaxation is welcome, don't you agree? I think the next few years are going to be very interesting."

"Yes, but as with the noble art, if one relaxes one tends to drop one's guard. And of course the noble art is anything but, merely a primeval instinct. Man needs enemies; that's the nature of the beast. So there is always a necessity to maintain vigilance. . . . That is why I thought we could use a man of your experience in these matters."

Fonthill thought, How subtly he is approaching the heart of the matter. He made no immediate response, convinced that his worst fears were about to be realized. The trap was there, baited and ready to be sprung, but he was given a further reprieve as the famed steak-and-kidney pie arrived and the Burgundy was poured. There was a certain irony to the fact that they were eating a patriotic dish while patriotism was under threat.

"Excellent pastry, but parsimonious with the kidneys," Control observed. "A note in the complaints book, I think. One must keep up standards."

There was a smear of gravy on his chin, and Fonthill wondered whether he should draw attention to it. His wife was fastidious about such things, always admonishing the children. But instead of mentioning it he said, "I'm not sure what experience we're talking about."

"Your inside knowledge," Control answered. "An invaluable commodity to interested parties. There are so many grey areas in my line of business; nothing is ever black and white, outlines get blurred. In the past that has sometimes led to unfortunate incidents. . . . So naturally one is anxious to avoid anything that could lead to a further scan-

dal. . . . Much better to turn"—he lingered briefly over the last word—
"possible embarrassments to one's own advantage. A man like yourself,
for instance—to use you as an example for the purposes of this little
chat—would not be averse to promotion, I imagine."

"Promotion?"

"Yes. I mentioned your career in the right quarters, and took the
liberty of suggesting that you are potential ambassador material—a
suggestion that was well received."

"Very flattering, I'm sure."

"Not at all; you did well in Buenos Aires, and it did not go unrecog-
nized by those who take note of such things. If we could arrive at an
accommodation beneficial to our mutual needs, it would be helpful all
around."

"Is that another way of saying you're recruiting me?"

"Oh, don't tell me I've been that obscure. How tiresome of me. I
stupidly imagined you took that for granted when you accepted my
invitation. I didn't misjudge the situation, did I? After all, it's a question
of exposure or cooperation—and you made such a quick, wise choice
with the pie that I'm sure you'll do the same where your own future is
concerned."

Smiling, Control finally dabbed the gravy from his chin.

26

SINCE THE EVENT the Fat Boy had cursed himself many times for
forgetting that the British police now operated unmarked cars on their
motorways. Although reasonably certain they had not gotten a close
look at him, he had taken no further chances: he did not return to his
original safe address but instead journeyed north by train to Bradford
and there made contact with a sleeper unit of one of the Libyan factions.

They provided him with a refuge while he destroyed all traces of "Allen Lyndon Witz" and equipped himself with a new identity. In the time still at his disposal he took steps to make small changes to his appearance, dying his hair and eyebrows blond. The gun he had used on the motorway also had to be disposed of and replaced, as did his clothes. His alias was now "John Dansie," an accountant.

Every day in hiding he scanned the newspapers for the latest on the shot policeman, anxious that the search for him would not turn into a more intensive murder hunt; he knew only too well that killing a policeman was the worst crime in British eyes. It appeared that though Lloyd was out of intensive care and his condition was stable, he was still on the critical list. From what the Fat Boy could gather, the search seemed to be concentrated on a gang of armed robbers who had been operating in the Kent area and had already shot a bank clerk. An Identikit image had been issued of one of the robbers, and this further reassured him.

"Make yourself comfortable, Alec," Abramov said. He was wearing his new uniform carrying the insignia of his enhanced rank. There were a few glints of grey in his hair, but he still looked younger than his years.

It was the first time Hillsden had ever been inside any of Abramov's private apartments. The one in Leningrad was impressive, denoting his rise to power, the furnishings modern and luxurious: he took in a Japanese television and hi-fi equipment, together with a stack of Western L.P.s, and the overall effect suggested masculine privilege. There were few feminine touches, although Hillsden was aware that Abramov did not live a chaste life. From what Inga had once let slip, he could call upon a pool of compliant girls whenever he wished.

Although the request for the meeting had taken him by surprise, Hillsden did not suspect any ulterior motive, thinking that Abramov was merely keen to talk about his trip to London.

"I thought it would be more pleasant if we talked here. The days when you and I had to meet in underground carparks and have our conversations recorded are over, thank goodness. Which vodka would you prefer?"

"I'd prefer scotch, if you've got it."

"Of course; I should have remembered. I have some excellent malt I brought back from London. Fifteen years old, according to the label."

"Malt would be fine. How was London?"

"A strange city of contrasts, I found. Dirtier than I had imagined. We

319

don't even allow people to smoke in Red Square, and I was disgusted at the amount of garbage littering your streets. It is a bad impression to give."

"But you had a good time?"

"An interesting time." He handed Hillsden his drink. "No ice, is that right?"

"Perfect."

"There are undercurrents in your society that I detected."

"Really?"

"Yes. I had some fascinating conversations with taxi drivers."

"Ah, well, they always like to air their grievances to tourists. And at least you can understand what they're saying, unlike their counterparts in New York. What undercurrents did they share with you?"

"I got a distinct feeling that not everybody is happy with the number of foreign immigrants that now make up your multiracial society."

"That surprised you?"

"I was surprised by the vehemence expressed. You are such a placid race on the outside, but fires smolder beneath."

Hillsden shrugged. "For years now tolerance has been on a short fuse, though it's conveniently ignored by the politicians. It'll be your turn next; you're now experiencing the ethnic revolution from within."

"You're not religious, are you? No, I asked you that a long time ago. You have no faith."

"It's difficult enough to have faith in one's own ability to survive without muddying the issue with religion." If I ever believed in anything, Hillsden thought, it died with Caroline.

"I ate well, that I will admit," Abramov continued. After removing his tunic and brushing off some fluff from the epaulettes before placing it on a hanger, he settled down in an easy chair opposite Hillsden. "I must confess that there London is superior to Moscow. I brought back one of the food guides and have marked those I visited." He reached into his bookshelves and extracted the volume in question, thumbing through the pages until he found the right place. "This one, for example—do you know it?" He handed the book to Hillsden.

"The Firm was never too generous with expenses. I would have had to take out a second mortgage to eat there."

"But I saw many young people patronizing such places."

"That's capitalism for you, Victor."

"I also saw many plays while I was there, including one—written by

an American, I think—about the differences between our two mentalities. A challenging evening, very well performed by one of your most distinguished old actors, but demonstrating that no matter how hard the West tries to understand our way of thinking it will never get inside our heads."

"You don't think so?"

"No. Take you, for example, Alec. You have had more opportunities than most, and yet you too fall short."

"In what way? I'm still willing to learn."

"Are you, Alec? Are you? I hope so."

There was a certain chill to his smile that reminded Hillsden of their first encounters.

"Do you recall, Alec, that when you and I became part of each other's life I said we were going to remake you? Do you remember my saying that?"

"Not exactly, but I'm sure you're right."

"Slowly, over many weeks, we began to trust each other, did we not?"

Hillsden nodded.

"We operated not as defector and interrogator, but more as two professionals each respecting the other's needs. I look back on that time with great satisfaction. Debriefing can be such a painful process sometimes. You impressed me, Alec. I admired the way you stood up to me, and of course I will always admire the way in which you passed the most difficult test I put to you. You know, of course, what I am referring to?" Again the conspiratorial thin smile.

"It's not something I'll ever easily forget," Hillsden replied. He picked up his glass and drained it.

"You wish another?"

"Not for the moment, thank you." Why is he bringing up Jock's death? he thought. The subject had not been mentioned between them since the event. The recollection brought back powerful images: Abramov's gloved hand tracing Jock's name on the steamed windscreen of the car, Jock's creased, drunken face on the pillow and somewhere a clock with a Mickey Mouse dial ticking like his own heartbeat. He remembered how casually the invitation to murder had been put to him: "If one can resolve two problems at once, there is a certain poetic justice." As though poetry and justice could ever be married to an execution.

"We were both of us, deceived, Alec."

321

Abramov waited, but Hillsden did not respond.

"Does it surprise you I said 'both of us'?"

"You've always had the ability to surprise me, Victor."

"But did I always admit to my own failures?"

"No, that's a new one. I fondly imagined that you were a stranger to failure."

"I think—maybe I said it, or maybe it was one of your more revealing remarks—that life is significant only when it is dangerous. The enigma of pain. The saints are supposed to have unraveled that final mystery of the human condition, but we lesser mortals continually have to struggle to come to terms with it. Not just physical pain, but in our case the pain of betrayal."

"We're going to have one of our philosophical discussions, are we?"

"In a manner of speaking, yes. Your Oxford dictionary defines a philosopher as one who shows calmness in trying circumstances, and as you can see I am sitting here calmness itself, even though the circumstances which bring us together on this occasion have tried me. I still admire you, Alec, and I have not yet stopped being your friend. I admire your courage, however misguided, but it saddens me that you felt the need to cling to particles of your past life."

Hillsden thought, Admit nothing, say nothing, let him tell me what he knows.

"Go back to the origins of our relationship. It's useful to remind each other how we came together. Just now I spoke of both of us being deceived. You were deceived by London, and in turn that deceit was passed to me. We got you, not Moscow Center. That was one up for us, and I was lucky that you became my property. I owe my promotion to that. But why do you think matters were so arranged?"

"I don't know. It puzzled me at the time. When I defected I expected the Third Department to claim me as their own."

Abramov did not conceal his contempt. "The Cheka," he said, deliberately using the original name of the K.G.B., "would like to think they have the edge on us. But Control couldn't risk your falling into their hands. In order for his plan to be watertight, we both had to be kept in the dark. It was vital that I accept you as the genuine article, Alec."

"What does that mean?"

"So many dark processes condition our lives, Alec, but eventually, inevitably, they are illuminated. We can never say that we will emerge unscathed from the tunnel. You see, somewhat late in the game I was

forced to acknowledge that though you told me the truths as you knew them, they were not the final truths. . . . Is that not so?"

Abramov reached for one of his foul-smelling cheroots, striking a match on the sole of his shoe.

"It's true that when I arrived here," Hillsden said carefully, "I had no idea of Jock's involvement. I thought he was dead and buried."

"Alec, I am more concerned with the whole picture than with one aspect of it. When you and I formed our friendshp—and note I still call it friendship—we were both victims of a conspiracy. The realization came to me later than you; that is why we have not had this talk before. You were sold a lie, and I bought the lie. That has grave implications for us, inherent dangers that we have to resolve."

"I never lied to you. I avoided certain areas, but I am sure you expected that."

"Alec, let's not split hairs. Your arrival here was a lie, was it not?"

"I wouldn't say that."

"You were given certain promises—promises that were immediately broken by Control. Let us consider your good friend Control for a moment. He is, after all, the instigator of our mutual discontent."

He blew a cloud of acrid smoke in Hillsden's direction, apologized, and waved it away. "Your glass is empty, and we are both going to need fortifying."

While Abramov was replenishing both their drinks Hillsden had a brief opportunity to collect his wits. Despite the protestations of friendship, he knew he was being drawn deeper into a mine field.

"You have converted me. I now prefer this to vodka. Let's drink to a solution, shall we? A solution that satisfies your dilemma and avenges me. We have both come such a long way, Alec, that it would be a pity if between us we could not arrange matters amicably. Don't you agree?"

"I'm not sure what I'm being asked to agree to."

"Have I been too subtle? Let me spell it out. You came here under false pretenses, though I admit there were mitigating circumstances. I've always known you were a romantic, Alec, and even though I can't share that rosy view of our world I have a certain respect for it. You came because you were driven by love for a cause. That is, after all, the essence of romance. Like that very good American musical I once saw, your cause, your lost Camelot, was a dead woman you once loved. Well, I helped you find the final answer, did I not?"

Hillsden nodded.

"You did us a great favor by the manner in which you disposed of that problem. Perhaps there is no greater test than to be asked to kill a friend, even a friend who has betrayed you. But you did not shirk it, and that is why we are sharing a drink and I am prepared to return the favor—to even the score, as it were."

Again Hillsden gave no response.

"But let us go back to the beginning. Let's consider the character of Control. Any man who has neither a wife nor a mistress and leads a life which on the surface is above suspicion should always be approached with care. Would you accept that?"

Hillsden nodded.

"So this man of contradictions, who had the power of life and death over you, whom you did not suspect, was in fact determined to eliminate you. Not in the brutal conventional sense—no, he was cleverer than that. Perhaps there was an element of hatred in the method he chose. You were so obsessed that you allowed your guard to drop. You played his cards for him, if I may mix my metaphors. What did he have to do? Nothing. He had only to suggest a route and you were packed and anxious to go. Stay away from Glanville, he instructed. You ignored the warning. Go back to where it all began, he said. You went willingly. He was ahead of you every step of the way."

"Yes," Hillsden said. He took the neat whisky like a convert taking altar wine for the first time.

"Now you know his motive, the extent of his duplicity. You made a brave decision, Alec, one that I can applaud, and you carried it off brilliantly." Abramov paused, smiling again. "But, my character being what it is, I always retained certain doubts. You gave us very little that we didn't already know, but your arrival in our midst came at a time when we needed a showpiece. If you recall, your defection was just after we had lost a senior officer to the C.I.A. . . . Tell me—I'm interested to know—when did you first realize that you had been tricked?"

Hillsden sensed that there was no escape. Abramov was too skilled an interrogator. He was like a Jack Russell terrier; once he had a grip he worked his prey to death. "I think I realized early on that I had said good-bye to England forever."

"Isn't that what you wanted?"

"There have been trade-offs in the past."

"But not for people like you, Alec. You said 'early on.' How early?"

"I was still in Austria waiting to be smuggled out, and I was shown

the English newspapers with my face on the front pages, wanted for the murder of that diplomat."

"Belfrage. Wasn't that his name?"

"Yes."

"Control made sure the door was securely locked. A spy who recants might possibly be forgiven, but not the murderer of a pillar of society, a member of your Establishment."

"It was a clever move."

"Of course, in a sense, if you can see the irony of it, you eventually performed his last task for him. Your friend Jock was the only remaining conspirator. He remained a threat as long as he was alive because, as we know, he could be bought. That is an irony, don't you agree?"

"That's one way of describing it."

"The fact that you knew you'd been tricked before you arrived here further reflects to your credit. You performed well, Alec, a truly professional job. To be betrayed by one's enemies is painful enough, but to be betrayed as you were is a living death. You could not endure it, could you, Alec? It burned into your soul. I understand that. You needed to take your revenge. In your place I would have done the same. Who was it who said 'The soul of the spy is the model of us all'?"

"I've no idea."

"It doesn't matter. The point I'm making is that you followed the dictum that the end justifies the means. You struck back at Control from afar, fighting fire with fire."

"Did I?"

"Yes, you did. With total disregard for your own safety, moreover. Unfortunately, you underestimated me, Alec. That was a mistake. I don't hold it against you; in fact, believe it or not, I am grateful to you."

Abramov paused again, letting this sink in.

"The written word is a dangerous weapon. It can imperil the author as well as bring down tyrants. We should use it sparingly, Alec, with enormous caution."

"What're you getting at?"

"Showing you the errors of your ways. Control might have delivered you, Alec, but he failed to understand your resolve—or call it foolish courage—just as he failed to deliver the rest of the package. What is the expression you British use—'too clever by half'? Once Bayldon had been given the keys of the kingdom, Control was meant to take them back. His role was to be the keeper, but he has proved less than adequate.

325

More important, he took me for a fool, so the scenario has to be rewritten . . . has *been* rewritten . . . partly by you, Alec, and your contribution was invaluable."

Abramov stared hard at Hillsden before resuming.

"You see, from the moment you requested a move to Leningrad, I had my suspicions of what you might be planning. In my place you would have reacted in the same way. Total trust is never part of our way of life, is it? . . . You didn't always need your winter overcoat by the Black Sea, did you?"

Panic twisted in Hillsden's body like an unborn child, and it required a conscious effort to keep his face composed.

Abramov smiled again. "Nobody's perfect, not even you, and you're as good as they come. There was a time, after Inga left, when the house was unattended and I had it searched. A fascinating document: so much detail. You write very well; it is the journal of an angry man. Well, that's understandable. You have a great deal to be angry about."

Finding his voice, Hillsden said, "Why have you waited this long to tell me?"

"We're a patient race, Alec. There's never anything to be gained by haste. My father never ran anywhere, but he always arrived on time. It was an invaluable lesson he taught me."

"And now what? Now that you have told me?"

"That's a good question, and I could answer it in many ways. You're lucky, Alec, that we have this bond between us. Had the information fallen into other hands, the outcome would have been hideous for you. Since the discovery I have given the matter much thought, examining all the possible alternatives. . . . I have to protect myself, as I'm sure you appreciate. My own feelings toward you might not be the same as my superiors."

"I realize that. Thank you."

"But you don't yet know what you're thanking me for. That still has to be decided. However, to move on, I admired the way in which you got word back to your friend in London. The blackmail of that pathetic tourist was a clever ruse; it showed that you had taken the trouble to learn our methods. And it succeeded. Your message was received as you planned. Your friend Waddington made the contact and deciphered your code."

"If you knew all this, why didn't you move earlier? Why wait until now?"

326

"Perhaps, Alec, you were doing my work for me. We were running Kiprensky. We pushed him onto Frampton. Did that never occur to you?" Seeing surprise flood into Hillsden's face, he smiled and continued, "One of your rare lapses, though two great minds were thinking alike, which is all that matters. Your manuscript contained a great deal of information that was new to me, much of it of personal interest. It enabled me to fill in certain gaps. As I said earlier, we were both deceived by your sea green Control. He seems to have overstepped his authority and taken decisions without first clearing them with us. Eliminating players should never be done crudely, in a panic. That is always a dangerous route. Waddington and Frampton had further uses alive. Therefore I had to take matters into my own hands. I don't have to tell you that the name of our game is survival. Take your present position: you wish to survive because of your unborn child. But in order to protect ourselves it sometimes becomes necessary to reduce the number of players."

Abramov paused and flicked an inch of ash from his cheroot. "What you had no means of knowing before you embarked on your literary efforts was that we had already made certain moves. We are patient, as I said, but even our patience wears thin when the desired results fail to materialize. It became necessary to jolt our friend in London out of his complacency."

"Which friend are we referring to?" Hillsden asked. "You have more than one in position, surely?"

"The one that matters. The one who by his very title should be in control, guiding the others. We gave him a little fright, something to disturb him. We discovered long ago that the cutting of umbilical cords has a salutary effect. Isolation in any form usually produces the desired results. We took his main contact out of circulation."

"Permanently?"

"There's no value in temporary measures."

"Somebody I would know?"

"I doubt it. A nonentity named Mitchell, well situated at your G.C.H.Q., where he had direct responsibility for all our Moscow traffic. One of our sleepers. It was a pity to lose him, but the situation demanded drastic action. It was done most skillfully and intended to seem the handiwork of the I.R.A., but we hadn't allowed for the expertise of the antiterrorist squad. They have a Commander Pearson you might know."

"Pearson? Yes, the name strikes a bell."

"A man of considerable abilities, though fortunately hamstrung by a lack of resources and the fact that he's compelled to work within the law—such mistaken idealism, don't you agree, if one is pitted against the pitiless? When you are at war you don't equip your army with spears to fight tanks."

"I suppose," Hillsden said, "it's known as not descending to the level of your enemy."

"I would call it suicide. The true order of the world is violence, and violence has always to be met with violence. Why pretend otherwise?"

"Unless one pretends, life would be intolerable."

"But for the majority life *is* intolerable; that is what makes revolution possible and sustains it. . . . However, we're getting sidetracked. The good Commander Pearson was getting very close, which is why I went to London to take charge of events. Of course, I was not actively involved myself; there is no merit in soiling one's own hands when others will do the job for you. Lines of demarcation have to be drawn, Alec, even in friendship. At the first opportunity I concentrated Control's mind, and as a result he felt compelled to dispose of certain liabilities. Your gay courier was the obvious first candidate . . . and then it was necessary to deal with your ex-colleague, Waddington."

Time stopped for Hillsden. It took him several moments to find his voice. "How did they deal with Waddington?"

"He met with an accident."

"An accident?"

"Yes, something to do with a gas leak, I was told."

"Did you believe that?" Hillsden struggled to keep his voice at its normal level.

"Alec, when you decided to contact him you put him in jeopardy. I believe what I want to believe. If I'm told he died as a result of a gas explosion, then that is how it happened. Perhaps your courier betrayed you both—who knows?"

"*You* know."

"But who started it, Alec? Who set these events in motion? You have no right to be outraged. Your friend Waddington died, just as the girl died, because he knew too much. You ensured that."

"What girl are you talking about?"

"The one Waddington was sleeping with—following your example, if memory serves me. The girl who escorted you on the first leg of your

journey here. I can understand why; like you, I met her on one occasion. Had the circumstances been different, I could have fancied her; she was a sexy creature."

This revelation, coming as it did before he had recovered from the news about Waddington, had the effect of making Hillsden's whole body tremble suddenly. He reached out to put his glass down, but missed the table by the side of his chair so that the glass shattered on the stone hearth. He paid no attention; he was hardly conscious of what he had done.

"You mean . . . that same girl? I never knew her real name; she called herself Wendy to me."

"Pamela, I think. Van Norden was her last name."

"And Waddington was having an affair with her?"

"Somewhat one-sided, I imagine. She didn't operate for love. She was sicced onto him by Control—isn't that the expression used over there?"

Sharp images flooded Hillsden's memory: a cabin in a cross-Channel ferry, Pamela's naked body in the narrow bunk they had shared on that last journey from England, the answer she had given him when asked what spurred her on: "It's a game, isn't it? You play it for all it's worth until it ends." Now he wondered how it had ended for her.

"One has to break all the links in a chain, Alec, if one is to feel secure. Would you like a fresh whisky? You look as though you're in need of one."

"You enjoyed telling me all that, didn't you?"

"You had to be made aware of the results of your actions, my friend. It's part of your reeducation. You see, now that the decks have been cleared, your own future has to be considered. No, I wouldn't say I've enjoyed this conversation. In many ways, you've been a great disappointment to me. The only reason we are here sharing these confidences is because all unknowingly, and for quite the wrong motives, you have actually helped to solve a problem for us. Equally, I have personal reasons that enable me to take a lenient view of your betrayal. I'm an ambitious man, Alec, and it wouldn't look good on my record if you were shown to be my failure; it could have a very adverse effect on my career, and I could not risk that. So you and I are going to conceal the truth, something we're both adept at. What I have in mind depends, ultimately, on the success of future events in England. If they work out as I believe they will, you're safe again—not totally safe, but given another chance. The proposition I am offering is this: you will say that

the idea of writing your story was mine and that we concocted it together in order to flush out the remaining liabilities in Britain. Such an arrangement will reflect the utmost credit on us both."

Abramov waited, but Hillsden said nothing.

"Not everybody would be as generous, Alec, but I have always felt we are brothers under the skin."

"And if things don't work out as you plan?"

"Then you will have to take your chances. The ground rules in our trade were laid down long ago. It's not what we do; it's whether we are caught doing it. You would be caught—by me—and our arrangement adjusted in my favor."

"Assuming it all goes smoothly, what is the price tag for me?"

"A life sentence of silence, Alec. A reasonable price under the circumstances. After all, you do have certain added loyalties now. We mustn't forget you have a Russian wife, and a child on the way; it would be a pity for the child to grow up without a father."

A different, more chilling fear struck Hillsden. He said, "Did you choose Galina for me too, like Inga?"

Abramov shook his head. "I can cause many things to happen to you, Alec, pleasant and unpleasant, but ensuring that a woman falls in love with you is beyond even my capabilities."

There was some cold comfort in that, yet having finally learned the cost of survival Hillsden felt compelled to push his luck and ask one more question: "Just tell me why?"

"Why what?"

"I thought you had it made in England—your Manchurian candidate in Downing Street manipulated by Control. My attempt to destroy that having failed, why disturb the status quo?"

"But your attempt didn't fail; that is why we are here now. Let me put it this way. I read an amusing maxim while I was in England; I think it was said in Parliament by a Tory politician, and possibly he did not mean it to come out as it did. He said, 'To sit on the fence is to be on the wrong side of it.' We never make that mistake. One must always be quick to adapt to changed circumstances, and we have the great advantage of not having to go through the democratic processes. The beauty of our system is that once the need is there we can start to adapt overnight. The world—the world you left and the world you now inhabit—has moved on since you first arrived here. Here we are going through a process of transition, a further stage in the revolution. We are

330

going to use the West for our own ends, and the time is going to come, perhaps sooner than anybody realizes, when the Western bloc will be glad of our company. You'll see, we will cease to be the enemy; the two superpowers will unite to fight the last great religious war together. It will be religion, not Communism, that will bring about Armageddon, and it will start in the Middle East when our common need for oil leaves the unholy alliance no choice. Forget the war of ideology; the Red menace will fade into the background; possession of the black gold is what will determine our fates. The internal combustion engine is a rapacious animal that we can't live without; denied it, we are helpless, our economies destroyed, we would be reduced to the status of savages. It's inevitable, Alec: if one studies history, it's always the unthinkable that eventually comes to pass."

Abramov's tone suggested that their meeting was at an end. Hillsden got up from his chair and started to pick up the pieces of broken glass.

"Don't bother. I have somebody."

They faced each other.

"I've never asked you this before, Victor," said Hillsden. "How old are you?"

"How old do you think?"

"I'm not very good at guessing ages; in the past it's always led me into trouble."

"Forty."

Hillsden nodded. "Will you ever have children, Victor?"

"Perhaps. For the moment I'm wedded to my work."

"Don't leave it too late, like me. It's taken all this time—taken a Russian woman—to make me realize that the worst betrayal is when we betray those we love."

Leaving Abramov, Hillsden went straight to Keating's hotel to warn him, but he was too late: the film unit had left that morning. He thought briefly of asking for a forwarding address; then the disciplines of a lifetime dictated caution. Despite—or maybe because of—his privileged status, such an inquiry could well arouse suspicion; he knew full well that even in the more relaxed climate the hotel staff was still the prime source of information about foreigners.

Before returning to his apartment he stopped at the post office to pick up his latest copy of *The Times*. Scanning the headlines before leaving, he read that there had been large-scale riots in London that had spread

to other parts of the British Isles. The lead story intimated that the government had not ruled out the possibility of imposing a curfew in the major cities if the disturbances continued. Naturally he had no means of knowing whether the violence heralded the softening-up process for the events Abramov had planned.

Although there were numerous explanations put forward afterwards, nobody was able to pinpoint the exact flashpoint of the first night of riots in Chelsea. Some said that it began with rival gangs of football fans after a local soccer derby between the home team and Tottenham was played under floodlights. Others blamed units of the workers' militia who ignored orders from the senior police officer to withdraw from the scene. Equally, and predictably, the police riot squads were heavily criticized for overreacting. But there was little doubt that whatever had sparked the riot, it was used by many different factions as an opportunity to pay off old scores—some directed at the police, others aimed at the ethnic population.

At the height of the disturbance some two thousand police were deployed; even so they were outnumbered. Police casualties were heavy, and towards midnight they came under fire from snipers and home-made Molotov cocktails. It was at this point that the deputy commissioner authorized the use of CS gas and rubber bullets in an effort to control the major confrontation in the area of World's End. Over sixty cars were set alight, and damage to property was later estimated to run to four million pounds. Shopkeepers subsequently reported widespread looting. In all, the police made nearly two hundred arrests, and the neighboring hospitals treated as many casualties. The final tally was one hundred and eighty injured and fourteen fatalities, including five policemen. The situation was only brought under control in the early hours of the following morning, and by daylight King's Road and its surrounds presented a scene reminiscent of the Blitz. Until the streets were cleared of debris and opened again, traffic jams built up throughout the capital, disrupting the state visit of a Third World dictator.

The Home Secretary, accompanied by the Commissioner, toured the area and later issued the usual statement that such violence would not be tolerated in a civilized society. This was of little comfort to those whose belief that they existed in a civilized society had already been irrevocably shattered.

"There is no doubt in my opinion, backed up by the reports of my

senior officers on the spot, that the whole thing was deliberately engi-
neered and orchestrated," the commissioner told the Home Secretary.

"I can't accept that without firm evidence. As you know, we have
announced we are immediately setting up a committee of inquiry."

"Whether you accept it or not, sir, I must hold to that view. Many
of those arrested came from far afield."

"But that's normal at a football match, isn't it? Since they're barred
from Europe, they're bound to seek other outlets for their violence."

"These were two London teams playing. Equally, one cannot use the
excuse that this was a ghetto riot like those in the past. This is an affluent
area, with no previous racist incidents of any consequence. The speed
with which it escalated points to a planned operation."

"I think that, like some of your men last night, you're overreacting,
Commissioner."

"Sir, I have five men dead and sixty-eight injured, many of them
seriously. I don't know how you under-react when a Molotov cocktail
sets you alight, but I suppose there must be a government pamphlet on
the subject setting out guidelines."

"This conversation is not helpful," said the Home Secretary, making
for his car and police escort.

Pearson felt his life was like the tangled weeping pear in his suburban
garden that bore no fruit. He blamed himself for the shooting of Lloyd;
if he had not started that schoolboy chase, it would not have happened.
Every day he contacted the C.I.D. to find out if they had any further
leads and made time to visit Lloyd in hospital. The stolen Opel had
proved to be the property of a butcher in Newcastle-upon-Tyne, who
was quickly cleared of any connection with the case. Although it had
been taken apart, the car was clean of fingerprints and surrendered no
other evidence.

Despite his personal involvement in this particular incident, detective
work on armed robbers was not Pearson's concern: he had other, more
pressing demands on his time. Militants in the animal rights movement
had stepped up their campaign: a research laboratory belonging to one
of the largest cosmetics houses had been firebombed, and letter bombs
had been sent to half a dozen doctors conducting animal experiments,
though all but one of these had been intercepted by a vigilant post office
staff and rendered harmless. The remaining one had slipped through the
net, and the doctor's secretary had lost a hand. Tracking down the

perpetrators was more difficult than dealing with the I.R.A. for the simple reason that when and if they were caught, they invariably proved to be ordinary citizens with no previous criminal history, often operating alone.

In Lloyd's absence, Pearson took over the interrogation of the Greek drug dealer who was being held without bail. If the Fat Boy was loose, it took precedence over everything else.

"You saw him in Athens, you say?"

"Yes," the Greek said.

"How come you recognized him?"

"I've told your people already."

"You haven't told me," Pearson said.

"What's it worth to me?"

"Right now it's worth nothing."

"I was promised a deal."

"If you convince me and if it leads to anything, then maybe you'll get seven years instead of life," Pearson answered, speaking off the top of his head. "Heroin smugglers aren't exactly favored visitors. So I'll ask you again: how come you recognized him when a dozen police forces have drawn a blank?"

"I knew him before."

"How?"

"About a year ago I had dealings in Libya."

"Dealings?"

The Greek shrugged. "Drugs, what else?"

"I don't buy that. He doesn't meddle with drugs; he doesn't need to, and he's too smart. Try again."

"It's true, I tell you. I was in Tripoli and I met with him at the house of a friend. And you're wrong. He may not deal, but he uses coke. Who doesn't?"

"I don't, for one. How did you know it was him?"

"My friend told me afterwards."

"Okay, assuming I buy that part of it, you then saw him in Athens. When was that?"

"Three weeks ago."

Pearson consulted the transcript of previous interrogations. "When my colleague questioned you, you said a month."

"Three weeks, a month, who's counting?"

"I want exact dates."

"Look at my passport. It was two days before I left."

"Where did you see him?"

"At the airport."

"Did you talk to him?"

"No. I'm not crazy."

"Do you know what flight he took?"

The Greek shook his head.

"Had he changed his appearance since Tripoli?"

"He was thinner. I've given the description."

"Then you saw him here, just before we arrested you?"

"Yes."

"Where?"

"Kensington. It's all there in your papers."

"You said you were coming out of the Underground station and he passed you on the way down?" Pearson read from the previous notes. "Did he see you?"

"I don't think so."

"You hope not anyway. And he was well dressed and clean-shaven, right?"

"Like I said."

"Take a good look at this photograph and think hard before you say anything. Is this the same man? Not a very good shot, but it's the most up-to-date one we've got." He turned it over. "Taken in Beirut five years ago. Look carefully, then tell me how much he's changed since then. Take your time and don't try to be clever. I don't want guesses. Mark any differences on this blank. Here, use this pencil."

The Greek studied the picture. "He's changed a lot since this was taken."

"Haven't we all?"

"He has dark hair now, and his chin is not like this."

"How does he wear his hair? Show me."

The Greek marked the blank outline of a face.

"And you're sure that's how it was when you spotted him in Kensington?"

"I'm sure."

"You know he doesn't travel anywhere for pleasure, so think carefully. Have you any idea why he might be in England?"

"I told you, killing people is not my scene."

"Heroin doesn't kill—is that what you're telling me? You're two of

a kind, and I don't know who I hate most. Answer the question."

"No, how could I?"

"Somebody knows; why shouldn't it be you? After all, you've admitted a connection. If we add terrorism to the other charges, you're never going to perform Zorba's dance again."

"I swear to you!"

"Well, have a good think. If you get any flashes of inspiration—I won't say *conscience,* because scum like you don't have one—ask to see me again. But only me, understood?"

"I cooperated, right? I've helped as much as I can."

"We'll see," Pearson said. He rapped on the cell door to be allowed out.

When he got back to his office, and after making sure the new description was immediately circulated, Pearson went through his various lists yet again, looking for possible targets. He had stated the truth to the Greek: the Fat Boy never traveled without a purpose. In the past his favorite victims had been Jews, though on his last known visit to England he had bungled the assassination of a prominent Jewish businessman, one of his rare failures. On that occasion they had discovered a notebook, left behind when he fled his hideout in haste, containing a hit list of a number of people in the public eye, including show business personalities, Gentiles as well as Jews, seemingly selected at random. Pearson had often puzzled over this.

Going over the same ground once again, he compared the old list with the latest ones he had compiled, looking for duplications. He studied the forthcoming public engagements of the royal family, then the schedules of members of the Cabinet, noting possible danger areas. Then he wrote a series of reports, putting his recommendations to the Palace, the Prime Minister's private office and the Commissioner of Police and MI5. He stressed that because of the possible presence of the Fat Boy, security should be intensified and members of the S.A.S. should be employed on occasions when possible targets were particularly vulnerable. Later he tracked down his S.A.S. chum, Hugh Woodley, who was at home on leave, having just finished another tour in Belfast, and gave him what details he had.

"I'm not like you people," Woodley said when he had heard the story. "I can't act unless I'm ordered to."

"Don't bullshit me. You have your own sources."

"Mostly concerned with the Irish situation, though."

"Well, you never know. Do me a favor and keep your ears peeled. I'm stymied right now. Everything I try to follow through ends in death. Remember the last occasion we met and discussed that MI6 defector, Hillsden? An ex-colleague of Hillsden's, a man called Waddington, had just contacted me with a strange story. Are you with me?"

Woodley nodded. "Something about Hillsden having written an explosive book he was trying to get smuggled out."

"That's right. Hillsden got word of its existence to Waddington using some tourist, and Waddington convinced me there was a case to answer. Well, the tourist, Frampton, was murdered, along with his father. Waddington, poor sod, was found dead in very dodgy circumstances—my conviction is that he too was murdered—and finally his girlfriend vanished without trace."

"Jesus!"

"An added factor is that we established a connection between the girlfriend and that K.G.B. man who was recently deported."

"Did the manuscript ever surface here?"

"No, not that I know of, but from the start Waddington was definitely the object of somebody's attentions. They bugged his house, and after Frampton's murder we felt it was too coincidental for comfort, so I encouraged him to go into hiding. Somehow he was flushed out, and eventually they discovered his body in some squat."

"And you've come up with nothing?"

"Hugh, I got involved early on, but I'm not a bloody detective. You know how sensitive the C.I.D. boys are if anybody poaches on their manor. I can't force the issue because I don't have any real evidence. The ones who could back me up are all dead."

"What about MI6 themselves—aren't they interested?"

"No way. As far as they're concerned Hillsden was a traitor. The last thing this government wants is to reopen the case. They remember the pig's dinner the Thatcher mob made of *Spycatcher*."

Woodley rolled a cigarette and licked the paper carefully before sealing the rough tube. "It's difficult to see how I can help."

"I realize that," Pearson said, "but I don't have anybody else to confide in."

"Originally you thought the trail could lead right back to Downing Street. Has anything that's happened since hardened that view?"

"Listen, I don't rule out *anything* any more. It seems to me that anything's possible these days. If you look at the record, why should we

believe otherwise? Read some of the memoirs that have been published. All those ex-ministers who apparently spent most of their time rushing home to write 'Dear Diary, how I stuck the knife in my best friend,' scribbling down their squalid versions of events. All the time they were in office conning us, making pious statements about the responsibility of power; then the moment they get slung out they reveal what really went on behind the scenes. Remember Wilson's moth-eaten old blood-hound, the good Colonel—sorry, Lord—Wigg? That holier-than-thou walking Gestapo. He was the one who fingered Profumo, but in the twilight of his noncareer he got nabbed curb-crawling for tarts. Don't talk to me about politicians; I'd rather lie down with panthers. What can I do, one man on my own?"

"I get the drift," Woodley said.

"The awful thing is—and it's a terrible admission—I don't want simple justice any more. I'm tired of being manipulated; I want revenge. Do you ever feel like that?"

"Two weeks ago I was in the land of bigotry. We had a patrol out on the border, breaking in some young soldiers, showing them the ropes. Except that some of them never finished the first lesson; they walked right into a booby trap and got blown to smithereens. A remote-control job, set off on the other side. I was lucky; I was in the lead group and just missed it. All that happened to me is I had to get a new uniform; my old one was covered in brains. . . . It got a mention on the news that night, sandwiched in between another stock exchange scandal and the marriage of a pop singer. So, yes, to answer you, I could do with some revenge myself."

Poor old Wadders, he deserved better from me, Hillsden thought as guilt crept up on him like a whipped cur. For the first time since he'd been a child, when for a few weeks he had believed in the Pre-Raphaelite Jesus of the Sunday-school postcards, he wished he had some sort of blind faith to turn to. But even that early, short-lived conversion had more to do with an unrequited passion for a small girl his own age than with any belief in a merciful God. He had a sudden memory of those halcyon days when love had meant sharing a bag of boiled sweets in St. Savior's dusty church hall, the innocents sitting in a circle listening without comprehension to the doctrines of an inexplicable god of wrath. Not that his weekly attendance had sprung from any true revelation: long afterward he realized he had been shunted toward God so that his

parents could have the house to themselves for the ritual of sex on a Sunday afternoon, equally incomprehensible in childhood. His passport to the country of the blind had been a penny for the collection, which had been his first betrayal, denying the missionaries half of it so that he could buy a kind of love with the gift of sweets. Now he could not even conjure up the little girl's name, though he recalled the image of her puzzled eyes before other betrayals crowded his memory. There had never been a Savior to give him absolution from a lifetime of deceit. He would carry Waddington's death to his own grave like a penitent's cross, continuing the long journey that had begun in the Austrian station. The choice had been made then, all those years ago, the choice between the risk of betrayal and the risk of love, and betrayal was a demanding god needing to be satisfied with a regular halfpenny bag of sweets by thieving children.

Time and time again Hillsden cursed his simplicity. How could he have overlooked Abramov's cleverness? The trade of spying was not conducted like a driving test; the inspectors did not give advance warning of an emergency stop. To have allowed for everything else and yet to have missed that, he deserved to be caught. The final hideous irony being of course, that all those deaths could have been avoided—Waddington's, Frampton's, the girl's. Writing my memoirs, he thought, I was so bloody sure of myself, believing I was throwing double sixes every time in a game I had to win. But there was never an end to the particular game he and Abramov played, and now the dice had been passed.

At night, ever sleepless, he would look at Galina, drawing from her the only comfort left: the realization that whatever happened he could at last love somebody without demanding a price.

27

CRUSHED BETWEEN TWO jolly female Promenaders on the packed floor of the Albert Hall—that "great Victorian cake," as it was sometimes called—Pearson sang himself hoarse during the sea shanties, for he was well aware that nobody went to the last night of the Proms to be seen and not heard. But the sound of his voice was not his prime concern. Like the other members of his team stationed around the arena, he felt slightly foolish wearing fancy dress, even though it attracted no undue attention. The perennial Promenaders, young and old, were likewise decked out for the occasion, many of them dressed like vintage *Punch* cartoons of John Bull, with waistcoats fashioned out of Union Jacks, wearing funny hats and false noses, blowing paper whistles that unfurled like snake's tongues, or waving flags and banners. It was vital, he had told his unit, for them to merge into the crowd and act like the genuine article.

Pearson's report on the possible sighting of the Fat Boy had been acted upon, and the presence of the Prime Minister and his party this evening had meant a full alert. Ensuring total security in a building like the Albert Hall was difficult at the best of times; on this occasion it was a nightmare for those concerned. Bayldon had insisted on occupying the royal box, where he was in full view of the majority of the house. The building had been swept for explosives before the audience was let in, members of the orchestra and choir had been vetted, and careful checks had been made on the occupants of the boxes on the opposite side of the arena. Tickets for the last night were always at a premium, and since it was inevitably oversubscribed, entry to the floor of the hall for the true Promenaders was allocated by lottery. All handbags had been scrutinized, but Downing Street had insisted that body searches would ruin the festive atmosphere and antagonize what was known to be a dedicated audience. In addition to Pearson's men, members of the Metropolitan police's elite C7 unit were positioned at various high vantage points around the arena.

Several times during the course of the evening it occurred to Pearson that he would never understand his own countrymen. Most comments about the youth of England emphasized loutish degeneracy, yet here he found himself among a cross section not only prepared to stand for hours listening to classical music in reverent silence, but also capable of responding to blatant jingoism, as though their once vaunted empire still existed and the entire audience had been transported back to the swan song of the Edwardian era. The hard core of dedicated Promenaders was contentedly squashed together. He could not detect any drug-induced hysteria; rather, the good-humored enthusiasm for the set proceedings seemed to stem from a true love of the occasion that needed no additional stimulus, the whole mass swaying to the familiar tunes that every year formed the second half of the hallowed ritual.

It was traditional for the Promenaders to enter into a good-humored race with the orchestra as the conductor gradually quickened the tempo; then, at the conclusion, a great roar of applause went up and those closest to the podium threw streamers and flowers toward the orchestra, so that soon the platform was inches deep in colored paper and blossoms.

There was another man on the floor of the arena who was also amazed by the atmosphere. Despite having studied and memorized the hallowed ritual of the last night, the actual performance nevertheless startled the Fat Boy. Like Pearson, he also thought how paradoxical it was that the same nation that exported the most violent tourists and football fans could also produce a capacity audience of docile music lovers.

Now expectancy hung in the air as the faithful waited for the highlight of the evening: the playing of Elgar's "Pomp and Circumstance March No. 1 in D Major," perhaps one of the most stunning tunes ever written and, by virtue of the verses subsequently given to it, transformed for many into an alternative national anthem. The emotion it generated when sung by a large crowd was a throwback to a land where perhaps there had been the prospect of hope and the realization of glory. But though the trench life of the First World War had made a mockery of those sentiments, the music itself still had the power to convert all but the most cynical. Succeeding generations sang it with fervor, perhaps harboring a subconscious nostalgia for an era they had never known and that would never come again. As with Blake's "Jerusalem," the winged chariots would be absent from their lives, the arrows of desire blunted, but it was inherent in the British character never to acknowledge that

341

their influence had waned. The Promenade audience sang for an England they would never see again.

Elgar's great march begins quietly. It was part of his genius to make his listeners wait for the splendor to come; he was rich enough in invention to afford to squander the first theme, giving no hint of what lies ahead—that sudden starburst of majestic melody that soars into the musical firmament.

Now, as the conductor raised his baton, waiting for the hall to become silent, the faces around the Fat Boy happily anticipated their coming role in the proceedings. There was a moment of total silence; then the baton descended and the first notes swelled into the hushed arena.

The Fat Boy was aware that the audience invariably demanded and were given two encores. He knew he must wait for the climax of the second encore, when the volume of sound would be at its height. He wore a comic top hat banded with a Union Jack and white gloves that gave him the appearance of an old-time minstrel. Now, as he joined in the singing of the verse, he removed the hat, allowing the gun concealed inside to slip into his hand.

. . . Mother of the Free . . .

He had loaded the gun with special ammunition designed to spread on impact and had fixed a small flag to hang down from its barrel.

. . . How shall we extol thee? . . .

He had a good view of the royal box from his position. Bayldon and the rest of his party were singing for dear life.

. . . Who are born of thee . . .

The Fat Boy's gloved fingers massaged the safety catch, and he risked another glance up at the royal box, calculating the angle.

. . . Wider still and wider . . .

The first time around the words were sung with muted fervor since the habituals knew they had to save their greatest efforts for the encores. Nobody wanted to run out of steam too early.

. . . God who made thee mighty . . . make thee mightier yet.

A solid roar of applause greeted the end of the first rendering, and the sweating conductor of the BBC Symphony Orchestra left the podium to disappear through the tunnel toward the changing rooms. It was part of the ritual to clap him back and force a repeat, and now the applause took on a deliberate rhythm. After a calculated interval the conductor reappeared and the noise swelled momentarily until once again he raised his baton and brought in the brass. The great sound swelled again, percussion and trumpets building to a new climax and

bringing the entire house to its feet. The Promenaders swayed like one amorphous mass, and to the Fat Boy's amazement he saw that several of those close to him actually had tears running down their cheeks. Looking up, he saw that Bayldon too was standing, giving him a larger target.

At the end of the first encore the audience refused to let go, demanding one final emotional splurge. Their insistence was rewarded; again the baton was raised and the buildup began again.

The Fat Boy released the safety catch. All eyes were on the orchestra as he brought the gun up to aim. With its attached flag it had the appearance of another party toy.

. . . God who made thee mighty . . .

Now his trigger finger took the first gentle pressure.

. . . Make . . . thee . . . migh-tier . . . yet . . .

The cacophony at the finale exceeded anything that had gone before: streamers arced through the air, balloons exploded, and it was at this moment the Fat Boy took aim in one swift movement, squeezing the trigger three times in quick succession. The first bullet struck Bayldon in the shoulder; then, as he twisted, his mouth gaping in an unheard cry, the second and third bullets tore most of his face away. Blood spattered his wife and other members of his party. The force of the impacts jerked him backwards, and he fell against another of his guests before slumping like a broken marionette on the velvet rim of the box.

Few in the audience were looking in his direction, but one of the police marksmen on the other side of the arena grasped what was happening and gave the alarm to the master control post over his walkie-talkie.

Sheltered in the still riotous and unaware crowd, the Fat Boy secreted the gun in his hat. He had predetermined the position of a trash basket by the nearest exit where he would get rid of the weapon. As the conductor began his customary speech of thanks, the Fat Boy started slowly to edge his way out, calmly excusing himself through the ranks like several others intent on beating the rush to the cloakrooms, but he had gone only part of the way to the nearest exit when the noise suddenly died.

On the podium the conductor had faltered in the middle of his speech, suddenly aware of the commotion in the royal box. An official in evening dress hurried to him and said something. The conductor nodded and gave way for the official to take his place.

"Ladies and gentlemen," the official announced, "I regret to inform

343

you that an attempt has been made on the Prime Minister's life." As he gave the news a single balloon exploded and a girl screamed. All eyes immediately went to the royal box, now crowded with security forces.

"Will you all remain where you are, both for your own safety and in order not to hamper the police and medical services. Do not leave your seats or make your way to the exits. It is believed that the assassin is still within the building. I ask everybody to remain calm."

Now the entire orchestra was on its feet, the carnival atmosphere extinguished. Most people stood in shock, some crying, unable to comprehend the enormity of what had happened. Bayldon's body had been lifted gently from the edge of the box and was no longer visible.

Immediately on learning what had taken place, Pearson had ordered all exits covered. Emergency services had been sent for, as well as police reinforcements, and outside the road was being blocked to traffic. A police marksman elbowed his way through the crowd to Pearson's side. "The shots could only have come from the floor, sir."

"Did you see it?"

"No, but I was watching the P.M. at that exact moment, and from the angle, the way it took him, the gunman must have fired from here."

"Well, we've got all exits blocked. If he's here, we'll get him."

By now armed policemen had ringed the arena, and the sight of their weapons induced a wave of panic. Some of the audience crouched down as though at any moment firing would commence. Shouted commands added to the sense of impending violence. Most of the occupants of the boxes had ducked out of sight, giving the impression that the hall had suddenly half emptied.

Experience dictated that the Fat Boy feign fear like the majority. Following the example of those nearest to him, he lay on the debris-strewn floor, the hat with the gun in it crushed beneath him. He was within sight of the exit he had chosen, but all escape routes were blocked by armed police. Although he could not believe they would risk opening fire in such a situation, he was under no illusions: his chances were nil unless he disposed of the gun.

Pearson arrived at the conductor's podium and addressed the entire house through a loudhailer. "Ladies and gentlemen, your attention, please. The building is now secure. Will you kindly obey the instructions I am about to give in an orderly manner? We intend to evacuate the building in stages and to take every precaution to ensure your safety. I must ask you to obey the orders given to you by my uniformed officers

quickly and calmly. For the moment, all those in the tiers are to remain where they are. I repeat, remain where you are. Those of you here on the floor of the hall will be directed to leave first, six at a time, when my officers give the word. Once you have been cleared, other officers outside will ask you to identify yourselves and to give your names and addresses. Once that has been done you are free to leave the area; for your own safety, do this as soon as possible without panic. Families should leave together and of course make sure that any children in the audience are accompanied by an adult. Are those instructions quite clear?"

Nobody answered, though the sound of a child crying could be heard.

As soon as Pearson finished speaking, the police began the orderly evacuation, choosing six at a time who were then body-searched as they passed through the exit doors. Although many were understandably fearful and shocked, the evacuation proceeded smoothly. Half a dozen at a time, the audience filtered out through the numerous exits.

The moment came when the Fat Boy was among the next batch to leave. He got to his feet, leaving the crushed hat on the floor, and was body-searched. Cleared, he was halfway through the exit door when a young girl in the group immediately behind shouted after him. "Sir! Mister! You dropped your hat."

For one second the Fat Boy's composure faltered and he made an involuntary turn of his head. At that moment the gun fell out of the proffered hat and dropped at the feet of one of the policemen. Before anybody had a chance to react, the Fat Boy savagely chopped the nearest man in the side of the throat, the force of the blow toppling him into his companion and opening up a narrow escape route. There were too many people milling about in the circular passageway for easy pursuit, nor did the Fat Boy present an immediate target for the police guns. He ran through the screaming crowd, cannoning into and scattering everybody in his path, desperately seeking an exit. Alerted by radio, at least a dozen armed police gave chase, converging on him from both directions as he raced around the rotunda. Because of the geography of the building and the fact that Pearson had sealed off all the stairways and exists, the Fat Boy had nowhere to go. Inexorably the gap between him and his pursuers narrowed. There was a moment when he considered taking a hostage but realized it could only be a delaying tactic before the inevitable end. He backed into one of the deserted bars only to find that it was windowless and had no exit. Cornered, he turned to

face the guns just as Pearson arrived on the scene. "Fuck you!" he screamed. "Fuck you all!" slipping the capsule between his fat lips and biting on it.

"Take him," Pearson said, but as four armed police advanced into the room the Fat Boy slumped behind the bar counter, falling sideways into a pool of spilled Coke that seeped from under him like blood. He was unconscious by the time they reached him and dead before they could remove his body from the room.

28

THE RIGHT HONORABLE Toby Bayldon lingered for seven hours beyond the moment when the lethal capsule ended his assassin's notorious career. Despite the combined and dedicated efforts of the surgical team at the Hammersmith Hospital, it proved impossible to save him. His wife and members of the Cabinet who had been summoned to the scene, including the Deputy Prime Minister, were present when death was pronounced. A short bulletin was issued to the waiting press and news media assembled outside. Scheduled radio and television programs had played solemn music following the first news flash, and now all stations carried tributes. After conferring with the Commissioner of Police and being told that all the available evidence pointed to the assassination being the work of a lone gunman, the Deputy Prime Minister went first to Buckingham Palace for a short audience with the Monarch and from there to the BBC and ITN studios to make a statement. He was an indifferent speaker and uneasy in front of the cameras, which was possibly one of the reasons Bayldon had chosen him to be his number two.

Although shocked by such an outrage, the country as a whole took the news stoically, and there was actually a letter to *The Times* com-

plaining of the desecration done to the memory of the founder of the Proms, Sir Henry Wood. The obituaries were complimentary but not overly fulsome, most of them stating that Bayldon had proved a stabilizing influence, coming to power as he did at a time of widespread disillusion. Others gave him the benefit of the doubt, saying that his murder would prevent history from recording whether he would have been successful in carrying through his major reforms. All of them praised his integrity and parliamentary skills. There was talk of a state funeral, but the Palace felt this would set an embarrassing precedent and the idea was shelved. Much of the editorial comment immediately switched to the question of his successor. It was none too tactfully hinted that the Deputy Prime Minister lacked the necessary qualities to reunite the country in the aftermath of such a tragedy, and that what was needed was a strong man who would tackle the rising tide of violence and corruption at all levels of society.

Three days after the assassination Bayldon's name disappeared from the front pages, the headlines being given over to an appalling air crash that realized everybody's nightmare: a fully loaded 747 caught fire shortly after takeoff from Manchester Ringway airport and crashed into a densely populated suburb of the city. All but five passengers out of nearly four hundred perished, and the death toll on the ground added another one hundred and seventy-six, including fifty-two children in a kindergarten. One whole street was virtually written off the map, and the emergency services took more than a week to bring out the last body from under the mountain of debris. Few of the victims could be positively identified, and while sabotage was not ruled out, the most widely accepted cause of the crash was structural fatigue. It was the worst domestic airline tragedy ever, and the Archbishop of Canterbury called for a national day of mourning on the day of Bayldon's funeral. At the express wish of his widow a disaster fund in Bayldon's name was set up for the victims of the Manchester crash. As might have been expected, the ordinary public were far more moved by the deaths of the small schoolchildren than by the departure from their midst of a prime minister.

Having observed the minimum period of neutrality that decency demanded, the Opposition parties went on the attack, clamoring for Parliament to be dissolved and a general election to be called. On this, as on other historical occasions, they completely misjudged the mood of the electorate. In the public's mind the twin tragedies were inter-

347

related, so that some of the sympathy felt for the victims of the air crash also passed to Bayldon; in death he was accorded a greater degree of popularity than he had ever achieved while alive. Within the inner circle of Bayldon's party various soundings from around the country confirmed this view, and the question of who should lead the party into the election became a matter of some urgency. After much infighting and clandestine meetings in back rooms, three names were put forward as the front-runners. Deacon's was not among them. When the first ballot was counted, no outright winner emerged. None of the three would concede, and it went to a second vote that again ended in stalemate. Judging the moment with some of his old skills, Deacon canvassed support from the backbenchers and—not without some bogus hesitation—allowed his name to be added to the ballot. He had timed his intervention well, since the procedures had attracted widespread derision from the Opposition and a great deal of acrimony within the party. On the third ballot he was returned with an overwhelming majority, a verdict greeted with relief. The following day he went to the Palace; Parliament was dissolved and a general election was called.

With memories of the assassination and plane crash still fresh in everybody's mind, the short period of electioneering that distinguishes the British system from the American was refreshingly free of dirty tricks. Deacon proved to be an able performer on television, statesman-like, giving the impression of being removed from the battle in the manner of de Gaulle, and his promises were few. Instead he appealed to the electorate to vote for a period of stability and reconstruction, a sentiment that went down well and cut across class barriers. The middle parties being in their usual state of confusion, the election became a straight fight between the Tories and Labor, and in the years since Thatcher, the former having never fully recovered from the shock of being thrust from office, the polls gave Deacon a healthy lead which, on the day, proved accurate. In a below-average turnout, Labor was returned to office with an overall majority of forty-six, more than sufficient to ensure a full term. The electorate returned to its customary stupor, the media allowed Deacon his honeymoon period and outwardly very little changed.

Deacon spent two thoughtful weeks before announcing his cabinet choices, bringing in several young backbenchers as junior ministers and in general appointing only those he believed he could trust. In his postelection address to the nation he promised to tackle the burning

problem of inner-city violence and the plight of old age pensioners, two very popular issues. Behind the scenes he prepared to pay off old scores and settle old debts. He had waited in the wings for a long time, and now was determined to enjoy playing the star role. Always a skillful debater in the House, he was less concerned with the day-to-day parliamentary scene than with consolidating his position in those areas where he knew he had to protect himself.

Deacon invited Control to be his house guest the first weekend he spent at Chequers, the unprepossessing Cromwellian pile that serves as a grace-and-favor dwelling for the prime minister of the day. It was here, after a dinner that could hardly be described as gourmet fare—Deacon always ate frugally—that the first of these old scores was settled.

"I think," Control said, raising a glass of port laid down by Churchill, "that modest congratulations are in order."

They were alone in the long gallery. "You fought a brilliant campaign, and perhaps you will grant that I played my own small part in bringing it about."

Deacon accepted the toast. "Though we should never forget the tragic circumstances that prompted the election."

"Indeed not."

"Naturally, I would have wished it otherwise."

"Wouldn't we all?"

"Not wishing to speak ill of the dead, it did seem to me that in certain respects Bayldon invited his own untimely end."

"Really? You think so? In what way?"

"It's always dangerous not to be the master in one's own house."

There was something about his tone, a note of overfriendliness, that gave Control a twinge.

"I always got the feeling that he was being manipulated. Again, one doesn't want to malign a man who can no longer defend himself, but the impression gained was that of a puppet."

"You mean his wife exercised undue influence?"

"Possibly that was a factor, but I was thinking of more sinister influences."

"They were never brought to my attention," Control said. "What excellent port this is. May I help myself?"

"Please. You surprise me," Deacon continued relentlessly, spotting

the ploy, "when you say you were unaware of outside pressures where Bayldon was concerned."

"There are always rumors, of course. I daresay that before long they'll rear their heads in your direction; it's a hazard of high office. My main function is to sort the wheat from the chaff."

At that moment their discussion was interrupted by a member of the staff. "Your other guest has arrived, Prime Minister."

"Oh, right. Ask him to be good enough to wait a few minutes, will you? Offer him a drink. I'll ring down when I'm ready."

"Am I in the way?" Control asked.

"Not at all. You were saying about your main function . . ."

"Yes. Looking after the security of the realm is always a balancing act. If one has a secret service, then it has to be secretive. People—especially Members of Parliament, if I may say so—feel that every aspect of confidentiality should be made public except that which concerns them personally. Is that a very cynical observation?"

Deacon did not give a direct answer. "Wouldn't you also say that also applies to the holders, past and present, of your position?" He lingered momentarily over the word "present." "We all need to recall Caesar's wife." He stretched to pick up the decanter and replenish his own glass. "A period in the wilderness has certain advantages. One has the time—employing one's own sources and using your own simile—to sort the wheat from the chaff with a degree of objectivity—sources, I might add, that appear to have a more reliable perspective on things than yourself. Tell me," he continued evenly before Control could react, "that case a few years back about your man Hillsden. . . . As I studied it, there was an element of mystery that was never fully explained."

"The facts spoke for themselves. He was a rotten egg, like too many others before him, but I think we can now say with confidence that our stables are clean."

"Clean, but perhaps not spotless," Deacon said.

"What does that mean?"

"Hillsden, it appears, like that other wretched case that surfaced some years back, had an urge to write his memoirs from afar. By sheer good fortune a précis of their contents found their way to me, and I must say they make fascinating reading. Unpublishable, of course, but of consuming interest to stable cleaners."

Control just managed to keep his face composed. He took a sip of port. "Can one ask how they found their way to you?"

"Yes, of course. Excuse me." He pressed a button on the house phone. "Charles, show my guest up."

Deacon turned back to Control. "I thought the most useful way of dealing with such a sensitive matter was to ask your successor here to explain matters. After all, we none of us want another tawdry scandal, do we? And I'm sure that once you've heard what he has to say you'll take the right course."

He stood up as a door opened halfway down the gallery and a man entered the room and advanced toward them. "I believe you know each other from way back," Deacon said as Keating joined them.

29

JUST BEFORE DAWN on a November morning, a firing squad drawn at random from units of the S.A.S. took up its position in an isolated field close to the permanent army encampments at Aldershot.

In front of them three members of the workers' militia stood bound to gun-carriage wheels secured by stakes driven into the damp soil. Each wore a uniform stripped of all insignia. Tried *in camera,* they had been found guilty of treason and the torture and murder of the ex-member of one of Her Majesty's security services, to wit Charles William Waddington.

The scene was witnessed by high-ranking officers from all three services, together with a small group of civilians, the deputy commissioner of the metropolitan police and a judge, together with an Army Medical Corps major, a Catholic priest and a Church of England padre. Two army ambulances waited on an adjacent roadway.

The officer commanding the firing squad, Lieutenant Colonel Hugh Woodley, attended by his regimental sergeant major, walked to the three men and made a final inspection of the bonds securing them. When

satisfied, he and the R.S.M. withdrew as the judge came forward to read the authority for the execution in a voice that failed to carry to the onlookers.

"Pursuant to the Suppression of Terrorism Act 1991, you have been found guilty of treason against the Crown and the elected government of the United Kingdom, for which the sentence is death. I am charged hereby to inform you that all the due processes of law having been exhausted, Her Majesty's Principal Secretary for Home Affairs could find no grounds for commuting the sentences, and that therefore the verdicts of the court of execution by firing squad will be carried out forthwith. And may God have mercy on your souls."

The three men listened without expression, staring past the judge as though trying to identify the faces in the firing squad. Once the judge had retired the two clergymen came forward passing along the line to intone the last rites. When they finished Woodley offered the condemned men blindfolds. Two accepted. He and the R.S.M. then came to attention in front of them, both turning to the left without command and marching away some thirty paces. Halting, they did a parade-ground about-face. Still at attention, Woodley gave the order to take aim.

The twelve men in the firing squad brought their automatic rifles to the ready. As was customary, only eleven of the weapons were loaded with live ammunition, and they had been scrambled before being issued.

Some of the official observers looked down at their feet in the wet grass as the sound of twelve safety catches being released broke the silence. There was a moment's pause, then Woodley dropped his hand. Each soldier in the squad fired three rounds rapid. As the reports died away a great gathering of rooks rose screaming from a nearby copse, the massed fluttering of their wings conjuring up, for some of those present, childhood images of the angels of death.

The three men sagged against their bonds, their shoulders distorted in the same way that the shoulders of cripples are contorted by crutches. Now Woodley marched forward again and removed his revolver from his side holster; stepping close to each man, he administered the *coup de grâce*. Then it was the turn of the medical officer to examine all three and pronounce that life had been extinguished. This done, Woodley handed over to the R.S.M., who brought the firing squad to attention before giving the order for dismissal. They marched in somewhat ragged fashion, for they were all young, as the ambulances drove across the field to remove the bodies.

352

The official party made their way to the officer's mess, where they were served a hot breakfast, the two clergymen saying grace before they ate. The Home Secretary put through a personal call to Deacon to inform him that the verdict of the court had been duly carried out without a hitch. No statement concerning the trial or execution was ever issued.

It was the first such execution since the end of the Second World War.

POSTSCRIPT

SHORTLY BEFORE THE birth of his daughter, Hillsden noticed a small item on the inside pages of *The Times*. Headed DEATH OF A DIPLOMAT, it stated that Sir Raymond Lockfield, who for many years had served in the Foreign Office, had been found dead in his car with a rubber hosepipe connected to the exhaust. At the inquest evidence was given that he had been suffering from depression and a verdict of suicide was recorded.

When next they met Hillsden naturally questioned Abramov for further details.

"I know as much as you, Alec. But don't worry about it. He's at peace. That's what we're all looking for: peace the world over. Look at your splendid daughter; she's peaceful enough. We must neither of us have regrets. 'The past is a foreign country'—isn't that what you once quoted to me?"

"There's another half to the quotation: 'They do things differently there.' Who will replace him?"

Abramov looked up from admiring the new baby. "Who can tell? Anything's possible in a democracy, isn't it?"

"Yes," Hillsden said as Galina joined them, "even the impossible."

ABOUT THE AUTHOR

BRYAN FORBES was born in London in 1926 and served in British Intelligence during the war. In addition to being a distinguished director of such films as *The L-Shaped Room, King Rat, The Wrong Box* and *Seance on a Wet Afternoon,* he has just completed the TV miniseries of *The Endless Game.* His published works include six other novels and a biography of Dame Edith Evans. He is married to actress Nanette Newman and currently lives in Surrey, England.